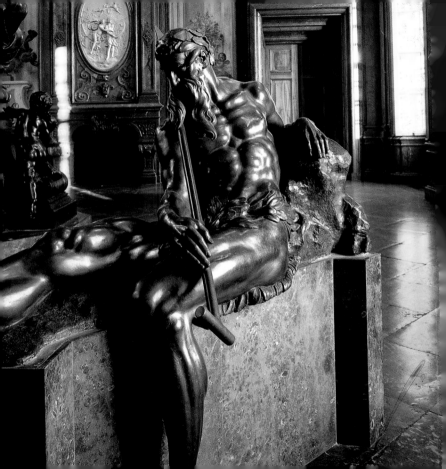

Text / Texto: Uwe Geese
Photography / Fotografías: Achim Bednorz

Sculpture

Romanesque • Gothic
Renaissance • Baroque

Renacimiento • Barroco
Románico • Gótico

Escultura

Feierabend

© 2004 Feierabend Verlag OHG
Mommsenstr. 43
D-10629 Berlin

Editor-in-chief: Rolf Toman
Layout: Rolf Toman, Thomas Paffen
Production management: Stephanie Leifert
Editing German text: Thomas Paffen
Bilingual management and typesetting:
 APE Intl., Richmond, VA
English translation: Tammi Reichel
Spanish translation: Lucía Borrero
Lithography: Maenken Kommunikation GmbH,
 Cologne
Cover Photo: © Marco Rabatti & Serge Alain
Domingie

Concept: Achim Bednorz, Rolf Taschen,
 Peter Feierabend

Printing and binding: Mladinska Knijga,
 Ljubljana
Printed in Slovenia

ISBN 3–89985–079–3
25–03070–1

ILLUSTRATION P. 2: **Georg Raphael Donner,** personification of the Enns River as an old man, originally from the Mehlmarkt Fountain, 1737–1739, tin-lead alloy, Vienna, Lower Belvedere

OPPOSITE: **Oloron,** Ste-Marie, Romanesque portal

REPRODUCCIÓN P. 2: **Georg Raphael Donner,** personificación del río Enns como anciano, original de la fuente Mehlmarkt, 1737–39, aleación de cinc-plomo, Viena, Belvedere inferior

ENFRENTE: **Oloron,** Ste-Marie, portal románico

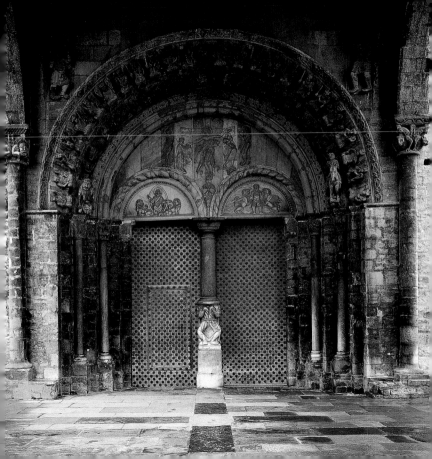

Contents

Contenido

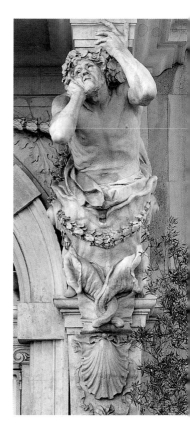

Foreword

The history of Western European sculpture is also in part a history of the reception of Antiquity. Whether it is ancient sarcophagi that are revisited by Romanesque sculptors, or ancient principles of the presentation of body position and stances that gradually and repeatedly worked their way into Gothic sculpture, the art of sculpture in antiquity frequently served as a source of innovations and inspiration. While the Renaissance era contains reference to ancient art in its very name, "rebirth," referring not only to architecture, but especially to sculpture, Baroque sculpture is also unthinkable without reference to antiquity.

This volume does not claim to represent this classicizing aspect adequately; such an account would also have to include the sculpture of Classicism. The format of this book does not lend itself to interpretation of the contents. Instead, it arose from the shared desire of the editor, photographer, and author for readers to develop and increase their pleasure in feasting their eyes on sculpture.

Prólogo

La historia del arte de la escultura occidental es también, al fin y al cabo, una historia de la recepción del arte antiguo. Bien sea que se trate de un nuevo reconocimiento de antiguos sarcófagos por parte de escultores románicos, o que se impongan en la escultura del gótico paulatinamente los principios de la antigüedad en la representación de la postura corporal y en la composición, el arte de la antigüedad es, una y otra vez, la base para el cambio y la inspiración. Así como la época del renacimiento ya lleva en su nombre el "renacer" del arte antiguo, donde junto a la arquitectura se hace referencia ante todo a la escultura, la escultura del barroco tampoco puede subsistir sin hacer referencia a la antigüedad.

La presente obra no pretende representar este aspecto por completo; para ello habría sido preciso incluir, asimismo, la escultura del clasicismo. El formato del libro tampoco se ajusta a la interpretación de contenido. En lugar de ello, cumple más bien el deseo del editor, el fotógrafo y el autor, de desarrollar y estimular en los "lectores" el deleite visual hacia la escultura.

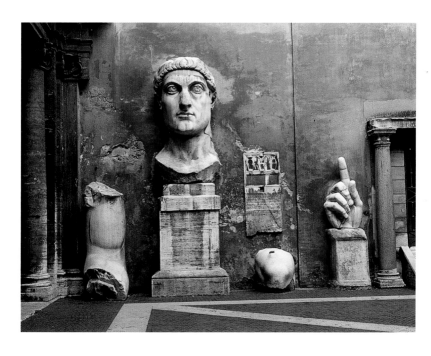

Rome, Capitoline, antique sculpture/torsos in the interior courtyard of the Palazzo dei Conservatori

Roma, colina del Capitolino, antiguas esculturas/torsos en el patio del palacio de los Conservadores

Sculpture of the
Romanesque

Around the year 1000, large-scale sculpture achieved a new respectability and simultaneous ubiquity resulting from a surge of interregional construction activity throughout the entire Christianized West. Early Romanesque sculpture at first appeared on simple architectural elements such as gables or the archivolts or lintels of portals. The former tended to depict secular themes, while the religious themes of the lintels, from which the tympanum developed, from the very beginning pointed to the fact that the portal, as a symbol of the entire church, is the most prominent location for Romanesque sculpture. In interiors, columns rest on bases and extend toward the heavens. Their still entirely earth-bound capitals are dedicated to the cosmic, since along with the vault they carry the symbolic representation of the cosmos in which God dwells. This is where Romanesque capital sculpture unfolded.

Escultura del
románico

Hacia el año 1000 las grandes artes plásticas experimentan una nueva estima y al mismo tiempo una considerable difusión debido a la actividad constructora suprarregional que tiene lugar en todo el occidente cristianizado. La escultura de principios del románico se halla ante todo en elementos arquitectónicos simples, como ménsulas de frontispicios o dinteles de portales, presentando, en el primer caso, elementos más bien profanos. Por su parte, los temas religiosos de los dinteles de las puertas, a partir de los cuales se desarrollan los tímpanos, indican ya desde el principio que el portal, en función de símbolo de toda la iglesia, es el lugar más prominente en la escultura románica. En el interior, las columnas se apoyan en bases y se elevan en dirección al cielo. Sus capiteles aún completamente mundanos se vuelven ya hacia lo cósmico, porque con la bóveda llevan la imagen simbólica del cosmos donde vive Dios. De este modo se desarrolla la escultura románica del capitel.

Romanesque sculpture is hierarchical in its formal design and subject matter, particularly the tympana above the portals: it follows strictly laid out, decidedly ceremonial, and often rigid forms that had emerged from the religious traditions. An example of this is the Christ figure standing in a mandorla (see opposite), which in this case is flanked by two angels. The pictorial themes of the capitals are freer, even achieving the burlesque at times. Although the majority of artists remain unknown, numerous artists' signatures have been handed down to us in France, Spain, and especially in Italy. Their existence demonstrates that it would be incorrect to speak of a self-conscious anonymity. The inscription on the capital shown below reads: *Gofridus me fecit* (Gofridus made me). Whether this is

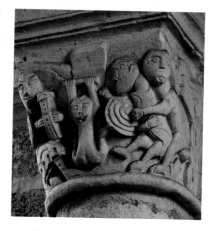

actually the name of the sculptor is not certain. Names with the tag "fecit" may name only the person who commissioned the work, rather than the artist who created it.

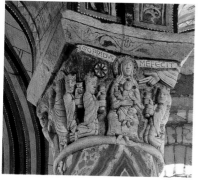

ABOVE: **La-Chaize-le-Vicomte**, capital with acrobat scene, 12th c.

LEFT: **Chauvigny**, St-Pierre, capital from the ambulatory with signature, second half of the 12th c.

OPPOSITE: **Charlieu**, St-Fortunat, tympanum of the west portal, end of the 11th c.

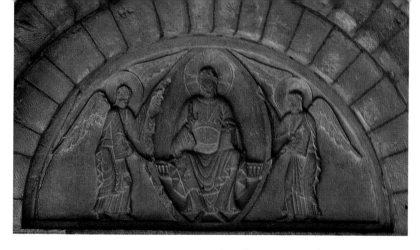

Por su aspecto formal y su contenido, la escultura románica —sobre todo en los tímpanos de los portales— es jerárquica: obedece a formas establecidas estrictamente, sin duda ceremoniales y a menudo rígidas, desarrolladas en tradiciones religiosas. Un ejemplo de ello es la figura de Cristo colocada en la *mandorla* (fotografía abajo) y flanqueada aquí por dos ángeles. Los temas de las imágenes de los capiteles se hacen más libres y en ocasiones llegan incluso a ser burlescos. A pesar de que la mayoría de los artistas permanece en el anonimato, se han transmitido, sin embargo, numerosas signaturas de artistas en Francia, España y sobre en todo Italia, las cuales demuestran que no puede tratarse de un intento consciente de anonimato. En el capitel que se presenta efrente abajo dice: *Gofridus me fecit* (Gofridus me ha hecho). No hay certeza de que estemos ante el nombre del escultor; los nombres con el añadido "fecit" suelen referirse con frecuencia sólo a quien encomendó el trabajo, no al artista que lo ejecutó.

Enfrente arriba: **La-Chaize-le-Vicomte**, capitel con escena de acróbatas, siglo XII

Enfrente abajo: **Chauvigny**, St-Pierre, capitel del deambulatorio con signatura, 2ª mitad del siglo XII

Arriba: **Charlieu**, St-Fortunat, tímpano del portal occidental, finales del siglo XI

Flavigny, St-Pierre, capital in the crypt, ca. 878

OPPOSITE: **Arles-sur-Tech**, Ste-Marie-de-Vallespir, tympanum, after 1046

Flavigny, St-Pierre, capitel de la cripta, hacia 878

ENFRENTE: **Arles-sur-Tech**, Ste-Marie-de-Vallespir, tímpano, después de 1046

Early Romanesque Sculpture in Southern France and Burgundy

The early Romanesque sculpture on some church portals in the south of France is "borrowed" from other locations. An entire group of eastern Pyrenean reliefs can be identified, which are exemplified by the door lintel of St.-Genis-de-Fontaine (p. 18/19). The examples of Romanesque sculpture in Burgundy shown here come from Dijon and Tournus (p. 16/17). The figural representations still appear quite awkward. Around 1220 an entirely different level of sculptural quality had already been attained (p. 20 ff.)

Escultura de principios del románico en el sur de Francia y Borgoña

Las artes plásticas principios del románico en algunos portales de las iglesias en el sur de Francia constan de piezas móviles. Digno de mención es todo un grupo de relieves de los Pirineos orientales que se encuentra representado ejemplarmente en el dintel de la puerta de St.-Genis-de-Fontaine (p. 18/19). Los ejemplos de la escultura románica en Borgoña consignados aquí proceden de Dijon y Tournus (p. 16/17). Las representaciones de figuras dan aún la impresión de desmaño. Hacia 1220, sin embargo, la calidad escultural se mueve ya a un nivel enteramente distinto (p. 20 y siguientes).

15

RIGHT: **Dijon**, St-Bénigne, rotunda capital, ca. 1010

OPPOSITE: **Tournus**, St-Philibert, Gerlanus arch in the upper story of the narthex, mask (left), man with hammer (right), second quarter of the 11th c.

FOLLOWING TWO PAGES:
St-Genis-des-Fontaines, , St-Genis, door lintel: Christ among angels and apostles, marble, 1019/1120

A LA DERECHA: **Dijon**, St-Bénigne, capitel circular, hacia 1010

ENFRENTE: **Tournus**, St-Philibert, arco gerlano en la planta superior de la nave occidental, máscara (a la izquierda), hombre con martillo (a la derecha), 2° cuarto del siglo XI

PÁGINA DOBLE SIGUIENTE:
St-Genis-des-Fontaines, St-Genis, dintel de la puerta: Cristo entre ángeles y apóstoles, mármol, 1019/20

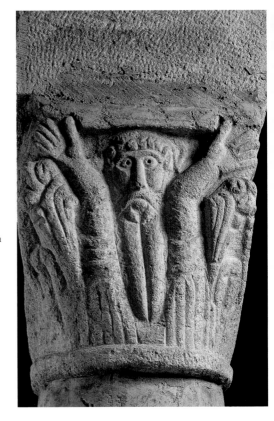

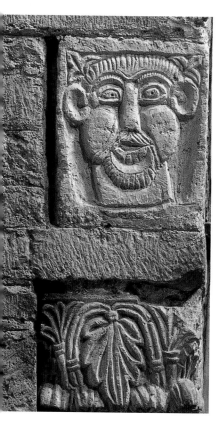
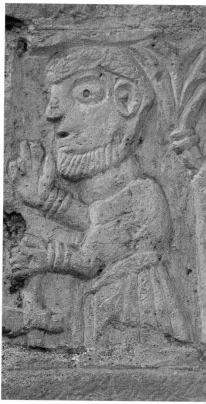

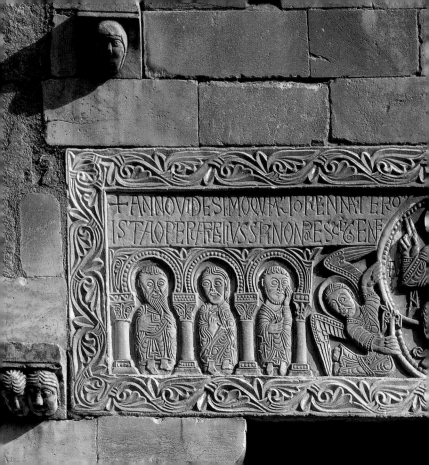

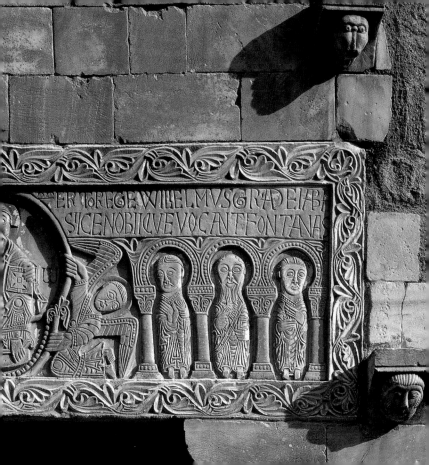

ER TOR EGE WILLELMVS GRA DEI FB
SI CENOBII CVE VOCANT FONTANA

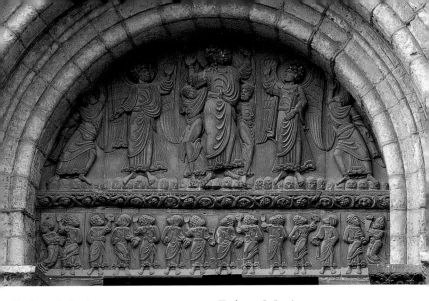

Toulouse, St-Sernin
ABOVE: Porte Miègeville, tympanum:
the Ascension of Christ; on the door lintel:
apostles, before 1118

OPPOSITE: Capital on the Porte des Comtes,
ca. 1100

Toulouse, St-Sernin
ARRIBA: Porte Miègeville, tímpano: Ascensión
de Cristo; en el dintel de la puerta, apóstol,
antes de 1118

ENFRENTE: Capitel en la puerta de Comtes,
hacia 1100

20

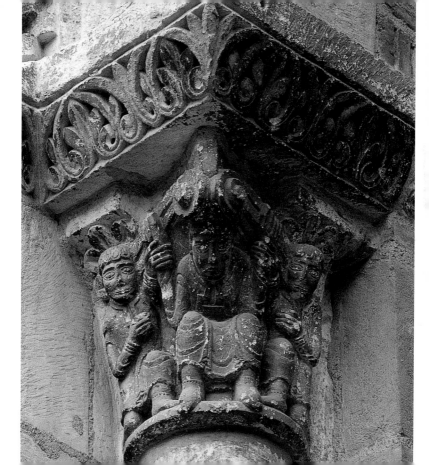

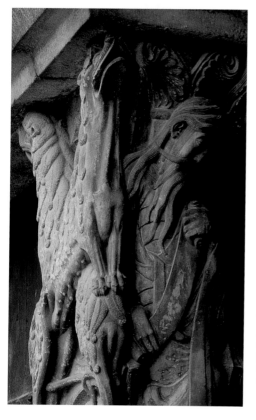

Moissac, St-Pierre
LEFT: South portal, 1120–1135,
trumeau with lions and the
prophet Jeremiah

OPPOSITE: South portal

P. 24/25: West wall of the atrium
of the south portal and detail: the
soul of a rich person is tormented
by the devil

Several figures from this portal are
of superior sculptural quality. The
prophet Jeremiah (left) is without
doubt the high point of Moissac
sculpture.

Moissac, St-Pierre
A LA IZQUIERDA: Portal sur, 1120–
35, costados del capitel (*trumeau*)
con leones y el profeta Jeremías

ENFRENTE: Portal sur

P. 24/25: Muro occidental del
atrio en el portal sur y detalle:
El alma del rico atormentada por
diablos

Algunas de las figuras en el portal
son de gran calidad escultural. El
profeta Jeremías (a la izquierda) es
considerado el punto culminante
de la escultura de Moissac.

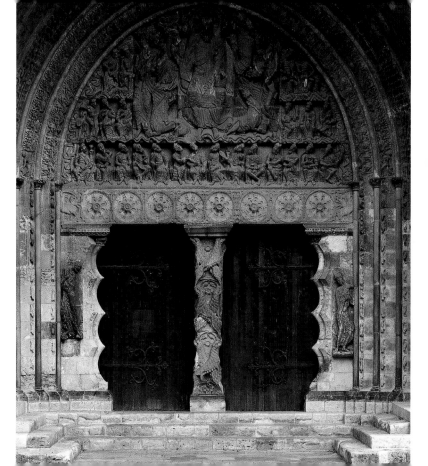

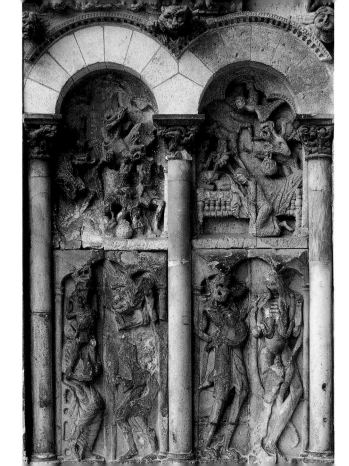

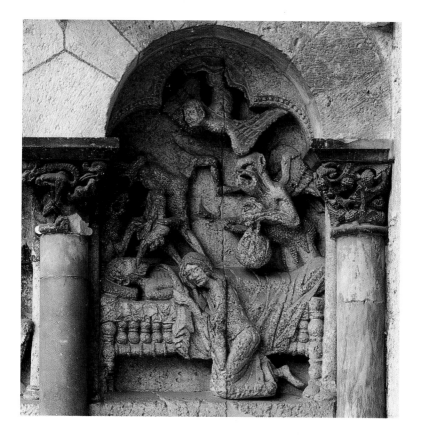

25

ABOVE, RIGHT AND P. 28/29:
Moissac, St-Pierre, cloister, column relief and two capitals in the cloister, 1100

ARRIBA, A LA DERECHA Y P. 28/29:
Moissac, St-Pierre, claustro, relieve de pilares y dos capiteles en el claustro, 1100

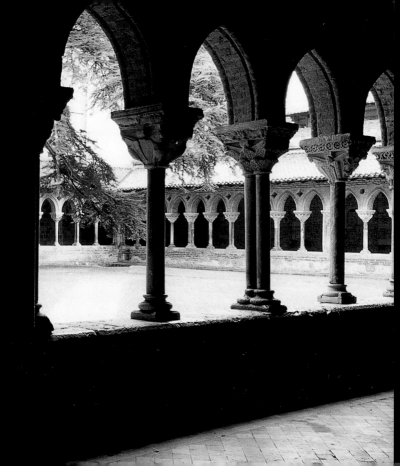

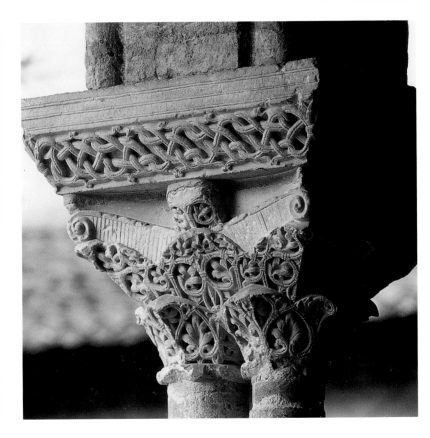

28

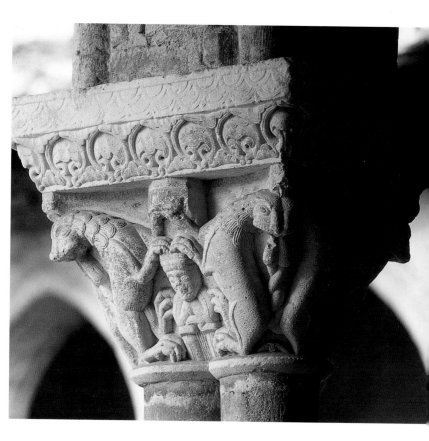

29

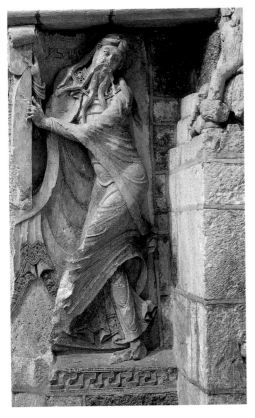

Souillac, Ste-Marie
LEFT: Relief on the interior west wall: the prophet Isaiah, 1120–1135

OPPOSITE: Detail

Stylistically, the depiction of Isaiah at Souillac is clearly derived from the Jeremiah of Moissac. With its exceptional dynamic, this Isaiah is the most significant portrayal of a prophet in all of Romanesque art.

Souillac, Ste-Marie
A LA IZQUIERDA: Relieve en el muro interior occidental: el profeta Isaías, 1120–35

ENFRENTE: Detalle

La representación del profeta Isaías de Souillac depende en su estilo directamente de la de Jeremías de Moissac. Por su dinámica excepcional, la figura de Isaías es la representación más importante de un profeta en el arte románico.

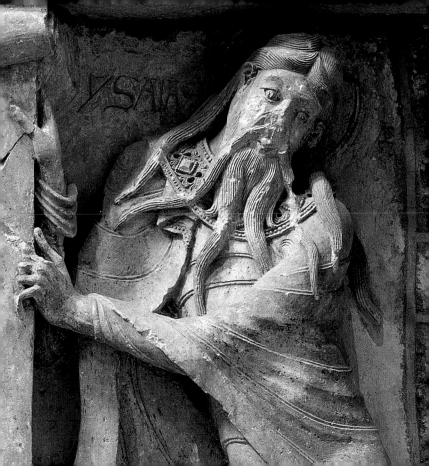

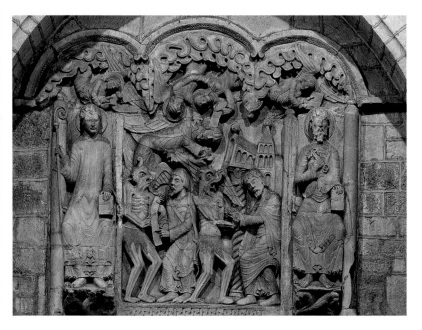

Souillac, Ste-Marie
ABOVE: Relief on the interior west wall

OPPOSITE LEFT: Former trumeau, zoomorphic beast column, now on the interior west wall, 1120–1135

OPPOSITE RIGHT: Detail, Abraham's sacrifice

Souillac, Ste-Marie
ARRIBA: Relieve, interior del muro occidental

ENFRENTE A LA IZQUIERDA: Antiguo costado de capitel, bestiario en columna, ahora en el interior del muro occidental, 1120–35

ENFRENTE A LA DERECHA: Sacrificio de Abraham

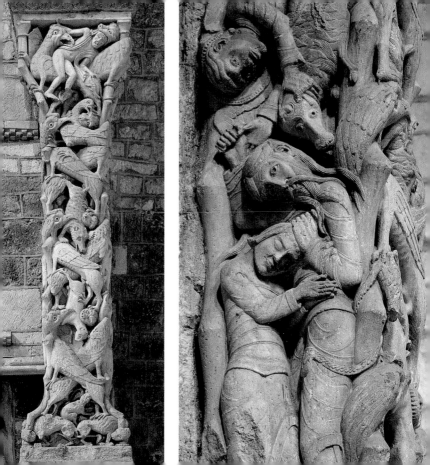

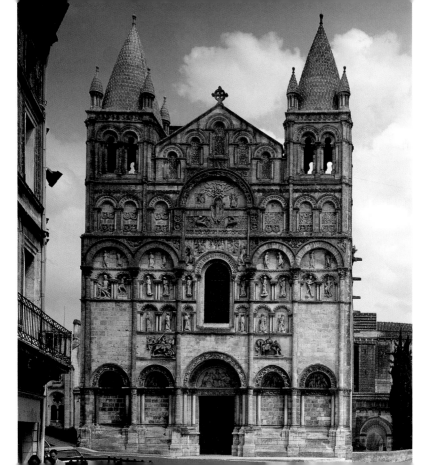

Western France

There is a rich trove of sacred sculpture in western France. Unlike in other regions, sculpture was not limited to relief-filled rounded tympana above the entrances: instead, the Church's messages are distributed across the entire facade. Especially impressive are the west views of St-Pierre in Angoulême and Notre-Dame-la-Grande in Poitiers (p. 41). The design of the upper story of Notre-Dame, which is divided into two registers of figures set in arcades, resembles the monumentalized side of a sarcophagus or shrine.

El occidente de Francia

En el occidente de Francia hay un gran número de obras plásticas sagradas. A diferencia de otras regiones, no se encuentra aquí exclusivamente el tímpano sobre la entrada ocupado con relieves. Los mensajes de la iglesia están distribuidos por toda la fachada. Particularmente asombrosas son las vistas occidentales de St-Pierre in Angoulême y Notre-Dame-la-Grande en Poitiers (p. 41). Dividida en dos registros, la planta superior de Notre-Notre-Dame semeja, con sus arcadas de figuras, el costado engrandecido de un sarcófago o relicario.

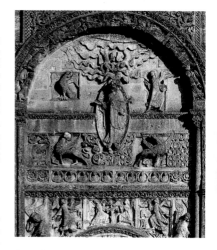

Angoulême, St-Pierre
OPPOSITE: West facade, ca. 1136

ABOVE: Central arcade of the upper story of the west facade: the Ascension, ca. 1136

Angoulême, St-Pierre
ENFRENTE: Fachada occidental, hacia 1136

ARRIBA: Arcada central de la planta superior de la fachada occidental: Ascensión al cielo, hacia 1136

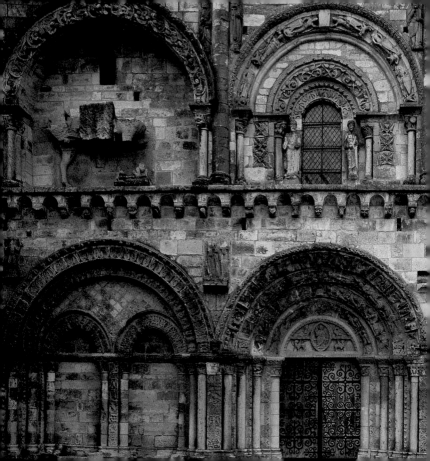

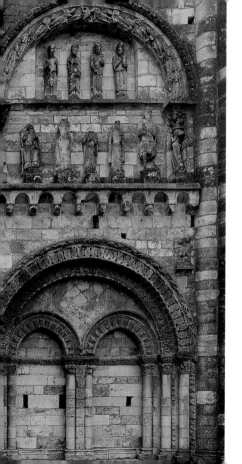

LEFT: **Civray**, St-Nicolas, detail of the west facade, second half of the 12th c.

P. 38: **Rioux**, Notre-Dame, exterior wall of the polygonal choir, last third of the 12th c.

P. 39: **Aulnay-de-Saintogne**, St-Pierre-de-la-Tour, portal of the south transept, after 1130

A LA IZQUIERDA: **Civray**, St-Nicolas, detalle de la fachada occidental, 2ª mitad del siglo XII

P. 38: **Rioux**, Notre-Dame, muro exterior del coro poligonal, último tercio del siglo XII

P. 39: **Aulnay-de-Saintogne**, St-Pierre-de-la-Tour, portal de la nave transversal sur, después de 1130

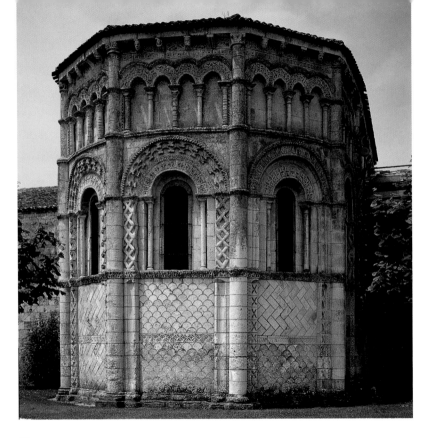

38

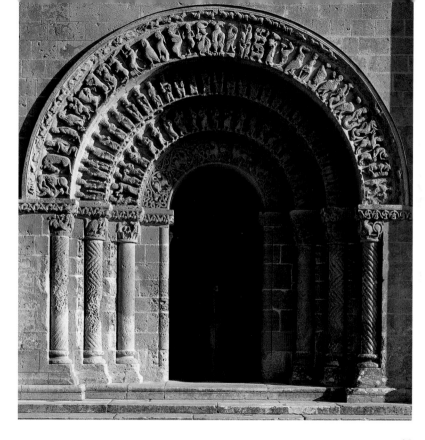

Poitiers, Notre-Dame-la-Grande
BELOW: West facade, detail: Birth of Christ,
bathing the Child, Joseph

OPPOSITE: West facade, mid-12th c.

FOLLOWING TWO PAGES: **Saintes**,
Ste-Marie-des-Dames, archivolts of the west
facade, detail, second third of the 12th c.

Poitiers, Notre-Dame-la-Grande
ABAJO: Fachada occidental, detalle:
Nacimiento de Cristo, baño del Niño, José

ENFRENTE: Fachada occidental, hacia
mediados del siglo XII

PÁGINA DOBLE SIGUIENTE: **Saintes**, Ste-Marie-
des-Dames, archivoltas de la fachada
occidental, detalle, 2º tercio del siglo XII

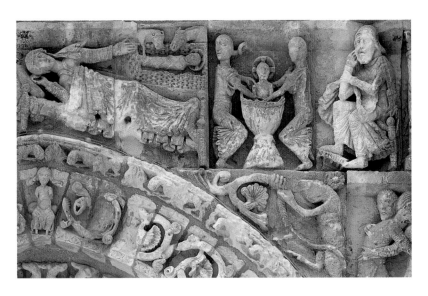

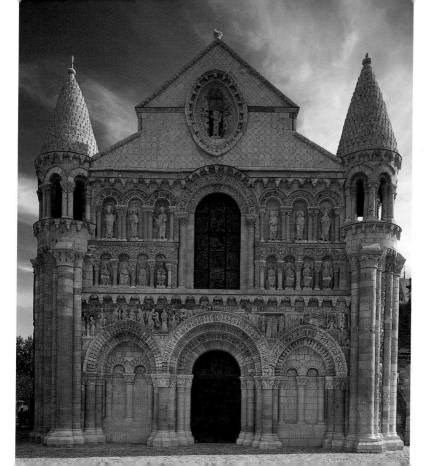

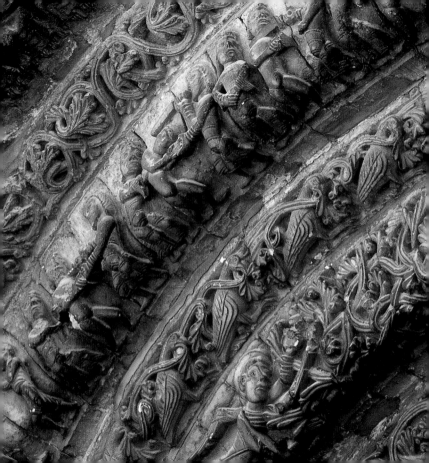

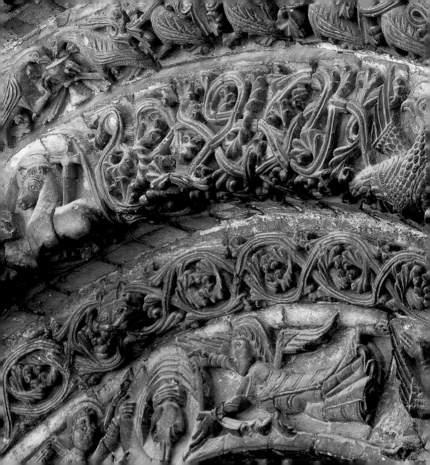

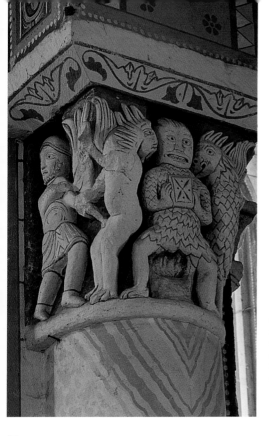

Chauvigny, St-Pierre, five capitals from the ambulatory, second half of the 12th c.

LEFT: The devil shows his altar with the symbol of death

OPPOSITE TOP/BOTTOM LEFT, TOP/BOTTOM RIGHT: Monster with tail ending in a hand; eagles carrying souls away; dragon (symbol of death) devouring a Christian; Sphinx with women's heads or bird sirens

Chauvigny, St-Pierre, cinco capiteles del deambulatorio, 2ª mitad del siglo XII

A LA IZQUIERDA: El diablo muestra su altar con el símbolo de la muerte

ENFRENTE ARRIBA/ABAJO IZQUIERDA, ARRIBA/ABAJO DERECHA: Monstruo con cola en forma de mano, águila elevando almas, dragón (símbolo de la muerte) engullendo a un cristiano, esfinge con cabezas de mujer o sirenas

44

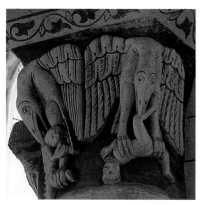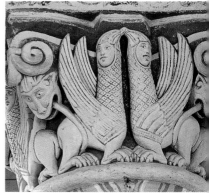

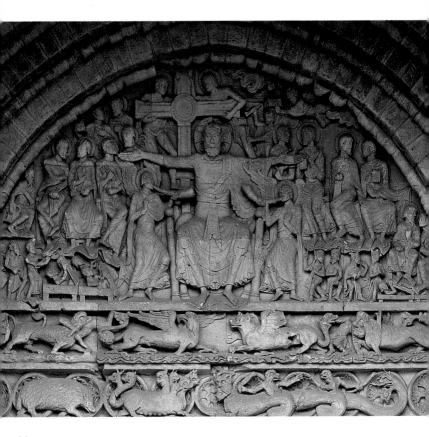

Tympanum and the Last Judgment

Perhaps the most important innovation of Romanesque sculpture is the tympanum, the sculpturally defined arched field above the entrance to a church. Anyone who entered was mercilessly confronted with what they saw there. Because the vengeful God of the Old Testament was still very much present in the mindset of the eleventh and twelfth centuries, the Last Judgment is depicted in the most significant tympana. The Judge of All sits on His throne on doomsday and judges the living and the dead. His judgment is terrible and severe, because He determines where each individual will spend eternity. In Beaulieu, Conques or Autun the Judge sits or stands in the center and directs the Good up toward Paradise, the realm of order, while He dispatches sinners down into open gorge of Hell, where the worst kinds of torture await them. Other eschatological themes are also found on Romanesque tympana, such as the Majestas Domini (Christ in Majesty), the Second Coming, or Pentecost.

OPPOSITE: **Beaulieu-sur-Dordogne**, St-Pierre, south portal, tympanum: The Last Judgment; on the door lintel, demonic beings, 1130–1140

El tímpano y el juicio final

Probablemente la invención más importante de la escultura de la época es el tímpano, o arco románico con ornamento escultórico, ubicado sobre la entrada de la iglesia. Quienes ingresaban en ella eran confrontados inexorablemente con lo que veían. Puesto que en el mundo imaginativo de los siglos XI y XII estaba aún muy presente el Dios justiciero del Antiguo Testamento, en los tímpanos más significativos se representa el juicio final. Allí reina el juez universal y sentencia sentencia a vivos y muertos. Su sentencia es terrible y dura, pues es él quien decide el lugar destinado a cada uno en la eternidad. En Beaulieu, en Conque o en Autun, el juez universal está sentado o de pie en el centro y dirige con la derecha hacia arriba a los buenos, al paraíso, el reino del orden, mientras que con la izquierda manda a los pecadores hacia abajo, al infierno, en cuyas fauces abiertas les aguardan los más horribles tormentos. En los tímpanos románicos se hallan asimismo otros temas de las postrimerías, como el Majestas Domini, el Secundus Adventus o la efusión del Espíritu Santo.

ENFRENTE: **Beaulieu-sur-Dordogne**, St-Pierre, portal sur, tímpano: El juicio universal; en el dintel de la puerta, criaturas del infierno 1130–40

Conque-en-Rouergue, Ste-Foy
BELOW: West portal, tympanum, second quarter of the 12th c.

OPPOSITE: Detail: the damned are shoved into the gorge of Hell

Conque-en-Rouergue, Ste-Foy
ABAJO: Portal occidental, tímpano, 2° cuarto del siglo XII

ENFRENTE: Detalle: Malditos empujados a las fauces del infierno

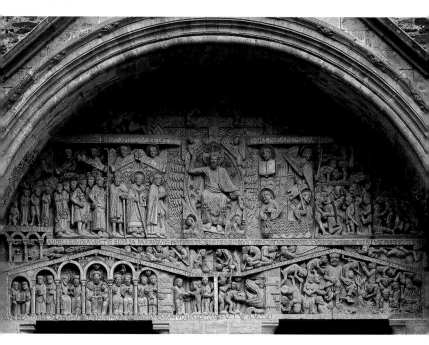

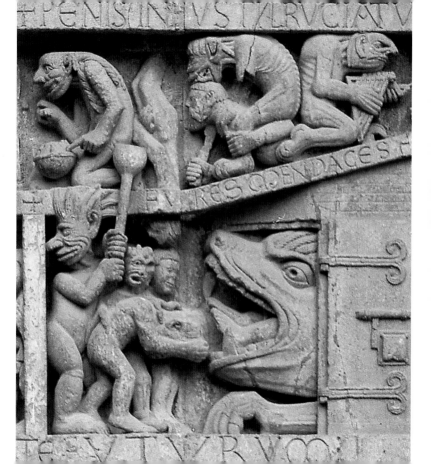

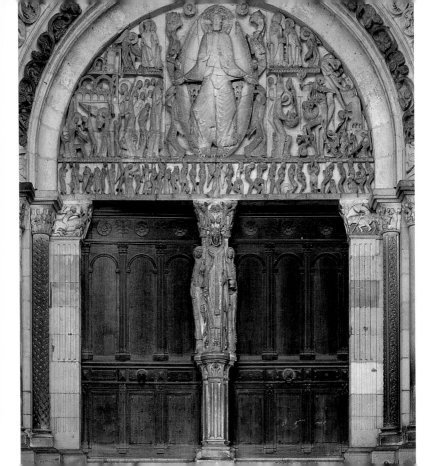

Autun, St-Lazare
OPPOSITE: Main portal,
tympanum with the Last
Judgment, 1130–1145

RIGHT: Detail of the trumeau

Autun, St-Lazare
ENFRENTE: Portal principal, tím-
pano con el juicio final, 1130–45

A LA DERECHA: Detalle de los
costados del capitel (*trumeau*)

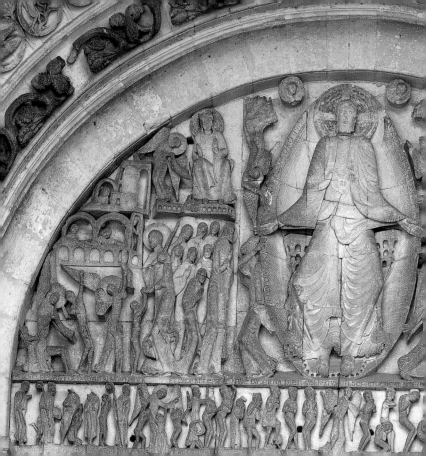

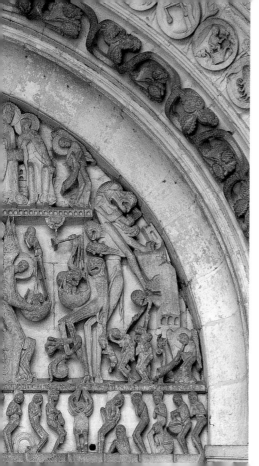

LEFT: **Autun**, St-Lazare, main portal, tympanum with the Last Judgment, 1130–1145

FOLLOWING TWO PAGES:
Autun, Musée Rolin, Eve from the door lintel of the former north transept portal of the cathedral, ca. 1130

A LA IZQUIERDA: **Autun**, St-Lazare, portal principal, tímpano con el juicio final, 1130–45

PÁGINA DOBLE SIGUIENTE:
Autun, Musée Rolin, Eva en el dintel de la puerta del antiguo portal de la nave transversal norte de la catedral, hacia 1130

53

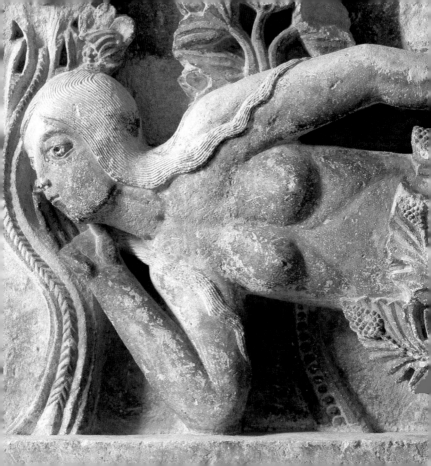

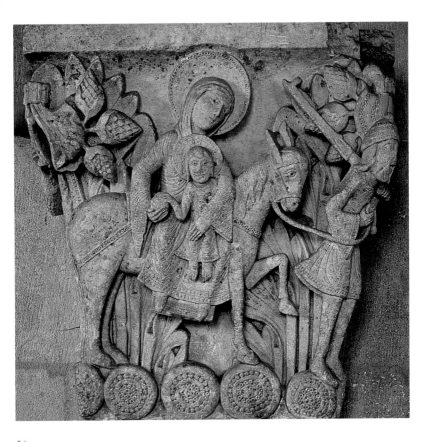

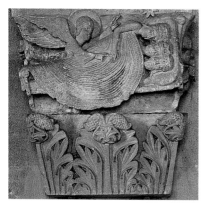

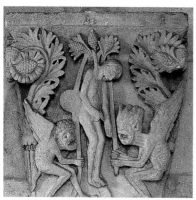

Autun, Salle Capitulaire, capitals from the St-Lazare Cathedral, 1120–1130
OPPOSITE: Flight to Egypt

LEFT TOP: Dream of the Three Kings

LEFT BOTTOM: Judas kills himself

Autun, Musée Rolin, figures from the tomb of St. Lazarus in St-Lazare Cathedral, ca. 1140/1145
P. 58: Mary Magdalene (left), Martha (right)

P. 59 LEFT: The apostle Andrew

Autun, Salle Capitulaire, capitel de la catedral St-Lazare, 1120–30
ENFRENTE: Huída a Egipto

A LA IZQUIERDA ARRIBA: Sueño de los reyes

A LA IZQUIERDA ABAJO: Suicidio de Judas

Autun, Musée Rolin, figuras de la sepultura de San Lázaro en la catedral de San Lázaro, hacia 1140/45
P. 58: María Magdalena (a la izquierda), Marta (a la derecha)

P. 59 A LA IZQUIERDA: El apóstol Andrés

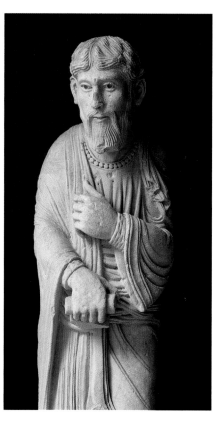
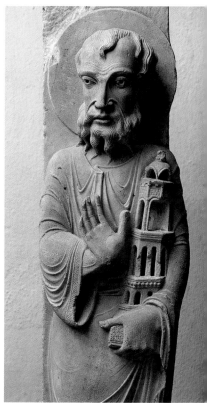

59

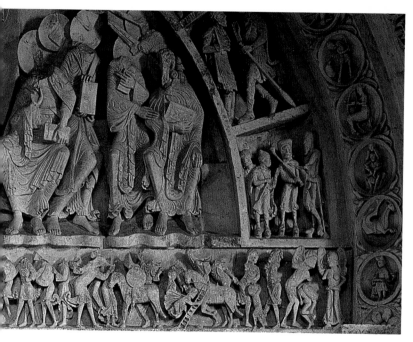

Vézelay, Ste-Madeleine
ABOVE: Detail from the tympanum,
1125–1130

OPPOSITE: Main portal; on the
tympanum: the Miracle of Pentecost

Vézelay, Ste-Madeleine
ARRIBA: Detalle del tímpano,
1125–30

ENFRENTE: Portal principal, en el
tímpano: El milagro de Pentecostés

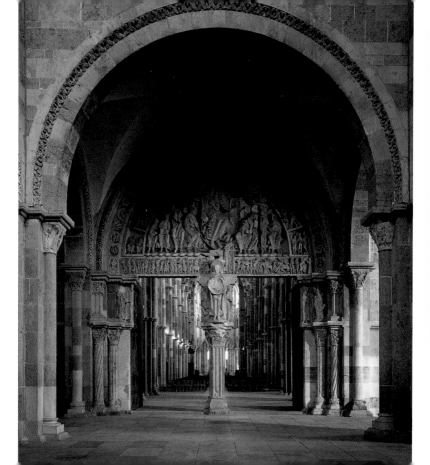

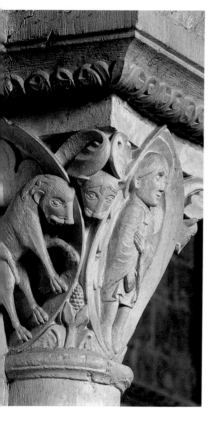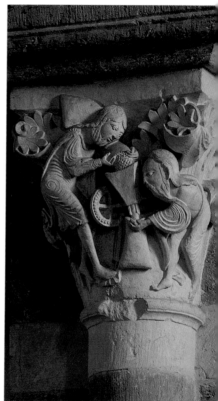

62

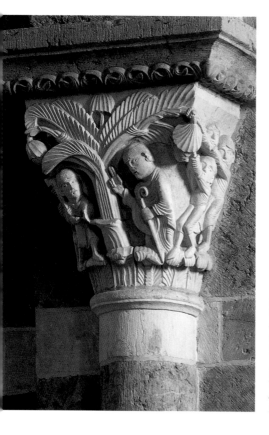

OPPOSITE AND LEFT:
Vézelay, Ste-Madeleine, three capitals from the interior with themes from the Old Testament, 1125–1130

ENFRENTE Y A LA IZQUIERDA:
Vézelay, Ste-Madeleine, tres capiteles del interior con temas del Antiguo Testamento, 1125–30

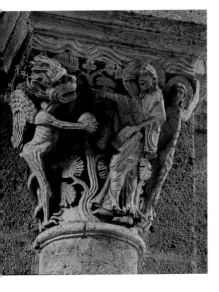

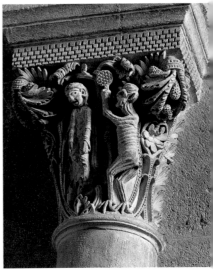

Saulieu, Ste-Andoche, capitals from the nave

ABOVE LEFT: The Temptation of Christ

ABOVE RIGHT: The devil hanging Judas

OPPOSITE LEFT: An angel blocks the way of Balaam and his ass

OPPOSITE RIGHT: The resurrected Christ appears to Mary Magdalene

Saulieu, Ste-Andoche, capitel de la nave principal

ARRIBA A LA IZQUIERDA: La primera tentación de Cristo

ARRIBA A LA DERECHA: El diablo cuelga a Judas

ENFRENTE A LA IZQUIERDA: El ángel obstruye el camino a Bileam y a su burrita

ENFRENTE Y A LA DERECHA: Cristo resucitado se le aparece a María Magdalena

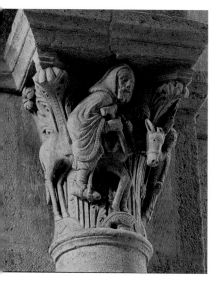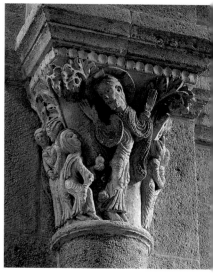

P. 66: **Dijon**, Musée Archéologique, two
tympana from St-Bénigne, Christ in a
mandorla (top), the Last Supper (bottom),
ca. 1170

P. 67: **Cluny**, Musée du Farinier, choir
capitals with the eight modes or tones of
the plainsong from the former monastery
of St-Pierre-et-St-Paul

P. 66: **Dijon**, Musée Archéologique, dos
tímpanos de St-Bénigne, Cristo en la
mandorla (arriba), la última cena (abajo),
hacia 1170

P. 67: **Cluny**, Musée du Farinier, capitel
de coro con los ocho tonos de la música
del antiguo convento de St-Pierre-et-
St-Paul

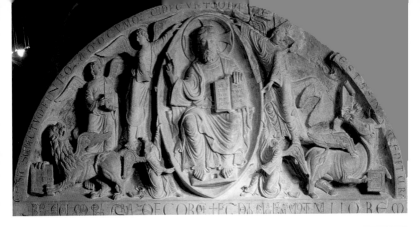

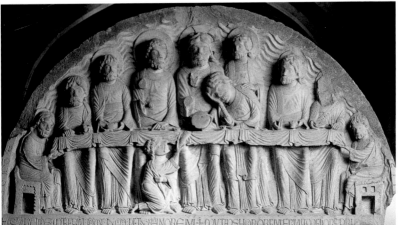

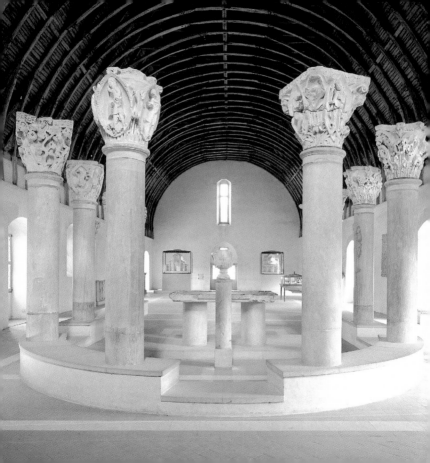

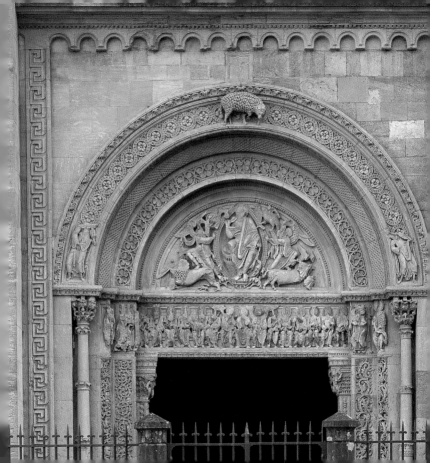

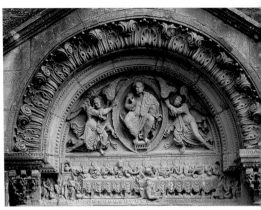

ABOVE: **Saint-Julien-de-Jonzy**, Saint-Julien-de-Jonzy, St-Julien, tympanum and door lintel of the west portal, mid-12th c.

LEFT: **Charlieu**, St-Fortunat, tympanum and door lintel of the north side of the narthex, mid-12th c.

FOLLOWING TWO PAGES: **Semur-en-Brionnaise**, St-Hilaire, west portal, tympanum and door lintel of the west portal, after mid-12th c.

ARRIBA: **Saint-Julien-de-Jonzy**, St-Julien, tímpano y dintel en el portal occidental, mediados del siglo XII

A LA IZQUIERDA: **Charlieu**, St-Fortunat, tímpano y dintel en la puerta norte de Narthex, mediados del siglo XII

PÁGINA DOBLE SIGUIENTE: **Semur-en-Brionnaise**, St-Hilaire, portal occidental, tímpano y dintel del portal occidental, después de mediados del siglo XII

69

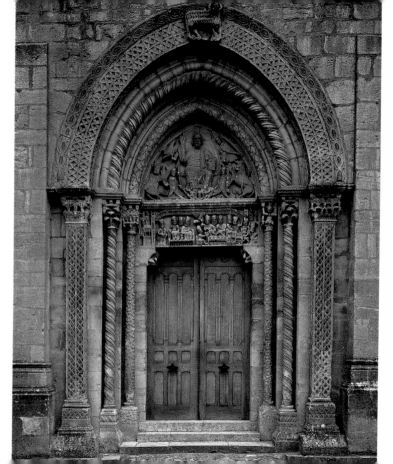

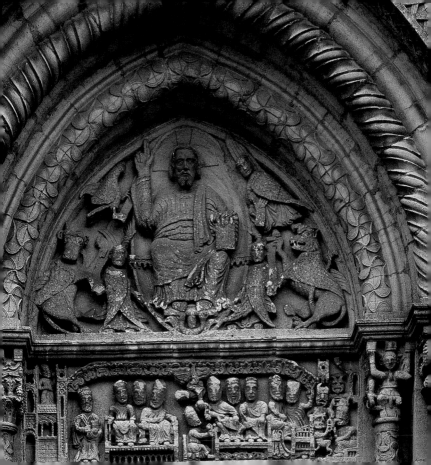

BELOW: **Elne,** Ste-Eulalie, cloister, after 1172

OPPOSITE: **St-Bertrand-de-Comminges,** cloister, pillar with the four evangelists, 13th c.

ABAJO: **Elne,** Ste-Eulalie, claustro, después de 1172

ENFRENTE: **St-Bertrand-de-Comminges,** claustro, pilar con los cuatro evangelistas, siglo XIII

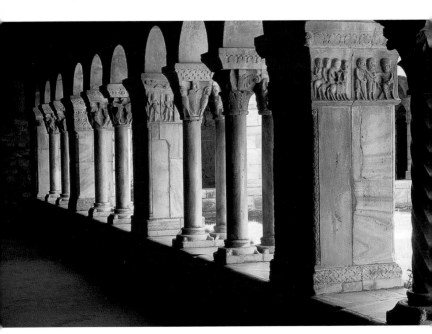

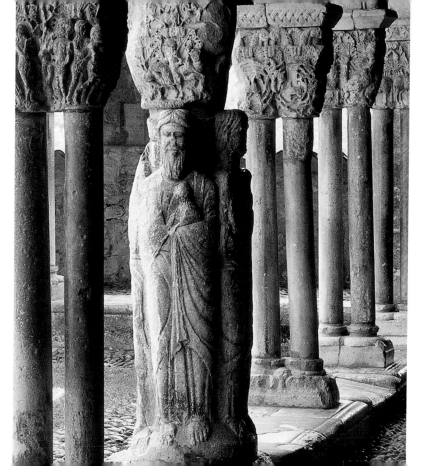

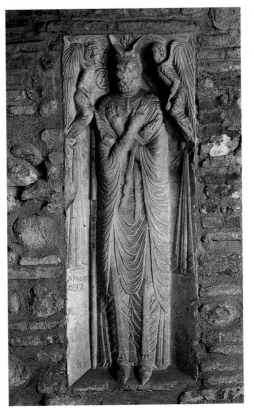

The *Gisant*

From the mid-twelfth century, the *gisant*, a prone representation of a deceased person on their tomb, spread from northern France. This type of grave monument became increasingly important, especially for the burial of secular rulers.

El yaciente

Hacia mediados del siglo XII se difunde desde el norte de Francia el yaciente, que es la figura yaciente del difunto sobre la tumba. Este tipo de sepultura va ganando importancia sobre todo en los entierros de los soberanos profanos.

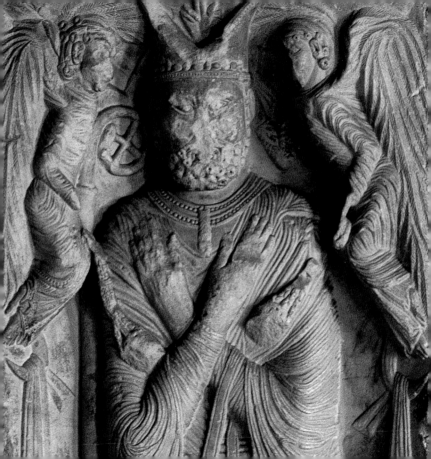

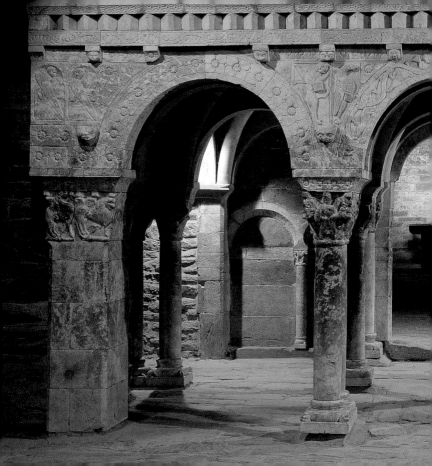

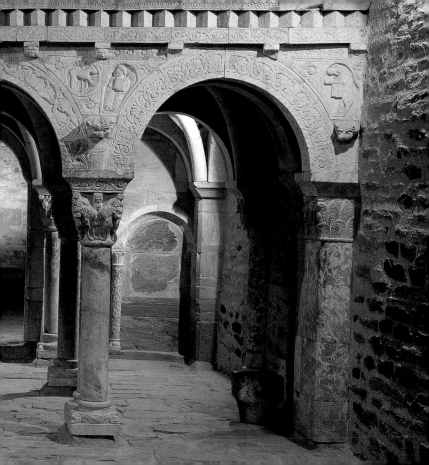

BELOW AND OPPOSITE:
Serrabone, Notre-Dame,
capitals of the choir gallery,
after mid-12th c.

ABAJO Y ENFRENTE:
Serrabone, Notre-Dame,
capitel de la tribuna del coro,
después de mediados del siglo XII

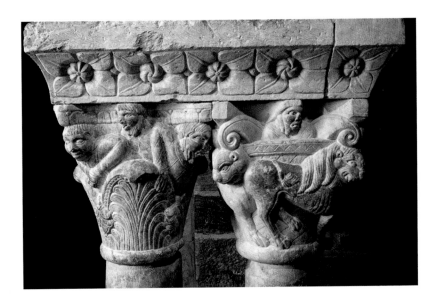

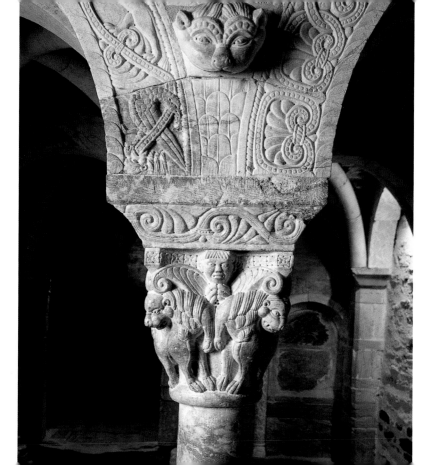

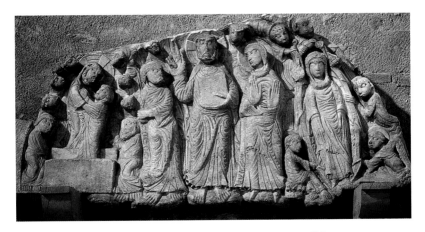

ABOVE AND OPPOSITE: **Cabestany**,
Notre-Dame, west wall of the north
transept, tympanum with Ascension
of the Virgin, Master of Cabestany,
second half of the 12th c.

ARRIBA Y ENFRENTE: **Cabestany**,
Notre-Dame, muro occidental en la nave
transversal norte, tímpano con la donación
del cinturón de María, maestro de
Cabestany, 2ª mitad del siglo XII

The Master of Cabestany

The work of an unknown, probably migra-
tory artist from Tuscany shows an idiosyn-
cratic style. He is named after the tympanum
in Cabestany. Characteristic of his figures
are large heads with long noses, slanted
almond-shaped eyes, and classically folded
garments.

El maestro de Cabestany

De un estilo caprichoso es la obra de un
artista ambulante desconocido, proveniente
posiblemente de Toscana. El nombre lo ha
obtenido de aquel tímpano en Cabestany que
se caracteriza por grandes cabezas con largas
narices, ojos almendrados oblicuos y vesti-
duras dobladas a la manera antigua.

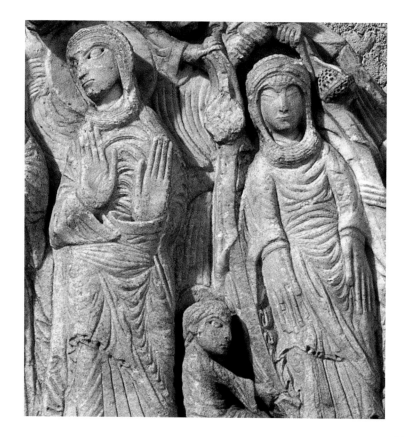

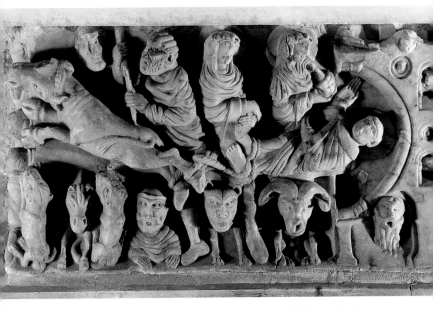

Saint-Hilaire-de-l'Aude, former
abbey church, relief: death and
martyrdom of St. Saturnin, detail,
Master of Cabestany, marble,
second half of the 12th c.

Saint-Hilaire-de-l'Aude, antigua
abadía, relieve: Muerte y martirio
de San Saturnino, detalle, maestro
de Cabestany, mármol, 2ª mitad
del siglo XII

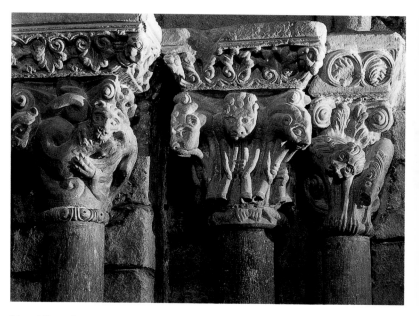

Rieux-Minervois, L'Assomption-de-Notre-Dame, capitals, Master of Cabestany or coworkers, second half of the 12th c.

Rieux-Minervois, L'Assomption-de-Notre-Dame, grupo de capitel, maestro de Cabestany o colaborador, 2ª mitad del siglo XII

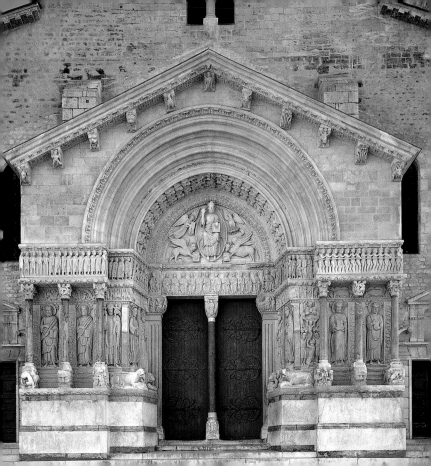

Provence

Although numerous artistic monuments are preserved from the time of the former Roman *provincia Gallia Narbonnensis*, Romanesque art appeared relatively late in Provence. At the same time, however, it is characterized by an exceptional maturity. Thus it is not surprising that two of the major works of Romanesque art in Provence, the portals of Saint-Gilles-du-Gard and in Arles, are modeled after Roman triumphal arches. The facade of the abbey church of St-Gilles is unique in Romanesque (p. 88 ff.): the three portals are connected through a single freize that spans the entire facade. It contains many figures and portrays the first complete cycle of the Passion depicted in the Romanesque period, and simultaneously the most extensive series of medieval sculptures. In Arles, the portal is in the form of a classical single-arched triumphal arch set in front of the unadorned wall of the former cathedral of St-Trophime. The cloister of that church also contains the greatest number of figures of any cloister in Provence (p. 86/87).

Provenza

Si bien en la región de Provenza subsisten numerosos monumentos artísticos de los tiempos de la antigua *provincia Gallia narbonnensis* romana, el arte románico aparece relativamente tarde aquí. Sin embargo, al mismo tiempo presenta una particular madurez, de modo que poco sorprende que dos de las principales obras del arte románico provenzal —los portales en Saint-Gilles-du-Gard y en Arles— imiten la arquitectura romana del arco de triunfo. Particularmente la fachada de la abadía St-Gilles es única en el arte románico (p. 88 y siguientes). Sus tres portales están unidos por un friso que abarca toda la fachada. La representación con múltiples figuras muestra el primer ciclo completo de la pasión en el arte románico, constituyendo al mismo tiempo la escultura más extensa de la edad media. En Arles, el portal con la forma de antiguo arco de triunfo se ha colocado ante la pared desnuda de la antigua catedral de St-Trophime. El claustro con el mayor número de figuras de la región provenzal se halla en el monasterio respectivo (p. 86/87).

OPPOSITE: **Arles**, St-Trophime, portal, second third of the 12th c.

ENFRENTE: **Arles**, St-Trophime, portal, 2º tercio del siglo XII

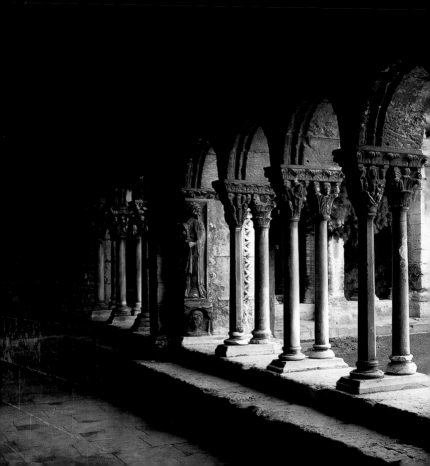

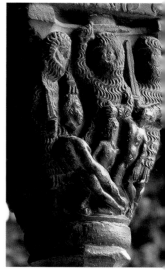

LEFT AND ABOVE: **Arles**,
St-Trophime, gallery of the
cloisters and capital, second half
of the 12th c.

A LA IZQUIERDA Y ARRIBA: **Arles**,
St-Trophime, galería del claustro y
capitel, 2ª mitad del siglo XII

Saint-Gilles-du-Gard, St-Gilles, west facade
OPPOSITE: Detail, north and south jambs of
the main portal: St. James the Elder and St.
Paul (left), St. John and St. Peter (right),
second quarter of the 12th c.

Saint-Gilles-du-Gard, St-Gilles, fachada
occidental. ENFRENTE: Detalle: Muros norte
y sur del portal central: Santiago el Mayor y
San Pablo (a la izquierda), Juan y Pedro (a la
derecha), 2° cuarto del siglo XII

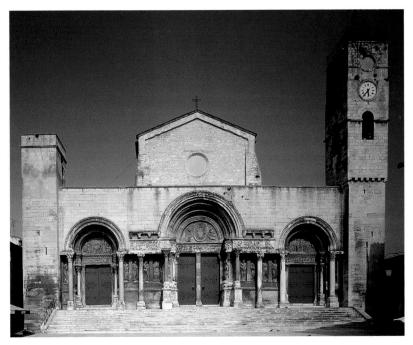

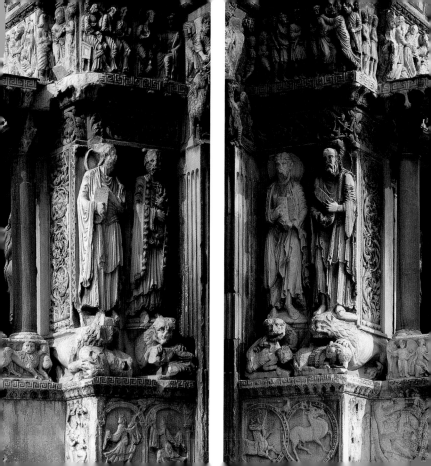

BELOW AND OPPOSITE:
Saint-Gilles-du-Gard, St-Gilles, west facade, detail of the frieze: Washing of the Feet, the Scourging, second quarter of the 12th c.

ABAJO Y ENFRENTE:
Saint-Gilles-du-Gard, St-Gilles, fachada occidental, detalle del friso: Lavado de los pies, flagelación, 2º cuarto del siglo XII

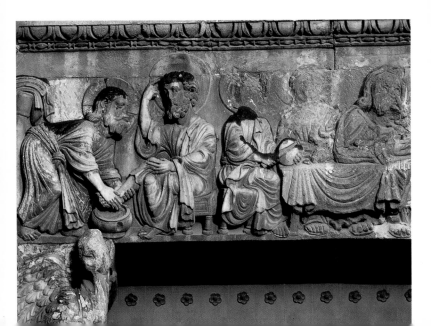

Spain

There was a wealth of building activity, especially along the pilgrimage routes leading to Santiago de Compostela. Correspondingly, art within Spain developed independently from early on. At the same time, the tight dynastic connections among the royal families of León, Castile, and Aragón led to construction of several significant churches with accompanying architectural sculpture. The first was the church of S. Martín in Frómista, where an independent sculptor's workshop was already established around 1070 (p. 112/113). Shortly thereafter, construction of the cathedral of Santiago de Compostela in Galicia was begun, where a "most admirable master," Bernhard the Elder, with a team of 50 stonemasons, executed the sculptural decoration (p. 116 f.). In Pamplona, two double capitals from the former cloister of the mid-twelfth-century cathedral have been preserved. One of them is dedicated to Job's suffering: incorporating all four sides of the capital, the story is related in a dense sequence of scenes around the column (p. 100 f.). The capitals and relief columns of the cloister in the Sto. Domingo de Silós monastery, south of Burgos, which date from the end of the twelfth century, are some of the greatest Romanesque sculptures anywhere (p. 104 f.).

OPPOSITE: **S. Juan de la Peña,** capitals from the cloister of the monastery ruins, 12th c.

España

Sobre todo a lo largo del camino de peregrinación de Santiago de Compostela se desarrolla una gran actividad constructora, creándose ya en sus principios una escultura autónoma profundamente española. Por los vínculos estrechamente dinásticos de las familias reales de León, Castilla y Aragón, se construyen al mismo tiempo algunas iglesias importantes con el correspondiente ornamento escultural. Inicialmente está la iglesia de San Martín en Frómista, donde se establece ya hacia 1070 una producción propia de imágenes esculturales (p. 112/13). Poco después se da inicio a la edificación de la catedral de Santiago de Compostela en Galicia, donde un "maestro admirable", Bernardo el Viejo, se encarga del ornamento escultural secundado por 50 canteros (p. 116 y siguientes). En Pamplona se han conservado dos capiteles dobles de mediados del siglo XII del antiguo claustro de la catedral. Uno de ellos está dedicado al sufrimiento de Job: la historia se cuenta en redondo en los cuatro costados del capitel, en una secuencia apretada de escenas (p. 100 y siguientes). A finales del siglo XII destacan los capiteles y pilares en relieve del claustro de Santo Domingo de Silos, al sur de Burgos, como una de las obras más imponentes del románico (p. 104 y siguientes).

ENFRENTE: **S. Juan de la Peña,** capitel del claustro de las ruinas del convento, siglo XII

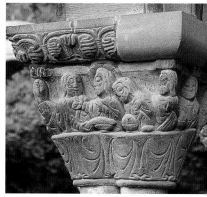

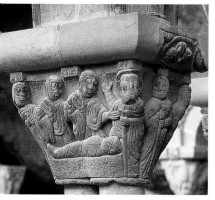

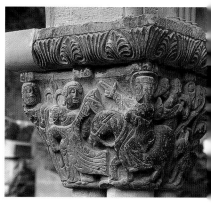

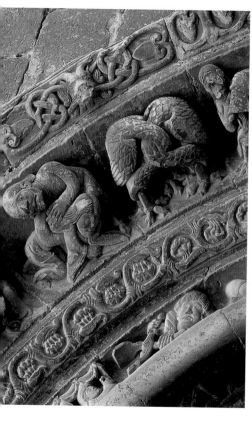

LEFT: **Uncastillo**, Sta. Maria, south portal, archivolt by the Master of Uncastillo, detail, mid-12th c.

OPPOSITE: **Ripoll**, Sta. Maria, west facade and portal: detail, second quarter of the 12th c.

A LA IZQUIERDA: **Uncastillo**, Santa María, portal sur, archivolta del maestro de Uncastillo, detalle, mediados del siglo XII

ENFRENTE: **Ripoll**, Santa María, fachada occidental y portal: Detalle, 2º cuarto del siglo XII

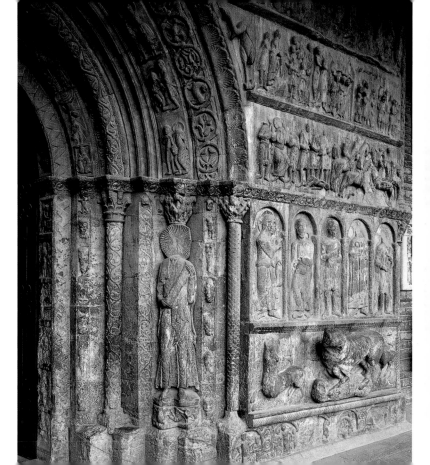

Leyre, S. Salvador, crypt, dedicated 1057

The barrel vaulting of this crypt rests on very slender and extremely short columns with widely branching capitals. The capital ornamentation, which suggests imitation of classical forms in a rather awkward way, identifies them as early Romanesque.

Leyre, San Salvador, cripta, consagrada en 1057

Las bóvedas de cañón de esta cripta descansan en columnas muy delgadas y extremadamente cortas, con capiteles provistos de amplios salientes. La ornamentación de los capiteles, que intenta con desmaño y a grandes rasgos imitar formas de la antigüedad, presenta un estilo de principios del románico.

97

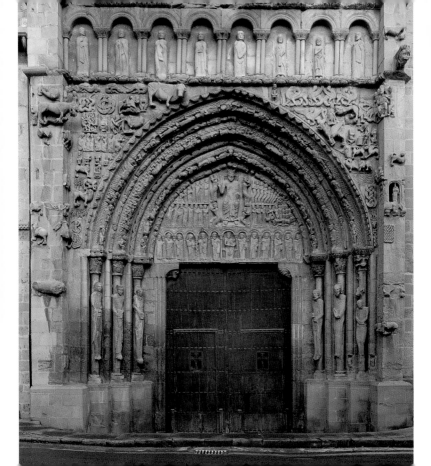

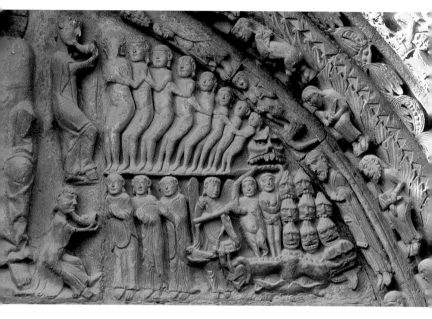

OPPOSITE AND ABOVE: **Sangüesa,**
Sta. Maria la Real, facade and
detail of the tympanum, last
quarter of the 12th c.

ENFRENTE Y ARRIBA: **Sangüesa,**
Santa María la Real, fachada y
detalle del tímpano, último cuarto
del siglo XII

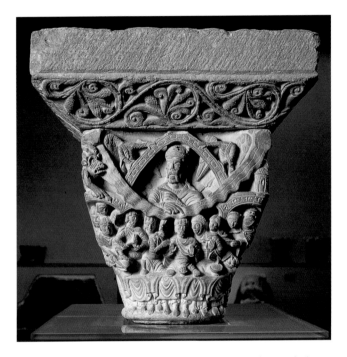

ABOVE, OPPOSITE AND P. 102/103:
Pamplona, Museo de Navarra,
four sides of a double capital
from the cathedral's cloister:
The Passion of Job, ca. 1145

Satan's wager on Job's true faith
and the feast of his sons (above)
The Story of Job: Robbery of his
herds (opposite)

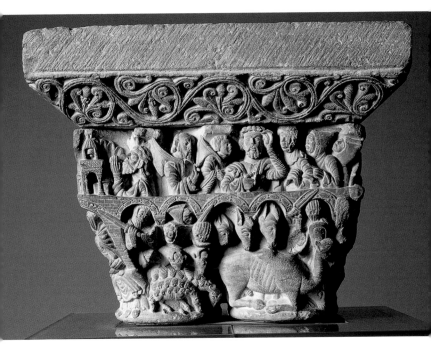

ENFRENTE, ARRIBA Y P. 102/03: **Pamplona**, museo de Navarra, cuatro costados de un capitel doble del claustro de la catedral: La pasión de Job, hacia 1145

La apuesta de Satán por el temor verdadero de Dios de Job y la comida festiva de sus hijos (enfrente)
La historia de Job: el robo de las manadas (arriba)

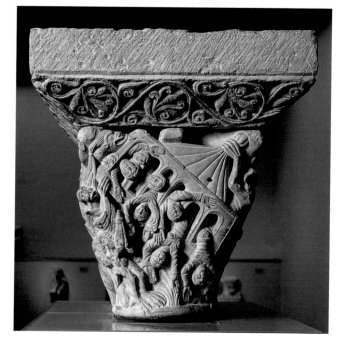

The Story of Job: The collapse of his house and death of its inhabitants

La historia de Job: el derrumbamiento de su casa y la muerte de sus moradores

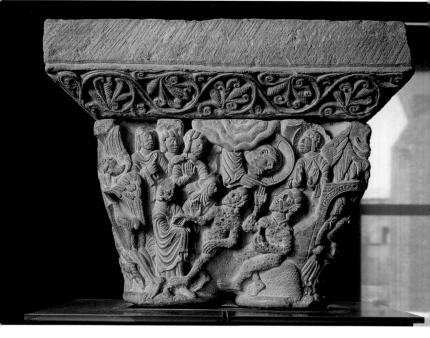

Job's leprosy, the rejection of his wife and friends, his steadfast faith and deliverance through God's blessing

La lepra de Job, la incomprensión de su mujer y sus amigos, su firmeza en el credo y su salvación por bendición divina

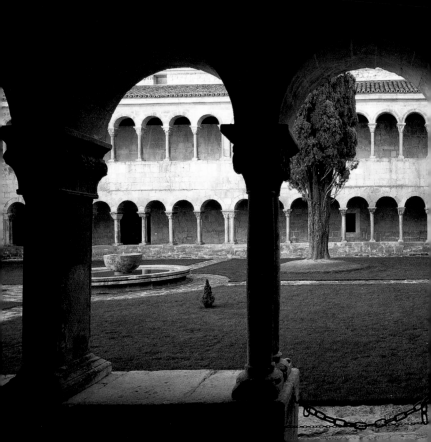

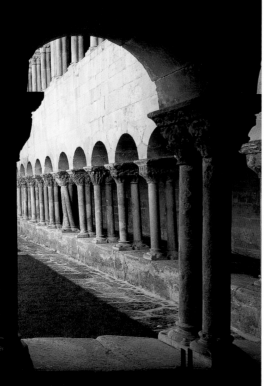

Silos, Sto. Domingo monastery, cloister, mid-12th c.

P. 106: Capital from the cloister

P. 107: Gallery of the cloister

Silos, convento de Santo Domingo, claustro, mediados del siglo XII

P. 106: Capitel del claustro

P. 107: Galería del claustro

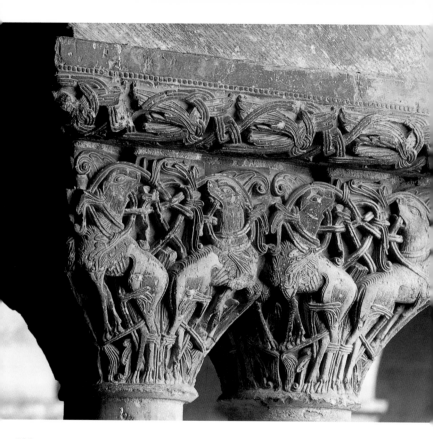

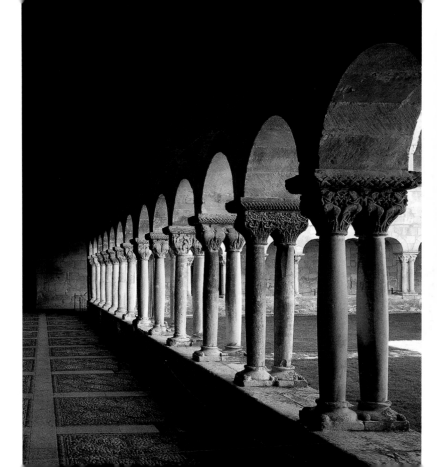

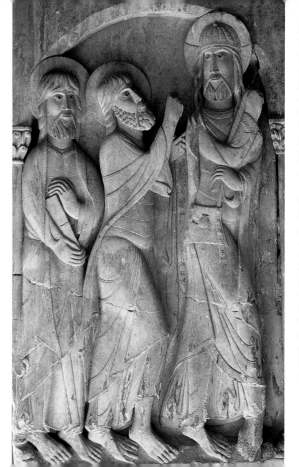

Silos, Sto. Domingo monastery, cloister

LEFT: Relief on a corner pier: Christ as a Santiago pilgrim

OPPOSITE: Relief on a corner pier: Descent from the Cross

P. 110/111: Relief on a corner pier: Doubting Thomas and detail, mid-12th c.

Silos, convento de Santo Domingo, claustro

A LA IZQUIERDA: Relieve de una pilastra angular: Cristo como peregrino jacobeo

ENFRENTE: Relieve de una pilastra angular: Descendimiento de la cruz

P. 110/11: Relieve de una pilastra angular: Tomás el Incrédulo y detalle de mediados del siglo XII

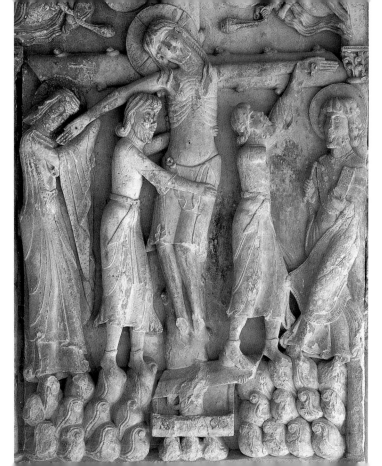

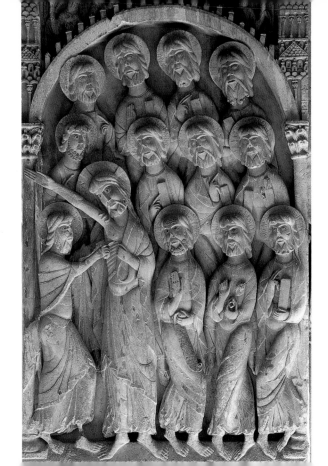

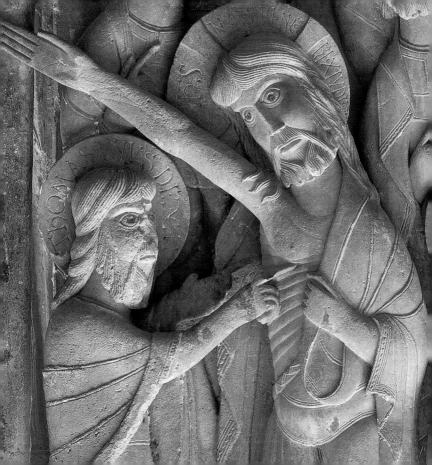

Frómista, S. Martín
ABOVE: Corbel figures on gable,
ca. 1085/1190

OPPOSITE LEFT: Nave arcades,
1066–1185/1190

OPPOSITE TOP AND BOTTOM: Capitals
of the pilasters between the nave and
side aisle, 1066–1185/1190

Only recently have art historians rec-
ognized that artistic initiative in the
sculpture of Frómista marks the lib-
eration of early Spanish Romanesque
from its supposed dependency on
French Romanesque.

Frómista, San Martín
ARRIBA: Figuras de consola en el
frontón, 1085/90

ENFRENTE Y A LA IZQUIERDA: Arcadas
de la nave central, 1066–85/90

ENFRENTE ARRIBA Y ABAJO: Capiteles
de las semicolumnas entre las naves
central y lateral, 1066–85/90

Sólo recientemente los historiadores
del arte han reconocido que la inicia-
tiva en la escultura de Frómista consti-
tuye la liberación del arte español de
principios del románico de su supuesta
dependencia del románico francés.

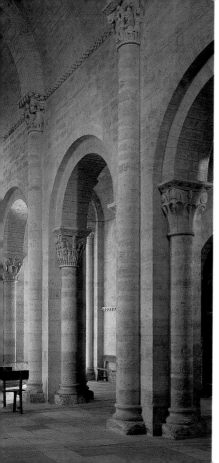

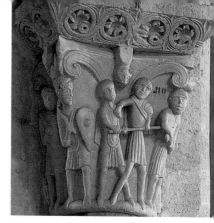

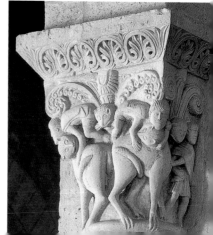

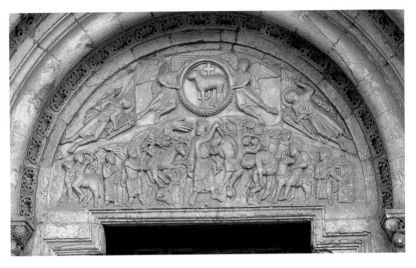

León, Colegiata de S. Isidoro
ABOVE: Puerta del Cordero,
tympanum

OPPOSITE: Puerta del Perdón,
early 12th c.

León, colegiata de San Isidoro
ARRIBA: Puerta del Cordero,
tímpano

ENFRENTE: Puerta del Perdón,
principios del siglo XII

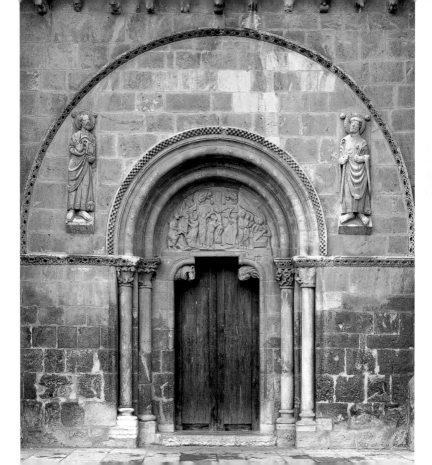

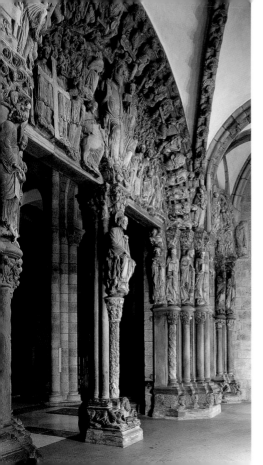

Santiago de Compostela, cathedral
LEFT: Pórtico de la Gloria, central
portal and entrance to nave,
sculpted by Master Mateo,
1168–1188

OPPOSITE: Puerta de las Platerías
on the south transept, completed
1103

P. 118: Puerta de las Platerías, left
jamb of the left door, completed
1103

P. 119: Puerta de las Platerías, left
tympanum: adulteress or original
sin, second decade of the 12th c.

Santiago de Compostela, catedral
A LA IZQUIERDA: Pórtico de la
Gloria, portal central y entrada a
la nave central, obra del maestro
Mateo, 1168–88

ENFRENTE: Puerta de las Platerías
en la nave transversal sur,
terminada en 1103

P. 118: Puerta de las Platerías,
abocinado izquierdo de la puerta
izquierda, terminada en 1103

P. 119: Puerta de las Platerías,
tímpano izquierdo: Adúltera o
pecado original, 2ª década del
siglo XII

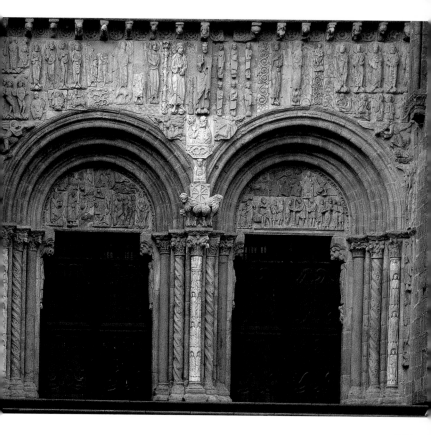

117

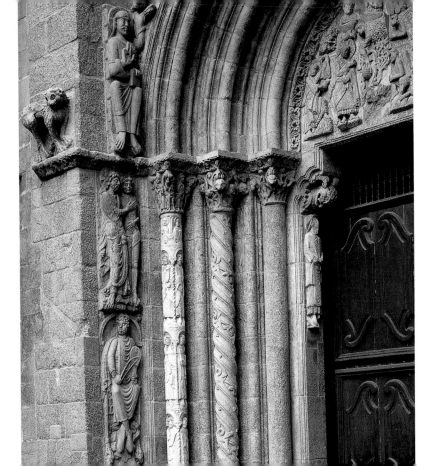

BELOW: **Toro**, Sta. María Mayor, begun 1160, north portal

OPPOSITE: **Zamora**, cathedral, south transept facade with the Puerta del Obispo, 1151–1171

FOLLOWING TWO PAGES: **Zamora**, cathedral, side portal

ABAJO: **Toro**, Santa María Mayor, comienzos de 1160, portal norte

ENFRENTE: **Zamora**, catedral, fachada en la nave transversal sur con la puerta del Obispo, 1151–71

PÁGINA DOBLE SIGUIENTE: **Zamora**, catedral, portal lateral

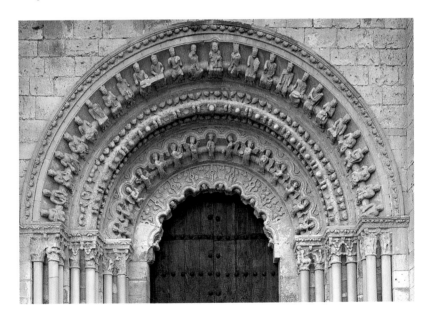

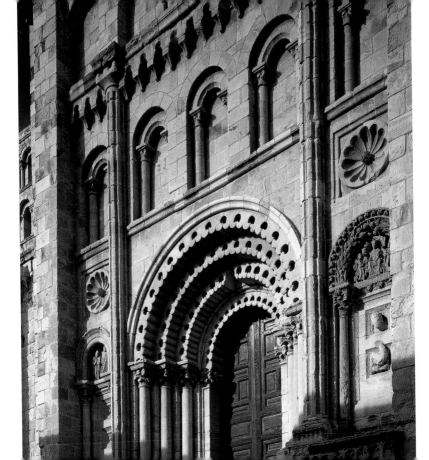

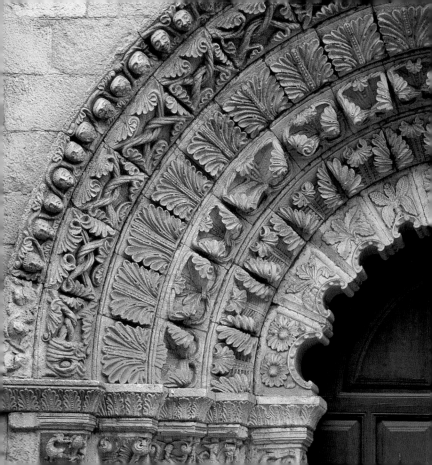

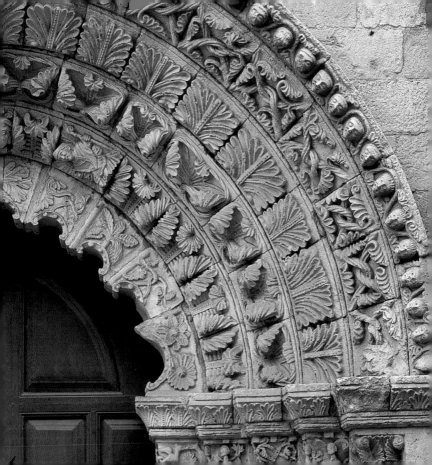

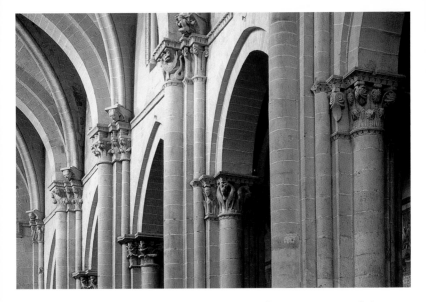

ABOVE: **Salamanca**, Old Cathedral, capital sculpture in the nave, before mid-12th c.–early 13th c.

OPPOSITE: **Soria**, Sto. Domingo, west facade portal, end of the 12th c.(?)

ARRIBA: **Salamanca**, antigua catedral, escultura de capitel en la nave principal, antes de mediados del siglo XII–principios del siglo XIII

ENFRENTE: **Soria**, Santo Domingo, portal de la fachada occidental, finales del siglo XII (?)

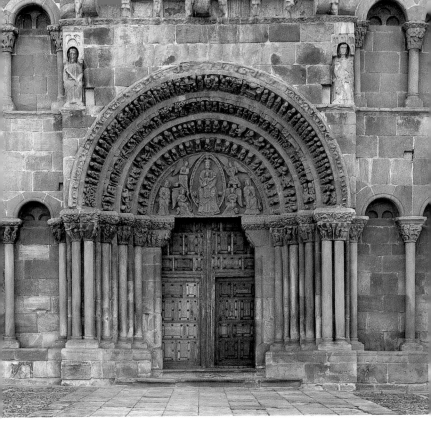

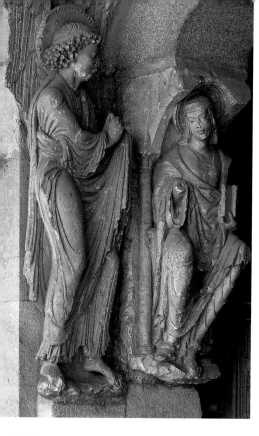

Ávila, Basílica de S. Vicente
LEFT: South portal, left jamb:
the Annunciation, ca. 1190

OPPOSITE: South portal, right
jamb: King Alfonso VI (1065–
1109[?]); Doña Urraca (died
1101), daughter of Alfonso VI, in
the form of Sta. Sabina (left);
S. Vicente (right); Doña Urraca
and S. Vicente, ca. 1100/1110

Ávila, basílica de San Vicente
A LA IZQUIERDA: Portal sur,
abocinado izquierdo: La
Anunciación de Nuestra Señora,
hacia 1190

ENFRENTE: Portal sur, abocinado
derecho: Rey Alfonso VI (1065–
1109[?]), doña Urraca (fallecida
en 1101), hija de Alfonso VI
en la figura de Santa Sabina
(a la izquierda); San Vicente
(a la derecha); doña Urraca y
San Vicente, hacia 1100/10

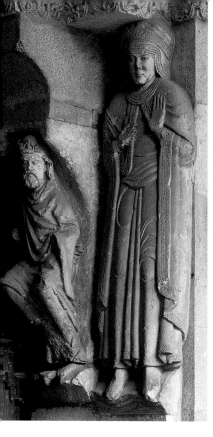
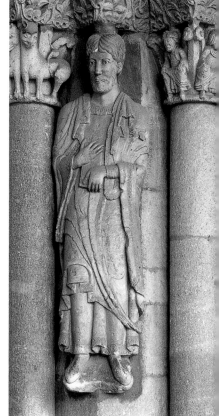

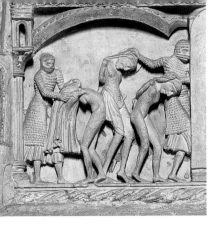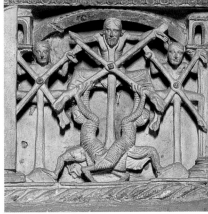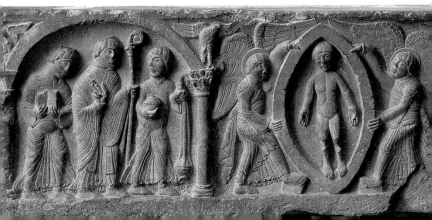

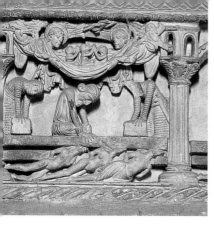

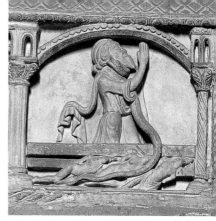

OPPOSITE TOP AND ABOVE: **Ávila**, Basílica de S. Vicente, tomb of S. Vicente, four scenes from the relief on the south side, ca. 1190

LEFT: **Jaca**, S. Salvador and S. Ginés, sarcophagus of the infanta Doña Sancha, viewing side, ca. 1100

ENFRENTE ARRIBA Y ARRIBA: **Ávila**, basílica de San Vicente, sepultura de San Vicente, cuatro escenas del relieve en el costado sur, hacia 1190

A LA IZQUIERDA: **Jaca**, San Salvador y San Ginés, sarcófago de la infanta doña Sancha, lado de exhibición, hacia 1100

Italy

In Italy, as well, the development of sculpture is tied to the rise of contemporary building activity. Here, however, sculpture was less closely tied to the architectural structure of churches than in France, for example. Instead, it more often serviced the diverse requirements of liturgy. Unlike in the other regions of Europe, in the young city republics of northern Italy one finds a great number of Romanesque artists' names. This demonstrates that by around 1100, sculptors had already distinguished themselves from the less respected stonemasons in terms of their work and their products. The names of sculptors often appear in flowery, praise-filled inscriptions above the founding or dedication dates of churches. One can conclude that the northern Italian city-states' craving for fame and the competition among them for prestige had already made heroes out of individual artists in the Middle Ages. Their achievements were additonal feathers in the cities' caps.

Opposite: **Parma**, baptistery, tympanum of the portal, 1196–1216

Following two pages: **Parma**, cathedral, Benedetto Antelami: Descent from the Cross, high relief, marble, 110 x 230 cm (height x width), 1178

Italia

En Italia depende igualmente el desarrollo de la escultura del incremento en la actividad constructora del momento. Sin embargo, aquí las artes plásticas están menos unidas a la estructura arquitectónica de la edificación de iglesias que, por ejemplo, en Francia, y sirven más para satisfacer las múltiples exigencias de la liturgia. A diferencia de las demás regiones de Europa, la mayoría de los nombres de artistas románicos se hallan en las jóvenes repúblicas estatales del norte de Italia. Esto demuestra que los escultores se habían distanciado ya hacia 1100, en razón de su trabajo y sus productos, del grupo menos respetado de los canteros. Los nombres de los escultores aparecen a menudo en glorificaciones epigráficas en datos de fundación o de consagración de iglesias. De ello se desprende que la avidez de fama de las ciudades del norte de Italia y su ansia de prestigio orientada por la competencia había convertido en héroes ya en la edad media a algunos artistas con cuya fama les gustaba adornarse.

Enfrente: **Parma**, baptisterio, tímpano del portal, 1196–1216

Página doble siguiente: **Parma**, catedral, Benedetto Antelami: Descendimiento de la cruz, alto relieve, mármol, 110 x 230 cm (alto x ancho), 1178

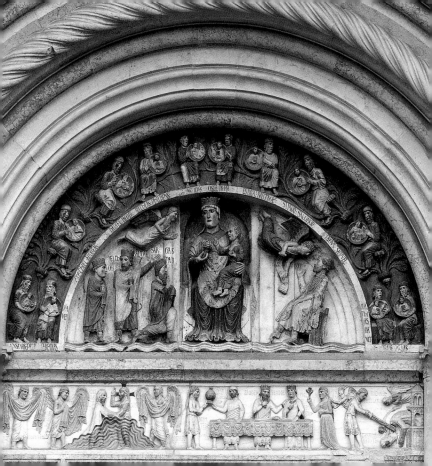

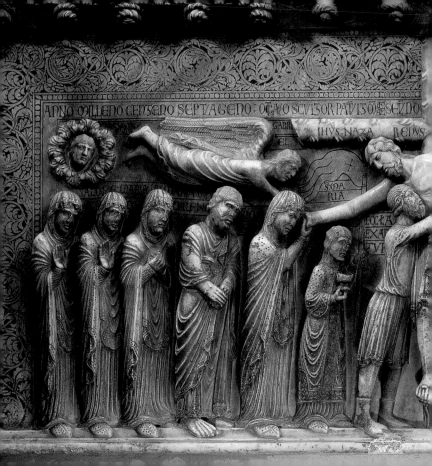

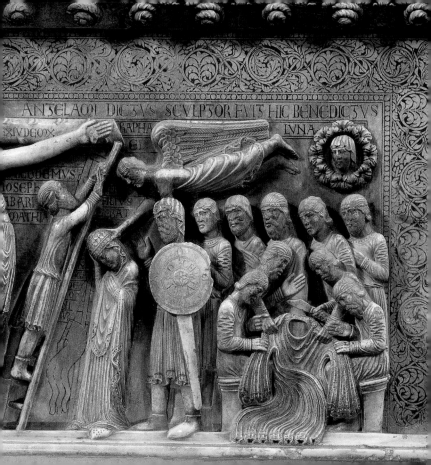

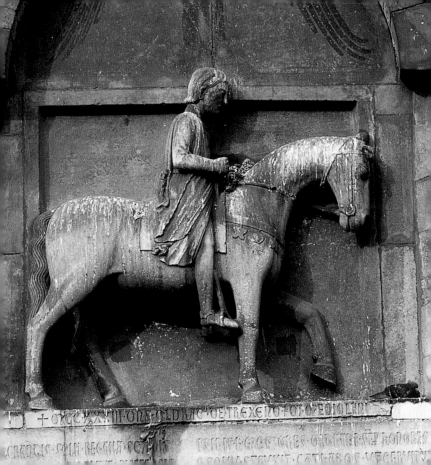

+ M CCC XXIIII ORS OLDRAC ꝙ DE TREXE...OF...OF...EDIOLINI
CREDE...FELI...REGGIE...EC...O... PRINCIPE...GRANDE...OTTO...REP...HONORE
...Q...ROMA...STRUXIT...CATLAROS...VT...GERVIT

OPPOSITE: **Milan,** Palazzo della Ragione, equestrian sculpture from 1233

RIGHT: **Lodi,** cathedral, portal figure: Eve, detail, last quarter of the 12th c.

ENFRENTE: **Milán,** Palazzo della Ragione, escultura ecuestre de 1233

A LA DERECHA: **Lodi,** catedral, figura de portal: Eva, detalle, último cuarto del siglo XII

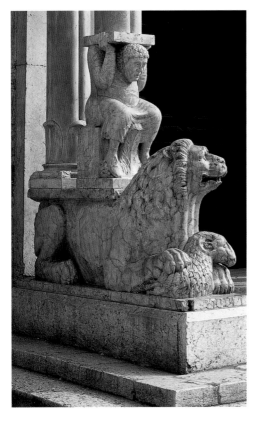

LEFT: **Ferrara**, cathedral, detail of the baldachin at the main portal: caryatid on lion, Niccolò, end of the 12th c.

OPPOSITE AND FOLLOWING TWO PAGES: **Modena**, cathedral, lion portal of the west facade, second quarter of the 11th c.; relief on the west facade: Creation of Adam and Eve, The Fall, Master Wiligelmo, early 12th c.

P. 140/141: **Fidenza**, cathedral, portals: baldachin supported by lions, niche statues, and side portals, end of the 12th c.

A LA IZQUIERDA: **Ferrara**, catedral, detalle del saliente del baldaquino en el portal principal: Telamón sobre un león, obra de Niccolò, finales del siglo XII

ENFRENTE Y PÁGINA DOBLE SIGUIENTE: **Módena**, catedral, portal con leones de la fachada occidental, 2º cuarto del siglo XI; relieve de la fachada occidental: La creación de Adán y Eva, El pecado original, obra de Wiligelmus, principios del siglo XII

P. 140/41: **Fidenza**, catedral, zona de portal: Baldaquino llevado por leones, figuras en nicho y portales laterales, finales del siglo XII

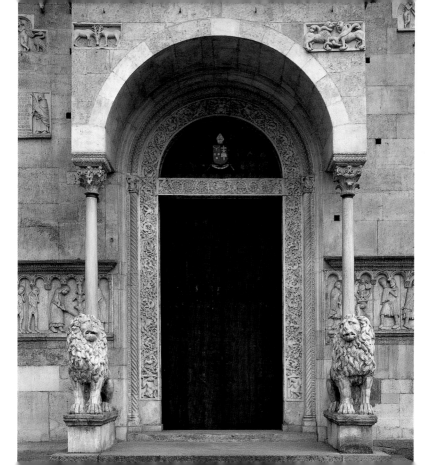

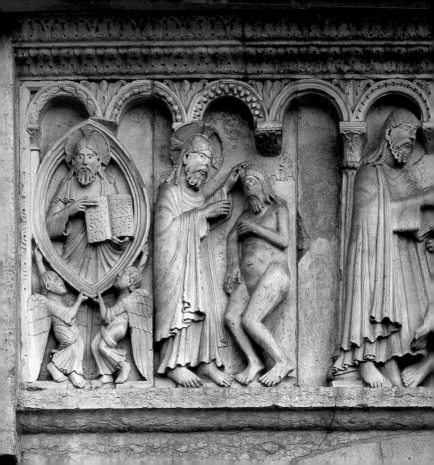

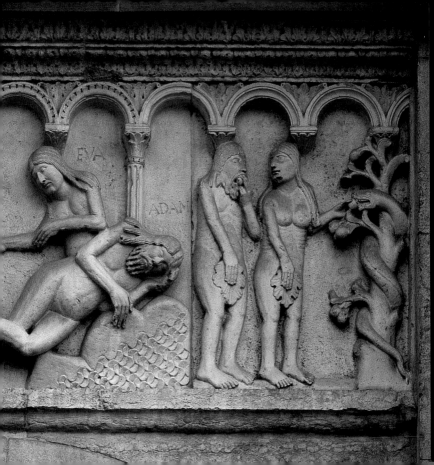

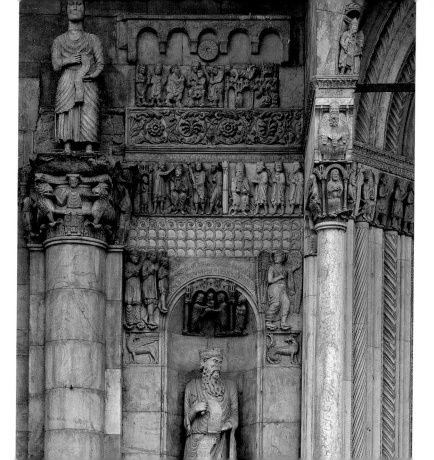

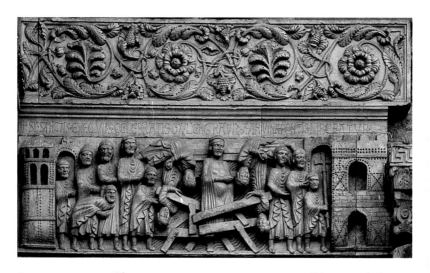

OPPOSITE AND ABOVE: **Fidenza,** cathedral, two details from the portals of the facade, end of the 12th c.

FOLLOWING TWO PAGES: **Pomposa,** S. Maria, detail of the facade, brick, marble, terracotta, second quarter of the 11th c.

ENFRENTE Y ARRIBA: **Fidenza,** catedral, dos detalles de la zona del portal de la fachada, finales del siglo XII

PÁGINA DOBLE SIGUIENTE: **Pomposa,** S. Maria, detalle de fachada, ladrillo, mármol, terracota, 2º cuarto del siglo XI

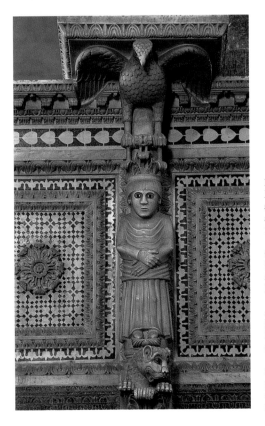

LEFT: **Florence**, S. Miniato al Monte, chancel with lion, man, and eagle (evangelists' symbols) as supports, second half of the 12th c.

OPPOSITE: **Lucca**, S. Frediano, baptismal font; one of the sculptors is known as Master Roberto, ca. 1150

A LA IZQUIERDA: **Florencia**, S. Miniato al Monte, púlpito con león, hombre y águila, 2ª mitad del siglo XII

ENFRENTE: **Lucca**, S. Frediano, pila bautismal; uno de los escultores es conocido como maestro Robertus, hacia 1150

146

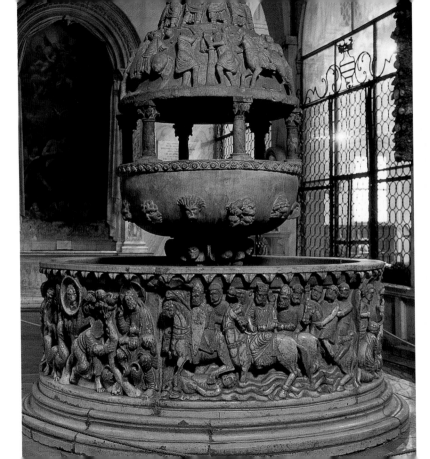

ABOVE AND OPPOSITE: **Spoleto**,
S. Pietro fuori le mura, details of
the facade reliefs, ca. 1200

The images in the facade reliefs
relate stories from the Bible and
animal fables. The top scene on
the opposite page shows the death
of a penitent sinner being freed
from his bonds by St. Peter, to the
great displeasure of a demon.

ARRIBA Y ENFRENTE: **Spoleto**,
S. Pietro fuori le mura, detalles del
relieve de la fachada, hacia 1200

En los relieves de las fachadas se
modelan historias de la Biblia y
fábulas de animales. En la escena
superior enfrente se representa la
muerte del pecador arrepentido
siendo liberado por Pedro, ante lo
cual el demonio se muestra enfadado.

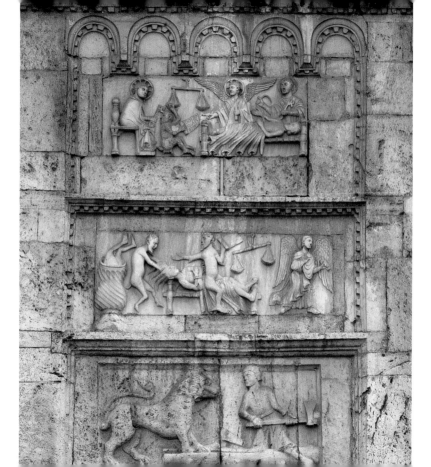

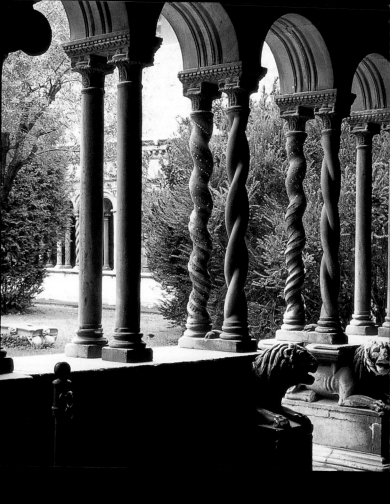

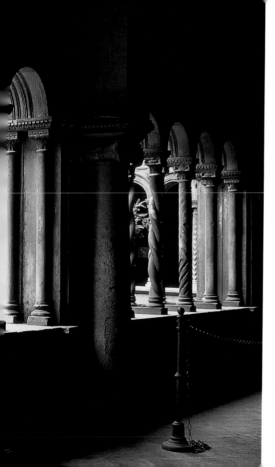

LEFT AND P. 152 LEFT:
Rome, St John Lateran, gallery of the cloisters with columns supported by lions along the passageway, as well as a twisted, mosaic column from the workshop of father and son Vassaletto, 1215–1232

P. 152 RIGHT AND P. 153:
Rome, S. Paolo fuori le mura, mosaic column from the cloister; passageway in one gallery of the cloister, the work of mosaic artists in the Vassaletto family, 1205–1241

A LA IZQUIERDA Y P. 152 A LA IZQUIERDA: **Roma**, basílica de Letrán, galería del claustro con columnas en el pasaje soportadas por leones, así como columnas retorcidas y mosaicadas del taller de Vassaletto padre e hijo, 1215–32

P. 152 A LA DERECHA Y P. 153:
Roma, S. Paolo fuori le mura, columna mosaicada del claustro, arcada de pasaje de una de las galerías del claustro, obra de mosaiquistas de la familia Vassaletto, 1205–41

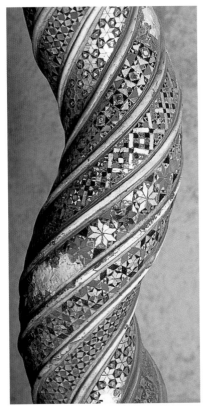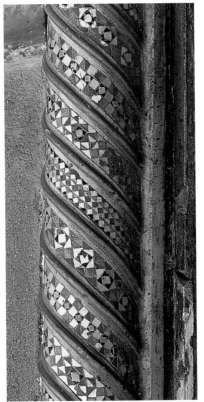

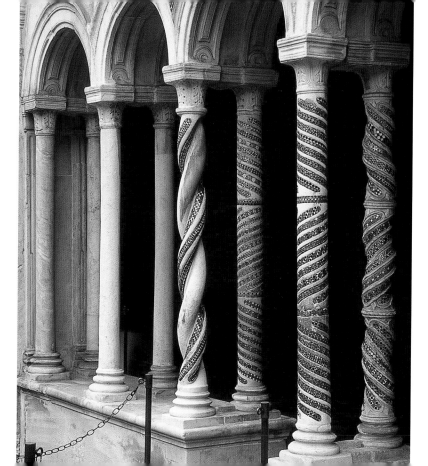

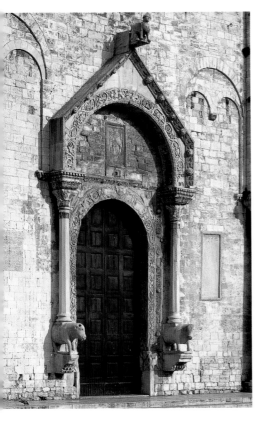

LEFT: **Bari**, S. Nicola, main portal, before 10988

OPPOSITE: **San Quirico d'Orcia**, S. Quirico, archivolts supported by knotted bundles of columns, late 12th c.

A LA IZQUIERDA: **Bari**, S. Nicola, portal principal, antes de 1098

ENFRENTE: **San Quirico d'Orcia**, S. Quirico, saliente de portal sobre grupos de columnas anudadas, finales del siglo XII

154

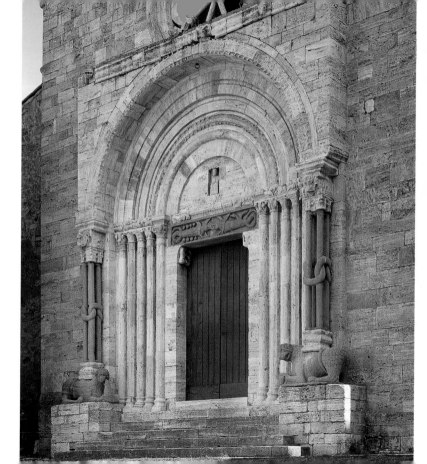

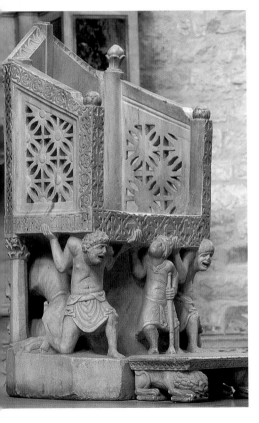

LEFT: **Bari**, S. Nicola, throne of Elijah, marble, end of the 11th or beginning of the 12th c.

OPPOSITE: **Moscufo**, S. Maria del Lago, chancel from the workshop of the sculptors Roberto and Nicodemo, 1159, most important Italian Romanesque chancel

A LA IZQUIERDA: **Bari**, S. Nicola, trono de Elías, mármol, finales del siglo XI o principios del siglo XII

ENFRENTE: **Moscufo**, S. Maria del Lago, púlpito del taller de los escultores Robertus y Nikodemus, 1159, el púlpito más importante del románico italiano

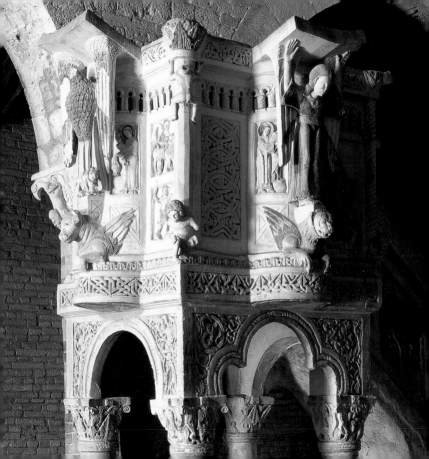

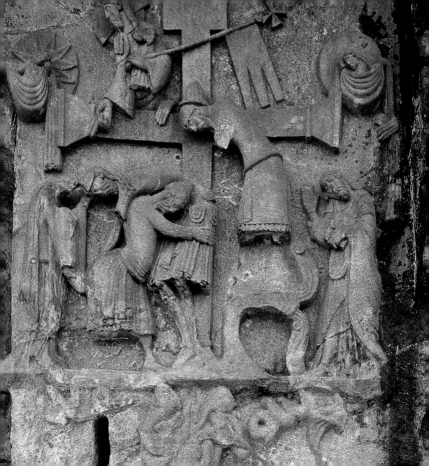

Germany

Unlike the Romance countries, a continuous development of Romanesque sculpture cannot be traced in Germany. There were also marked regional differences. The bronze workshop in Hildesheim under Bishop Bernward, for instance, was a hub of Ottonian metallurgy in the early eleventh century. Primarily cultic decorative objects and liturgical implements were made there. Stone sculpture, too, was most often designed for interior spaces. Overall, German sculpture shows the influence of northern Italian sculptors, who were often called to Germany. In areas along the Rhine, however, with Cologne as their center, a direct confrontation with the remains of antiquity was still taking place, which explains why established stone-cutting techniques were being used seemingly out of the blue in the eleventh century. This made it possible for an independent tradition of high quality sculpture to develop quite early.

Alemania

A diferencia de lo que ocurre en los países románicos, en Alemania no es posible observar una historia continua del desarrollo de la escultura románica. Además, hay grandes diferencias regionales, como es el caso del taller de bronce en Hildesheim bajo el obispo Bernward a principios del siglo XI, que constituye un centro de trabajos otónicos en metal, donde se modelan principalmente piezas ornamentales para el culto u objetos litúrgicos. La escultura en piedra se produce asimismo principalmente para interiores. Sin embargo, se puede ver cómo influyen en Alemania los escultores del norte de Italia, llamados a menudo para trabajar aquí. En Renania, sin embargo, con Colonia como centro, aún estaba teniendo lugar una confrontación directa con los remanentes de la antigüedad, que explica el uso aparentemente inesperado en el siglo XI de las técnicas establecidas del trabajo de la piedra. Por esta razón pudo desarrollarse pronto una escultura propia y de alta calidad.

LEFT AND OPPOSITE: **Gernrode**,
St. Cyriacus, Holy Sepulchre,
west exterior wall of the tomb
chamber, martyr and bishop
Metronius and detail, 1100/1130

A LA IZQUIERDA Y ENFRENTE:
Gernrode, San Ciriaco, sepultura
santa, muro exterior occidental
de la cámara funeraria con obispo
mártir Metronus y detalle,
1100/30

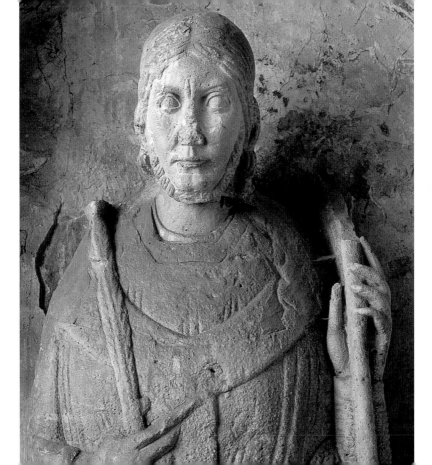

RIGHT AND OPPOSITE LEFT: **Riesenbeck/ Tecklenburg**, St. Calixtus, tomb of Reinhildis and detail, limestone, ca. 1130/1135

The trapezoid-shaped tomb slab of Reinhildis may have originally served as the lid of a sarcophagus. The young haloed woman turns her gaze upward, where an angel carries her soul to heaven in the form of a child.

OPPOSITE RIGHT: **Merseburg**, St. Johannes der Taufer and St. Laurentius, tomb slab of Rudolf of Swabia (died 1080), bronze, prior to 1100

This tomb slab is probably the earliest example of a tomb bearing a figural representation. Burial within a church had previously been reserved for clergy. The inscription justified this tomb's presence in the church because the man buried there died while fighting for the Church, and thus earned the right to be buried in that place.

ENFRENTE A LA DERECHA: **Merseburg**, San Juan Bautista y San Lorenzo, losa de la sepultura de Rodolfo de Suabia (fallecido en 1080), bronce, antes de 1100

Esta losa es probablemente la sepultura con figuras más temprana de que se tiene noticia. Como la aparición dentro de una iglesia estaba reservada hasta entonces únicamente a los eclesiásticos, en la losa se justifica que la persona enterrada allí había fallecido luchando por la iglesia, razón por la cual había adquirido ese derecho.

A LA DERECHA Y ENFRENTE A LA IZQUIERDA: **Riesenbeck/Tecklenburg**, San Calixto, sepultura de Reinhildis y detalle, arenisca, hacia 1130/35

La losa trapezoidal de la sepultura de Reinhildis pudo haber sido originalmente la tapa de un sarcófago. La joven mujer con aureola dirige la vista hacia arriba, donde un ángel lleva su alma al cielo en la figura de un niño.

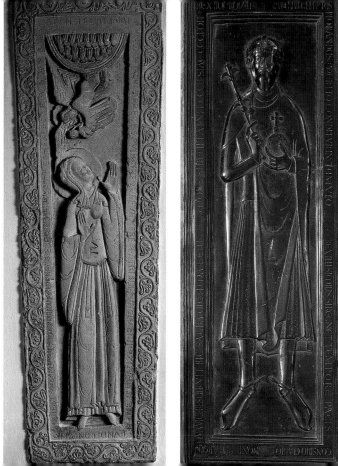

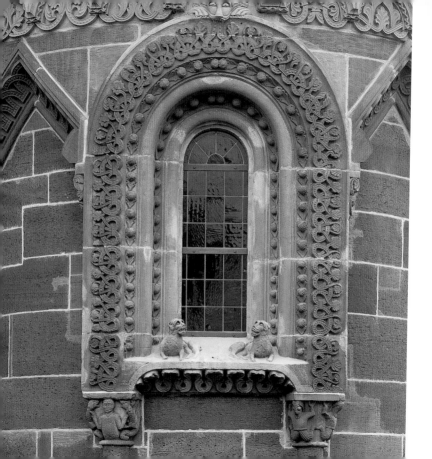

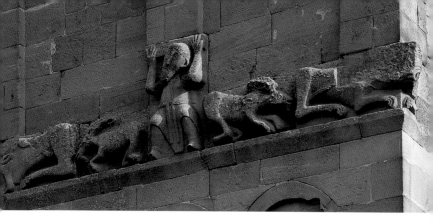

Above: **Calw-Hiersau,** "Owl Tower,"
figural decoration, early 12th c.

Opposite: **Murrhardt,** Walterichskapelle,
apse window with rich ornamentation and
figural sculpture, corbels, with a mask at the
top of the arch, 13th c.

Following two pages: **Königslutter,**
St. Peter and Paul, arched frieze on the
main apse, after 1135–late 12th c.

Arriba: **Calw-Hiersau,** torre de las
lechuzas, decoración con figuras,
principios del siglo XII

Enfrente: **Murrhardt,** capilla Walterich,
ventana de ábside con rica ornamentación y
esculturas de figuras, consolas y máscara en
el vértice, siglo XIII

Página doble siguiente: **Königslutter,**
San Pedro y San Pablo, friso de arco de
medio punto en el ábside principal,
después de 1135–finales del siglo XII

165

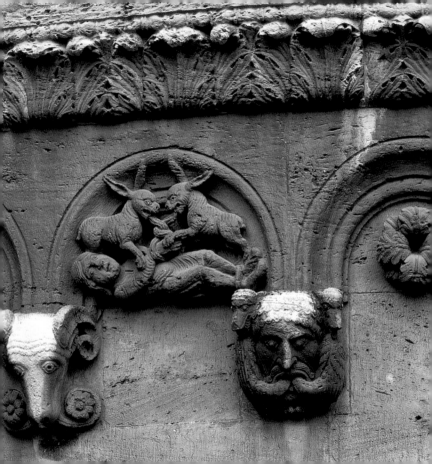

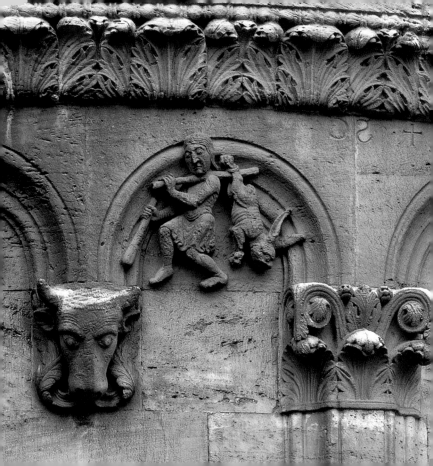

Capitals in Germany

The elaborate stories related in pictures on capitals in Spain or France have no counterpart in the Romanesque churches of Germany. Although the capitals made do with varied decorations, masks, or fantastic beings, they did not lack for ornamentation, as demonstrated by the examples on pages 168–171.

TOP: **Cologne**, St. Maria im Kapitol, cubic capital, 1040–1165
BOTTOM: **Hildesheim**, St. Michael, cubic capital with foliage and heads, before 1186
OPPOSITE: **Quedlinburg**, St. Servatius, cubic capital with figuration, before 1129

Capiteles en Alemania

Las historias ricamente ilustradas de los capiteles en España o Francia no encuentran equivalente en las iglesias románicas de Alemania. Si bien basta a los capiteles alemanes con diversos tipos de decoración, máscaras o monstruos, en modo alguno prescinden de adornos, como muestran los ejemplos en las p. 168–71

ARRIBA: **Colonia**, St. Maria im Kapitol, capitel cúbico, 1040–65
ABAJO: **Hildesheim**, San Miguel, capitel cúbico con hojarasca y cabezas, antes de 1186
ENFRENTE: **Quedlinburg**, San Servacio, capitel cúbico con figuras, antes de 1129

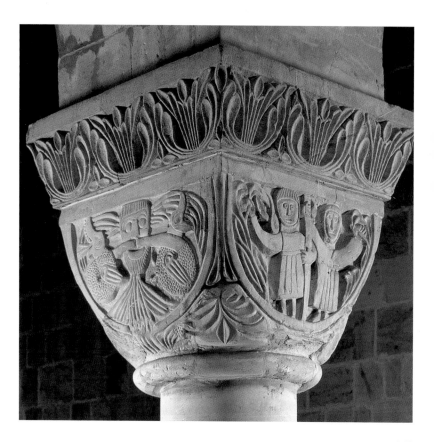

169

LEFT: **Gelnhausen**, former church of St. Marien, corbel of the choir arcade: man in tendrils, ca. 1240

OPPOSITE LEFT: **Goslar**, St. Simon and Judas, capital of the Hartmannus column with mask and dragons, third quarter of the 12th c.

OPPOSITE RIGHT: **Spieskappel**, St. Johannes der Täufer, capital from the nave with bearded face and heads, ca. 1200

A LA IZQUIERDA: **Gelnhausen**, antigua Santa María, consola de una arcada de coro: Hombre en sarmiento, hacia 1240

ENFRENTE Y A LA IZQUIERDA: **Goslar**, San Simón y San Judas, capitel de la columna de Hartmannus con máscara y dragón, tercer cuarto del siglo XII

ENFRENTE Y A LA DERECHA: **Spieskappel**, San Juan Bautista, capitel de la nave principal con máscara de barba y cabezas, hacia 1200

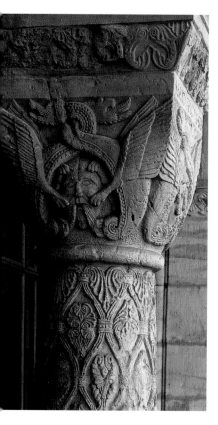
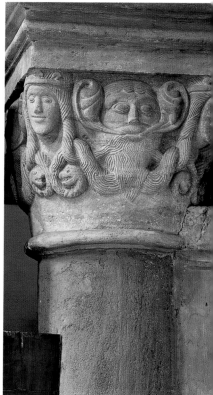

171

Romanesque Portals in Germany

Among the most significant works of Romanesque sculpture in Germany are the portals in Basel, Regensburg and Freiberg near Dresden. Like the Gallus Gate in Basel, the design of the north portal of the former Benedictine abbey in Regensburg is based on Roman triumphal arches. While the Gallus Gate is surrounded by an architectural frame of tabernacles and *aediculae*, the Regensburg portal is inserted in a display wall of reliefs. The Golden Gate in Freiberg, in contrast, an eight-layer staggered-jamb portal, already displays the influence of the Gothic cathedral portals that had been developing in France since the mid-twelfth century.

OPPOSITE: **Regensburg**, St. Jakob, north portal, ca. 1190

P. 174/175: **Basel**, Unserer Lieben Frauen (Cathedral of Our Lady), Gallus Gate and jamb figures on the staggered portal
Right: The evangelists Mark and Luke, end of the 12th c.

P. 176/177: **Freiberg near Dresden**, Unserer Lieben Frauen (parish church), Golden Gate and detail with tympanum and archivolts, ca. 1230

Portales románicos en Alemania

Entre las obras escultóricas románicas más importantes destacan los portales en Basilea, Regensburg y Freiberg cerca de Dresde. Igual que el portal Gallus en Basilea, el diseño del portal norte de la antigua abadía benedictina en Regensburg sigue el modelo de los arcos de triunfo romanos. Mientras que el portal Gallus está rodeado de una especie de arquitectura de tabernáculo y edícula, el portal en Regensburg se incorpora a un muro de exhibición con relieves. Por su parte, el portal dorado en Freiberg, con su abocinado en ocho escalones, se muestra influido ya por los portales góticos de las catedrales se venían desarrollando en Francia desde mediados del siglo XII.

ENFRENTE: **Regensburg**, San Jacobo, portal norte, hacia 1190

P. 174/75: **Basilea**, catedral Unserer Lieben Frauen, portal Gallus y figuras abocinadas en el portal escalonado, a la derecha: Evangelistas Marcos y Lucas, finales del siglo XII

P. 176/77: **Freiberg cerca de Dresde**, catedral Unserer Lieben Frauen, portal dorado y detalle con tímpano y archivoltas, hacia 1230

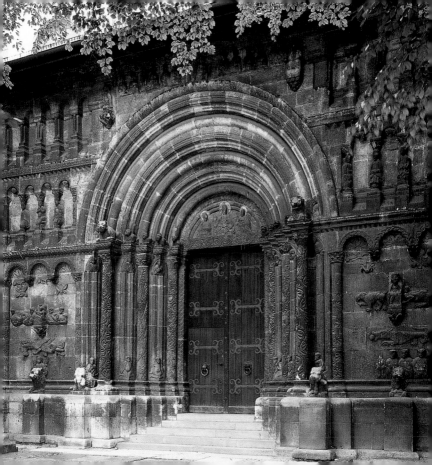

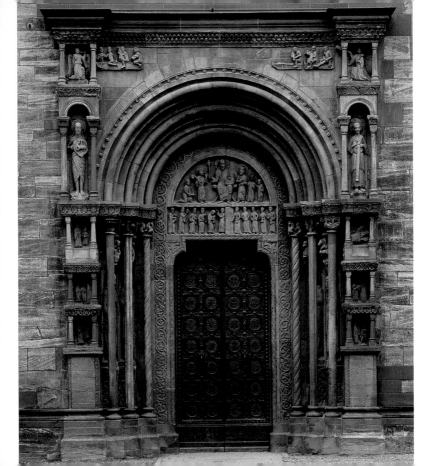

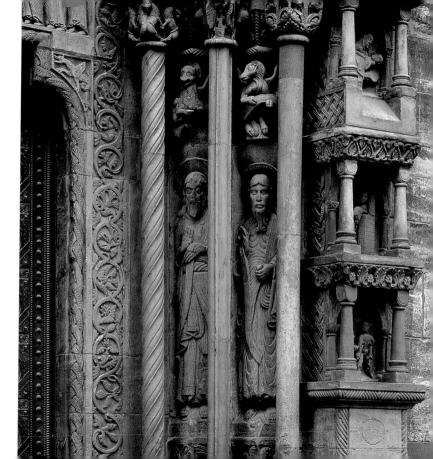

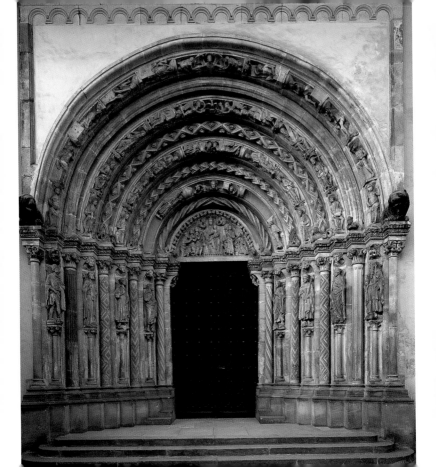

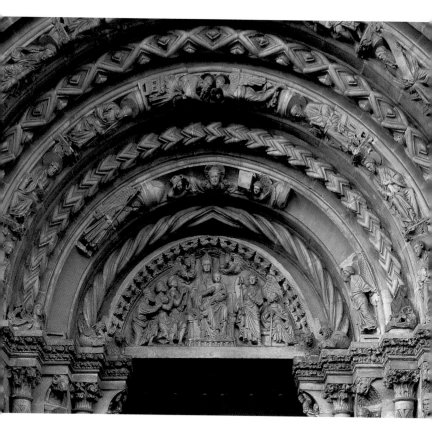

177

ABOVE: **Bonn**, St. Martin, side piece of choir stall depicting an angel and a demon, limestone, ca. 1210

OPPOSITE: **Freising**, St. Maria and St. Korbinian, crypt, beast column, ca. 1200

ARRIBA: **Bonn**, San Martín, almas de la sillería del coro con representación de ángeles y demonios, arenisca, hacia 1210

ENFRENTE: **Freising**, St. Maria y St. Korbinian, cripta, columna con bestiario, hacia 1200

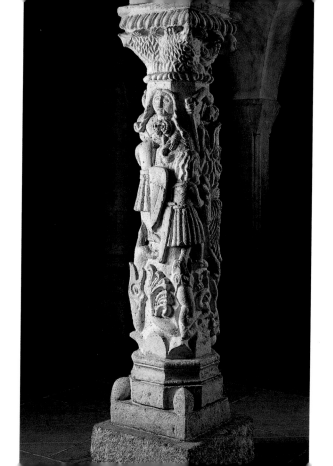

179

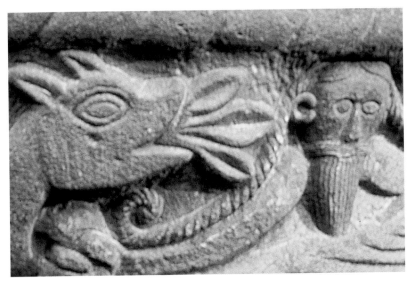

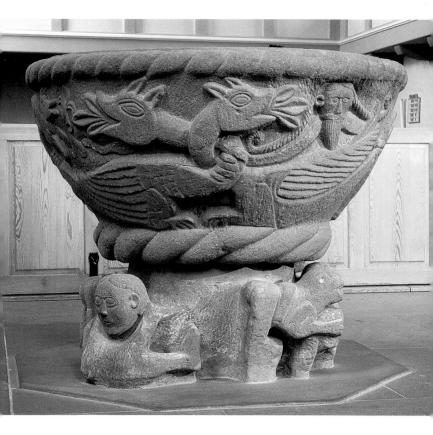

England

There was lavish production of Anglo-Saxon art from approximately the eighth century, which was tied to Roman and Celtic origins. With the Norman invasion spearheaded by William the Conqueror in 1066, however, the situation changed: Romanesque sculpture developed under myriad influences, whereby native forms melded with Scandinavian and continental styles, resulting in Anglo-Norman art.

LEFT: **Patrixbourne**, Romanesque church, archivolts of the portal, last third of the 12th c.

OPPOSITE: **Ely**, cathedral, The Prior's Door, before 1139

Inglaterra

Aproximadamente desde el siglo VIII hay una abundante producción artística anglosajona que está ligada a orígenes romanos y celtas. Con el normando Guillermo el Conquistador se inicia un cambio a partir del año 1066: la escultura romana se desarrolla bajo gran número de influencias, fusionándose formas autóctonas con formas escandinavas y continentales para resultar en un arte anglo-normando.

A LA IZQUIERDA: **Patrixbourne**, iglesia románica, archivoltas del portal, último tercio del siglo XII

ENFRENTE: **Ely**, catedral, The Prior's Door, antes de 1139

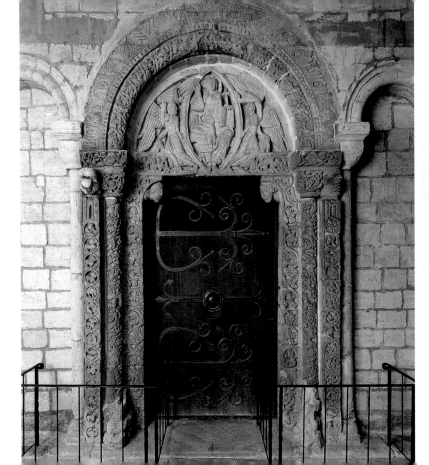

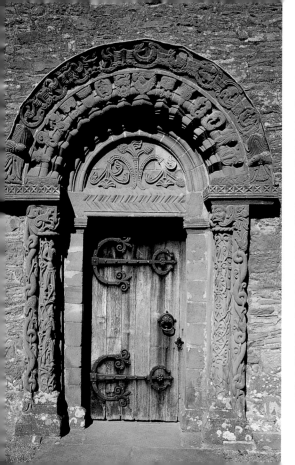

Kilpeck, St. Mary
and St. David
LEFT: south portal with
beast columns, ca. 1140

OPPOSITE: Corbel figure:
"Sheela na-gig" ("ugly as
sin"), mid-12th c.

FOLLOWING TWO PAGES:
Malmesbury, St. Mary and
St. Aldhelm, lunette on a
side wall of the south
portal atrium, ca. 1155–
1170

Kilpeck, St. Mary y
St. David
A LA IZQUIERDA: Portal sur
con columnas con
bestiario, hacia 1140

ENFRENTE: Figura de
consola: "Sheela Na-Gig"
("feo como el pecado"),
mediados del siglo XII

PÁGINA DOBLE SIGUIENTE:
Malmesbury, St. Mary and
St. Aldhelm, luneta en uno
de los murales laterales del
atrio del portal sur, hacia
1155–70

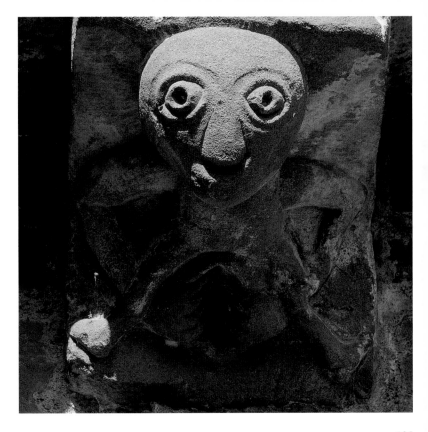

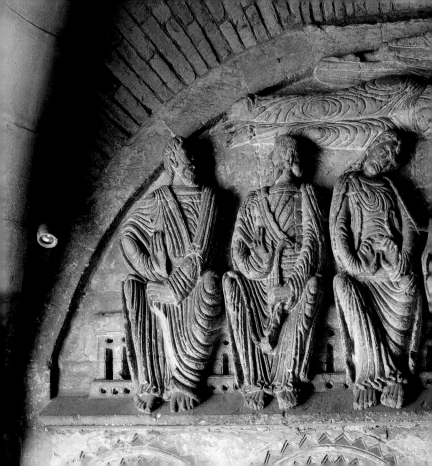

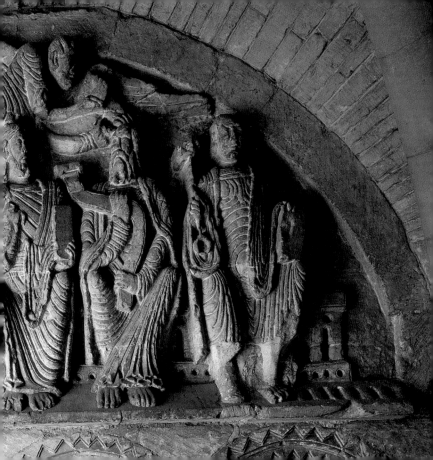

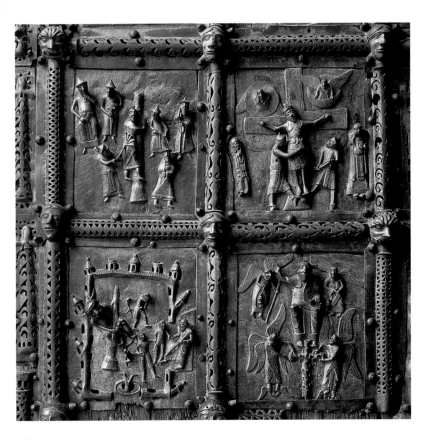

188

Wood, Bronze, and Ivory

A variety of materials were used in Romanesque art, and frequently combined with each other. Although the proportion of Romanesque sculpture executed in wood may have been relatively small, several of the outstanding works of the period are made of this material. In these cases, the sculptors often delivered a rough version of sculptures, which were then adorned with sumptuous mountings or overlaid with gold or silver. Of the base metals, bronze was considered the noblest, and because it is virtually indestructible it was considered the material for eternity. Tomb slabs and church doors were fashioned from bronze, as were baptismal fonts and other ritual objects. In addition to gold and silver, ivory was also of incalculable value. However, at the time, nothing was more valuable than the relics of saints, so only the most precious materials could be used to create the vessels that contained them.

OPPOSITE: **Verona**, S. Zeno, door of the west portal, wood with bronze reliefs, ca. 1138

P. 190/191: **Tróia in Apulia**, cathedral, begun 1093, west facade, portal zone and door (1119) of the west portal, Oderisius of Benevento, bronze, 366 x 205 cm (height x width)

Madera, bronce, marfil

En el románico se trabaja con variados y diferentes materiales, a menudo en combinación. Aunque el empleo de la madera en la escultura románica es muy limitado, debemos algunas de las obras más destacadas a este material. Los escultores entregaban con frecuencia las tallas en bruto de las obras escultóricas y estas eran revestidas luego con materiales más valiosos, como el oro y la plata. Entre los metales no nobles el bronce es el más valorado, por ser virtualmente indestructible y visto como un material para la eternidad. Se fabrican con bronce losas de sepulturas y puertas de iglesias, así como pilas bautismales y otros objetos para el culto. Junto al oro y la plata, el marfil tiene igualmente un valor inestimable. Pero nada consigue superar el valor de las reliquias de aquella época, porque sólo se podían fabricar los receptáculos con los materiales más valiosos.

ENFRENTE: **Verona**, San Zeno, puerta del portal occidental, madera con relieve de bronce, hacia 1138

P. 190/91: **Tróia en Apulia**, principios de 1093, fachada occidental, zona de portal y puerta (1119) del portal occidental, Oderisius von Benevent, bronce, 366 x 205 cm (alto x ancho)

Hildesheim, St. Michael

RIGHT AND OPPOSITE: Bernward's Doors in west portal, double bronze door with reliefs of Old and New Testament scenes; detail: scenes from the life of Jesus, Bernward of Hildesheim, completed 1015

P. 194/195: Romanesque baptismal font and details: one of the personified rivers of paradise as a foot of the font; detail of the relief on the cover with themes symbolizing baptism, Hildesheim casting workshop, bronze, 170 cm, diameter 96 cm, ca. 1225

Hildesheim, catedral

A LA DERECHA Y ENFRENTE: Puerta de Bernward en el portal occidental, puerta de dos alas con representaciones en relieve del Antiguo y Nuevo Testamento, detalle: Escenas de la vida de Jesús, terminada en 1015

P. 194/95: Pila bautismal románica y detalles: Uno de los ríos personificados del paraíso como pie de la pila bautismal; detalle del relieve de la tapa con temas simbólicos referidos al bautismo, taller de fundición en Hildesheim, bronce 170 cm, diámetro 96 cm, hacia 1225

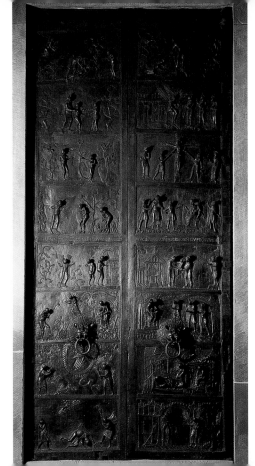

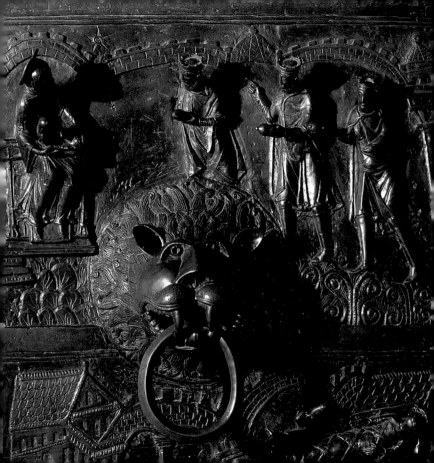

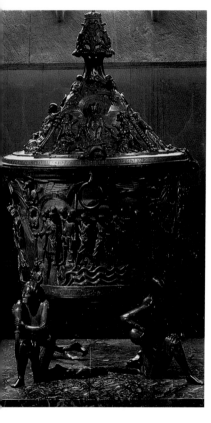

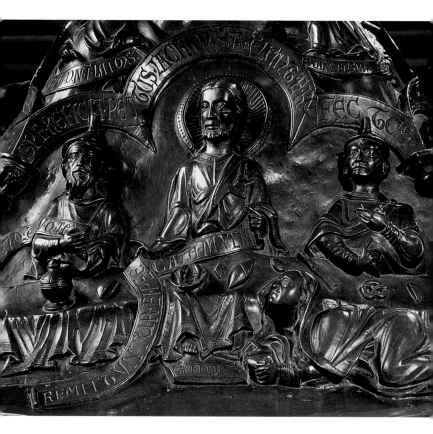

195

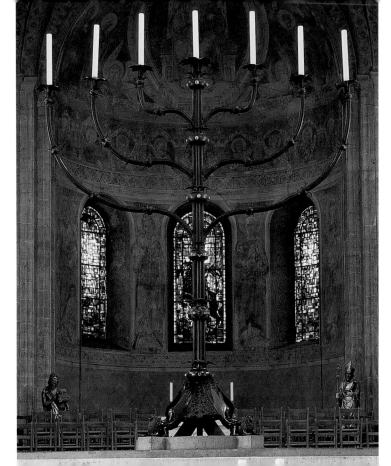

OPPOSITE: **Brunswick**, cathedral, seven-arm candelabra, bronze, enamel, approximately 4.8 m, insets in the base from 1896, ca. 1170–1190

RIGHT: **Brunswick**, Burgplatz, lion of Duke Henry the Lion, bronze copy; original bronze, 1163/1169, Braunschweig, Herzog Anton Ulrich Museum

ENFRENTE: **Brunswick**, catedral, candelabro de siete brazos, bronce, tabicado bizantino (*cloisonné*), aprox. 480 cm, inserciones en el pie de 1896, hacia 1170–90

A LA DERECHA: **Brunswick**, Burgplatz, león del duque Enrique el León, copia de bronce; original bronce 1163/69, Brunswick, museo Duque Anton-Ulrich

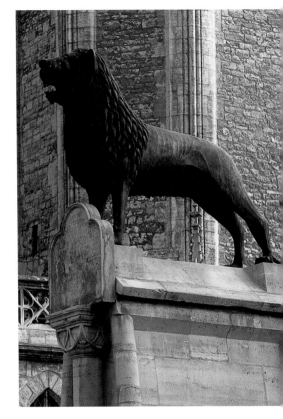

197

LEFT: **Cologne**, St. Maria im Kapitol, Hermann-Josef madonna, wood, ca. 1180

OPPOSITE: **Cologne**, Schnütgen Museum, crucifix from St. Georg, detail, walnut, 190 cm, ca. 1070

A LA IZQUIERDA: **Colonia**, St. Maria im Kapitol, Hermann-Josef-Madonna, madera, hacia 1180

ENFRENTE: **Colonia**, Schnütgen-Museum, crucifijo de San Jorge: Cabeza del crucificado, nogal, 190 cm, hacia 1070

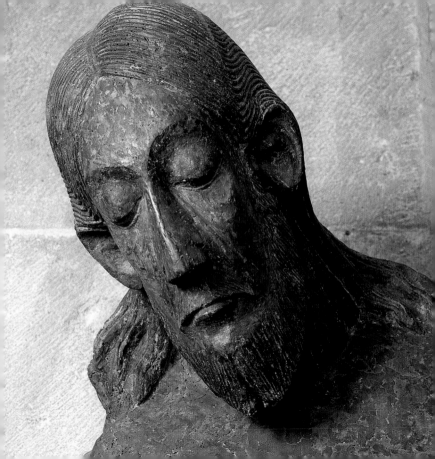

RIGHT: **Conques-en-Rouergue,** Ste-Foy, gold statue of St. Foy, gold plate on wood, precious stones, ca. 1000, church treasury

OPPOSITE LEFT: **Orcival,** Notre-Dame, enthroned Madonna and Child, wood, silver-plated copper, 74 cm, 12th c.

OPPOSITE RIGHT: **Tournus,** St-Philibert, enthroned Madonna and Child, "Notre-Dame-la-Brune," colored wood, partially gilt, 73 cm, second half of the 12th c.

A LA DERECHA: **Conques-en-Rouergue,** Ste-Foy, estatua de oro de San Fides, corazón de madera, chapas doradas, piedras preciosas, hacia 1000, tesoro de la iglesia

ENFRENTE A LA IZQUIERDA: **Orcival,** Notre-Dame, Madre de Dios en el trono con Niño, madera, cobre, plateado, 74 cm, siglo XII

ENFRENTE A LA DERECHA: **Tournus,** St-Philibert, Madre de Dios en el trono con Niño, "Notre-Dame-la-Brune", madera, pintado y parcialmente dorado, 73 cm, 2ª mitad del siglo XII

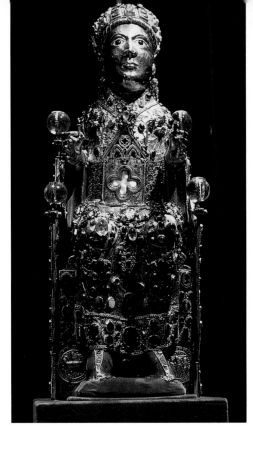

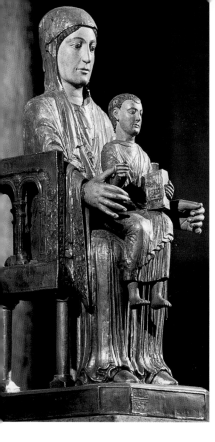
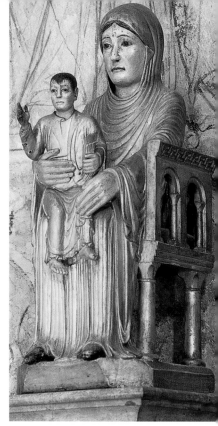

201

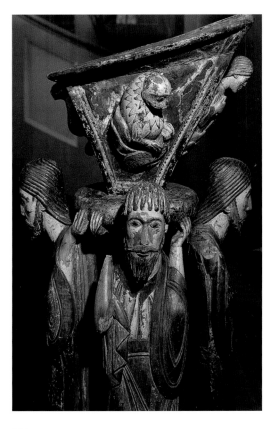

LEFT: **Freudenstadt**, Protestant parish church, pulpit from the abbey church of Alpirsbach, colored wood, 137 cm, mid-12th c.

OPPOSITE: **Cologne**, St. Maria im Kapitol, left door wing, detail, colored wood, total height of the door 4.74 m, width of the door wing 2.26 m, ca. 1065

A LA IZQUIERDA: **Freudenstadt**, iglesia parroquial evangélica, atril de la iglesia conventual de Alpirsbach, madera, pintada, 137 cm, mediados del siglo XII

ENFRENTE: **Colonia**, St. Maria im Kapitol, a la izquierda de la puerta, detalle, madera, pintada, altura total de la puerta 474 cm, ancho del ala 226 cm, hacia 1065

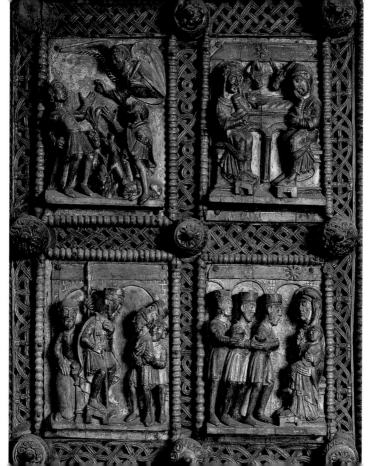

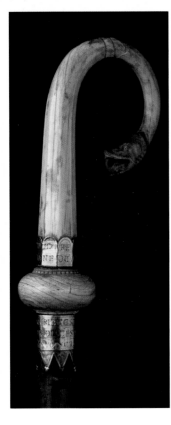

LEFT: **Siegburg**, treasury of St. Servatius, crook of St. Anno, ivory, height 20 cm, ca. 1063

OPPOSITE: **Pamplona**, S. Miguel in Excelsis, detail of retable, copper, gilt, chemplevé and cloisonné enamel, 1175–1180

P. 206: **Brunswick**, Herzog Anton Ulrich Museum, Gospel Book from St. Aegidien, gilt and silver-plated wood, inlaid with pearls and semi-precious stones, morse ivory, 30.9 x 22 cm (height x width), end-12th c.

P. 207: **Berlin**, Kunstgewerbemuseum, copper reliquary from the Guelf treasure, wooden core, enamel on copper and gilt, reliefs/figures of morse ivory, varnished base, pedestals bronze and gilt, 45.5 x 41 cm (height x width), ca. 1175–1180

A LA IZQUIERDA: **Siegburg**, tesoro de San Servacio, báculo del Año Santo, marfil, 20 cm, hacia 1063

ENFRENTE: **Pamplona**, San Miguel in Excelsis, detalle del retablo, cobre, dorado, tabicado bizantino (*cloisonné*) y *champlevé*, 1175–80

P. 206: **Braunschweig**, museo Duque Anton Ulrich, evangeliario de St. Aegidien, corazón de madera, chapa plateada, dorado, perlas y piedras semipreciosas, diente de morsa, 30,9 x 22 cm (alto x ancho), finales del siglo XII

P. 207: **Berlín**, museo de los Oficios Artesanos, relicario de la cúpula del tesoro güelfo, corazón de madera, tabicado bizantino (*cloisonné*) sobre cobre, dorado, relieves/figuras diente de morsa, base barnizada, pies de bronce, dorados; 45,5 x 41 cm (alto x ancho), hacia 1175–80

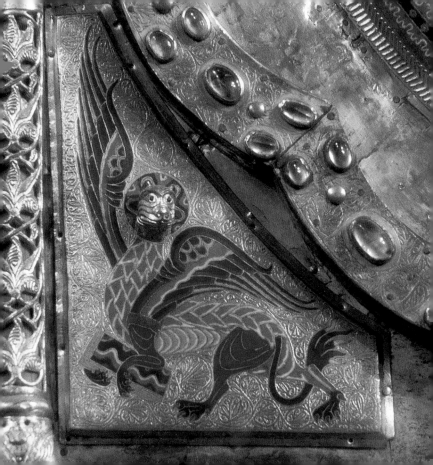

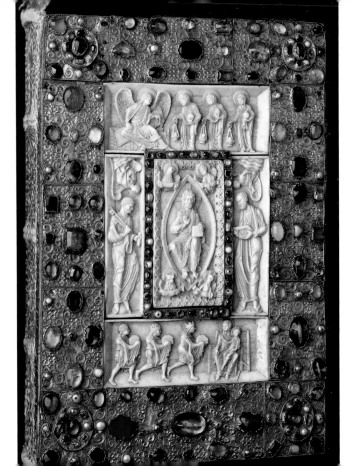

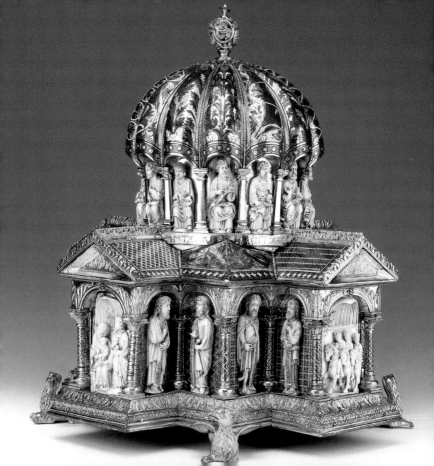

Sculpture of the
Gothic

The sculpture of the central west portal of Chartres Cathedral, which was executed between 1145 and 1155, marked an epochal transition in the history of Western sculpture. Of primary importance, the figures stepped out of the stone screen of Romanesque relief walls. At the same time, however, since they remain integrated into columns that only appear to be located behind them, the figures themselves are part of the cathedral's architecture and thus an element of the hierarchy of theology and kingdom. The narrowly defined theological context of the Gothic figures is in opposition to fantastic, apotropaic Romanesque portal sculpture, in effect banishing heathen powers. At the same time, Gothic sculptors achieved superb masterpieces of drapery, anatomy, and social characterization.

Escultura del
gótico

Entre 1145 y 1155 se construyen las esculturas del portal central occidental de la catedral de Chartres. Estas esculturas marcan un cambio trascendental en la historia de la escultura occidental. Por una parte, se salen de los planos de piedra de los relieves de los muros románicos. Al mismo tiempo, sin embargo, en la medida en que permanecen unidas en la forma de columnas colocadas sólo en apariencia detrás de ellas, se convierten en arquitectura de la catedral y, así, en componente de la jerarquía de la teología y la monarquía. A la magia defensiva y llena de fantasía de las esculturas románicas en los portales, estas esculturas oponen una estructura teológica muy demarcada para conjurar sus arcaicos poderes. Los escultores del gótico logran también resultados sobresalientes en estudios de vestiduras, representaciones de figura humana y caracterizaciones sociales.

France

Although they are not the earliest Gothic figures, the sculptures on the triple Royal Portal at Chartres (p. 212/213) are considered the epitome of Gothic sculpture. They seem to have broken out of their Romanesque bondage to the surface of the masonry to stand right in front of the jamb columns on the portal. The slender forms, draped in rich courtly robes of the time, have a very special aesthetic appeal. Their creation testifies to a new way of viewing nature and humankind. In spite of their column-like appearance and the ceremonial stylization, each of the figures still has a separate, almost individual characterization, in which age and youth are naturalistically differentiated.

Francia

Si bien no se trata de las figuras más antiguas del gótico, las esculturas en el portal Real en Chartres (p. 212/13) se consideran la síntesis de la escultura gótica. Es como si las figuras del aparejo mural románico en relieve se hubieran puesto delante de las columnas del portal abocinado, desplegando así un encanto particularmente estético, procedente de las esbeltas figuras ataviadas en ricas vestiduras cortesanas de la época. Su transformación, no obstante, denota un nuevo modo de ver de la naturaleza y el hombre. Porque a pesar del aspecto columnario y la estilización ceremonial cada una de las figuras presenta una caracterización propia, diferenciando con mucho realismo vejez y juventud.

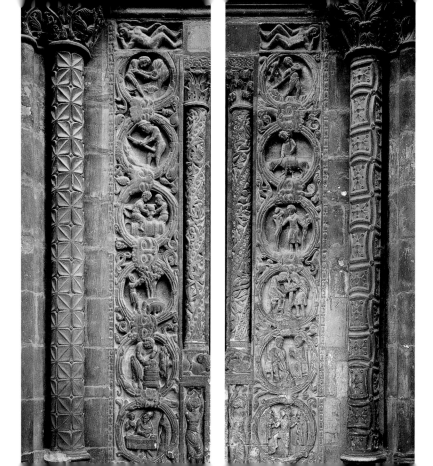

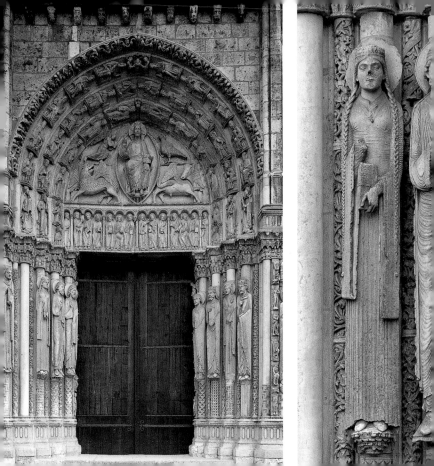

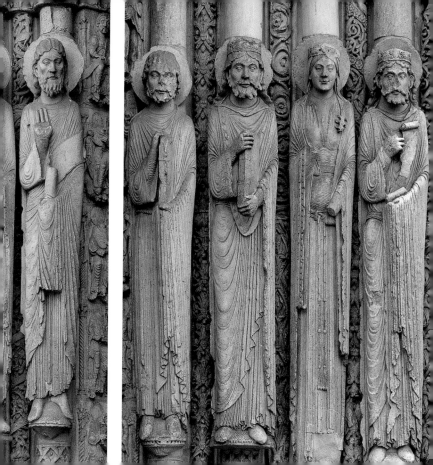

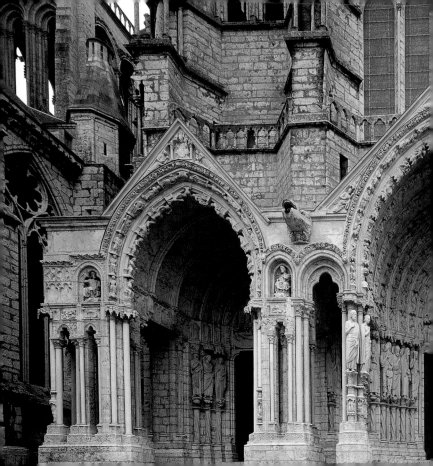

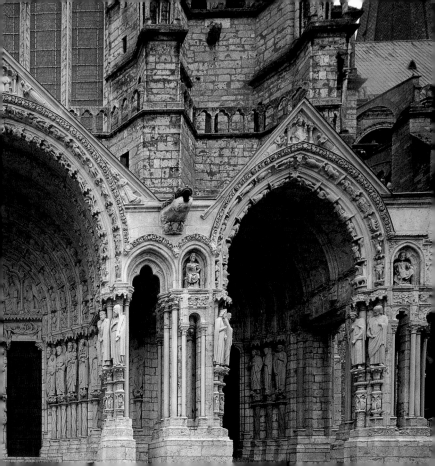

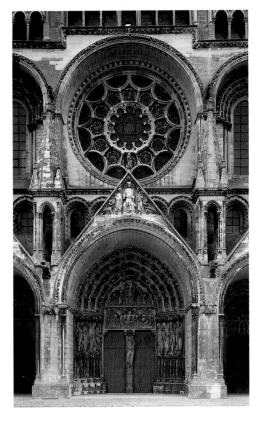

LEFT: **Chartres**, Notre-Dame, center portal of the south transept with the Last Judgment, ca. 1210

OPPOSITE: **Laon**, Notre-Dame, west facade, center portal, begun before 1200

A LA IZQUIERDA: **Chartres**, Notre Dame, portal central de la nave transversal sur con el juicio final, hacia 1210

ENFRENTE: **Laon**, Notre Dame, fachada occidental, portal central, comienzo antes de 1200

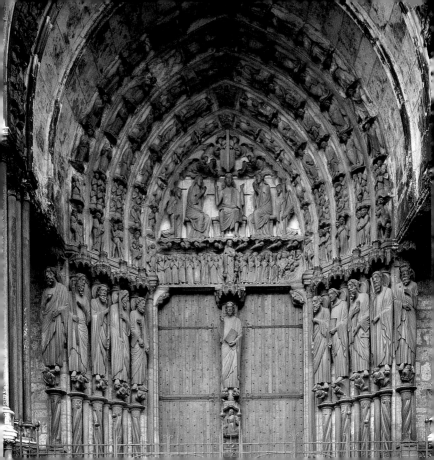

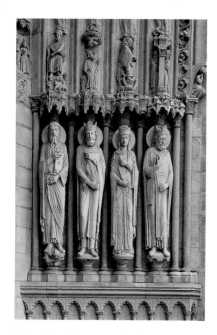

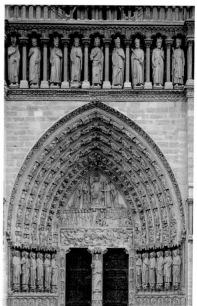

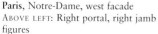

Paris, Notre-Dame, west facade
ABOVE LEFT: Right portal, right jamb
figures

ABOVE RIGHT: Center portal

OPPOSITE: Center portal, tympanum,
begun 1200

París, Notre Dame, fachada occidental
ARRIBA A LA IZQUIERDA: Portal derecho,
figuras en el abocinado derecho

ARRIBA A LA DERECHA: Portal central

ENFRENTE: Portal central, tímpano,
comienzo en 1200

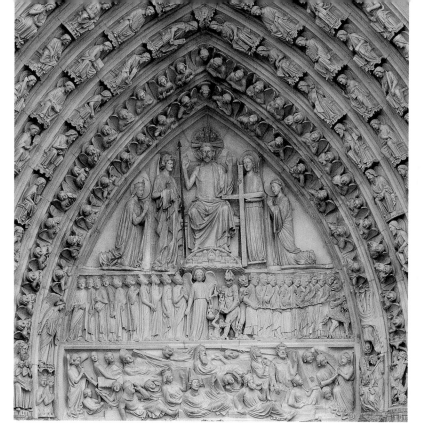

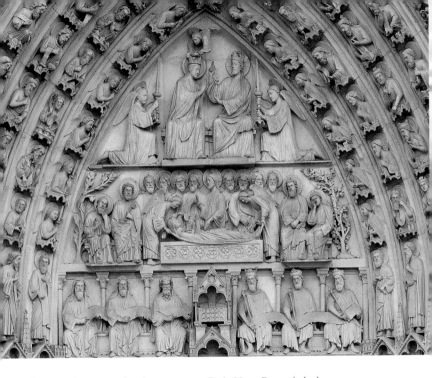

Paris, Notre-Dame, west facade, left portal, Coronation of the Virgin in the tympanum, begun 1200

París, Notre Dame, fachada occidental, portal izquierdo, coronación de la Virgen María en el tímpano, comienzo en 1200

220

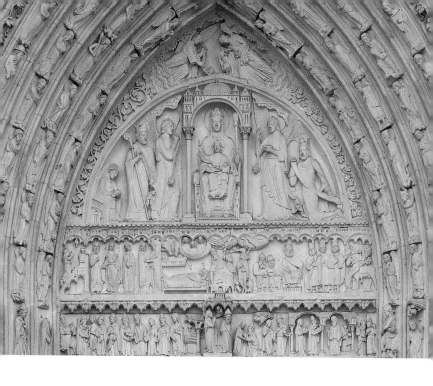

Paris, Notre-Dame, west facade, right portal, Portal of St. Anne, tympanum, begun 1200

París, Notre Dame, fachada occidental, portal derecho, portal de St. Anne, tímpano, comienzo en 1200

221

Reims, Notre-Dame, west facade, after 1252

Opposite left: Center portal

Opposite right: Interior view of the center portal

P. 224: Right portal, left jamb figures

P. 225: Center portal, right jamb figures

Reims, Notre Dame, fachada occidental, después de 1252

Enfrente a la izquierda: Portal central

Enfrente a la derecha: Vista interior del portal central

S. 224: Portal derecho, figuras en el abocinado izquierdo

S. 225: Portal central, figuras en el abocinado derecho

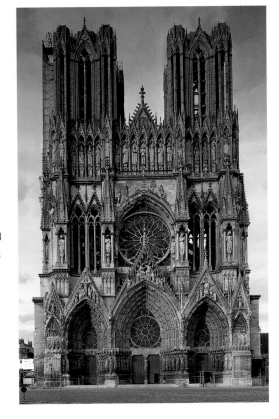

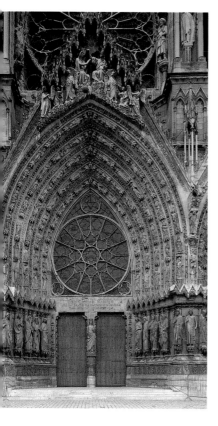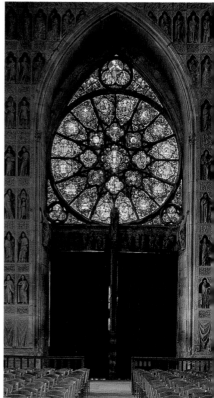

223

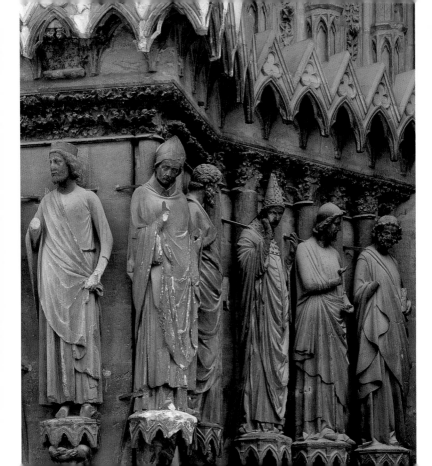

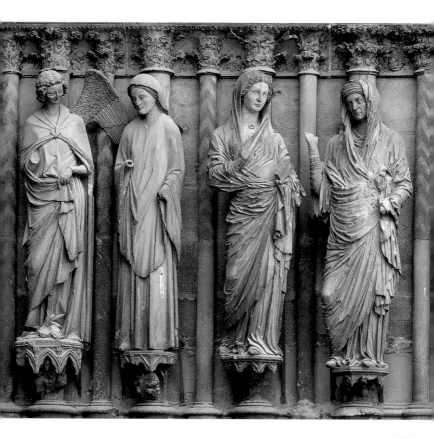

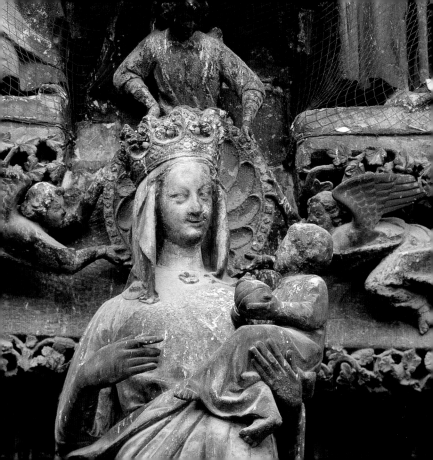

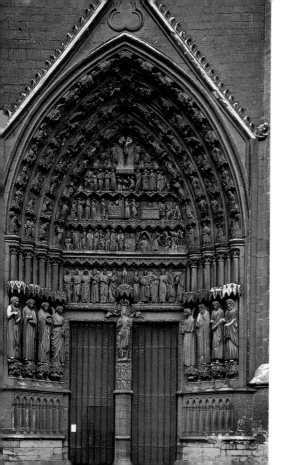

Amiens, Notre-Dame
OPPOSITE: Detail of the
Golden Virgin trumeau figure

LEFT: Portal of the south
transept, ca. 1240/1245

P. 228: West facade, center
portal, right jamb figures

P. 229: West facade, center
portal, trumeau figure,
1220/1230

Amiens, Notre Dame
ENFRENTE: Detalle de la figura
en el pilar central del portal,
Vierge Dorée

A LA IZQUIERDA: Portal
de la nave transversal sur,
hacia 1240/45

P. 228: Fachada occidental,
portal central, figuras en el
abocinado derecho

P. 229: Fachada occidental,
portal central, figuras en el
pilar, 1220/30

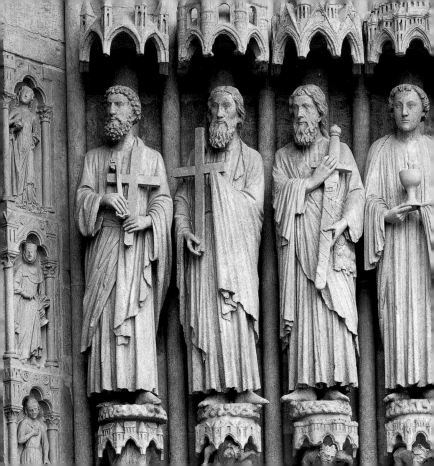

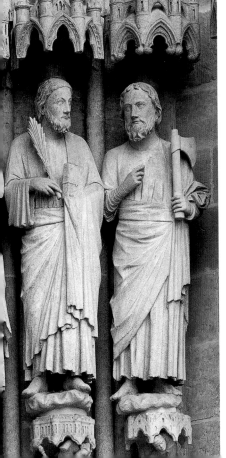

As Gothic sculpture freed itself from the constraints of the Romanesque bondage to the surface, the figures themselves became more animated. They entered into a new relationship with space and became more humanized, in accordance with their increasing freedom of movement.

RIGHT: **Sens**, St-Étienne, center west portal, St. Stephen on the trumeau, ca. 1200

OPPOSITE: **Rouen**, Notre-Dame, south transept, tympanum in the Calende Portal, ca. 1300

Con la solución de la escultura gótica de salirse del aparejo mural románico, la figura misma se pone en movimiento también y entra en una nueva relación con el espacio, experimentando una humanización que va unida a su mayor movilización.

A LA DERECHA: **Sens**, St-Étienne, portal central occidental, San Esteban en el pilar central del portal, hacia 1200

ENFRENTE: **Rouen**, Notre Dame, nave transversal sur, tímpano en el Portal de la Calende, hacia 1300

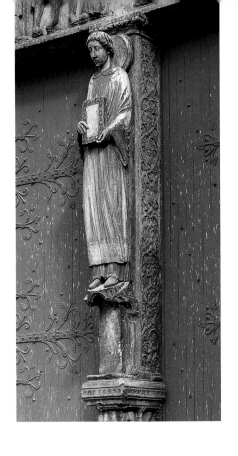

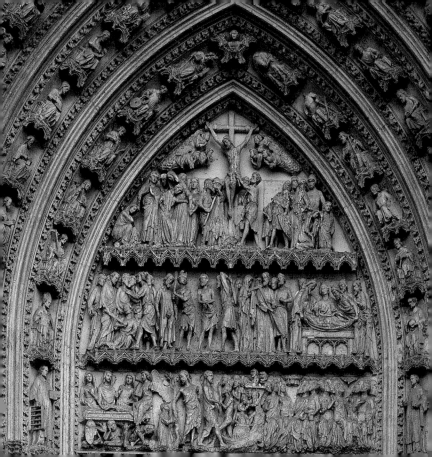

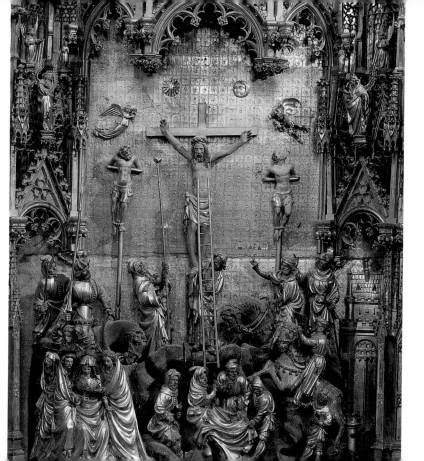

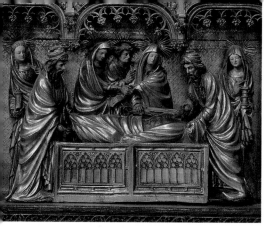

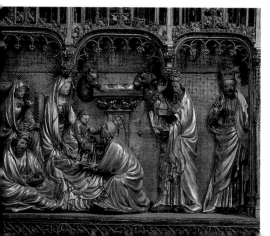

OPPOSITE: **Jacques de Baerze and Melchior Broederlam**, Passion Altar, ca. 1390, Dijon, Musée des Beaux-Arts

LEFT TOP AND BOTTOM: details

ENFRENTE: **Jacques de Baerze y Melchior Broederlam**, altar de la pasión, hacia 1390, Dijon, museo de Bellas Artes

A LA IZQUIERDA ARRIBA Y ABAJO: Detalles

Claus Sluter

The Dutch sculptor Claus Sluter worked in Dijon from 1385 onward, where numerous important works were created under his direction. Sluter fashioned a portal for the Chartreuse de Champmol (p. 238/239). The life-like quality of his sculpture associates this work with "Flemish Realism," and marks a transition to the Renaissance north of the Alps.

Claus Sluter, Tomb of Philip the Bold
OPPOSITE: Detail: Profile of head with angel

FOLLOWING TWO PAGES:
Detail: *Pleurants* (mourners)
1405–1411, Dijon, Musée
des Beaux-Arts

Claus Sluter, Chartreuse de Champmol
P. 238: Portal of the chapel, 1389–1406

P. 239 LEFT: Detail: Madonna and Child from the trumeau, ca. 1391

P. 239 RIGHT: Right jamb with figures of the sponsor and intercessor, 1393

Claus Sluter

El escultor holandés Claus Sluter trabaja desde 1385 en Dijon, donde se crean numerosas obras importantes bajo su dirección. En el convento de cartujos de Champmol Sluter acaba un portal (p. 238/39) que, por la similitud con la naturaleza de sus esculturas, se atribuye al realismo flamenco, marcando al norte de los Alpes la transición al estilo renacentista.

Claus Sluter, sepultura para Felipe el Atrevido
ENFRENTE: Detalle: Cabeza de perfil con ángel

PÁGINA DOBLE SIGUIENTE:
Detalle: Dolientes
1405–11, Dijon, museo de Bellas Artes

Claus Sluter, Dijon, convento de cartujos de Champmol
P. 238: Portal de la capilla, 1389–1406

P. 239 A LA IZQUIERDA: Detalle: Virgen María con Niño en el pilar central, hacia 1391

P. 239 A LA DERECHA: Abocinado derecho con las figuras de la oferente y la intercesora, 1393

234

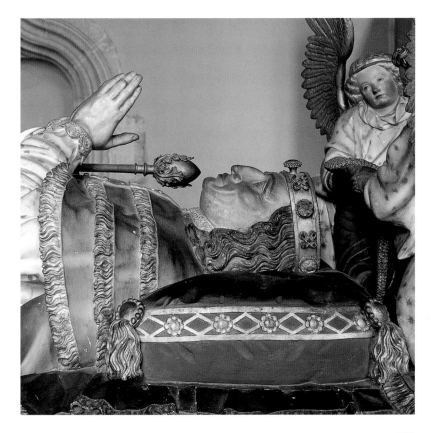

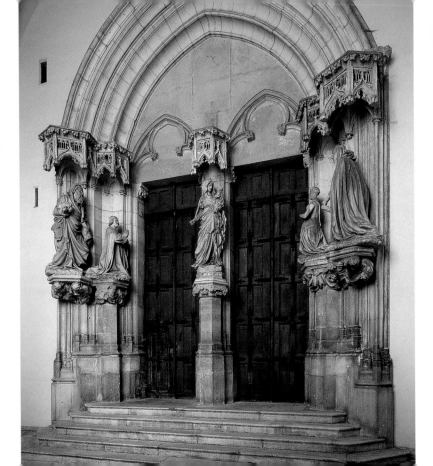

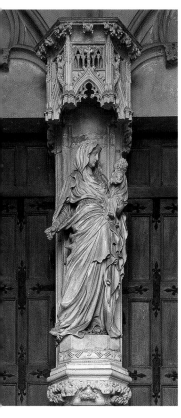
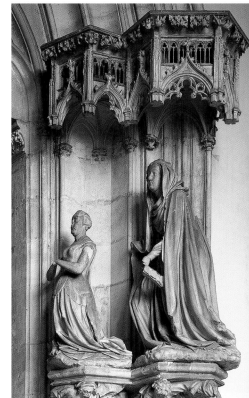

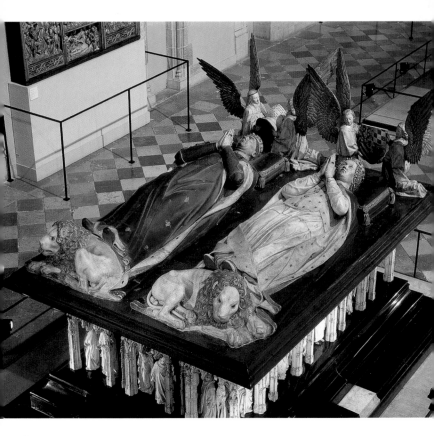

Burial Groups (p. 242–244)

Depictions of the Burial of Christ, which originated from Byzantine art, are positioned between the Deposition from the Cross and the Lamentation in the Passion Cycle. Burial and lamentation scenes cannot always be distinguished from one another, and were often purposely combined. In conjunction with the emergence of the veneration of the Holy Corpse, Christ is shown not wrapped in shrouds, but wearing only a loin cloth. In the fifteenth century, Holy Sepulcher groups evolved into Burial groups and appeared most often in the predellas of Passion altars.

Conjuntos sepulcrales (p. 242–44)

Las representaciones del conjunto fúnebre de Cristo, procedentes primeramente del arte bizantino, se desarrollan en el ámbito de la pasión entre el descendimiento de la cruz y la aflicción. El entierro y la aflicción aparecen con frecuencia unidos, por lo que no siempre se puede delimitar una parte de la otra. Probablemente debido a la propagación del culto al cuerpo santo, no se representa a Cristo envuelto en un sudario sino llevando únicamente las enagüillas. Los conjuntos funerarios santos se amplían en el siglo XV en grupos sepulcrales y aparecen la mayoría de las veces en las predelas de los altares de la pasión.

OPPOSITE: **Dijon**, Musée des Beaux-Arts, double tomb of Duke John the Fearless († 1419) and his wife Margaret of Bavaria; made by Jean de la Huertá and his workshop based on the tomb for Philip the Bold by Claus Sluter, from 1443

ENFRENTE: **Dijon**, Dijon, museo de Bellas Artes, sepultura doble para el duque Juan sin Miedo († 1419) y su esposa Margarita de Baviera; obra de Jean de la Huertá y su taller, a partir de 1443, según el modelo de la sepultura para Felipe el Atrevido de Claus Sluter

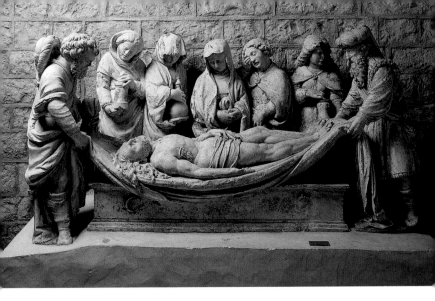

Talant, Notre-Dame, burial group,
early 14th c.

Talant, Notre Dame, grupo sepulcral,
principios del siglo XIV

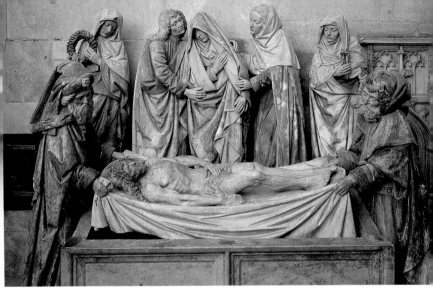

Semur-en-Auxois, Notre-Dame, burial group, 1490

Semur-en-Auxois, Notre Dame, grupo sepulcral, 1490

FOLLOWING TWO PAGES:
Tonnere, former hospital, burial group, 1454

PÁGINA DOBLE SIGUIENTE:
Tonnere, antiguo hospital, grupo sepulcral, 1454

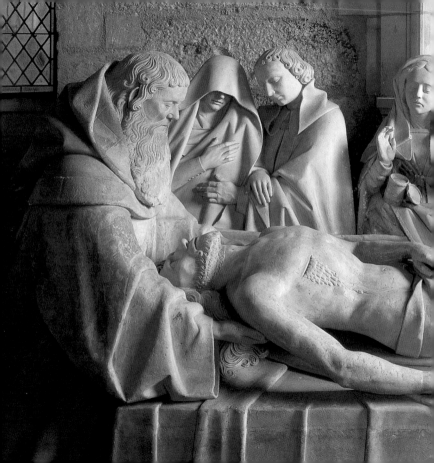

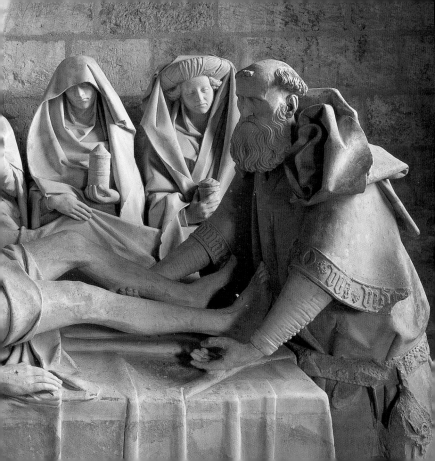

LEFT: **Fontenay**, Fontenay Abbey, *Madonna of Fontenay*, ca. 1300

OPPOSITE LEFT: **Auxonne**, Notre-Dame, *Madonna with Grapes* (after Sluter), mid-15th c.

OPPOSITE RIGHT: **Autun**, Musée Rolin, *Madonna of Autun*, 15th c.

A LA IZQUIERDA: **Fontenay**, abadía Fontenay, *Virgen de Fontenay*, hacia 1300

ENFRENTE A LA IZQUIERDA: **Auxonne**, Notre Dame, *Virgen con uvas* (sucesión de Sluter), hacia siglo XV

ENFRENTE A LA DERECHA: **Autun**, museo Rolin, *Virgen de Autun*, siglo XV

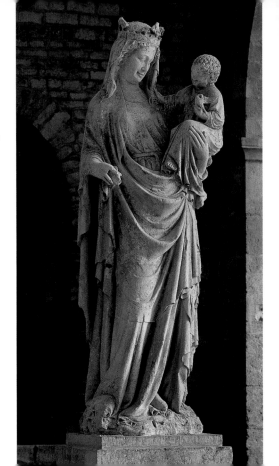

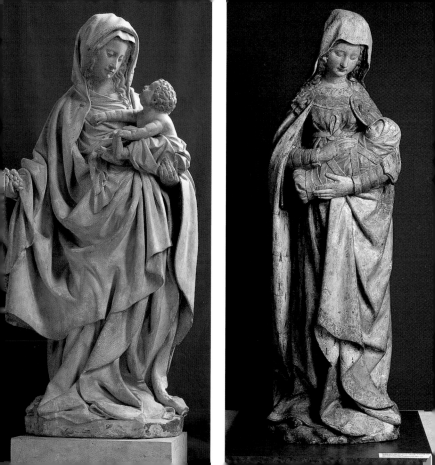

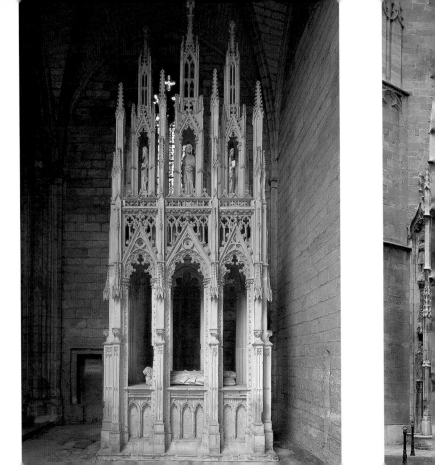

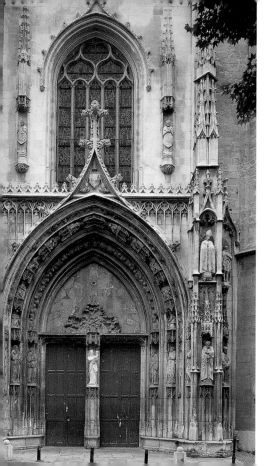

OPPOSITE: **Villeneuve-lès-Avignon**, charterhouse of Val-de-Bénédiction, tomb of Pope Innocent VI, ca. 1360

LEFT: **Aix-en-Provence**, St-Sauveur, south side, flamboyant style portal, beginning of the 16th c.

FOLLOWING TWO PAGES: **Albi**, St-Cécile, chancel screen, detail, 1287–ca. 1400

ENFRENTE: **Villeneuve-lès-Avignon**, iglesia del convento de cartujos Val-de-Bénédiction, sepultura de Inocencio VI, hacia 1360

A LA IZQUIERDA: **Aix-en-Provence**, St-Sauveur, lado sur, portal estilo flamboyant, principios del siglo XVI

PÁGINA DOBLE SIGUIENTE: **Albi**, St-Cécile, coro alto, detalle, 1287–hacia 1400

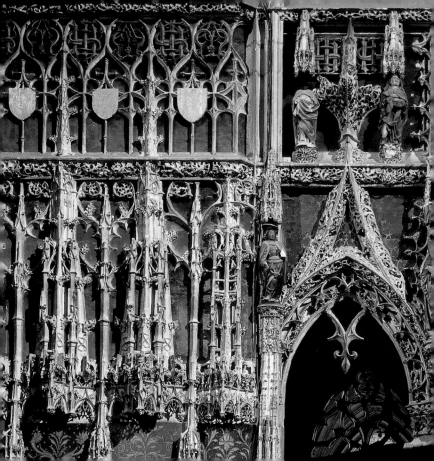

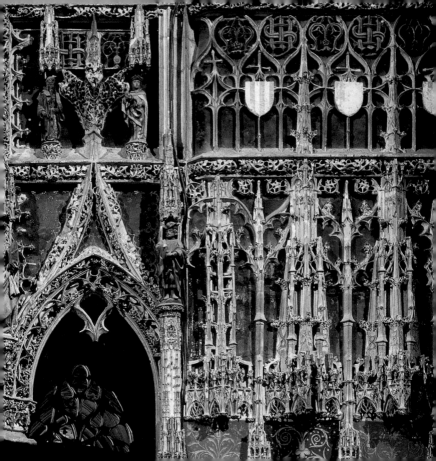

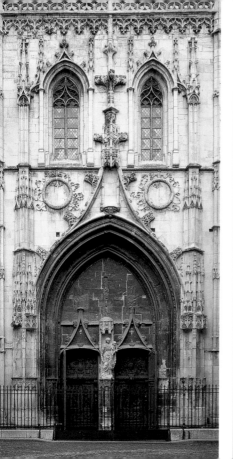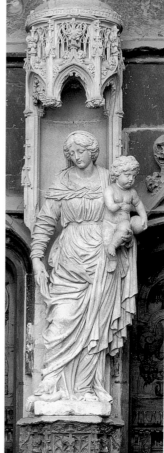

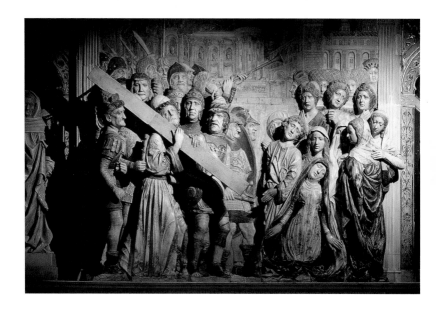

ABOVE: **Francesco Laurana**, Bearing
of the Cross group, 1478, Avignon,
St-Didier

OPPOSITE: **Avignon**, St-Pierre, west
facade, detail (left), Madonna and Child
on the trumeau (right), end of the 15th c.

ARRIBA: **Francesco Laurana**, conjunto
cruciferario, 1478, Aviñón, St-Didier

ENFRENTE: **Aviñón**, St-Pierre, fachada
occidental, detalle (a la izquierda),
Virgen María Niño en el pilar central
(a la derecha), finales del siglo XV

253

Italy

The figural portal of the French cathedral with its wealth of jamb and archivolt sculpture was not able to establish itself in Italy; it follows that Italian Gothic sculpture was less closely related to architecture. Nonetheless, early thirteenth-century Italian sculpture was clearly influenced by the art of the Ile-de-France. Elements of Romanesque sculpture are visible, yet other factors can also be identified that suggest contact with the Orient or the more severe formal concepts of Byzantine art. In addition, the remains of antique art were far more vividly present for sculptors here than was the case north of the Alps. Italian sculptors, confident of their abilities, stepped forward and were known by name earlier than elsewhere in Europe, such that the history of Italian art in the thirteenth century, with few exceptions, can already be seen as a history of individual artists.

Italia

Como en Italia no pudo implantarse el portal de figuras de las catedrales francesas con su rico ornamento escultural abocinado y archivoltas, la escultura gótica italiana está también menos unida a la arquitectura. No obstante, la escultura italiana de principios del siglo XIII muestra una clara influencia de la escultura de la Île-de-France. Por un lado, aunque son perceptibles reminiscencias de la escultura románica, pueden reconocerse también rasgos que indican un contacto con el oriente o con el estricto mundo de formas del arte bizantino. Además, se hallan aquí vestigios del arte antiguo más evidentes a los ojos de los escultores que al norte de los Alpes. Los escultores en Italia, conscientes de su saber, se manifiestan asimismo por su nombre antes que en el resto de Europa, de tal modo que la historia del arte italiano del siglo XIII, salvo algunas pocas excepciones, se puede considerar ya como una historia de los mismos artistas.

Opposite: **Nicola Pisano,** Pisa, baptistery, pulpit, marble, 465 cm, 1260
Right top: Detail: Presentation in the Temple
Right center: Detail: Crucifixion
Right bottom: Detail: Last Judgment

Enfrente: **Nicola Pisano**, Pisa, pila bautismal, púlpito, mármol, 465 cm, 1260
A la derecha arriba: Detalle: Ofrenda en el templo
A la derecha centro: Detalle: Crucifixión
A la derecha abajo: Detalle: Juicio final

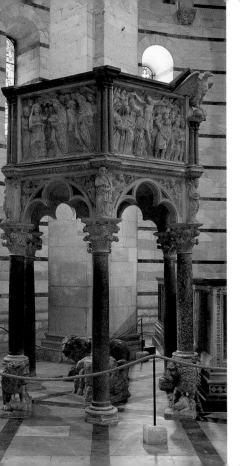

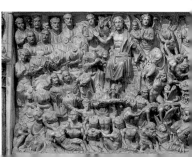

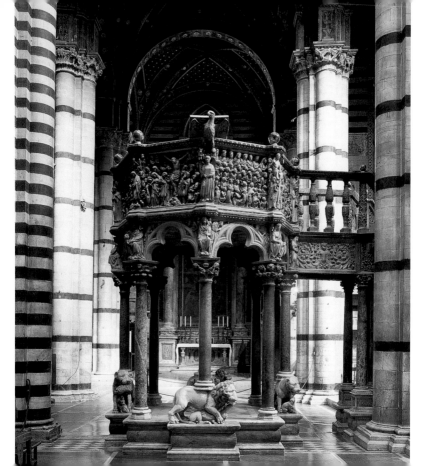

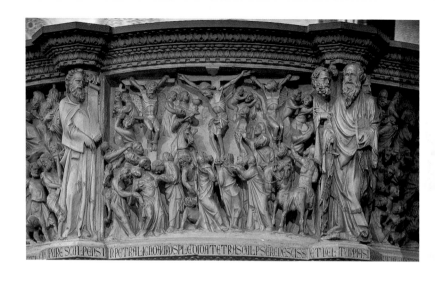

OPPOSITE: **Nicola and Giovanni Pisano**, pulpit, marble, 460 cm, 1265–1286, Siena, cathedral

ABOVE AND FOLLOWING TWO PAGES: **Giovanni Pisano**, pulpit, marble, 461 cm, relief on the pulpit wall, Crucifixion, Flight to Egypt, 1301–1311, Pisa, cathedral

ENFRENTE: **Nicola y Giovanni Pisano**, púlpito, mármol, 460 cm, 1265–86, Siena, catedral

ARRIBA Y PÁGINA DOBLE SIGUIENTE: **Giovanni Pisano**, púlpito, mármol, 461 cm, relieve del pretil: Crucifixión, huida a Egipto, 1301–11, Pisa, catedral

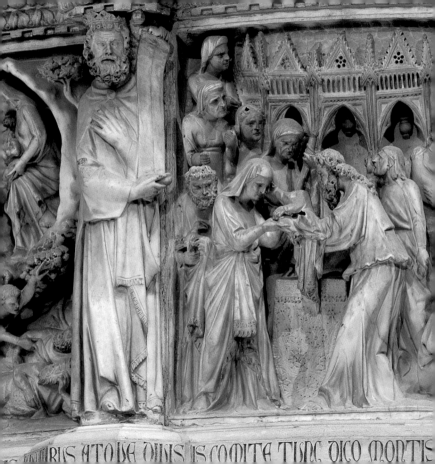

RRS ATOVE VINS IS COMITE TISNE DICO MONTIS

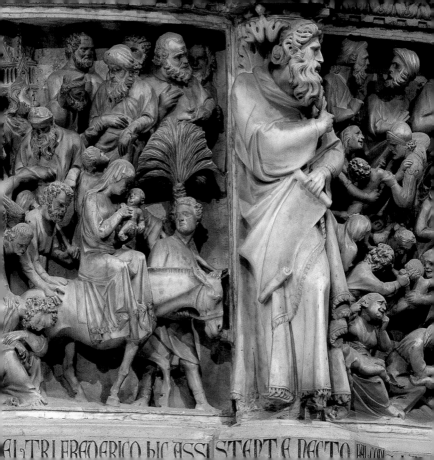

AL·TRI·FRANARICO·HIC·ASSI·STANT·E·RACTO

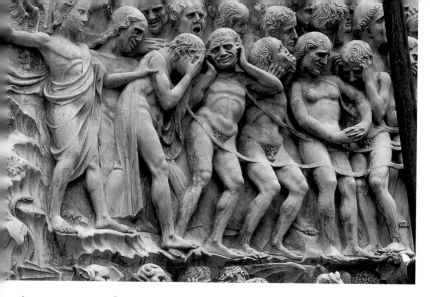

ABOVE AND OPPOSITE: **Lorenzo Maitani**, depiction of hell, details, 1310–1330, Orvieto, cathedral

ARRIBA Y ENFRENTE: **Lorenzo Maitani**, representaciones del infierno, detalles, 1310–30, Orvieto, catedral

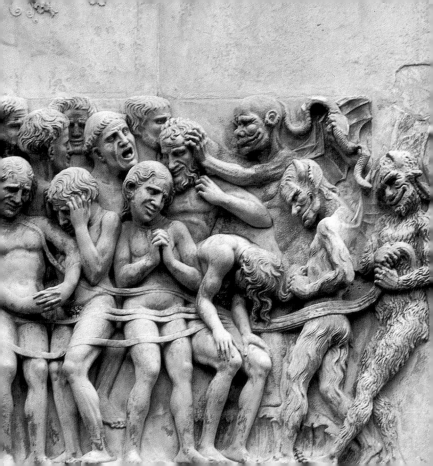

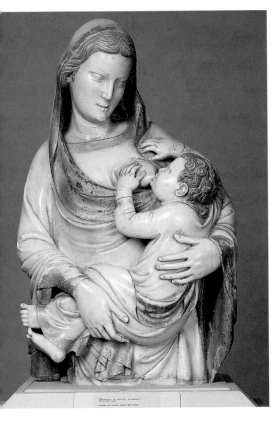

LEFT: **Andrea and Nino Pisano**, Madonna and Child, marble, ca. 1343–1347, Pisa, Museo Nazionale di San Matteo

OPPOSITE: **Andrea Orcagna**, Dormition and Assumption of the Virgin, 1355–1359, marble and mosaic, Florence, tabernacle in Orsanmichele

A LA IZQUIERDA: **Andrea y Nino Pisano**, Virgen María con el Niño, mármol, hacia 1343–47, Pisa, museo Nacional de San Mateo

ENFRENTE: **Andrea Orcagna**, Muerte y asunción de Nuestra Señora, 1355-59, mármol y mosaico, Florencia, tabernáculo en Orsanmichele

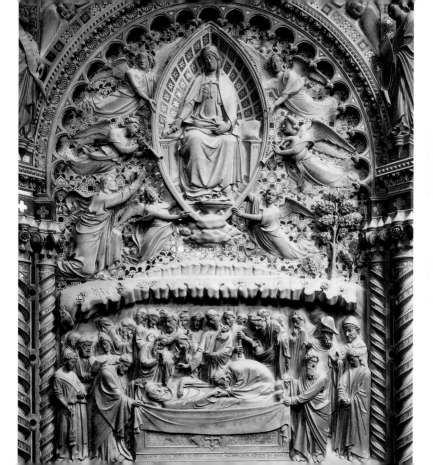

In late Gothic Florence, Andrea Pisano and Giotto di Bondone worked side-by-side on the most significant municipal projects of their time. While Pisano completed the first bronze door of the baptistery, Giotto headed construction of the campanile. Pisano took over this role upon Giotto's death in 1337.

RIGHT AND OPPOSITE: **Andrea Pisano,** Florence, baptistery, bronze door of the south portal, completed 1336, detail: Baptism of Christ

BOTTOM: **Andrea Pisano and Giotto,** relief formerly on the campanile with the figure of the metalsmith Tubal-Cain, between 1334 and 1337, Florence, Museo dell'Opera del Duomo

En la Florencia del gótico tardío colaboran Andrea Pisano y Giotto di Bondone en las obras municipales más importantes de la época. Mientras Pisano moldea la primera puerta de bronce del baptisterio, Giotto dirige la construcción del campanile. Pisano asume este cargo tras la muerte de Giotto en 1337.

A LA DERECHA Y ENFRENTE: **Andrea Pisano,** Florencia, baptisterio, puerta de bronce del portal sur, acabado en 1336, detalle: Bautismo de Cristo

ABAJO: **Andrea Pisano y Giotto,** Antiguo relieve en el campanile con la figura del forjador Tubal-Kaijn, entre 1334 y 1337, Florencia, museo dell'Opera del Duomo

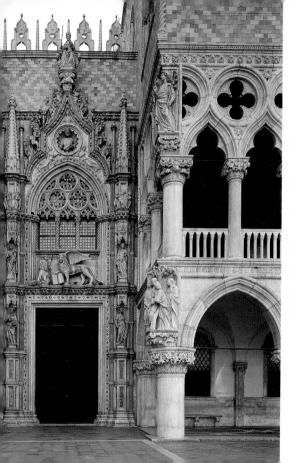

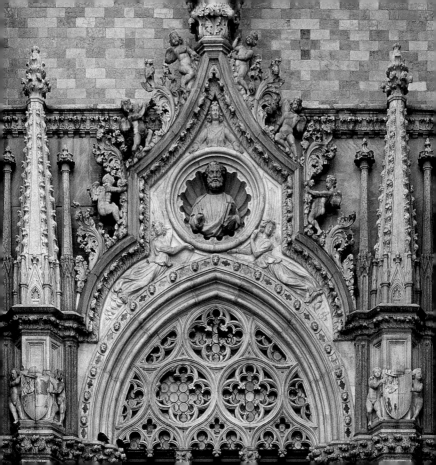

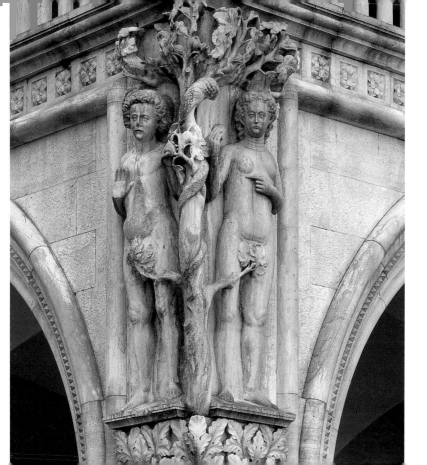

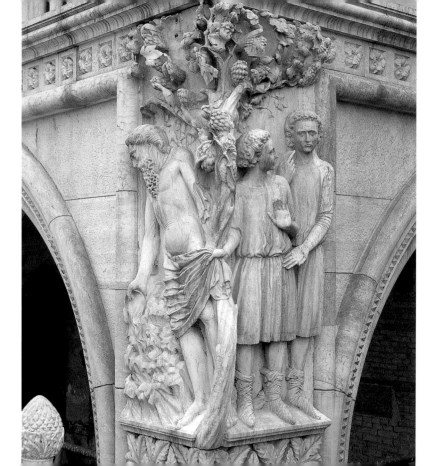

Germany

Although Gothic sculpture in Germany was also impacted by French portal sculpture, this never served as a model to be copied. In fact, that would not have been possible, because early Gothic sculpture in France was tightly connected to a spate of construction that found no counterpart in Germany in the twelfth century. Even when this changed in the thirteenth century, there was still no concomitant development of portal design in German Gothic churches. Only in a few exceptions, such as Strasbourg, could an entire figural program unfold on portals. Nonetheless, Gothic monumental sculpture in Germany is in no way inferior to that in France. It was precisely this distance from architecture that made it possible for German sculpture to develop its own independent high artistic qualities. Thus it is not surprising that some of the most important sculptures of the thirteenth century were created for the decoration of church interiors.

Alemania

A pesar de que la escultura gótica en Alemania se ve igualmente influida la escultura francesa de los portales, esta no sirve, no obstante, de modelo imitable. De todas maneras esto no hubiera sido posible, porque la escultura de principios del gótico en Francia está estrechamente unida a la actividad constructora, para la cual no hay equivalente en la Alemania del siglo XII. Si bien esta situación se modifica en el siglo XIII, no se refleja adecuadamente en el diseño de los portales en las iglesias góticas en Alemania. Salvo pocas excepciones, como por ejemplo en Estrasburgo, se pueden desarrollar conjuntos de figuras en portales. A pesar de esto, la escultura monumental gótica en Alemania no es en nada inferior a la de Francia, porque precisamente ese distanciamiento de la arquitectura le permite desarrollar una autonomía de gran calidad artística. No sorprende, entonces, que algunas de las obras más importantes del siglo XIII se creen en asociación con la ornamentación interior de iglesias.

OPPOSITE: **Halberstadt**, cathedral, Triumphal Cross group, ca. 1220

ENFRENTE: **Halberstadt**, catedral, grupo con cruz triunfal, hacia 1220

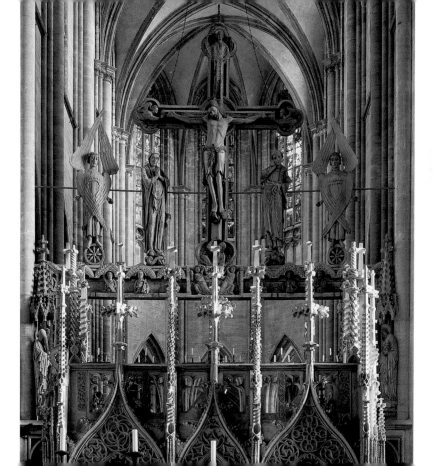

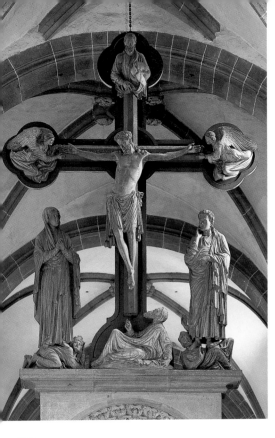

LEFT AND OPPOSITE:
Wechselburg, castle church,
Triumphal Cross group and
detail, ca. 1235/1240

P. 274: **Erwin von Steinbach,**
Strasbourg, cathedral, detail of
the west facade, begun 1277

P. 275: **Strasbourg,** cathedral,
south transept, left tympanum
of the double portal: Dormi-
tion of the Virgin, ca. 1235

A LA IZQUIERDA Y ENFRENTE:
Wechselburg, iglesia de pala-
cio, grupo con cruz triunfal y
detalle, hacia 1235/40

P. 274: **Erwin von Steinbach,**
Estrasburgo, catedral, detalle
de la fachada occidental,
comienzo en 1277

P. 275: **Estrasburgo,** catedral,
nave transversal sur, tímpano
izquierdo del portal doble:
Muerte de Nuestra Señora,
hacia 1235

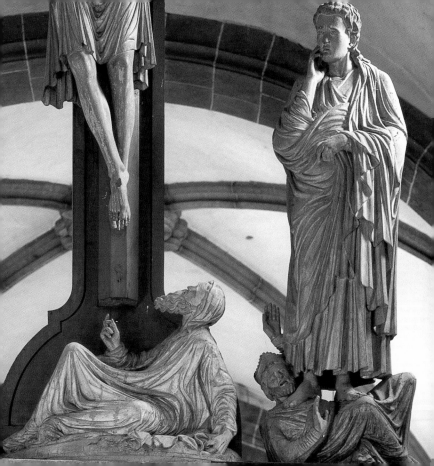

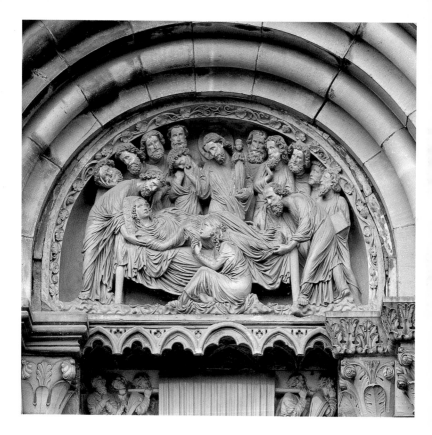

275

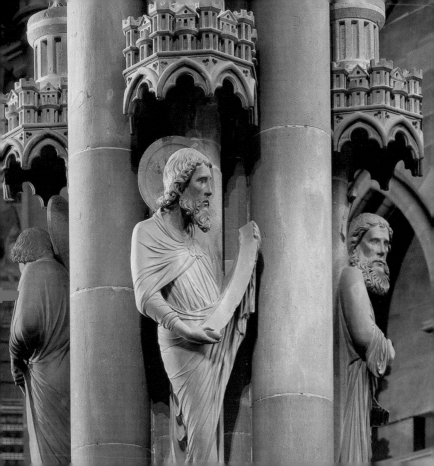

OPPOSITE AND LEFT: **Strasbourg**, cathedral, details of the Angel Column with the figural program of the Last Judgment: apostles from the lower level and Christ surrounded by angels with instruments of the Passion presiding over the Last Judgment from the third level, ca. 1225–1230

FOLLOWING TWO PAGES: **Bamberg**, St. Peter, portal on the north side of the nave, *Fürstenportal* (Princes' Portal), tympanum with the Last Judgment, between 1225 and 1237

ENFRENTE Y A LA IZQUIERDA: **Estrasburgo**, catedral, detalles de la columna de ángeles con el conjunto de figuras del juicio final: Evangelistas de la zona inferior y Cristo, rodeados de ángeles con los utensilios del calvario, presidiendo el juicio final de la tercera zona, hacia 1225–30

PÁGINA DOBLE SIGUIENTE: **Bamberg**, San Pedro, portal en el lado norte de la nave principal, el denominado portal de los Príncipes, tímpano con el juicio final, entre 1225 y 1237

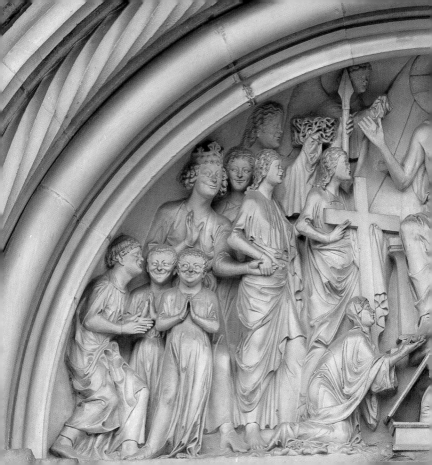

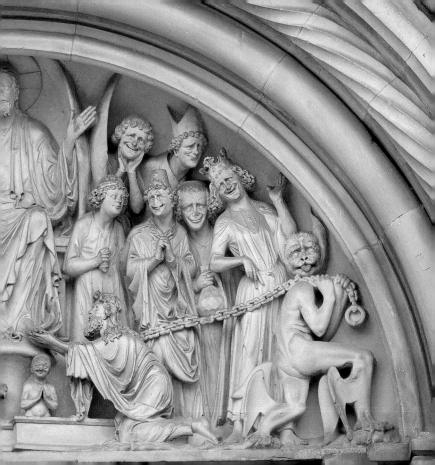

Bamberg, St. Peter,
St. George's choir
RIGHT: Equestrian statue of a
king, *The Bamberg Rider*,
first pier on the north side,
sandstone, 233 cm, before
1237

OPPOSITE: St. Elizabeth from
the second pier on the north
side (left), *Synagogue* from the
second pier on the south side
(right), between 1225 and
1237

Bamberg, San Pedro, coro
de San Jorge
A LA DERECHA: Rey a caballo,
el denominado *Jinete de
Bamberg*, en el primer pilar del
lado norte, arenisca, 233 cm,
antes de 1237

ENFRENTE: Elisabeth en el
segundo pilar del lado norte
(a la izquierda), *Sinagoga* en el
segundo pilar del lado sur (a la
derecha), entre 1225 y 1237

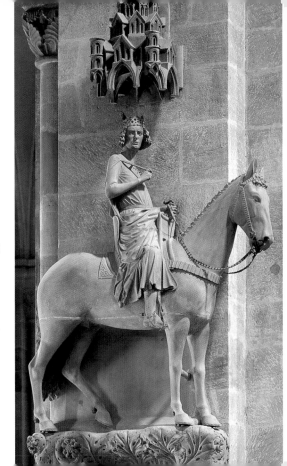

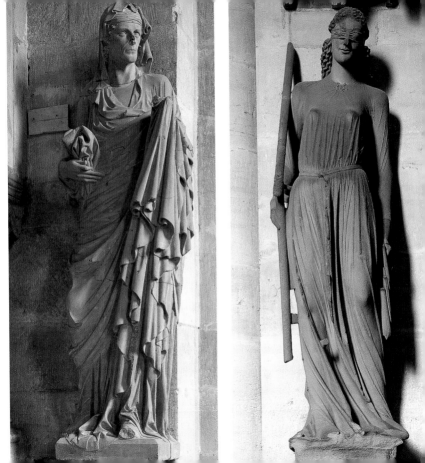

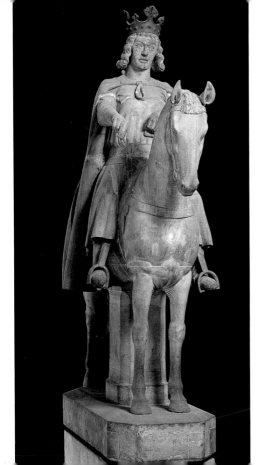

LEFT AND OPPOSITE:
Magdeburg, Kulturhistorisches Museum, equestrian statue from the Old Market (Emperor Otto I?), ca. 1245/1250

P. 284/285: **Magdeburg**, cathedral, drapery of the Paradise Portal, The Wise Virgins (p. 284) and The Foolish Virgins (p. 285), ca. 1245

A LA IZQUIERDA Y ENFRENTE:
Magdeburg, museo de la Historia de la Cultura, figura ecuestre del antiguo mercado (emperador Otón I?), hacia 1245/50

P. 284/85: **Magdeburg**, catedral, abocinado del denominado portal del Paraíso, vírgenes listas (p. 284) y tontas (p. 285), hacia 1245

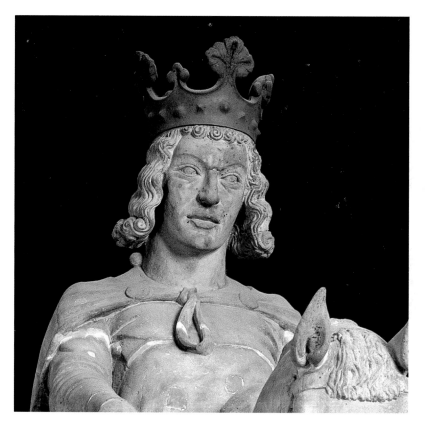

283

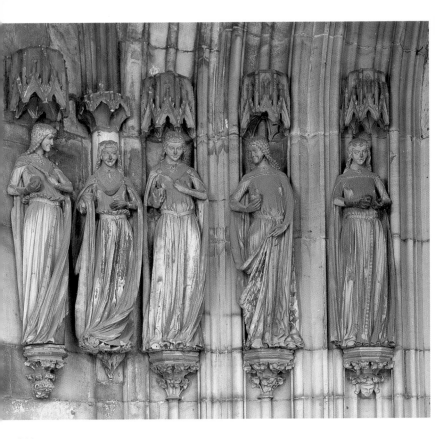

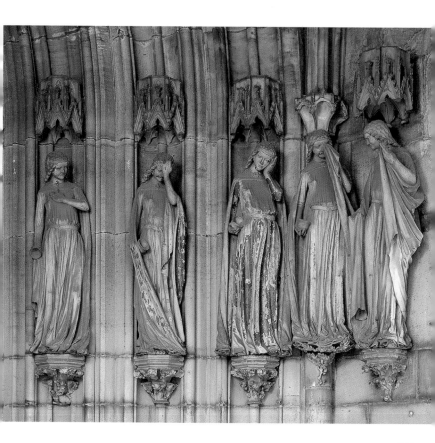

285

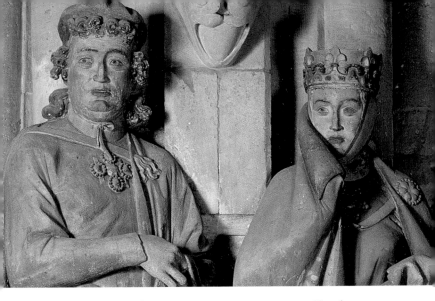

ABOVE AND OPPOSITE: **Naumburg,**
SS. Peter and Paul, Ekkehard and
Uta, founder figures in the west
choir, ca. 1250

ARRIBA Y ENFRENTE: **Naumburg,**
San Pedro y San Pablo, Ekkehard
y Uta, figuras oferentes del coro
occidental, hacia 1250

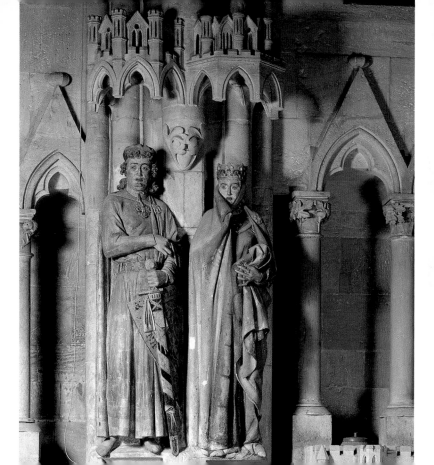

The Naumburg Founder Figures

Among the most outstanding works of Gothic sculpture in Germany are the twelve founder figures in the west choir of Naumburg Cathedral. Since they are hewn from the same stone as the piers that support the vault—in the tradition of the French jamb figures—we can conclude that they were created at the same time as the west choir, around 1249. Those depicted, however, are the founders of the church from the eleventh century. These long-dead sponsors appear in garments of the thirteenth century, as if they were still alive and well. This extreme individualization of secular people, even to the extent that particular character traits are represented, is what makes their presence in the choir of Naumburg Cathedral so convincing. In a way that had never been seen before, the Naumburg Master brought to life a royal Saxon pair (p. 286/287) who are conscious of their dignity as rulers, also in the sense of responsibility. The most prominent figure, Uta of Naumburg, beautiful and graceful, at the same time appears as an aloof and self-confident aristocrat.

OPPOSITE: **Naumburg**, SS. Peter and Paul, portal of the western rood screen, ca. 1250

Los oferentes naumburgueses

Entre las obras más importantes de las artes plásticas góticas en Alemania destacan los doce oferentes en el coro occidental de la catedral de Naumburg. Como fueron moldeados —siguiendo el modelo de las figuras francesas en el abocinado— en la misma piedra de las columnas que soportan la bóveda, es posible concluir que se crearon al mismo tiempo que el coro occidental, hacia 1249. Sin embargo, estas figuras representan eclesiásticos oferentes del siglo XI que aparecen aquí ataviadas con vestiduras del siglo XIII y plenas de vida, a pesar de haber fallecido mucho tiempo antes. Es fundamentalmente esta individualización máxima de personas profanas —llegando a la representación de las peculiaridades síquicas— lo que confiere un aspecto tan convincente al coro de la catedral de Naumburg. Los maestros de Naumburg consiguen dar vida de un modo nunca visto antes a los príncipes sajones (p. 286/87), los cuales aparecen conscientes de su dignidad soberana y de la responsabilidad que conlleva. La figura más prominente, Uta de Naumburg, bella y encantadora, se muestra asimismo como aristócrata inalcanzable y segura de sí misma.

ENFRENTE: **Naumburg**, San Pedro y San Pablo, portal del coro alto occidental, hacia 1250

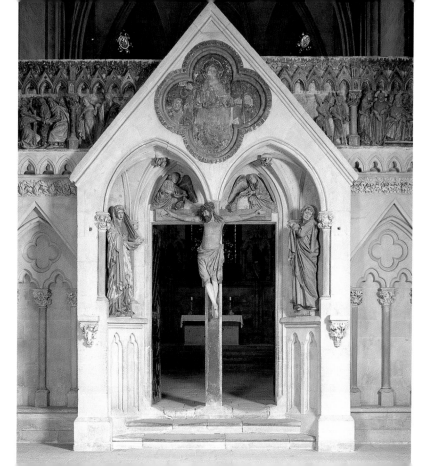

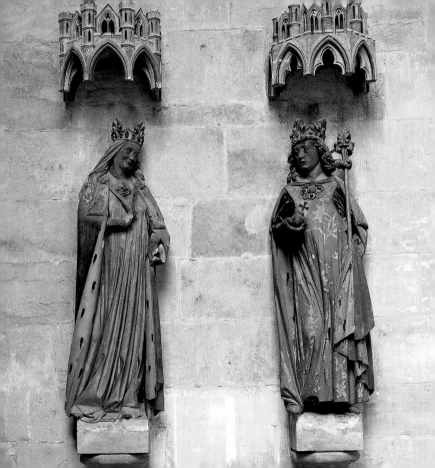

Opposite and below: **Meissen**,
cathedral, north choir wall, Emperor
Otto I and his wife Adelheid, detail:
baldachin above Adelheid, ca.
1255–1260

Enfrente y abajo: **Meissen**, catedral,
pared norte del coro, emperador
Otón I y su esposa Adelaida, detalle:
Baldaquino de Adelaida, hacia
1255–60

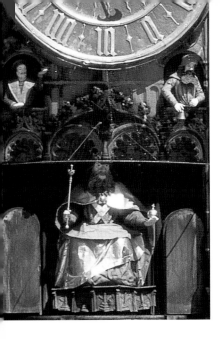

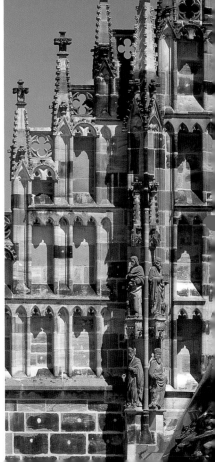

Nuremberg, Frauenkirche (Church of Our Lady), details of the facade, 1350–1358

Nuremberg, iglesia Frauenkirche, detalles de la fachada, 1350–58

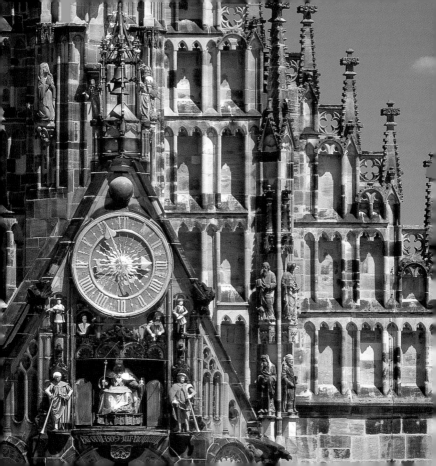

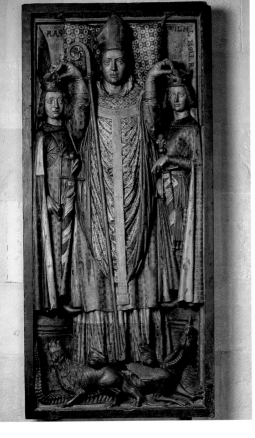

Mainz, SS. Martin and Stephen
LEFT AND OPPOSITE: Left and
opposite: tomb slab of Archbishop
Siegfried III von Epstein and
detail, after 1249

P. 296/297: Tomb of Archbishop
Uriel von Gemmingen and detail,
between 1514 and 1519

Maguncia, San Martín y San
Esteban
A LA IZQUIERDA Y ENFRENTE:
Losa de la sepultura del arzobispo
Sigfrido III de Epstein y detalle,
después de 1249

P. 296/97: Sepultura del
arzobispo Uriel de Gemmingen y
detalle, entre 1514 y 1519

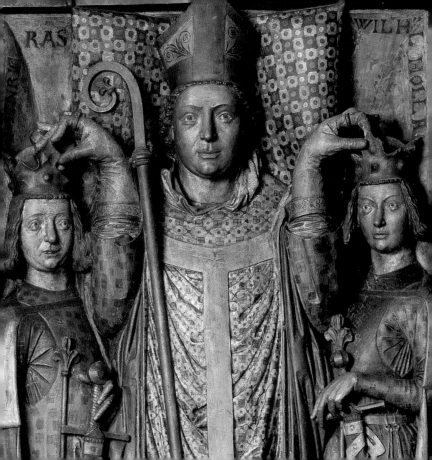

St. Stephen's Cathedral

The Gothic sculptural program of Austria's most famous church is remarkably varied. The artistic highlight is the richly decorated pulpit by Anton Pilgram (p. 304/305)

Vienna, St. Stephen's Cathedral
RIGHT: detail of the north tower, from 1230

OPPOSITE: Singer's Door: Rudolf IV with a model of the church, 1359–1365

FOLLOWING TWO PAGES:
Singer's Door: tympanum with scenes from the life of St. Paul, 1359–1365

Catedral de San Esteban

La iglesia más importante de Austria presenta un programa de esculturas góticas verdaderamente variado. El punto culminante artístico es el púlpito ricamente ornamentado de Anton Pilgram (p. 304/05).

Viena, catedral de San Esteban
A LA DERECHA: Detalle de la torre norte, a partir de 1230

ENFRENTE: Singertor: Rodolfo IV con modelo de iglesia, 1359–65

PÁGINA DOBLE SIGUIENTE:
Singertor: Tímpano con escenas de la vida del apóstol Pablo, 1359–65

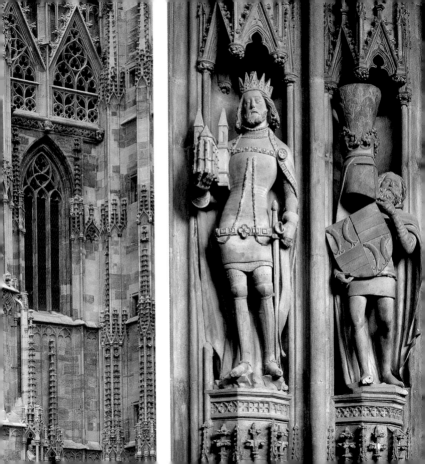

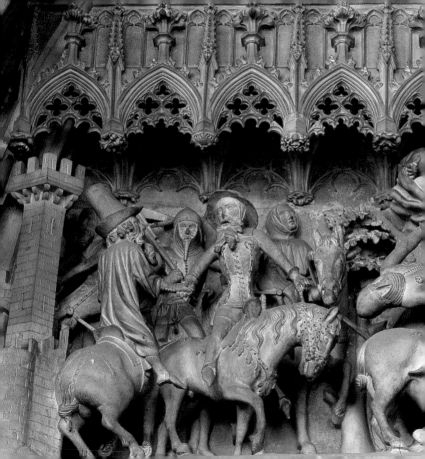

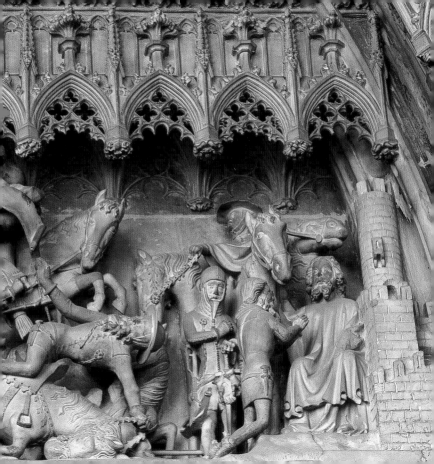

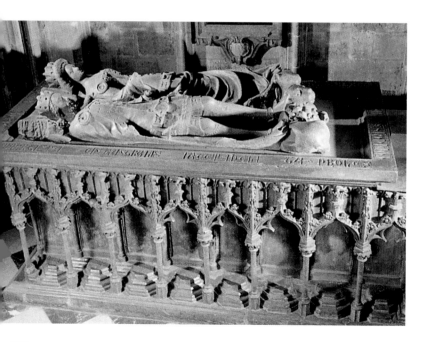

Nikolaus Gerhaert van Leyden,
Vienna, St. Stephen's Cathedral,
south choir chapel, sepulcher of
Frederick III, 1476

Nikolaus Gerhaert van Leyden,
Viena, catedral de San Esteban,
capilla sur del coro, sepultura de
Federico III, 1476

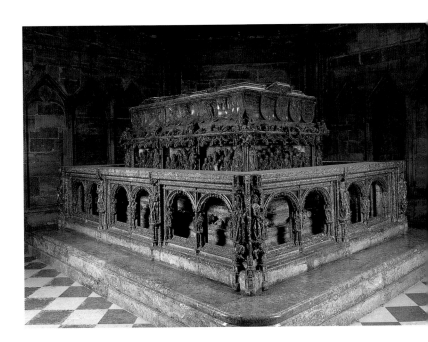

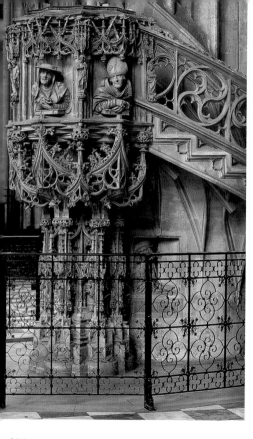

Anton Pilgram, pulpit, 1514/1515, Vienna, St. Stephen's Cathedral Detail: Self-portrait of Pilgram in the "window peep" under the pulpit (below); one of the four Church Fathers on the pulpit wall (opposite)

Anton Pilgram, púlpito, 1514/15, Viena, catedral de San Esteban Detalle: Autoretrato de Anton Pilgram en la postura de observador por la ventana (abajo); uno de los cuatro padres de la iglesia en el pretil del púlpito (enfrente)

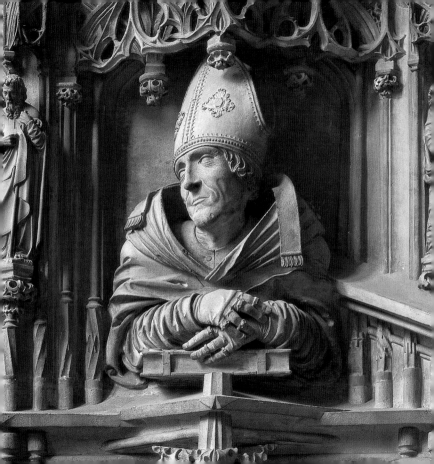

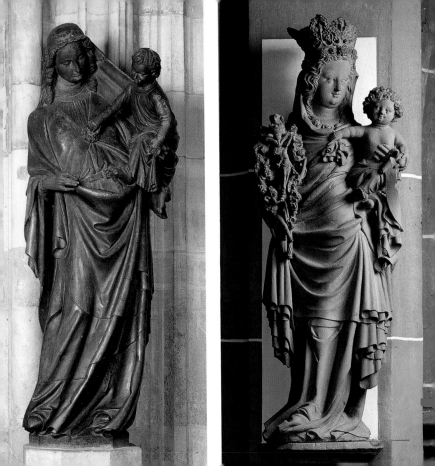

Images of the Veneration of Mary

In addition to traditional architectural and tomb sculpture, wood pieces were created in greater numbers in the second half of the thirteenth century. They were carved by sculptor/craftsmen, who were organized in trade guilds, and given their colored decoration by barrel painters. This freed the sculptures entirely from architecture, making them self-contained and portable works of art. That meant the very popular and widespread vesper images (closely related to Piétas) could be carried in reenactments of the Passion. They are a variation on the Madonna theme, popular because they offered the viewer many different possibilities for veneration. The great prevalence of madonnas is explained by the promotion of the cult of Mary by the Prague court and the archbishops. Both the intimate mother-child relationship of the "beautiful madonnas" (which could also be made of stone), and the ideal of courtly, aristocratic elegance found their greatest expression in the "soft style" of around 1400.

OPPOSITE LEFT: **Vienna**, St. Stephen's Cathedral, Peasant Madonna, ca. 1320/1325

OPPOSITE RIGHT: **Mainz**, Carmelite Church, Madonna, Central Rhine, ca. 1390, red sandstone, additions in plaster, 151 cm

Esculturas del culto mariano

Junto a la escultura tradicional arquitectónica y sepulcral, en la segunda mitad del siglo XIII van creándose cada vez más esculturas en madera, talladas por artesanos escultores organizados en gremios, y policromadas en temple por pintores especializados en esta técnica. De esta forma se liberan las esculturas definitivamente de la arquitectura y se convierten en obras autónomas y portátiles. Así, por ejemplo, se pueden trasladar de un sitio a otro, en pasiones, las populares y difundidas imágenes de la Piedad. Son una variante de la representación de María y, por esta razón, se convierten en imágenes tan estimadas; ofrecen a los espectadores múltiples posibilidades de practicar la veneración. La considerable difusión de las imágenes de la Virgen procede del fomento del culto mariano por parte de la corte de Praga y de los arzobispos. Siguiendo el "estilo suave" del arte hacia 1400, se manifiesta en las bellas madonas —que también podían ser de piedra— tanto la relación entrañable de la madre con el niño como el ideal de elegancia de la aristocracia cortesana.

ENFRENTE A LA IZQUIERDA: **Viena**, catedral de San Esteban, Virgen de los sirvientes, hacia 1320/25

ENFRENTE A LA DERECHA: **Maguncia**, iglesia carmelitana, Madre de Dios, región renana central, hacia 1390, arenisca roja, complementos en yeso, 151 cm

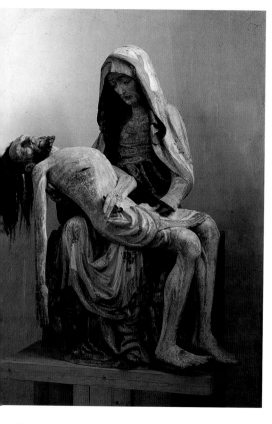

LEFT: **Freiberg**, cathedral, Pietà, early 15 c., colored wood

The drastic naturalism of actual hair contrasts with the refined introspection and the courtly taste of this group, and was added at a later time.

OPPOSITE: **Vienna**, Cathedral and Diocesan Museum, Descent from the Cross, ca. 1330/1340

A LA IZQUIERDA: **Freiberg**, catedral, Piedad, principios del siglo XV, madera, policromada en temple

El drástico naturalismo de la cabellera adherida se contrapone a la intimidad refinada y al gusto cortesano de este grupo, y es un complemento de una época posterior.

ENFRENTE: **Viena**, museo de la Catedral y Diocesano, descendimiento de la cruz, hacia 1330/40

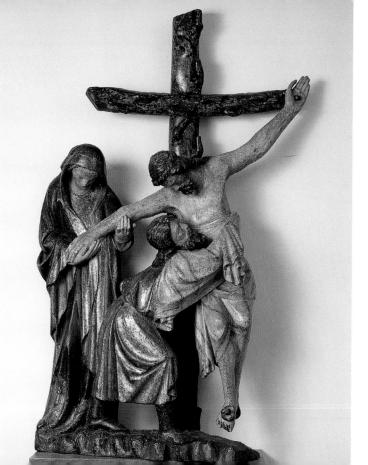

Late Gothic Altars

The development of Gothic altars was subject to a series of changes due to numerous reforms of the liturgy. Because priests celebrated mass behind the altar during the Romanesque period, the antependium was an early pictorial vehicle. Placing relics on the altar allowed the priest to step in front of the altar table and celebrate mass with his back to the congregation. The reliquaries eventually developed into picture canvases on the back side of the altar table, called retables. Their architectural configuration, in turn, was continually expanded well into the sixteenth century. That was the great period of carvers, whose works filled churches everywhere. Among the most prominent representatives are Veit Stoss and Tilman Riemenschneider, whose workshop in Würzburg flourished to the extent that some art historians even make reference to a "sculpture factory." In addition to singular altars, his workshop also produced almost serial sculptures, which resulted in stylistic simplifications.

Altares en el gótico tardío

El desarrollo del altar gótico se ve sometido una y otra vez a las numerosas reformaciones de la liturgia. Como el sacerdote del románico celebra la misa detrás del altar, es el Antependium un medio temprano para la presentación de imágenes. La disposición de los relicarios sobre el altar obliga al sacerdote a ubicarse delante de la mesa del altar y a celebrar la misa de espaldas a los feligreses. Con el tiempo, los relicarios terminan convirtiéndose en tablas escultóricas colocadas en el lado posterior de la mesa del altar, es decir, retablos, a los cuales se van añadiendo elementos hasta el siglo XVI. Es la gran época de los imagineros, tallistas de imágenes sagradas, cuyas obras llenan las iglesias de todas partes. Entre sus representantes más importantes destacan Veit Stoss y Tilman Riemenschneider, que mantiene en Würzburg un floreciente taller denominado incluso, en la historia del arte, "fábrica de esculturas". De su taller proceden no sólo altares únicos sino también casi obras en serie, lo que tiene como consecuencia una simplificación estilística.

OPPOSITE: **Veit Stoss**, center section of the high altar, 1477–1489, detail, colored wood, Krakow, Church of Our Lady

ENFRENTE: **Veit Stoss**, parte central del altar mayor, 1477–89, detalle, madera, policromada en temple, Cracovia, iglesia de Nuestra Señora

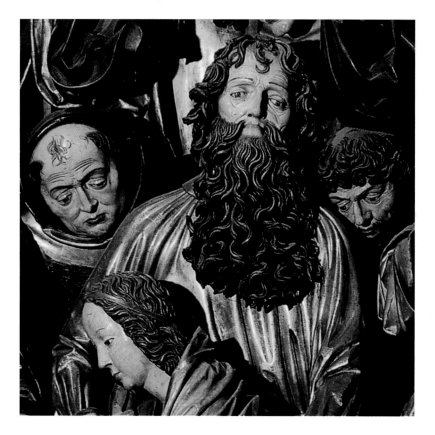

311

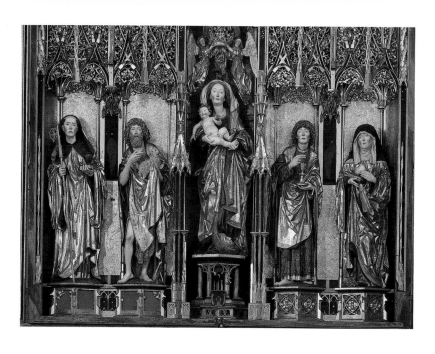

Opposite and above:
Michel and Gregor Erhart,
high altar of the abbey church in
Blaubeuren, 1493–1494, full view,
center panel

Enfrente y arriba:
Michel y Gregor Erhart, altar
mayor de la iglesia conventual
de Blaubeuren, 1493–94, vista
general, retablo central

313

RIGHT AND
FOLLOWING TWO PAGES:
Tilman Riemenschneider,
Altar of the Holy Blood, 1499–
1504, details, sculpture of
limewood, uncolored, Rothenburg
ob der Tauber, St. Jakob

A LA DERECHA Y
PÁGINA DOBLE SIGUIENTE:
Tilman Riemenschneider,
Heilig-Blut-Altar, 1499–1504,
detalles, esculturas de madera de
tilo, sin pintar, Rothenburg ob der
Tauber, San Jaime

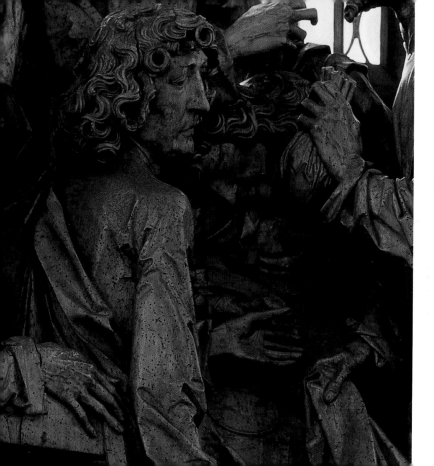

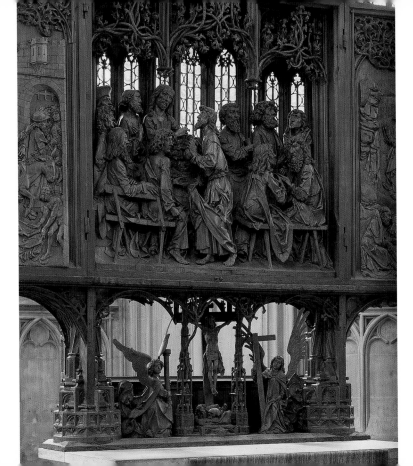

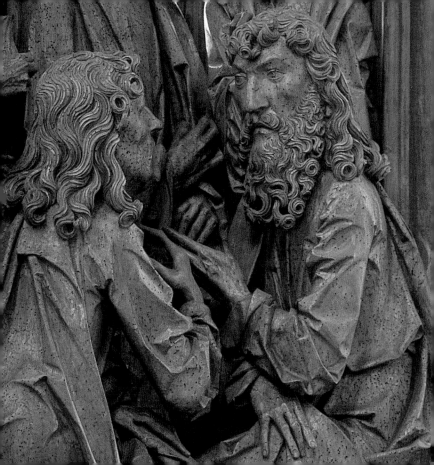

BELOW AND OPPOSITE:
Michael Pacher, St. Wolfgang Altar
and details, 1477–1481, St. Wolfgang
am Abersee, parish church

ABAJO Y ENFRENTE:
Michael Pacher, altar de San Wolfgang
y detalles, 1477-81, San Wolfang en el
lago Abersee, iglesia parroquial

England

The portals of Gothic cathedrals or collegiate churches in England are too small or too shallow to accommodate elaborate figural programs. Exceptions are the west facades of the cathedrals of Wells and Exeter. There, entire "picture walls" in the style of the Romanesque cathedral facades of western France unfolded. Much of this has been lost, but we can recognize a stylistic transition from the formal language of the Romanesque to that of the Gothic in sculptures excavated in York and other places. The more significant portion of British Gothic sculpture, however, is that which decorates tombs. An extremely vivified type of knightly tomb emerged in western England in the thirteenth century, in which the right hand of the prone figure reaches for the sword on its left hip. The sculptors used wood for these monuments, which is easier to work with than stone, and realistic painting further intensified the life-like effect.

Inglaterra

Los portales de las catedrales o colegiatas góticas en Inglaterra son o demasiado pequeños o demasiado profundos como para incorporar grandes grupos de figuras. Las excepciones son las fachadas occidentales de las catedrales de Wells o Exeter. Se encuentran allí murales escultóricos enteros, como se conocen en las fachadas románicas de las catedrales al occidente de Francia. Mucho se ha perdido también. Obras como por ejemplo las excavadas en York dejan entrever en las antiguas esculturas de los portales las transiciones estilísticas del mundo románico al gótico. La parte más importante de las artes plásticas en el gótico de Inglaterra se halla, no obstante, en la escultura sepulcral. Así, en el siglo XIII se establece al occidente de Inglaterra un tipo de sepultura de caballero extremadamente dotado de vida, en la que el yaciente empuña la espada con la mano derecha en la cadera izquierda. Para ello, los escultores utilizan madera, que es más fácil de moldear que la piedra; gracias a un policromado natural parecen aún más animadas.

OPPOSITE: **Wells**, cathedral, detail of the west facade, ca. 1230

ENFRENTE: **Wells**, catedral, detalle de la fachada occidental, hacia 1230

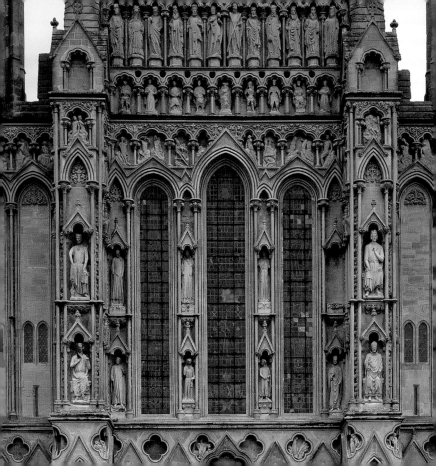

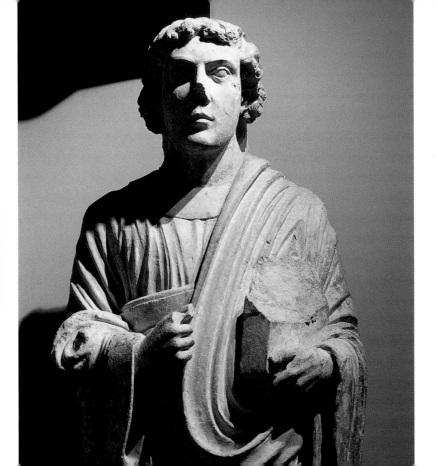

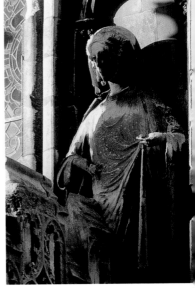

OPPOSITE: **York**, Yorkshire Museum,
St. John from St. Mary's Abbey,
sandstone, ca. 1200–1210

ABOVE: **Lincoln**, cathedral, 1192–
1235, capitals in the nave (left),
Queen Margaret (right), sandstone,
ca. 1260

ENFRENTE: **York**, museo de Yorkshire,
San Juan de St. Mary's Abbey, arenisca,
hacia 1200–10

ARRIBA: **Lincoln**, catedral, 1192–1235,
capitel en la nave principal (a la izquier-
da), la denominada Queen Margret
(a la derecha), arenisca, hacia 1260

323

BELOW AND OPPOSITE: **Gloucester**, cathedral, tomb of King Edward II and detail: head with angel, Purbeck marble and alabaster, ca. 1330–1335

ABAJO Y ENFRENTE: **Gloucester**, catedral, sepultura del rey Eduardo II y detalle: Cabeza con ángel, mármol de Purbeck y alabastro, hacia 1330–35

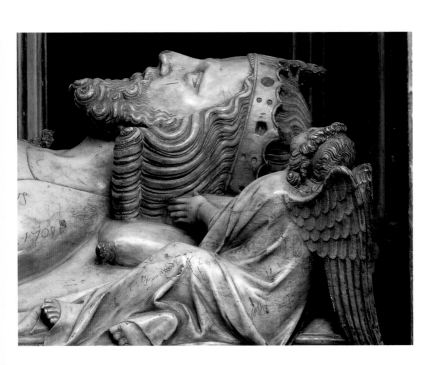

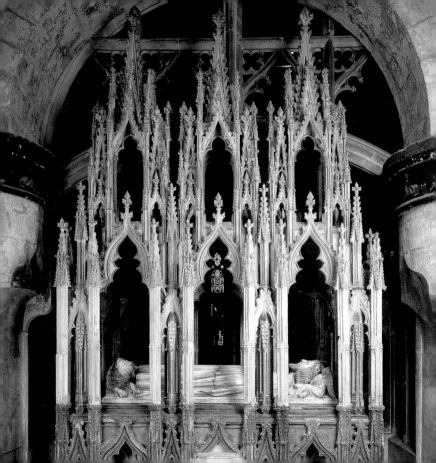

OPPOSITE: **Canterbury**, cathedral, tomb of the Black Prince, copper, between 1377 and 1380

RIGHT: **Gloucester**, cathedral, tomb of Robert Curthose (detail), oak, last quarter of the 13th c.

BELOW: **Worcester**, cathedral, tomb of King John I Lackland, Purbeck marble, ca. 1225

ENFRENTE: **Canterbury**, catedral, sepultura del Príncipe Negro, cobre, entre 1377 y 1380

A LA DERECHA: **Gloucester**, catedral, sepultura del caballero Robert Curthose (detalle), madera de roble, último cuarto del siglo XIII

ABAJO: **Worcester**, catedral, sepultura del rey Juan I sin Tierra, mármol de Purbeck, hacia 1225

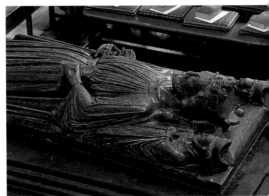

Spain and Portugal

There is a strong correlation between the south transept portal of the cathedral of Burgos and the portal at Amiens. Burgos was a pivotal point for the further development of Gothic portal design in Spain, as was León in the course of the thirteenth century. There one finds early examples of enfeu, wall niche tombs based on French models. Free-standing sarcophagi, on the other hand, tended to follow local Romanesque traditions. While in Castile-León Gothic sculpture declined in the early fourteenth century, it only began to flower in the late thirteenth century in Catalonia and Aragón, as a result of Mediterranean trade. In Portugal, too, Gothic sculpture first became widespread at the end of the thirteenth century. Coimbra, along with Lisbon and Évora, were centers of that movement. The late Gothic sculpture at the monasteries in Batalha and Tomar is superb. There, as well as in the Hieronymite monastery in Belém, one finds magnificent examples of the Manueline style of sculpture.

Burgos, cathedral
OPPOSITE: Cloister portal (south transept, east wall)

P. 330: Cloister, west wing, statues of kings and bishops

P. 331: Cloister, northwest corner pier, figures of kings 1265–1270

España y Portugal

El portal de la nave transversal sur de Burgos corresponde estrechamente al portal en Amiens. Burgos es un punto crucial para el desarrollo posterior del diseño gótico de los portales en España, al que se agrega León en el transcurso del siglo XIII. Allí se hallan ejemplos tempranos del *enfeu*, la sepultura colocada en un nicho de la pared, según el modelo francés. Comparado con esto, el sarcófago aislado manifiesta más bien la tradición local románica. Mientras que la escultura gótica declina en Castilla-León a principios del siglo XIV, no revive en Cataluña y Aragón sino hasta finales del siglo XIII debido al comercio mediterráneo. En Portugal tampoco se extiende hasta finales del siglo XIII, siendo Coimbra, junto a Lisboa y Évora, uno de los centros más importantes. Digna de mencionar es la escultura del gótico tardío de los conventos en Batalha y Tomar. Tanto allí como también en el convento de los jerónimos en Belém se hallan ejemplos magníficos de la escultura manuelina.

Burgos, catedral
ENFRENTE: Portal del claustro (nave transversal sur, muro oriental)

P. 330: Claustro, ala occidental, estatuas de reyes y obispos

P. 331: Claustro, pilar angular noroccidental, figuras de reyes 1265–70

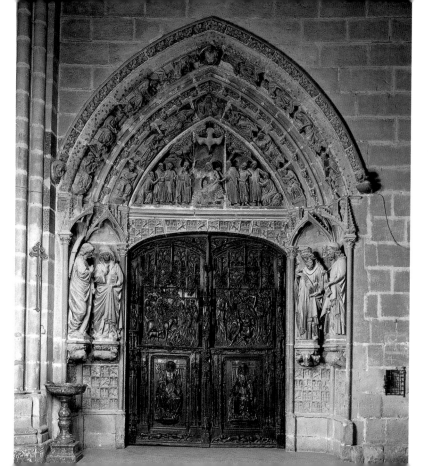

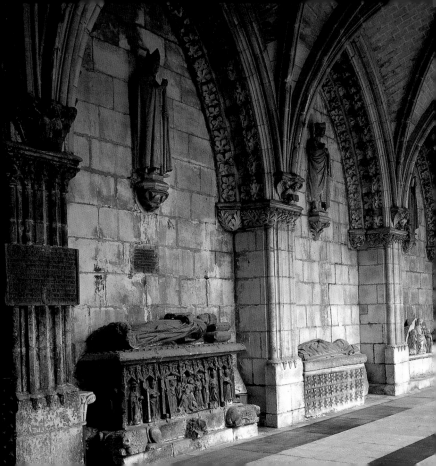

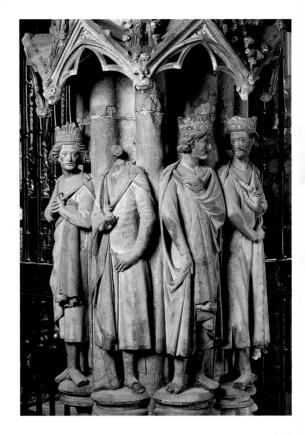

331

León, cathedral, south transept, center portal, left jamb figures (below), west facade, center portal (opposite), second half of the 13th c.

P. 334/335: **Toro**, Sta. Maria la Mayor, west portal and detail: lintel and tympanum with Dormition and Coronation of the Virgin, late 13th c.

León, catedral, nave transversal sur, portal central, abocinado izquierdo (abajo), fachada occidental, portal central (enfrente), 2ª mitad del siglo XIII

P. 334/35: **Toro**, Santa María la Mayor, portal occidental y detalle: Clave y tímpano con muerte y coronación de la Virgen María, finales del siglo XIII

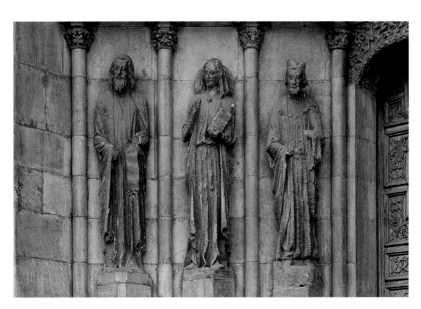

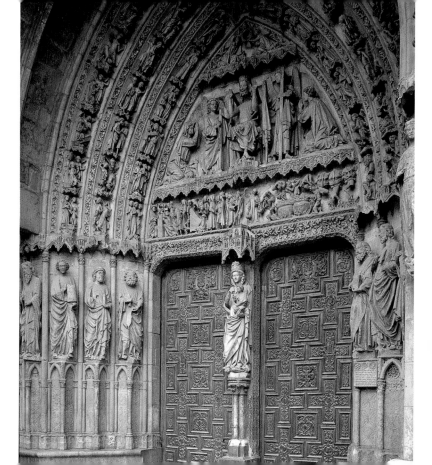

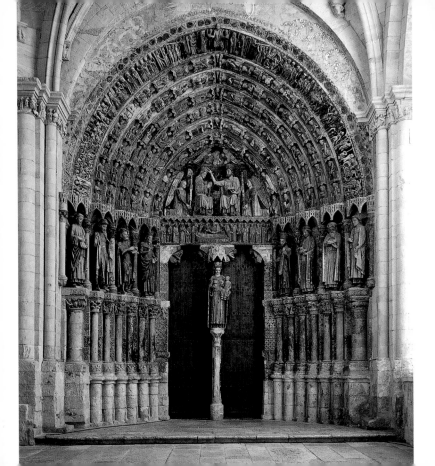

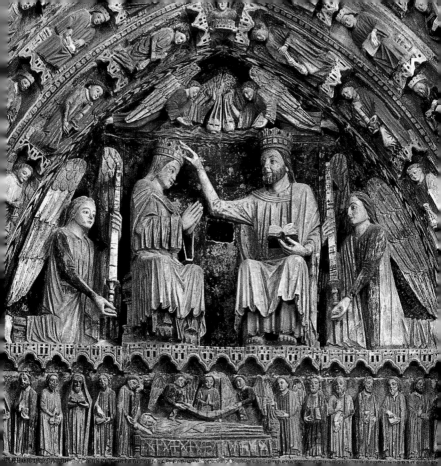

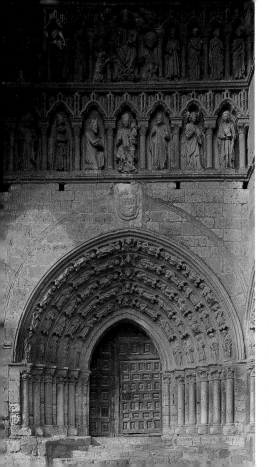

LEFT AND OPPOSITE:
Villalcázar de Sirga, Sta. Maria, south portal and detail of the facade, late 13th c.

A LA IZQUIERDA Y ENFRENTE:
Villalcázar de Sirga, Santa María, portal sur y detalle de la fachada, finales del siglo XIII

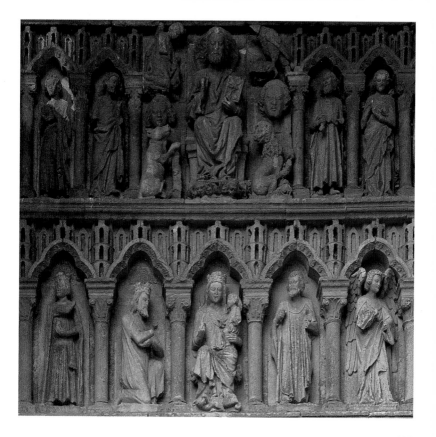

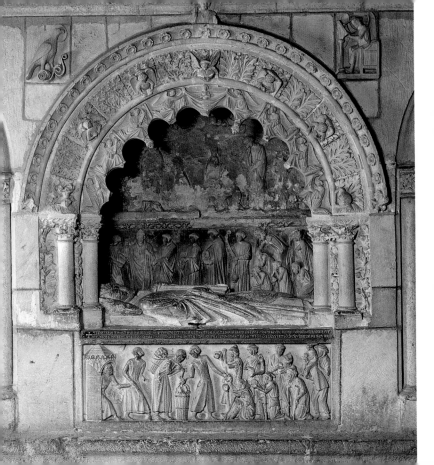

OPPOSITE AND BELOW: **León**, cathedral, north transept, tomb of Bishop Martin II Rodriguez († 1242) and detail

ENFRENTE Y ABAJO: **León**, catedral, nave transversal norte, sepultura del obispo Martín II Rodríguez († 1242) y detalle

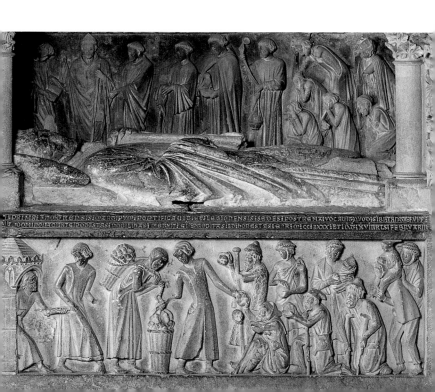

Valladolid, Diocesan and Cathedral
Museum, sarcophagus of Sta. Maria
de Palazuelos, ca. 1300

Valladolid, museo Diocesano y
Catedralicio, sarcófago de Santa
María de Palazuelos, hacia 1300

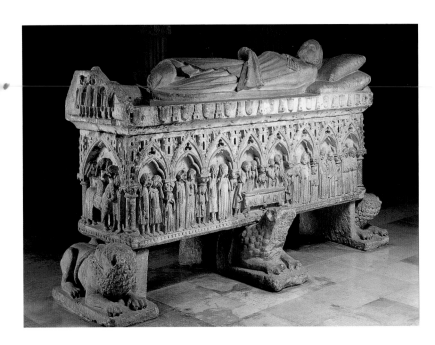

Villalcázar de Sirga, Sta. Maria,
sarcophagus of the infante Felipe
(† 1274)

Villalcázar de Sirga, Santa María,
sarcófago del infante Felipe
(† 1274)

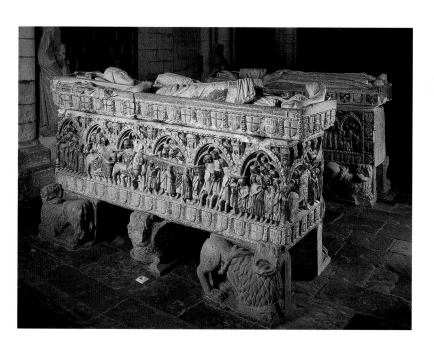

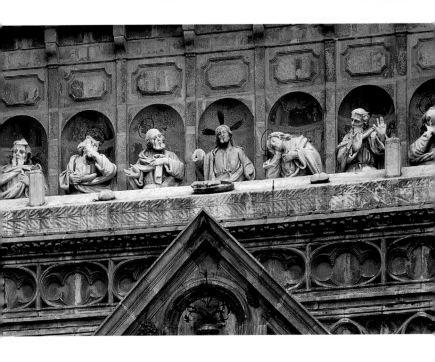

ABOVE AND OPPOSITE: **Toledo**, cathedral, west facade and enlarged detail: Last Supper scene, first half of the 14th c.

ARRIBA Y ENFRENTE: **Toledo**, catedral, fachada occidental y corte en detalle: Escena de la última cena, 1ª mitad del siglo XIV

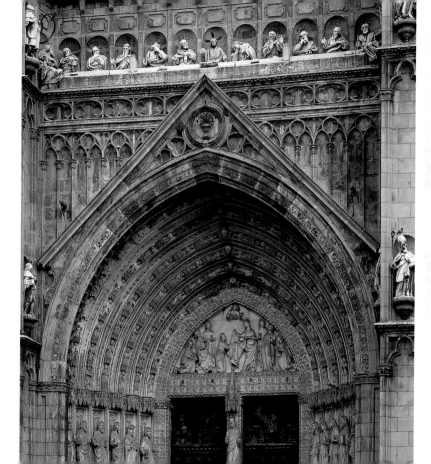

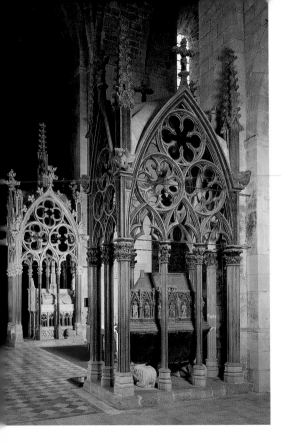

LEFT: **Master Barthomeu,**
tombs of Pedro III. († 1285)
and Constance of Sicily
(front) as well as King James II
(† 1327) and Blanche of
Anjou (back), 1291–1300,
Santes Creus, transept

OPPOSITE: **Tarragona,**
cathedral, west portal,
ca. 1277 and 1375

P. 346/347: **Santes Creus,**
Cistercian abbey, corbels and
capitals in the cloister, 14th c.

A LA IZQUIERDA: **Maestro
Barthomeu,** sepulturas del rey
Pedro III († 1285) y Constanza
de Sicilia (delante), así como
del rey Jaime II († 1327) y
Blanche de Anjou (detrás),
1291–1300, Stes. Creus, nave
transversal

ENFRENTE: **Tarragona,**
catedral, portal occidental,
hacia 1277 y 1375

P. 346/47: **Stes. Creus,** abadía
cisterciense, consolas y
capiteles en el claustro,
siglo XIV

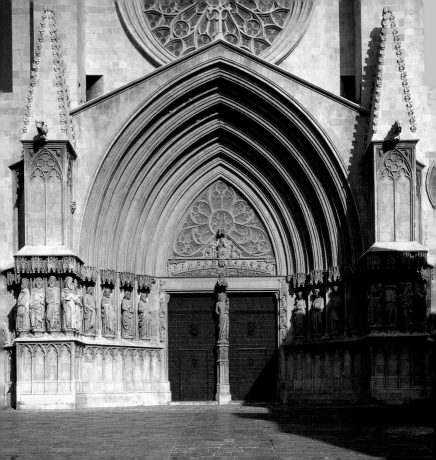

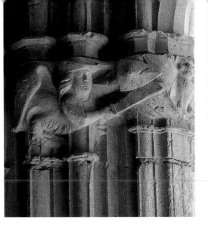
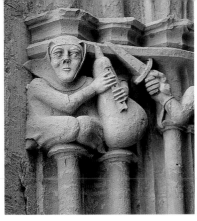
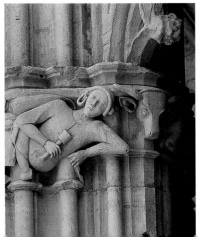
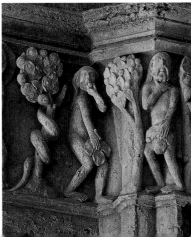

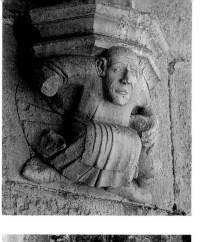

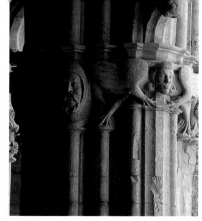

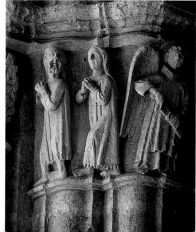

BELOW AND OPPOSITE: **Barcelona**, cathedral, crypt, marble sarcophagus of St. Eulàlia and detail, between 1327 and 1339

ABAJO Y ENFRENTE: **Barcelona**, catedral, cripta, sarcófago de mármol de Santa Eulalia y detalle, entre 1327 y 1339

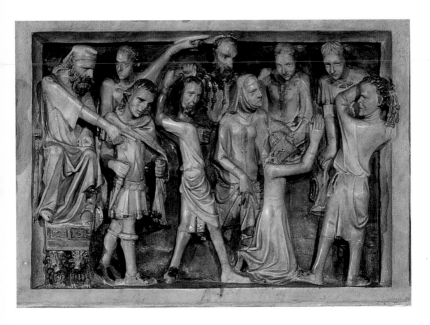

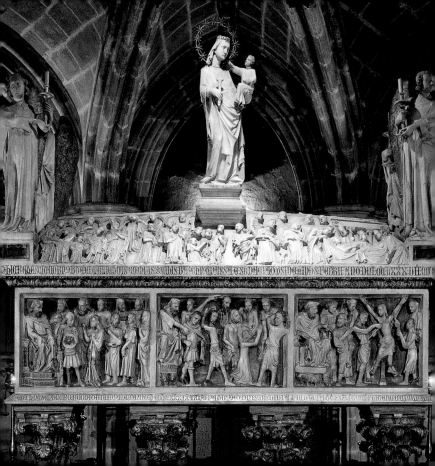

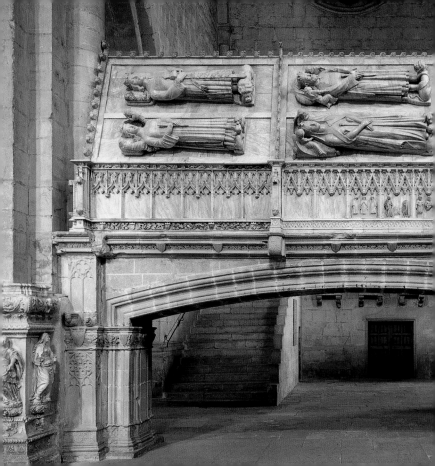

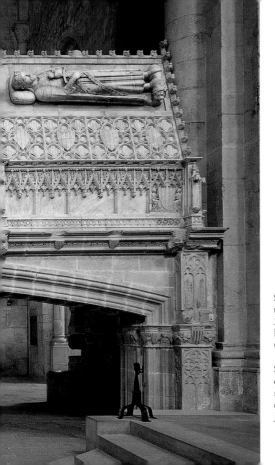

Santa María de Poblet, church of the Cistercian abbey, royal tombs, 2nd half of the 14th c., sculpture by Aloi de Montbrait, Jaume Cascalls and Jordi Johan

Santa María de Poblet, iglesia del convento cisterciense, sepulturas reales, 2ª mitad del siglo XIV, escultura de Aloi de Montbrait, Jaume Cascalls y Jordi Johan

Burgos, Cartuja de Miraflores
LEFT: Tomb of the infante Alfonso
(† 1468), 1489–1493

OPPOSITE: Altar retable, 1496–
1499; in front of it the tomb of
King Juan II († 1454) and Isabella
of Portugal, 1489–1493

Burgos, Cartuja de Miraflores
A LA IZQUIERDA: Sepultura del
infante Alfonso († 1468), 1489–93

ENFRENTE: Retablo de altar,
1496–99; delante sepultura del
rey Juan II († 1454) e Isabella
de Portugal, 1489–93

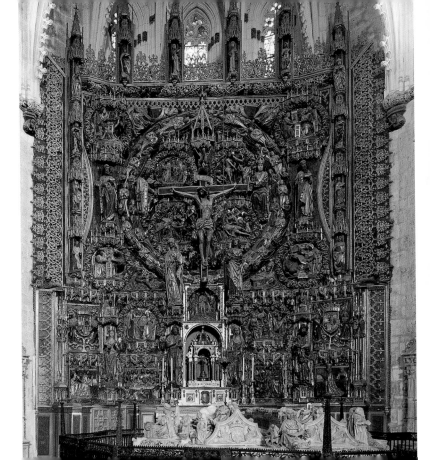

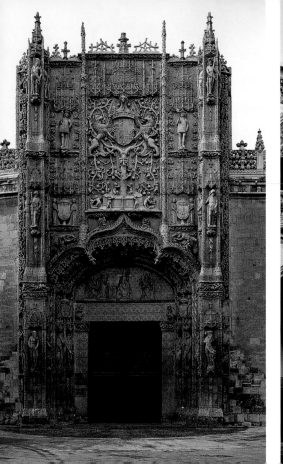
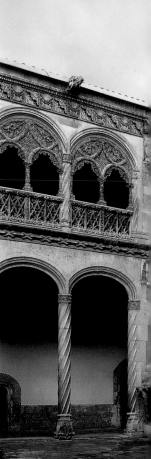

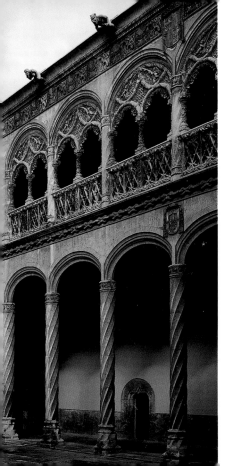

OPPOSITE, LEFT AND ABOVE:
Gil de Siloé and Diego de la Cruz(?),
Valladolid, S. Gregorio, 1488–1496, highly
decorated portal of the church, arcades in the
cloister and detail

ENFRENTE, A LA IZQUIERDA Y ARRIBA:
Gil de Siloé y Diego de la Cruz(?),
Valladolid, San Gregorio, 1488–96, portales
de la iglesia, arcadas del claustro y detalle

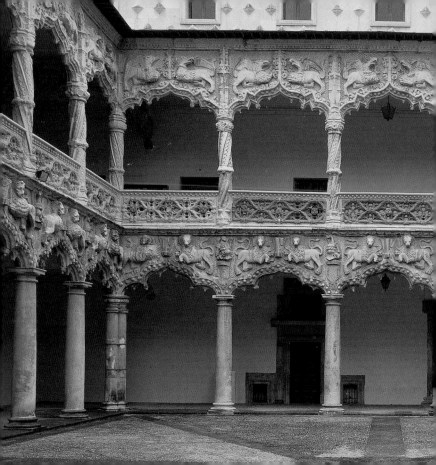

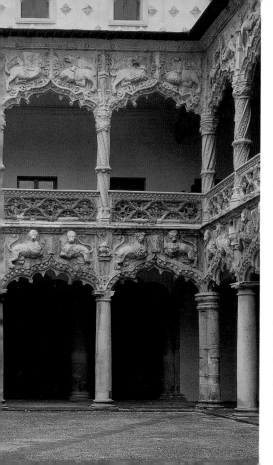

Juan Guas(?), Guadalajara, Palacio del Infantado, 1480–1483, arcades of the two-story interior courtyard

P. 358/359: **Alcobaça (Portugal)**, Alcobaça (Portugal), Sta. Maria, sarcophagus of King Pedro I, side view (p. 358/359) and end view (p. 359 right), between 1360 and 1367

Juan Guas(?), Guadalajara, palacio del Infantado, 1480–83, arcadas del patio de dos plantas

P. 358/59: **Alcobaça (Portugal)**, Alcobaça (Portugal), Santa María, sarcófago del rey Pedro I, vista lateral (p. 358/59) y vista del lado de la cabecera (p. 359 arriba), entre 1360 y 1367

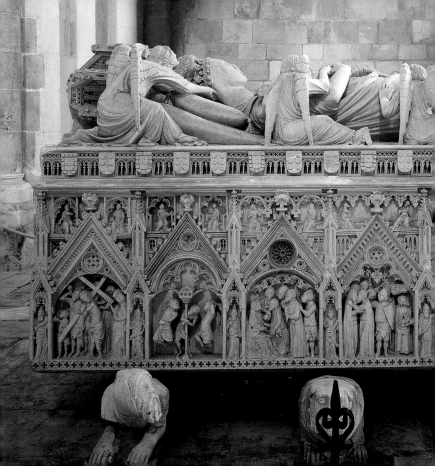

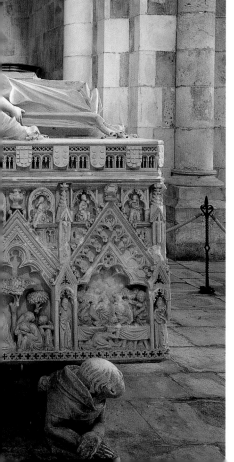

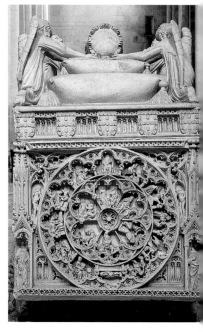

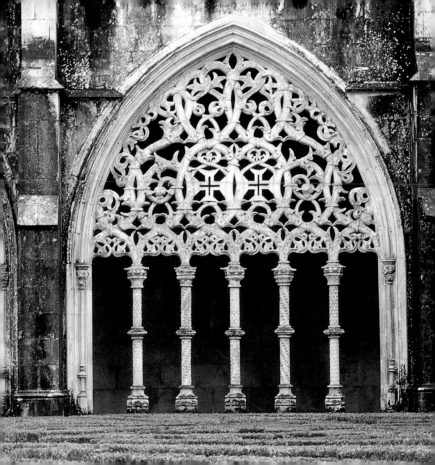

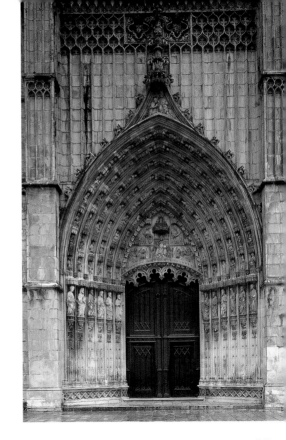

Batalha (Portugal),
Sta. Maria da Vitória
OPPOSITE: Cloister arcade,
between 1495 and 1521

RIGHT: west portal,
ca. 1426–1434

Batalha (Portugal),
Sta. Maria da Vitória
ENFRENTE: Arcada del
claustro, entre 1495 y 1521

A LA DERECHA: Portal
occidental, hacia 1426–34

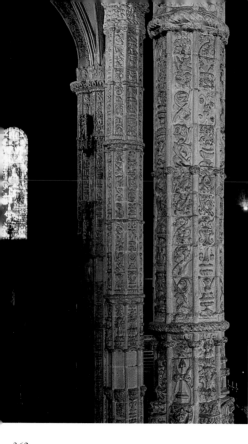

Lisbon-Belém (**Portugal**),
Hieronymite monastery
LEFT: Sculpted piers of the church,
1515–1520

RIGHT: West portal, after 1517

Lisboa-Belém (**Portugal**),
convento de los jerónimos
A LA IZQUIERDA: Columnas
esculpidas de la iglesia, 1515–20

A LA DERECHA: Portal occidental,
después de 1517

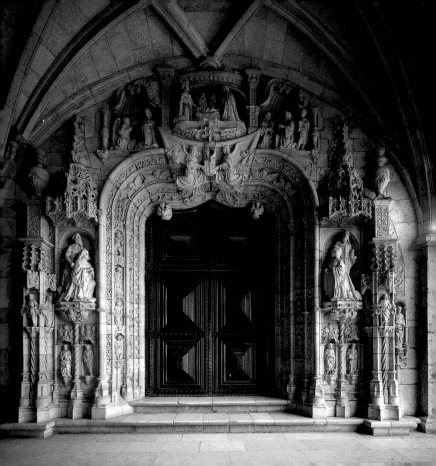

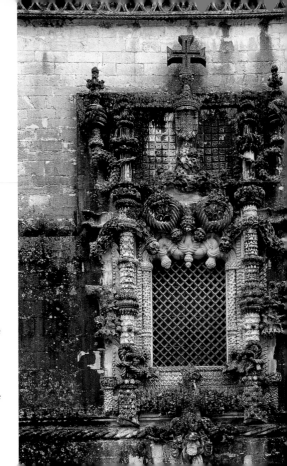

RIGHT: **Diogo de Arruda or João de Castilho(?)**, Tomar (Portugal), Convent of the Order of Christ, window of the chapter house, early 16th c.

OPPOSITE: **João de Castilho**, Tomar (Portugal), Convent of the Order of Christ, main portal, 1515

A LA DERECHA: **Diogo de Arruda o João de Castilho(?)**, Tomar (Portugal), convento de los Caballeros de Cristo, ventana de la sala del cabildo, principios del siglo XVI

ENFRENTE: **João de Castilho**, Tomar (Portugal), convento de los Caballeros de Cristo, portal principal, 1515

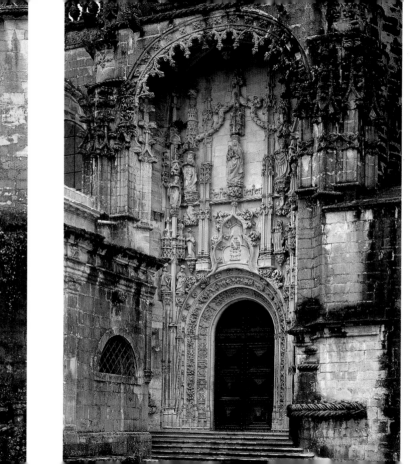

Sculpture of the
Renaissance

In the transcendentally oriented Middle Ages, the period of Antiquity—which focused on the here and now—was regarded as the heathen past: a foreign world that continued to survive as a threat. From Petrarch's time, at the latest, humanists had made efforts to overcome this undesirable perception and allow Antiquity to be recognized as an independent cultural force. At the turn of the fourteenth to the fifteenth century, two sculptural works were created independent of each other that gave expression to this major change. The earlier of them is in Dijon and represents a ruling couple in place of the saints that were otherwise typical on the jamb of the church portal. The second was produced in Florence in the context of a competition, and incorporates compositional elements that are taken directly from Antiquity.

Escultura del
renacimiento

Para la edad media orientada trascendentalmente, el período de la antigüedad —que se enfocaba en el aquí y el ahora— era considerado el equivalente de un pasado pagano: un mundo extraño que seguía perviviendo como una amenaza. A partir de Petrarca, a lo sumo, los humanistas se habían esforzado por superar esta percepción defensiva, a fin de permitir que la antigüedad fuera reconocida una fuerza cultural autónoma. En la transición del siglo XIV al siglo XV se crean, independiente una de otra, dos obras escultóricas en las cuales se puede apreciar este cambio. La más temprana se halla en Dijon y sitúa a una pareja de gobernantes en el lugar de las habituales figuras sagradas del abocinado en el portal de la iglesia. La segunda se crea en Florencia en el marco de un concurso, e incorpora elementos de la composición que son tomados directamente de la antigüedad.

Florence

The competition for the design of the second baptistery door in 1401 placed Florence at the forefront of Renaissance sculpture. The winner, Lorenzo Ghiberti, was thereafter considered the most significant bronze sculptor of the early Renaissance. In spite of traces of the International Gothic style, the relief with which he won the competition (p. 371) is characterized by a new approach to perspective and space. The third door of the baptistery was to become one of Ghiberti's artistic masterpieces; for the first time, the artist himself determined the program of this work (p. 374–377). The best sculptors in Florence in the early fifteenth century offered the very best of their abilities for the figural decoration of Orsanmichele and the campanile, creating pieces of extraordinary prestige. One of the artists, the Florentine Donatello, went to great lengths to distinguish his figures from one another. He gave them such naturalistic, individual traits that the contemporary biographer of artists, Giorgio Vasari, believed he could recognize in them actual people living in Florence.

Florencia

Con el concurso de la segunda puerta del baptisterio, Florencia se pone en 1401 a la cabeza de la escultura renacentista. El ganador, Lorenzo Ghiberti, es considerado, a partir de entonces, como el escultor de bronce más importante de principios del renacimiento. No obstante las reminiscencias internacionales góticas, el relieve que presentó Ghiberti en ese concurso (p. 371) revela un nuevo concepto de la perspectiva y el espacio. Entre sus mejores obras destaca la tercera puerta del baptisterio, en donde por primera vez el artista mismo determina el contenido (p. 374–77). Para las figuras ornamentales de Orsanmichele y del campanile, los mejores escultores de la Florencia de principios del siglo XV hacen gala de todo su saber a fin de crear obras de categoría excepcional. Para diferenciar sus figuras, uno de los artistas, el florentino Donatello, las dota de rasgos tan naturales que Giorgio Vasari, el biógrafo artístico de la época, cree reconocer en ellas a personas reales de Florencia.

OPPOSITE: **Florence**, cathedral, Porta della Mandorla, detail of door jamb: Hercules, 1391–1421

ENFRENTE: **Florencia**, catedral, Porta della Mandorla, detalle del abocinado: Hércules, 1391–1421

369

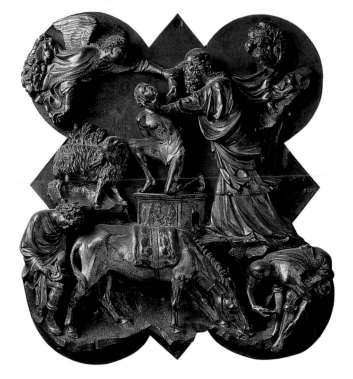

Filippo Brunelleschi, the Sacrifice of Isaac, 1401–1402, relief, gilt bronze, 45 x 38 cm (height x width), Florence, Museo Nazionale del Bargello

Filippo Brunelleschi, sacrificio de Isaac, 1401-02, relieve, bronce, dorado, 45 x 38 cm (alto x ancho), Florencia, Museo Nazionale del Bargello

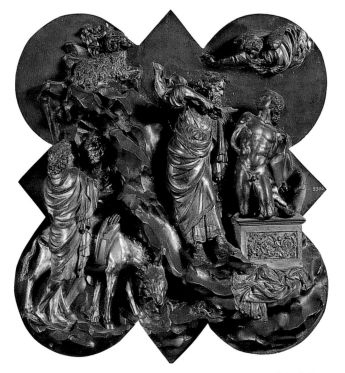

Lorenzo Ghiberti, the Sacrifice of Isaac, 1401–1402, relief, gilt bronze, 45 x 38 cm (height x width), Florence, Museo Nazionale del Bargello

Lorenzo Ghiberti, sacrificio de Isaac, 1401-02, relieve, bronce, 45 x 38 cm (alto x ancho), Florencia, Museo Nazionale del Bargello

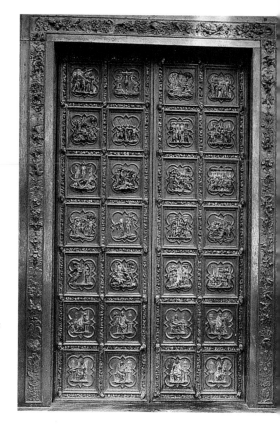

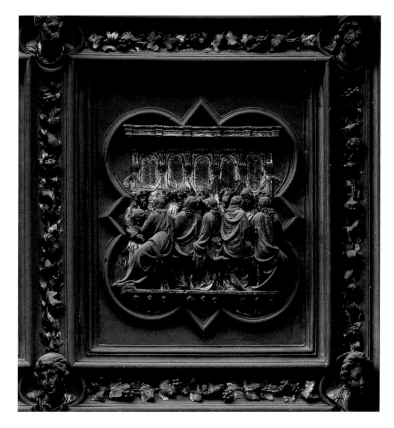

Lorenzo Ghiberti, Florence, baptistery, Gates of Paradise (east doors), 1425–1452, gilt bronze, frame 506 x 287 cm (height x width)

LEFT: Self-portrait of Ghiberti at around age 70 in the architrave of the Gates of Paradise, ca. 1447, high relief

P. 376: Detail: Creation of Adam and Eve, the Fall, and Expulsion from Paradise, 80 x 80 cm

P. 377: Detail: The story of Cain and Abel, relief, 80 x 80 cm

Lorenzo Ghiberti, Florencia, baptisterio, puerta del Paraíso (puerta occidental), 1425-52, bronce, dorada, marco 506 x 287 cm (alto x ancho)

A LA IZQUIERDA: Autorretrato de Ghiberti con aprox. 70 años en el marco de la puerta del Paraíso, hacia 1447, altorrelieve

P. 376: Detalle: Creación de Adán y Eva, pecado original y expulsión del paraíso, 80 x 80 cm

P. 377: Detalle: Historia de Caín y Abel, relieve, 80 x 80 cm

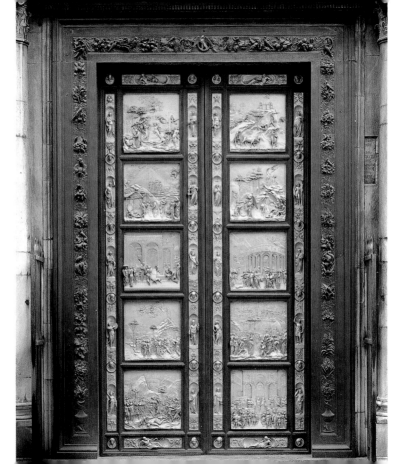

377

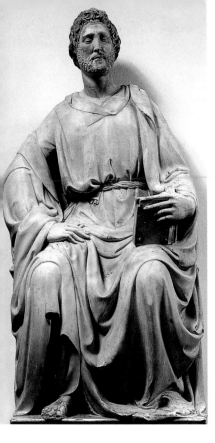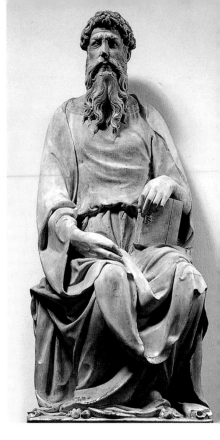

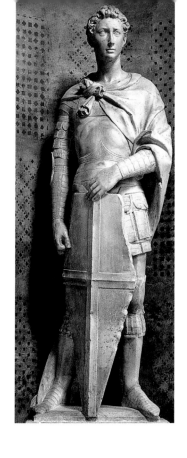

P. 378 LEFT: **Nanni di Banco**, St. Luke, 1408–1413, marble, 208 cm, Florence, Museo dell'Opera del Duomo

P. 378 RIGHT AND P. 379: **Donatello**, St. John (middle), 1408–1415, marble, 215 cm; St. George (left), ca. 1416, marble, 209 cm, Florence, Museo dell'Opera del Duomo

P. 378 A LA IZQUIERDA: **Nanni di Banco**, San Lucas, 1408-13, mármol, 208 cm, Florencia, Museo dell'Opera del Duomo

P. 378 A LA DERECHA Y P. 379: **Donatello**, San Juan (p. 378), 1408-15, mármol, 215 cm, San Jorge (a la izquierda), hacia 1416, mármol, 209 cm, Florencia, Museo dell'Opera del Duomo

Donatello

The Florentine sculptor Donatello is without question the most important and influential representative of the Italian Early Renaissance. Until the mid-1420s he primarily contributed to the figural decoration of large-scale buildings in Florence; thereafter he created numerous works in marble, clay, bronze, and wood. He most often worked for patrons in Florence, but also for some from Pisa, Siena, and Prato. In Padua, he executed the famous equestrian monument known as

"Gattamelata." In his work, Donatello established a new relationship between architecture and sculpture, in which sculpture was granted greater significance in its own right than had previously been the case. In addition to the liveliness and emotional temperament of his figures, his reliefs, in particular, display a spatial depth that had never been seen before. Among the most significant sculptures of the Early Renaissance is Donatello's bronze *David* (p. 386/387), the first life-size nude figure fully sculpted on all sides since Antiquity. This pivotal work finally freed sculpture from its functional integration into architecture. Donatello was the true precursor of Michelangelo throughout the sixteenth century.

Donatello

El escultor florentino Donatello es sin duda el representante más importante e influyente de principios del renacimiento italiano. Después de contribuir fundamentalmente hasta mediados de los años 20 del siglo XV en la ornamentación con figuras de los grandes edificios florentinos, vinieron numerosas obras en mármol, arcilla, bronce y madera. Aunque trabajó principalmente para patronos florentinos, también lo hizo para otros de Pisa, Siena y Prato. En Padua crea el famoso monumento ecuestre "Gattamelata". Con sus obras genera una nueva relación entre la arquitectura y la escultura, dando a la última mayor predominancia que hasta entonces. Especialmente en sus relieves muestra, junto a la gran viveza y temperamento emocional de sus figuras, una profundidad espacial no vista hasta entonces. Entre las obras más importantes del renacimiento temprano destaca el *David* de bronce de Donatello (p. 386/87), que presenta por primera vez tras la antigüedad un tamaño natural y un desnudo perfecto por todos los costados. Con esta figura se libera finalmente la escultura de su integración funcional a la arquitectura. En Donatello, el siglo XVI ve al precursor mismo de Miguel Ángel.

Opposite: **Donatello**, *Feast of Herod*, ca. 1425, relief, gilt bronze, 60 x 60 cm, Siena, baptistery, baptismal font

Enfrente: **Donatello**, *Banquete de Herodes*, hacia 1425, relieve, bronce, dorado, 60 x 60 cm, Siena, baptisterio, fuente bautismal

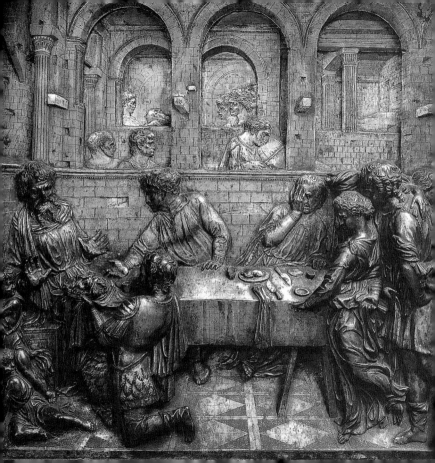

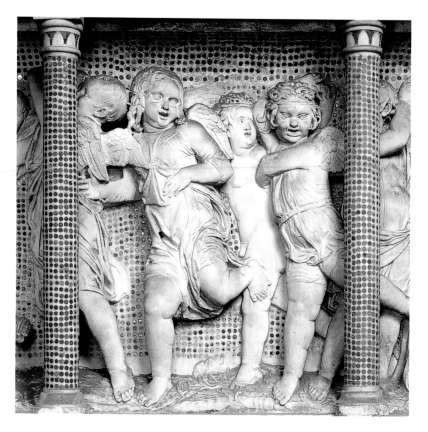

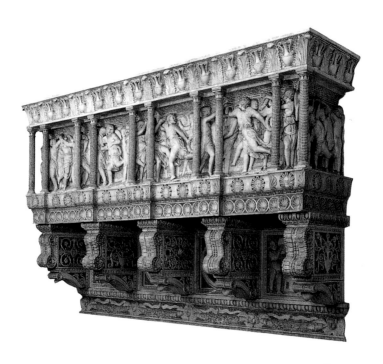

ABOVE AND OPPOSITE: **Donatello**, choir loft from the Florence cathedral, detail, 1433–1438, marble, Florence, Museo dell'Opera del Duomo

ARRIBA Y ENFRENTE: **Donatello**, púlpito de cantores de la catedral florentina, 1433-38, mármol, Florencia, Museo dell'Opera del Duomo

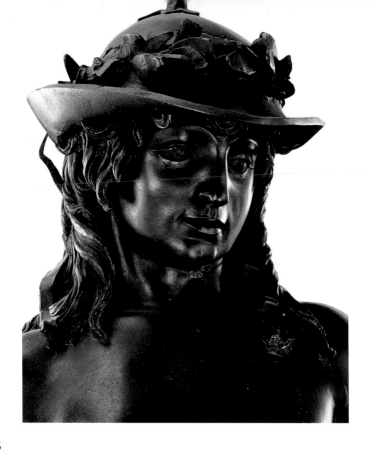

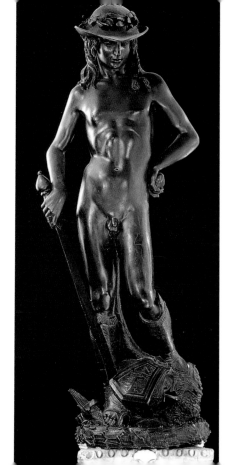

Donatello

LEFT AND OPPOSITE: *David*, detail,
ca. 1444–1446, bronze, 158 cm,
Florence, Museo Nazionale del
Bargello

P. 388/389 LEFT: *Mary Magdalene*,
detail, ca. 1453–1455, colored wood,
188 cm, Florence, Museo dell'Opera
del Duomo

P. 389 RIGHT: *Judith and Holofernes*,
ca. 1456–1457, bronze, partially gilt,
236 cm, Florence, Palazzo Vecchio

Donatello

A LA IZQUIERDA Y ENFRENTE: *David*,
detalle, hacia 1444–46, bronce,
158 cm, Florencia, Museo Nazionale
del Bargello

P. 388/89 A LA IZQUIERDA: *Santa
María Magdalena*, detalle 1453–55,
madera, pintada, 188 cm, Florencia,
Museo dell'Opera del Duomo

P. 389 A LA DERECHA: *Judith y
Holofernes*, hacia 1456–57, bronce,
parcialmente dorada, 236 cm,
Florencia, Palazzo Vecchio

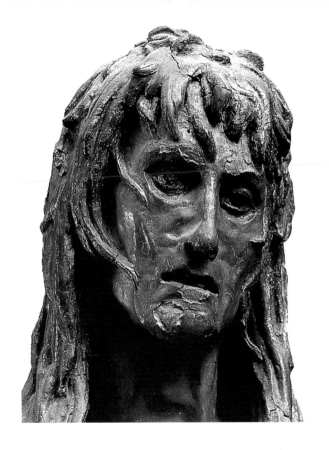

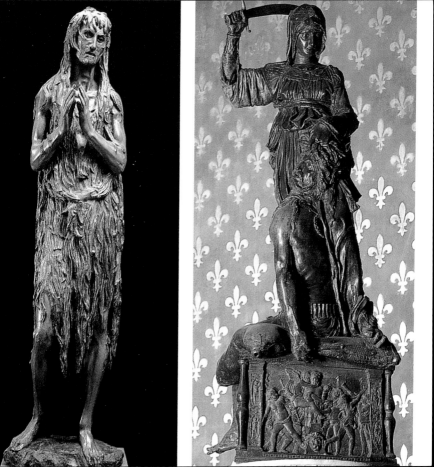

Jacopo della Quercia

The first reliable record of Sienese sculptor Jacopo della Quercia is as a participant in the competition for the second baptistery doors in Florence. His relief for the baptismal font in Siena is indebted to Donatello's *Feast of Herod* relief. In 1429–1430, Quercia also fashioned the marble tabernacle crowning the baptismal font.

RIGHT AND OPPOSITE: **Jacopo della Quercia** (et al), baptismal font, 1416–ca. 1429, marble, gilt bronze, detail: *Zachariah in the Temple*, 1428–1430, relief, gilt bronze, 60 x 60 cm, Siena, baptistery

Jacopo della Quercia

El primer registro confiable del escultor sienés Jacopo della Quercia se obtiene con su participación en el concurso de la segunda puerta del baptisterio. El relieve que hace para la fuente bautismal en Siena se orienta fuertemente en el relieve de *Salome* de Donatello. Entre 1429 y 1430 Quercia crea también el tabernáculo de mármol que corona la fuente bautismal.

A LA DERECHA Y ENFRENTE: **Jacopo della Quercia** (entre otros), fuente bautismal, 1416-hacia 1429, mármol, bronce, dorado, detalle: Anunciación a Zacarías, 1428-30, relieve, bronce, dorado, 60 x 60 cm, Siena, baptisterio

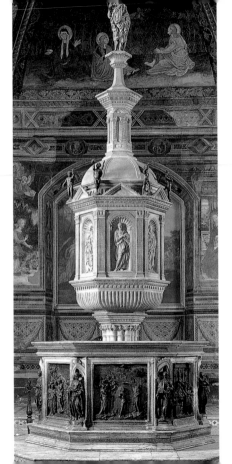

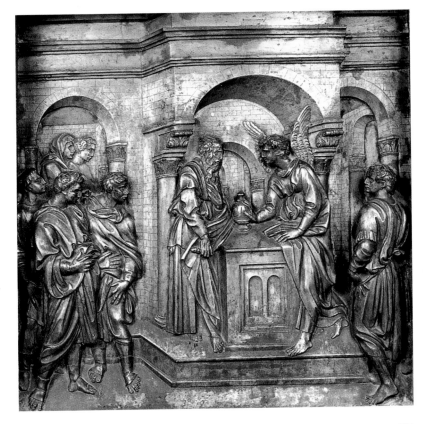

ABOVE: **Luca della Robbia**, portrait of a woman, 1465, 54 cm, relief, glazed terracotta

OPPOSITE: **Andrea della Robbia**, *Madonna of the Stonemasons*, 1475–1480, 134 x 96 cm (height x width), relief, glazed terracotta, Florence, Museo Nazionale del Bargello

ARRIBA: **Luca della Robbia**, retrato de una dama, 1465, 54 cm, relieve, terracota, vidriado

ENFRENTE: **Andrea della Robbia**, *La Virgen de los canteros*, 1475-80, 134 x 96 cm (alto x ancho), relieve, terracota, vidriado, Florencia, Museo Nazionale del Bargello

RIGHT: **Bernardo Rossellino**, tomb of
Leonardo Bruni, ca. 1448–1450,
marble, partially gilt, 7.15 m,
Florence, Sta. Croce

OPPOSITE: **Antonio Rossellino**, tomb
of the Cardinal of Portugal, 1461–
1466, marble, partially gilt, 4.0 m,
Florence, S. Miniato al Monte

P. 396: **Mino da Fiesole**, bust of Piero
de'Medici, ca. 1455–1460, marble,
55 cm

P. 397: **Benedetto da Maiano**, bust of
Pietro Mellini, 1474, marble, 53 cm,
Florence, Museo Nazionale del Bargello

A LA DERECHA: **Bernardo Rossellino**,
sepultura de Leonardo Bruni, hacia
1448-50, mármol, dorado parcial-
mente, 715 cm, Florencia, Santa Croce

ENFRENTE: **Antonio Rossellino**, sepul-
tura para el cardenal de Portugal, 1461-
66, mármol, dorado parcialmente, 400
cm, Florencia, San Miniato al Monte

P. 396: **Mino da Fiesole**, busto de
Piero de'Medici, hacia 1455-60,
mármol, 55 cm

P. 397: **Benedetto da Maiano**, busto de
Pietro Mellini, 1474, mármol, 53 cm,
Florencia, Museo Nazionale del
Bargello

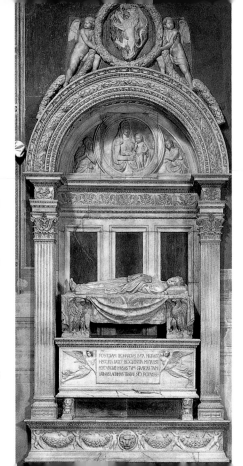

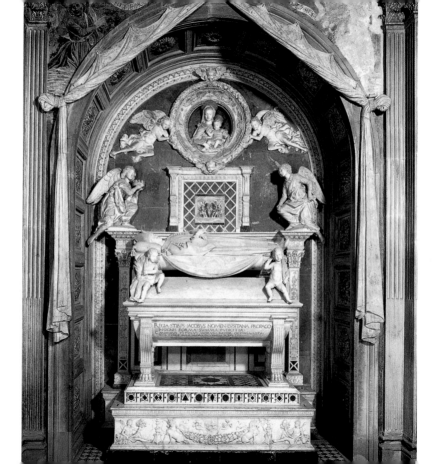

397

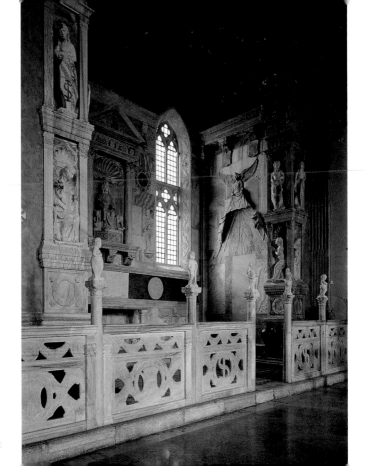

Sculptors of the Fifteenth Century

The Florentine artist Luca della Robbia was the first to use terracotta with colored glaze for the creation of altarpieces. This technique became characteristic of his family workshop, which was continued with great success after his death by his nephew, Andrea della Robbia (p. 392/393).

Bernardo Rossellino from Settignano designed the tomb of the famous humanist and historian Leonardo Bruni in Florence (p. 394), as well as those of other significant personalities of his time.

The unfortunate Agostino di Duccio, on the other hand, suffered the vagaries of fate until he played a substantial role in furnishing the church of S. Francesco in Rimini, also known as the *Tempio Malatestiano* (p. 398–403). Previously, in Florence, his attempts to work with the block of marble from which Michelangelo would later carve his *David* had met with little success.

The Lamentation groups by Emilia Romagna are among the most expressive works of the period. Sculptors Guido Mazzoni in Modena and Niccolò dell'Arca in Bologna also created Lamentation groups of extreme intensity (p. 404–407).

OPPOSITE: **Rimini**, S. Francesco (also known as Tempio Malatestiano), view of the Chapel of St. Sigismondo, 1450–1457

Escultores del siglo XV

El artista florentino Luca della Robbia utiliza por primera vez terracota vidriada en colores para la ornamentación de altares, lo cual se convierte en la característica de calidad de su taller familiar, que continua dirigiendo con mucho éxito tras su fallecimiento su sobrino Andrea della Robbia (p. 391/93).

Bernardo Rossellino de Settignano se encarga, entre otras sepulturas de grandes personalidades, de la sepultura florentina del famoso humanista e historiador Leonardo Bruni (p. 394).

Por el contrario, el hasta entonces desfavorecido por el destino Agostino di Duccio participa en Rímini en parte considerable de la ornamentación de la iglesia de San Francisco, también llamada *Tempio Malatestiano* (p. 398-403). Anteriormente había intentado trabajar con poco éxito en Florencia aquel bloque de mármol del que posteriormente Miguel Ángel moldearía su *David*.

Los grupos de afligidos de Emilia Romania forman parte de las obras más expresivas. El escultor Guido Mazzoni en Módena y Niccolò dell'Arca en Bolonia crean grupos de afligidos de gran intensidad (p. 404-07).

ENFRENTE: **Rímini**, San Francisco (también Tempio Malatestiano), vista de la capilla de San Sigismundo, 1450-57

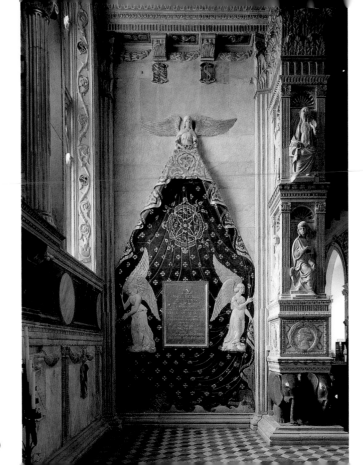

Rimini, S. Francesco (*Tempio Malatestiano*)
OPPOSITE: East wall and piers of the Chapel of St. Sigismondo, 1450–1457

ABOVE: **Agostino di Duccio**, relief portrait of Sigismondo Malatesta, marble

Rímini, S. Francesco (*Tempio Malatestiano*)
ENFRENTE: Muro oriental y pilar de la capilla de San Sigismundo, 1450-57

ARRIBA: **Agostino di Duccio**, retrato en relieve de Sigismundo Malatesta, mármol

Agostino di Duccio
RIGHT: Luna, ca. 1450–1457, relief on a pier in the Capella dei Pianeti, marble, partially colored and gilt

OPPOSITE: Putti playing musical instruments, Rimini, S. Francesco (Tempio Malatestiano)

Agostino di Duccio
A LA DERECHA: Luna, hacia 1450-57, relieve en un pilar de la Capella dei Pianeti, mármol, pintado y dorado parcialmente

ENFRENTE: Angelotes musicantes, Rímini, S. Francesco (Tempio Malatestiano)

402

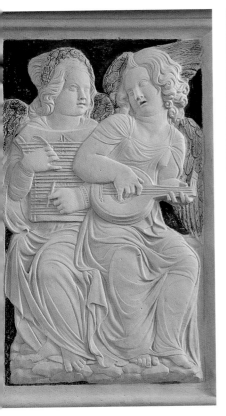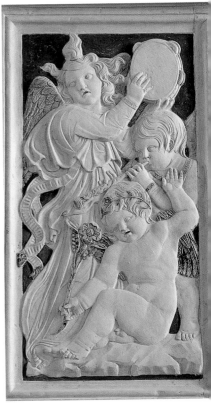

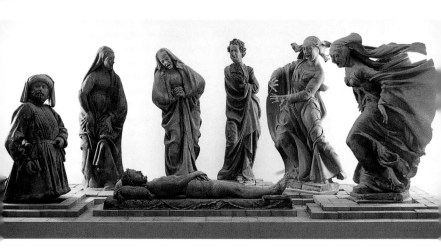

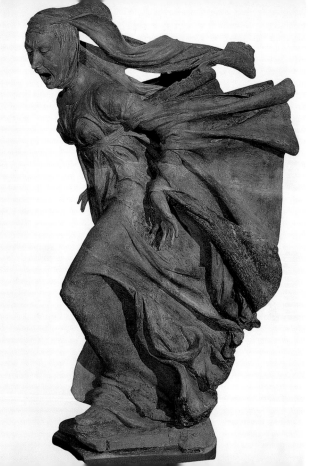

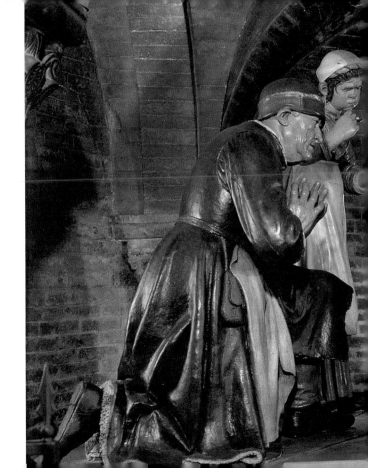

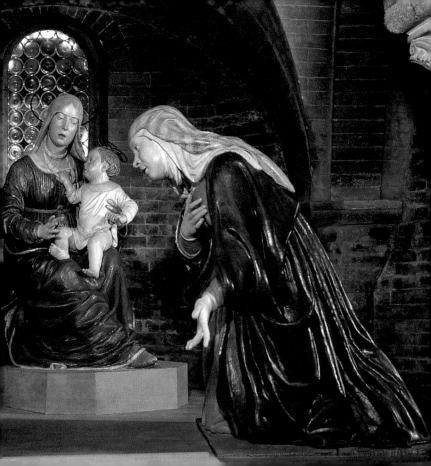

Pietro Lombardo, tomb of Doge Pietro Mocenigo, 1476–1481, marble, limestone, partially gilt and colored, Venice, SS. Giovanni e Paolo

Along with Antonio Rizzo, Pietro Lombardo, who came from Carona on Lake Lugano, is one of the main representatives of the Venetian early Renaissance. The tomb of the doge Pietro Mocenigo, who died in 1476, is viewed as Lombardo's masterpiece; it is possible that his sons Tullio and Antonio also contributed to it.

Pietro Lombardo, sepultura para el duque Pietro Mocenigo, 1476-81, mármol, arenisca, dorado parcialmente y pintado en temple, Venecia, San Giovanni e Paolo

Pietro Lombardo de Carona, junto al lago de Lugano, es considerado de la mano de Antonio Rizzo como el principal representante del renacimiento temprano veneciano. La sepultura del duque Piero Mocenigo, fallecido en 1476, es su obra maestra; en ella posiblemente también colaboraron sus hijos Tullio y Antonio.

Andrea del Verrocchio, Christ and Doubting Thomas, 1483, bronze, 230 cm (Christ), 200 cm (Thomas), Florence, Orsanmichele

Andrea del Verrochio, a goldsmith by trade, was also a sculptor, bronze founder, painter, and musician. He is primarily famous, however, for his work in bronze. As a Florentine sculptor, he was accorded the privilege of leading Italian sculpture of the quattrocento to its fullest glory.

Andrea del Verrocchio, Christus Cristo y Tomás el Incrédulo, 1483, bronce, 230 cm (Cristo), 200 cm (Tomás), Florencia, Orsanmichele

Andrea del Verrochio, originalmente orfebre, trabaja como escultor, fundidor de bronce, pintor y músico. Su fama se debe ante todo, no obstante, a su actividad como escultor de bronce. Como escultor florentino se le reserva el derecho de dirigir la escultura italiana del siglo XV en Florencia hacia su punto culminante.

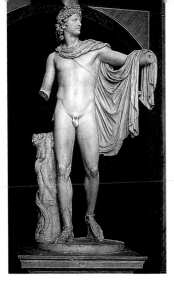

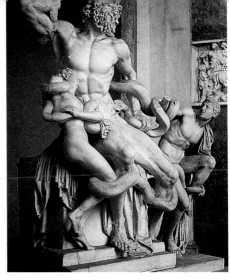

LEFT: *Apollo Belvedere*, Roman copy
of a Greek original from 330 BC, 224
cm, attributed to Leochares

RIGHT: *Laocoon and his Sons*,
AD 14–37, copy by the sculptors
Athanadoros, Hagesandros and
Polydoros of Rhodes after a Greek
bronze original dating from ca.
140 BC
Rome, Vatican Museums

A LA IZQUIERDA: *Apolo de Belvedere*,
copia romana de un original griego de
330 a. C., 224 cm, atribuido a
Leochares

A LA DERECHA: *Grupo de Laocoonte*,
14-37 d. C., copia de los escultores
Athanadoros, Hagesandros y
Polydoros de Rodos según un original
de bronce griego hacia 140 a. C.
Roma, museos Vaticanos

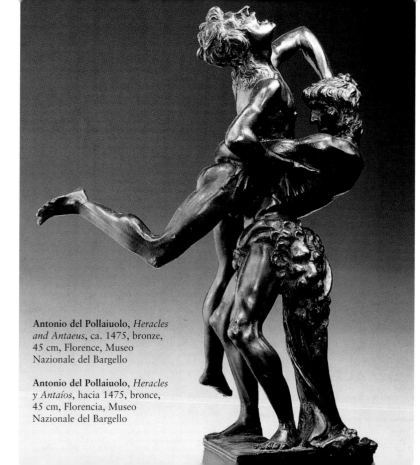

Antonio del Pollaiuolo, *Heracles and Antaeus*, ca. 1475, bronze, 45 cm, Florence, Museo Nazionale del Bargello

Antonio del Pollaiuolo, *Heracles y Antaíos*, hacia 1475, bronce, 45 cm, Florencia, Museo Nazionale del Bargello

Michelangelo

Michelangelo Buonarroti is the most out-standing artistic figure of his time. He worked as an architect, painter, and poet, but his true calling was sculpture, which he learned in the art school of Lorenzo de Medici under the tutelage of the bronze sculptor Bertoldo di Giovanni. Lorenzo "the Magnificent" took him under his wing in his Florentine palazzo in 1490, initiating an almost familial relationship between the exceptional artist and the Medici dynasty. From that point on, Michelangelo's life and artistic career unfolded between the Medicis in Florence and the popes in Rome as his ardent supporters and sponsors. He created numerous sculptures in which he intensively grappled with principles of design found in antique sculpture. The installation of his *David* in front of the Palazzo Vecchio in June 1504 was groundbreaking for further sculpture of the sixteenth century (p. 416/417). Its colossal size as well as the figure's nude, athletic build are directly orientated on Antiquity, while Michelangelo's ferocious mental force (*terribilità*) points to the future.

Miguel Ángel

Miguel Ángel Buonarroti es la personalidad artística más destacada de su época. Trabaja como arquitecto, pintor y poeta, pero su vocación verdadera es la escultura, que aprende con el escultor de bronce Bertoldo di Giovanni, mentor en la escuela de arte de Lorenzo de'Medici. Como Lorenzo il Magnifico lo acoge en 1490 en su palacio florentino, se inicia una relación casi familiar entre el artista excepcional y la casa de los Medici. A continuación, su vida y su trabajo artístico se desenvuelven entre Florencia con los Medici y Roma con los papas patrocinadores y contratantes. Crea numerosas obras pictóricas en las que ahonda intensamente en los antiguos principios del diseño escultórico. Revolucionaria para la escultura posterior del siglo XVI es la exposición de su *David* (p. 416/17) en junio de 1504 frente al Palazzo Vecchio. Tanto las medidas colosales como su desnudez y figura atlética hacen referencia directa a la antigüedad, mientras que la expresión de fuerza espiritual es de amplio porvenir.

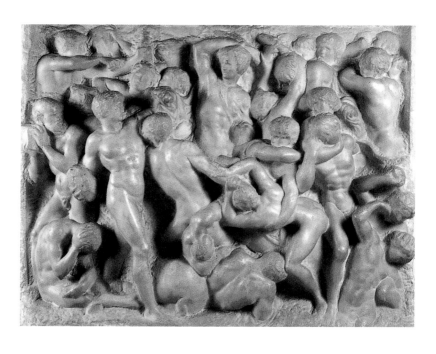

Michelangelo, *Battle of the Centaurs*, ca. 1490–1492, marble, 80.5 x 88 cm (height x width), Florence, Casa Buonarroti

Miguel Ángel, *Batalla de los centauros*, hacia 1490-92, mármol, 80,5 x 88 cm (alto x ancho), Florencia, casa Buonarroti

Michelangelo

RIGHT: *Madonna of the Stairs*, ca. 1490, marble, 55.5 x 40 cm (height x width), Florence, Casa Buonarroti

P. 415: *Bacchus*, 1496–1497, marble, 184 cm (without base), detail, Florence, Museo Nazionale del Bargello

Miguel Ángel

A LA DERECHA: *Virgen en la escalera*, hacia 1490, mármol, 55,5 x 40 cm (alto x ancho), Florencia, casa Buonarroti

P. 415: *Baco*, 1496-97, mármol, 184 cm (sin base), detalle, Florencia, Museo Nazionale del Bargello

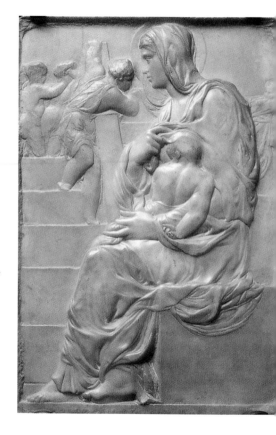

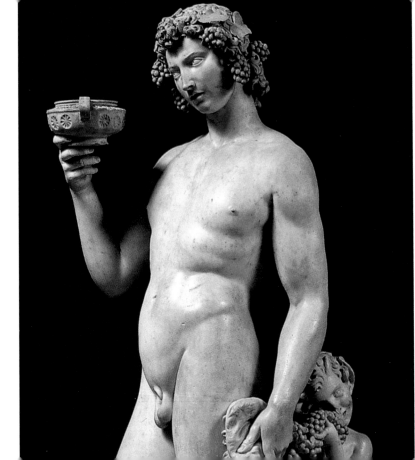

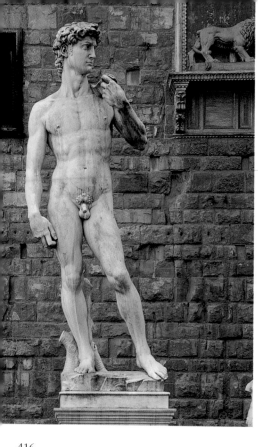

Michelangelo
LEFT: *David*, 1501–1504, marble, 434 cm (with stone base), copy, Florence, Piazza Signoria

OPPOSITE: Head of the original *David*, Florence, Galleria dell'Accademia

Miguel Ángel
A LA IZQUIERDA: *David*, 1501-04, mármol, 434 cm (con base de roca), copia, Florencia, Piazza Signoria

ENFRENTE: Cabeza del original, Florencia, Galleria dell'Accademia

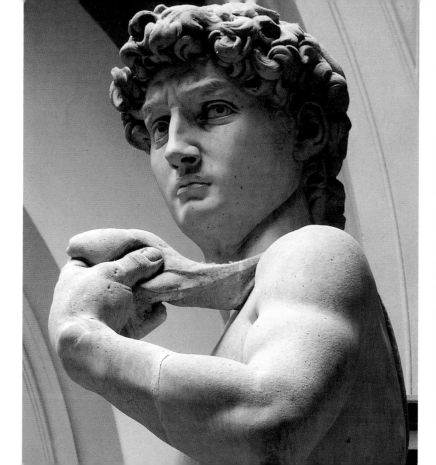

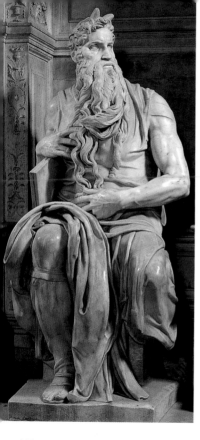

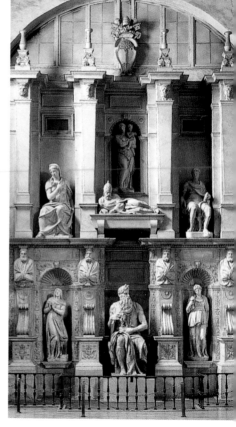

Michelangelo

Opposite left: *Moses*, ca. 1513–1516, marble, 235 cm, Rome, S. Pietro in Vincoli

Opposite right: Tomb of Julius II, completed 1542–1545, marble, Rome, S. Pietro in Vincoli

Right: Victory group, ca. 1520–1525, marble, 261 cm, Florence, Palazzo Vecchio

P. 420/421: Tomb of Lorenzo de'Medici, detail: Aurora (left), 1521–1534, marble, 178 cm (Lorenzo)

Miguel Ángel

Enfrente a la izquierda: *Moisés*, hacia 1513-16, mármol, 235 cm, Roma, San Pietro in Vincoli

Enfrente a la derecha: Sepultura del papa Julio II, terminada en 1542-45, mármol, Roma, San Pietro in Vincoli

A la derecha: Grupo de vencedores, hacia 1520-25, mármol, 261 cm, Florencia, Palazzo Vecchio

P. 420/21: Sepultura del duque Lorenzo de'Medici, detalle: La aurora, 1521-34, mármol, 178 cm (Lorenzo)

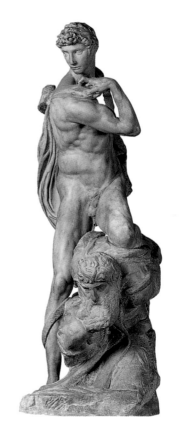

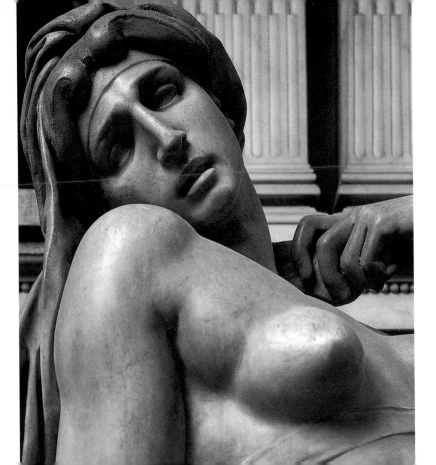

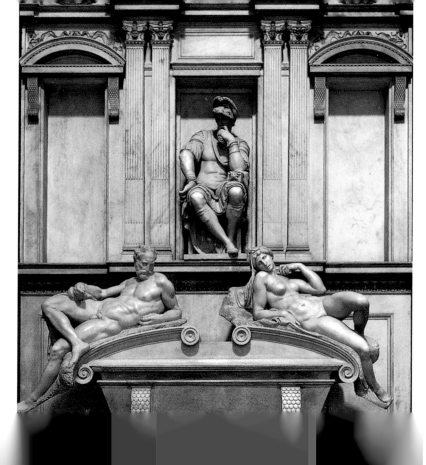

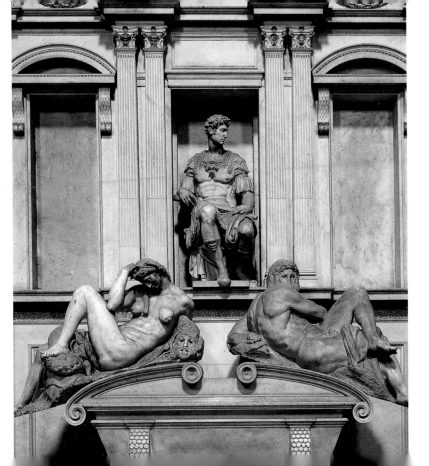

OPPOSITE AND BELOW: **Michelangelo**, tomb of Giuliano de'Medici, detail: allegory of Day, 1521–1534, marble, 178 cm (Giuliano), Florence, S. Lorenzo, Medici Chapel

ENFRENTE Y ABAJO: **Miguel Ángel**, sepultura del duque Giuliano de'Medici, detalle: Alegoría del día, 1521-34, mármol, 178 cm (Giuliano) Florencia, San Lorenzo, capilla de los Medici

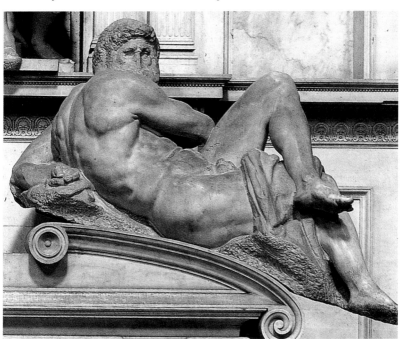

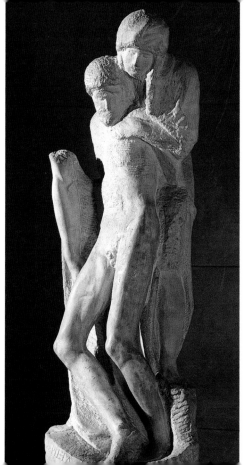

While the famous *Pietà* in St. Peter's in Rome is among Michelangelo's early works, he revisited this theme and created two additional works devoted to it toward the end of his life. They remained unfinished, leading to the use of the term *nonfinito* in art history.

Michelangelo
OPPOSITE: *Pietà*, 1497–1499, marble, 174 cm, Rome, St. Peter's

LEFT: *Pietà Rondanini*, 1552/53–1564, marble, 195 cm, Milan, Castello Sforzesco

Si bien la famosa *Piedad* en San Pedro en Roma es una obra temprana de Miguel Ángel, existen otras dos obras sobre el mismo tema, en las cuales trabaja en los últimos años de su vida. Como quedaron inconclusas, la historia del arte ha introducido el término *nonfinito*.

Miguel Ángel
ENFRENTE: *Piedad*, 1497-99, mármol, 174 cm, Roma, San Pedro

A LA IZQUIERDA: *Rondanini-Pietà*, 1552/53-64, mármol, 195 cm, Milán, Castello Sforzesco

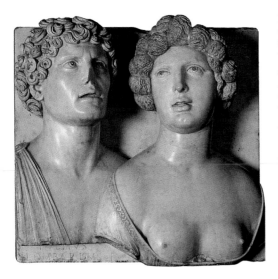

The many-figured and richly emotional *Deposition of Christ* by Jacopo Sansovino was the first to incorporate the deposition of the thieves from their crosses in its staging. By working with antique models for individual figures, as well, the sculptor created a new type of Deposition that had lasting impact on later works of art.

El *Descendimiento de la cruz* de Jacopo Sansovino, de gran movimiento y numerosas figuras, incluye en la representación por primera vez también el descendimiento de los ladrones. El escultor labra en esta obra las diversas figuras según modelos de la antigüedad, creando un nuevo tipo de descendimiento de la cruz que repercutirá en el arte posterior.

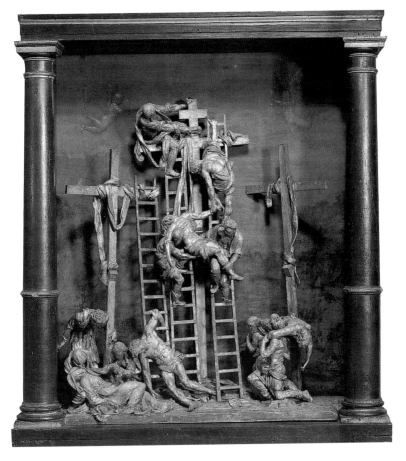

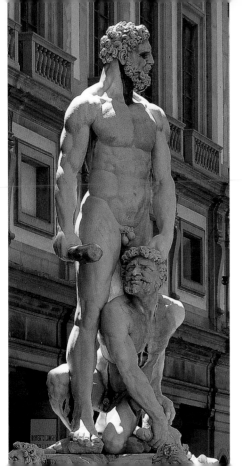

The sculptor Baccio Bandinelli from Florence is a somewhat problematic artist, in human terms. He boasted that he could surpass the model of the antique *Laocoon*, and then sculpted a copy infused with a pathos that was at least in accordance with contemporary tastes.

Baccio Bandinelli
LEFT: *Hercules and Cacus*, 1525–1534, marble, 496 cm, Florence, Piazza della Signoria

OPPOSITE: *Laocoon*, copy based on the *Laocoon* in the Belvedere, marble, Florence, Galleria degli Uffizi

El escultor florentino Baccio Bandinelli es considerado un artista más bien problemático. A su autoglorificación —afirma ser capaz de superar escultóricamente el modelo del antiguo *Laocoonte*— sigue una copia de tal patetismo, que al menos corresponde al gusto de la época.

Baccio Bandinelli
A LA IZQUIERDA: *Hércules y Caco*, 1525-34, mármol, 496 cm, Florencia, Piazza della Signoria

ENFRENTE: *Laocoonte*, copia según el *Laocoonte* del Belvedere, mármol, Florencia, Galleria degli Uffizi

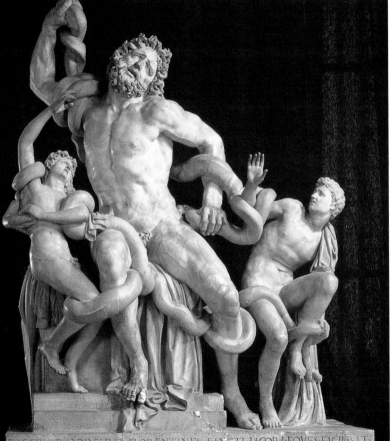

BACCIVS · BANDINELLVS · FLORENTINVS · SANCTI · IACOBI · EQVES · FACIEBAT

Mannerism

In the second quarter of the sixteenth century, Italian sculpture began to turn away from the Classical harmony of the Renaissance. The sculptures are attenuated and are configured in virtuostically artificial poses. Characteristic of Mannerist sculpture is the *figura serpentinata*, an innovation of Michelangelo's for the Victory group on the tomb of Pope Julius II. In it, the figures are related to each other with an almost exaggerated turning motion and effortless flexibility. One of the leading and most influential sculptors of Mannerism was Giovanni da Bologna, also known as Giambologna. In his *Rape of the Sabine* group, he incorporated the *figura serpentinata* and used it almost formulaically for his own purposes to create a masterpiece of virtuosity. Mannerism can thus be seen as an intermediate period of increased enthusiasm for artistic beauty and elegance. While Benvenuto Cellini produced such sumptuous examples of the goldsmith's art as the salt cellar for Francis I of France, Bartolomeo Ammanati created numerous fountain and garden figures.

Manierismo

En el segundo cuarto del siglo XVI se presenta en la escultura italiana un distanciamiento de la armonía clásica del renacimiento. Las esculturas aparecen alargadas y moldeadas en poses virtuosamente artificiales. Característica de la escultura manierista es la "figura serpentinata", una creación de Miguel Ángel con ocasión del grupo de vencedores para la sepultura del papa Julio II. Las figuras se relacionan unas con otras en giros exagerados de elástica ligereza. Uno de los escultores más influyentes del manierismo es Giovanni da Bologna, llamado también Giambologna. En su conjunto *Rapto de la sabina* hace suyo el motivo de la *figura serpentinata* y lo modela casi por fórmula para sus propios propósitos con el fin de crear una obra de arte. El manierismo se manifiesta como época intermedia de entusiasmo creciente por la belleza y la elegancia artística. Mientras Benvenuto Cellini produce valiosos trabajos de orfebrería, como el salero para Franciso I, Bartolomeo Ammanati crea numerosas figuras en fuentes y jardines.

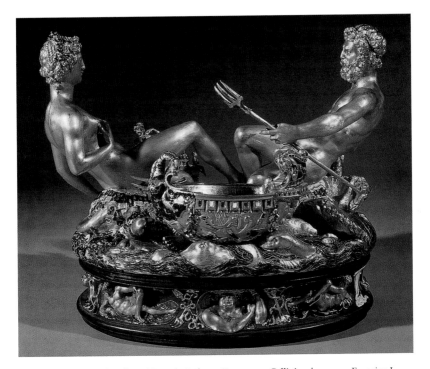

Benvenuto Cellini, salt cellar of Francis I of France, 1540–1543, ebony and gold, partially enameled, 26 x 33.5 cm (height x width), Vienna, Kunsthistorisches Museum

Benvenuto Cellini, salero para Franciso I, 1540-43, madera de ébano, oro, esmaltado parcialmente, 26 x 33,5 cm (alto x ancho), Viena, museo de la Historia del Arte

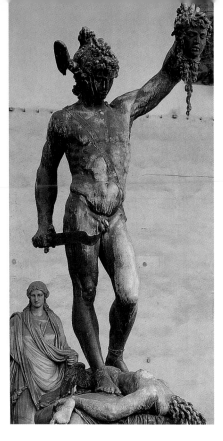

Benvenuto Cellini, *Perseus*, 1545–1554, bronze, 320 cm (with base), Florence, Loggia dei Lanzi

Giambologna (Giovanni da Bologna)
OPPOSITE LEFT: *Mercury*, 1564–1580, bronze, 180 cm, Florence, Museo Nazionale del Bargello

OPPOSITE RIGHT: *Rape of the Sabine*, 1581–1583, marble, 4.1 m, Florence, Loggia dei Lanzi

Benvenuto Cellini, *Perseo*, 1545-54, bronce, 320 cm (con base), Florencia, Loggia dei Lanzi

Giambologna (Giovanni da Bologna)
ENFRENTE A LA IZQUIERDA: *Mercurio*, 1564-80, bronce, 180 cm, Florencia, Museo Nazionale del Bargello

ENFRENTE A LA DERECHA: *Rapto de la sabina*, 1581-83, mármol, 410 cm, Florencia, Loggia dei Lanzi

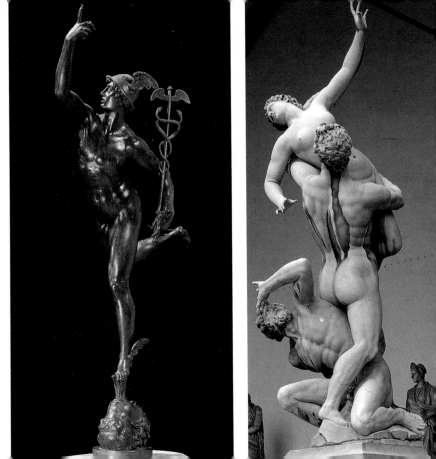

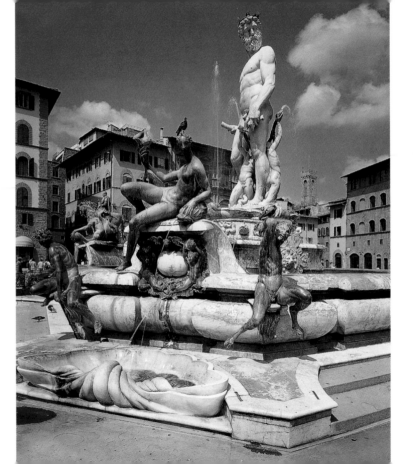

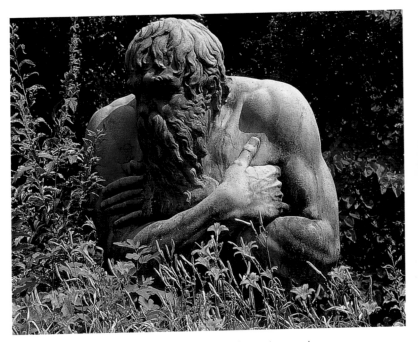

Bartolomeo Ammanati
ABOVE: Allegory of Winter, 1563–1565,
Castello, Villa Medici, garden
OPPOSITE: Neptune Fountain, 1560–1575,
marble and bronze, ca. 5.6 m, Florence,
Piazza della Signoria

Bartolomeo Ammanati
ARRIBA: Alegoría del invierno, 1563-65,
Castello, Villa Medicea, jardín
ENFRENTE: Fuente de Neptuno, 1560-75,
mármol y bronce, aprox. 560 cm, Florencia,
Piazza della Signoria

Jörg Syrlin the Elder
Busts of important poets and
philosophers of Antiquity and the
Renaissance, 1468–1474, wood,
sculpted in the round, unpainted,
Ulm, cathedral, choir stalls

LEFT: Cicero, Roman statesman,
orator, and author

RIGHT: Terence, Roman poet and
author of comedies

Jörg Syrlin el Viejo
Bustos de poetas y filósofos
importantes de la antigüedad y
del renacimiento, 1468-74, madera,
sin pintar, Ulm, catedral, sillería del
coro

A LA IZQUIERDA: Cicerón, estadista
romano, orador y autor

A LA DERECHA: Terencio, poeta
cómico romano

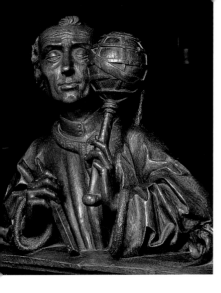

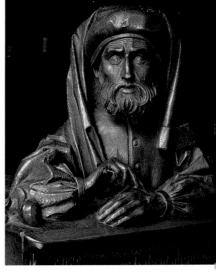

LEFT: Ptolemy, Greek scientist

RIGHT: Seneca, Roman poet and philosopher

A LA IZQUIERDA: Patolomeo, naturalista griego

A LA DERECHA: Séneca, poeta romano y escritor filosófico

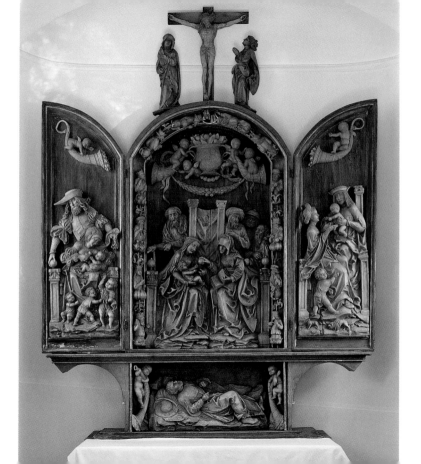

Renaissance Gardens and their Sculpture

The post-Medieval approach to nature included not only understanding it, but also the attempt to dominate it. Efforts to restructure nature according to rational principles and achieve the highest possible level of refinement found artistic expression in the art of garden design in the Renaissance and the Mannerist period. The model for all Renaissance gardens is without doubt the Belvedere Court at the Vatican, designed by Bramante. In contrast to the rational harmony of Renaissance gardens, Mannerist parks tended to favor the excessive, bold combination of extreme opposites. Minute, dwarf-like elements are juxtaposed with enormous, giant-like ones. In Bomarzo near Viterbo, Vicino Orsini constructed a sculpture garden that is peculiarly enigmatic. A large number of mysterious and monstrous beings are gathered there, in addition to a house that stands completely askew, apparently piecing the formerly orderly world together in an entirely new way.

Jardines renacentistas y sus esculturas

Del afán posterior a la edad media por comprender la naturaleza hace parte no sólo el intento por discernirla, sino también por dominarla. Ordenar la naturaleza según principios racionales y moldearla hasta su máximo refinamiento es una realidad artística en los jardines renacentistas y manieristas. El modelo de todos los jardines renacentistas se halla sin duda en el patio del Belvedere en el Vaticano, creado por Bramante. Frente a la armonía casi natural del jardín renacentista, el jardín manierista favorece la combinación exagerada y audaz de lo opuesto en extremo. El enanismo mínimo se enfrenta al máximo gigantismo. En Bomarzo junto a Viterbo, Vicino Orsini construye un jardín escultórico particularmente enigmático. Allí se reúnen numerosas y misteriosas monstruosas criaturas de fábula junto a una casa totalmente inclinada, que vuelven a unir de una manera diferente el mundo hasta ese momento aún ordenado.

Above and p. 444/445: **Giacomo Barozzi,**
called Il Vignola, fountain complex with
river gods and view of the garden facade of
Palazzina Farnese, begun ca. 1560,
Caprarola

Arriba y p. 445/45: **Giacomo Barozzi,**
llamado Il Vignola, fuentes con dioses
fluviales y vista a la parte frontal del jardín
del Palazzina Farnese, comenzado hacia
1560, Caprarola

Bagnaia, Renaissance garden at
Villa Lante

OPPOSITE: Fountain with sculptural
ensemble

BELOW: Parterre garden and pool in
several sections

Bagnaia, jardín renacentista de la
Villa Lante

ENFRENTE: Fuentes y conjunto de
esculturas

ABAJO: Parterre y estanque en varias
secciones

Bagnaia, Renaissance garden at Villa Lante
ABOVE: Water chain

OPPOSITE: Fountain at the end of the water chain

P. 450/451: **Pratolino**, Villa Demidoff, male figure with an eagle in the wooded area (p. 450); pond with colossal figure *Apennines* by Giovanni da Bologna in the background, ca. 1580 (p. 451)

Bagnaia, jardín renacentista de la Villa Lante
ARRIBA: Escalera de agua

ENFRENTE: Fuente al final de la escalera de agua

P. 450/51: **Pratolino**, Villa Demidoff, figura masculina con águila en el área de bosque (p. 450), estanque, al fondo la figura colosal del *Apenino* de Giovanni da Bologna, hacia 1580 (p. 451)

449

Bomarzo, the Sacred Grove of Vicino Orsini, 1547–ca. 1580
LEFT: Roland, viewed from the reservoir

OPPOSITE: Fight between a dragon and a lion (above left), Aztec mask with globe and the Orsini crest (above right), Demeter with a fruit bowl (below)

Bomarzo, el bosque sagrado de Vicino Orsini, 1547-hacia 1580
A LA IZQUIERDA: Rolando, visto desde el embalse

ENFRENTE: Lucha entre un dragón y un león (arriba a la izquierda), máscara azteca con globo terrestre y el escudo de los Orsini (arriba a la derecha), Demetrio con frutero (abajo)

Bomarzo, the Sacred Grove of Vicino Orsini, 1547–ca. 1580
OPPOSITE: Leaning house

ABOVE: The gorge of hell by day

FOLLOWING TWO PAGES: Pegasus Fountain (p. 456 left), elephant with a Roman soldier (p. 456/457), Turtle with Fortune (p. 457 right)

Bomarzo, el bosque sagrado de Vicino Orsini, 1547-hacia 1580
ENFRENTE: Casa inclinada

ARRIBA: Fauces del infierno de día

PÁGINA DOBLE SIGUIENTE: Fuente de Pegaso (p. 456 a la izquierda), elefante con guerrero romano (p. 456/57), tortuga con fama (p. 457 a la derecha)

Sculpture of the
Baroque

Sculpture experienced an extraordinary burgeoning during the baroque period, as artists strove to increase the overall effect of their art through virtuosic blending of the most diverse elements. Sculpture was often employed as ornamentation of the architecture and its highest accomplishment, for example, when horizontal rows of statues crowned a building. In the interior decoration of churches and palaces, sculpture often served the function of shifting the borders between various levels of reality in the sense of the baroque *Gesamtkunstwerk* ("total work of art") toward illusion. It was most often the sculptors who gave the *Gesamtkunstwerk* its final, crowning touches.

Escultura del
barroco

La escultura experimenta un extraordinario apogeo en la época del barroco porque los artistas, con el fin de acentuar el efecto general que producen sus obras, comienzan a mezclar con gran virtuosismo los más diversos elementos. Así, la escultura se manifiesta a menudo como decoración de la arquitectura y como su perfeccionamiento máximo, por ejemplo cuando se coronan construcciones con secuencias horizontales de estatuas. Con respecto a la decoración interior de iglesias y palacios, a la escultura se le otorga con frecuencia la tarea de desplazar los límites entre los diversos niveles de la realidad en todo el conjunto de la obra barroca a favor de la ilusión, siendo la mayoría de las veces los escultores quienes conceden al conjunto de la obra de arte el acabado definitivo.

Baroque Sculpture in Rome

In the final third of the sixteenth century, the period of the Counter-Reformation, the Roman Church exerted considerable influence over art and its subject matter. The formal principles of sculpture were based on the design techniques of ponderation, the use of a "real" leg and a "fake" leg to support the figures, and *contrapposto*, which the sculptors adopted from antiquity. A spiral turning motion of the figures, the *figura serpentinata*, was added in the period preceding baroque, known as Mannerism. While the form of baroque sculpture referred back to these principles again and again, its content shifted in the direction of featuring the suffering of Christ and the martyrs. Sculptors no longer aimed for admiration of their works' artistic perfection, but for a direct and deeply felt emotional response of the human soul, even deep distress. At the same time, the location of the sculptures—church interiors and chapels, but especially the altars—unfolded as sometimes grandiose sets for religious "world theater."

Escultura barroca en Roma

La influencia de la iglesia romana de la Contrarreforma fue ganando terreno considerablemente en el último tercio del siglo XVI en el arte y su contenido, tomando como base los principios formales de la *ponderazione* y el *contrapposto*, provenientes de la escultura de la antigüedad. A estos había agregado la fase precedente al barroco, designada como manierismo, la *figura serpentinata*. Si bien la escultura del barroco recurre formalmente una y otra vez a estos principios, muestra una tendencia a modificar su contenido, de tal modo que el sufrimiento de Jesucristo y de los mártires va pasando al primer plano. El escultor ya no desea la admiración de la perfección artística sino la conmoción directa del alma humana, su profunda emoción. Al mismo tiempo, los lugares de exposición de las esculturas —interiores de iglesias y capillas pero ante todo los altares— se convierten en bastidores, en parte grandiosos, de un "teatro" del mundo religioso.

OPPOSITE: **Carlo Maderna**, Rome, S. Susanna, 1597–1603, facade

ENFRENTE: **Carlo Maderna**, Roma, Santa Susana, 1597–1603, fachada

RIGHT: **Carlo Maderno**, Rome, St. Peter's, 1607–1612, facade

A LA DERECHA: **Carlo Maderno**, Roma, San Pedro, 1607–12, fachada

BELOW: **Gianlorenzo Bernini**, Rome, St. Peter's Square, 1656–1657, detail of the colonnade

ABAJO: **Gianlorenzo Bernini**, Roma, plaza de San Pedro, 1656–57, detalle de las arcadas

Francesco Borromini
LEFT: Rome, S. Carlo alle Quattro Fontane, 1664–1667, facade

OPPOSITE: Rome, S. Andrea delle Fratte, 1653–1656, bell tower

Francesco Borromini
A LA IZQUIERDA: Roma, S. Carlo alle Quattro Fontane, 1664–67, fachada

ENFRENTE: Roma, S. Andrea delle Fratte, 1653–56, campanario

465

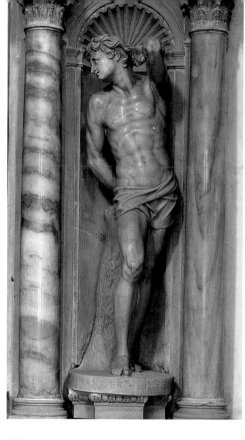

Alessandro Vittoria
LEFT: *St. Sebastian*, 1561–1563,
marble, 117 cm, Venice,
S. Francesco della Vigna

OPPOSITE: *St. Sebastian*, ca. 1600,
marble, 170 cm, Venice,
S. Salvatore

Alessandro Vittoria
A LA IZQUIERDA: *San Sebastián*,
1561–63, mármol, 117 cm,
Venecia, S. Francesco della Vigna

ENFRENTE: *San Sebastián*, hacia
1600, mármol, 170 cm, Venecia,
S. Salvatore

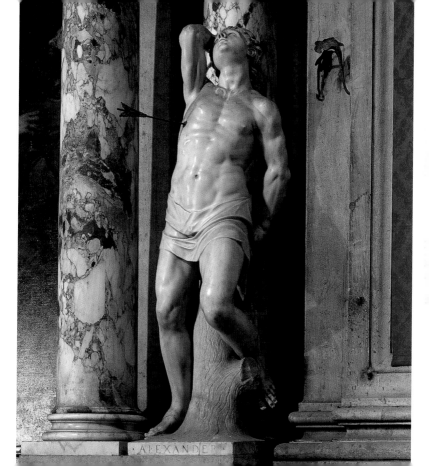

ALEXANDER

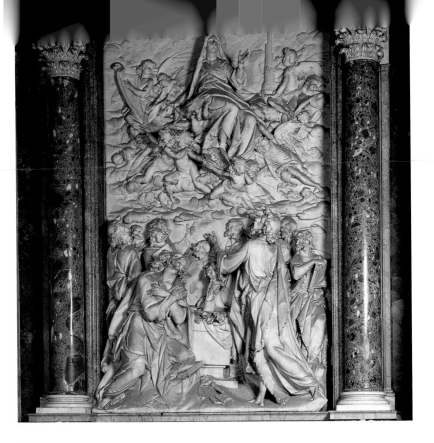

468

Bernini

The singular artistic phenomenon of the Roman baroque, without doubt, was Giovanni Lorenzo Bernini (1598–1680). Like Donatello in the fifteenth century and Michelangelo in the sixteenth, Bernini was the dominant artistic personality who had decisive impact on Roman art of the seventeenth century. His sculptures for the Villa Borghese, which allegorize mythological themes in various ways, are attributed to his first contiguous creative phases. Thanks to the influence of his powerful patron, Pope Urban VIII, he was commissioned with the monumental interior decoration of St. Peter's Basilica. The stupendous baldachin rising over the papal altar stands directly above the tomb of St. Peter, transforming the entire space. With its four twisted bronze columns, which are intended to recall Solomon's temple in Jerusalem, this masterpiece demanded superb technical skill in working with bronze. Of the four crossing piers, Bernini adorned only one of them with a sculpture. It portrays St. Longinus, the Roman soldier who jabbed a spear in the side of the Crucified One.

Bernini

Giovanni Lorenzo Bernini (1598–1680) domina el barroco romano por su extraordinaria producción artística. De modo semejante a Donatello en el siglo XV y a Miguel Ángel en el siglo XVI, Bernini es la personalidad artística determinante en el arte romano del siglo XVII. A su primera fase creadora continua se atribuyen las esculturas de la villa Borghese con diversas alegorías de temas mitológicos. Gracias a su poderoso promotor, el papa Urbano VIII, es encargado de realizar la monumental ornamentación interior de la basílica de San Pedro. El magnífico baldaquino que cubre la sepultura de San Pedro y el altar papal, con sus cuatro columnas retorcidas de bronce, evoca el templo de Salomón en Jerusalén y da prueba de los excelentes conocimientos técnicos del trabajo con bronce por parte del artista. Bernini adornó con una escultura sólo uno de los cuatro pilares de la intersección de la nave; esta muestra a San Longinos, aquel soldado romano que traspasó con su lanza a Jesucristo crucificado.

Gianlorenzo Bernini
LEFT: *David*, 1623–1624, 170 cm

OPPOSITE LEFT: *Pluto and Proserpina*, 1621–1622, 255 cm

OPPOSITE RIGHT: *Apollo and Daphne*, 1622–1625, 243 cm

marble, Rome, Galleria Borghese

Gianlorenzo Bernini
A LA IZQUIERDA: *David*, 1623–24, 170 cm

ENFRENTE A LA IZQUIERDA: *Plutón y Proserpina*, 1621–22, 255 cm

ENFRENTE A LA DERECHA: *Apolo y Dafne*, 1622–25, 243 cm

mármol, Roma, galería Borghese

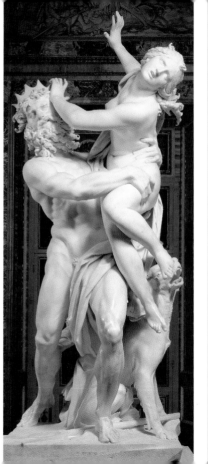
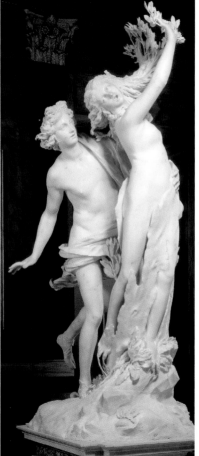

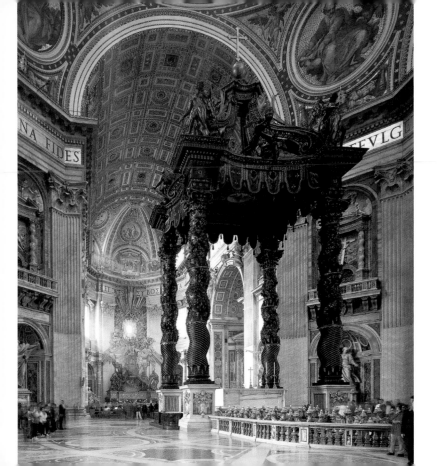

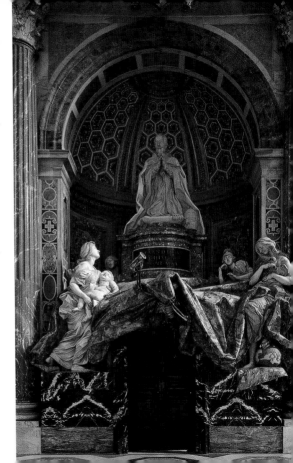

Gianlorenzo Bernini
OPPOSITE: Baldachin, 1624–
1633, marble, bronze and
gold, 28.5 m

RIGHT: Tomb of Pope
Alexander VII, 1673–1674,
marble, gilt bronze

P. 474: *St. Longinus*, 1629–
1638, marble, 440 cm

P. 475: **François
Duquesnoy**, *St. Andreas*,
1629–1633, marble,
ca. 450 cm

Rome, St. Peter's

Gianlorenzo Bernini
ENFRENTE: Baldaquino,
1624–33, mármol, bronce y
oro, 28,5 m

A LA DERECHA: Tumba del
papa Alejandro VII, 1673–
74, mármol, bronce dorado

P. 474: *San Longinos*,
1629–38, mármol, 440 cm

P. 475: **François
Duquesnoy**, *San Andrés*,
1629–33, mármol, aprox.
450 cm

Roma, San Pedro

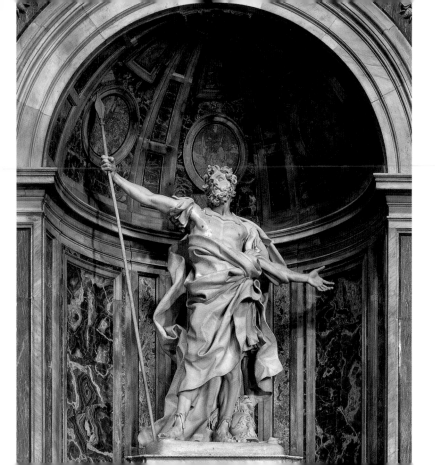

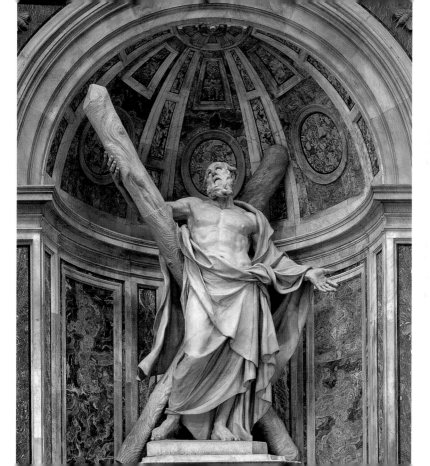

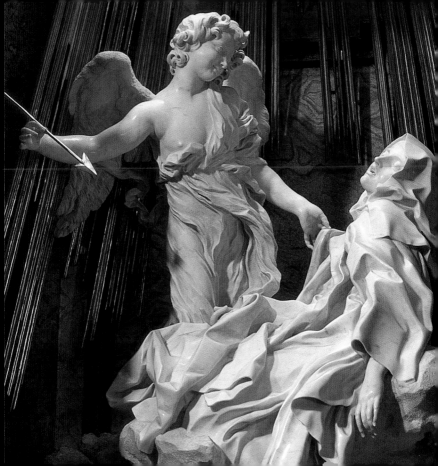

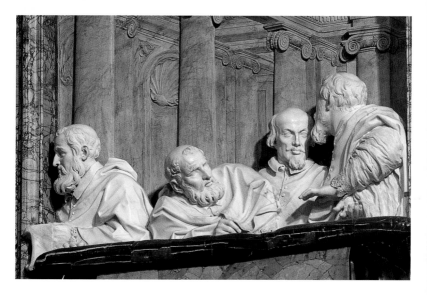

Gianlorenzo Bernini, chapel and altar of the Cornaro family, 1647–1652. *The Ecstasy of St. Theresa,* marble, 350 cm (opposite), *Donor's Balcony* on the right side wall (above), Rome, S. Maria della Vittoria

FOLLOWING TWO PAGES: *The Blessed Ludovica Albertoni,* 1671–1674, marble and jasper, length 188 cm, Rome, S. Francesco a Ripa

Gianlorenzo Bernini, capilla y altar de la familia Cornaro, 1647–52. *El éxtasis de Santa Teresa de Ávila,* mármol, 350 cm (enfrente), logia de donadores del lateral derecho (arriba), Roma, Santa María de la Victoria

SIGUIENTE PÁGINA DOBLE: *La bienaventurada Ludovica Albertoni,* 1671–74, mármol y jaspe, 188 cm de longitud, Roma, San Francisco de Ripa

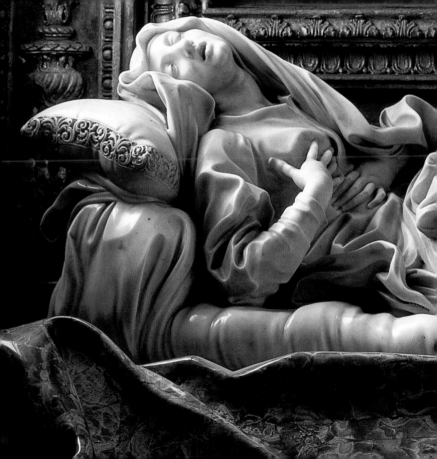

S. ANNA · 1675

Bernini's Fountains

In addition to the depiction of such intimate scenes as the *Ecstasy of St. Theresa* in the Cornaro Chapel of S. Maria della Vitoria, Bernini also created numerous fountains for public spaces. The baroque art fountain incorporated an entirely new style of interplay between water and stone, but also of allegorical ideas and Christian-imperial claims. At the same time, the figures frequently drawn from ancient river and sea mythology were hardly bound by an architectural context anymore. The Triton Fountain on the Piazza Barberini, for example, consists of four dolphins rising backwards out of the water; the dolphins support an open scallop bearing Triton, who sounds a trumpet. The depiction follows the recounting of the end of the deluge in Ovid's *Metamorphosis* and is a civic glorification of Pope Urban VIII. The Fountain of the Four Rivers in the Piazza Navona symbolizes the concept of the Center of the World in a similarly allegorical fashion.

Las fuentes de Bernini

Junto a la representación de un escenario tan íntimo como *El éxtasis de Santa Teresa de Ávila* en la capilla Coronaro de Santa María de la Victoria, Bernini diseña numerosas fuentes destinadas a ornamentar plazas públicas. La fuente artística de estilo barroco experimenta no sólo así una compenetración del agua y de la piedra que es por completo nueva, sino que adquiere también una idea alegórica que satisface las pretensiones cristiano-imperiales. Al mismo tiempo, apenas si se acomodan las numerosas figuras procedentes de la antigua mitología fluvial y marítima a la continuidad arquitectónica. La fuente del Tritón en la plaza Barberini, por ejemplo, está formada por cuatro delfines que emergen del agua hacia atrás llevando una concha de Santiago abierta, sobre la cual el Tritón sopla por una caracola. La obra se inspira en la narración sobre el fin del diluvio de las *Metamorfosis* de Ovidio, y fue construida para honrar al papa Urbano VIII. Del mismo modo alegórico, la fuente de los cuatro ríos en la plaza Navona simboliza la noción del centro del mundo.

OPPOSITE: **Gianlorenzo Bernini,** Triton Fountain, 1624–1643, travertine, over life-size, Rome, Piazza Barberini

ENFRENTE: **Gianlorenzo Bernini,** Fuente del Tritón, 1624–43, travertino, de tamaño mayor que el natural, Roma, plaza Barberini

482

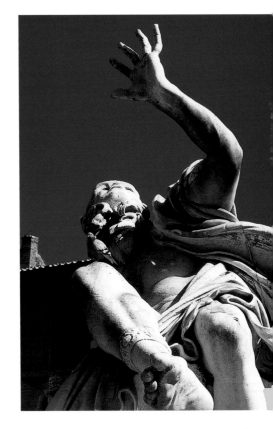

Rome, Piazza Navona
with Palazzo Pamphilj and
Sant'Agnese; in the center is
Bernini's Fountain of the
Four Rivers

Roma, plaza Navona con
palacio Pamphilj e iglesia
Sant'Agnese; en el centro, la
fuente de los cuatro ríos
de Bernini

BOTTOM AND OPPOSITE:
Gianlorenzo Bernini,
Fontana del Moro, 1653–1654,
marble, Rome, Piazza Navona

ABAJO Y ENFRENTE:
Gianlorenzo Bernini,
fuente del Moro, 1653–54,
mármol, Roma, plaza Navona

LEFT: **Gianlorenzo Bernini,** Fountain of the Four Rivers, 1648–1651, detail, marble and travertine, Rome, Piazza Navona

OPPOSITE: **Alessandro Specchi and Francesco de Sanctis,** Rome, Spanish Steps with the Fontana della Barcaccia by Gianlorenzo Bernini

A LA IZQUIERDA: **Gianlorenzo Bernini,** Fuente de los cuatro ríos, 1648–51, detalle, mármol y travertino, Roma, plaza Navona

ENFRENTE: **Alessandro Specchi y Francesco de Sanctis,** Roma, escalera española con la Fontana della Barcaccia de Gianlorenzo Bernini

490

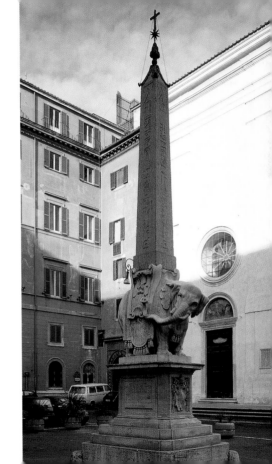

OPPOSITE AND RIGHT:
Gianlorenzo Bernini, elephant and obelisk, 1665–1667, marble, Rome, Piazza S. Maria sopra Minerva

ENFRENTE Y A LA DERECHA:
Gianlorenzo Bernini, elefante y obelisco, 1665–67, mármol, Roma, plaza S. Maria sopra Minerva

BELOW: Rome, bridge of Sant'Angelo

OPPOSITE: **Gianlorenzo Bernini and students**, two angels, 1667–1669, marble, ca. 270 cm, Rome, bridge of Sant'Angelo

ABAJO: Roma, puente de Sant'Angelo

ENFRENTE: **Gianlorenzo Bernini y alumnos**, dos ángeles, 1667–69, mármol, aprox. 270 cm, Roma, puente de Sant'Angelo

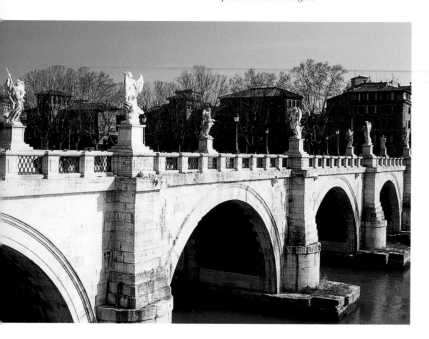

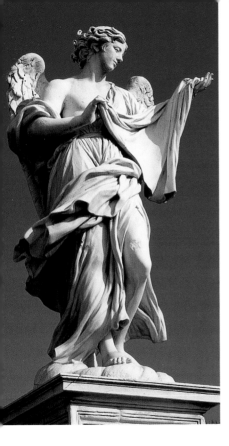
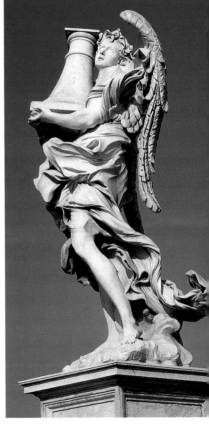

Before and After Bernini

In the seventeenth century, Rome continued to be considered the capital of the art world. Numerous artists from all corners of Europe were drawn to Rome to study the famous works of antiquity and of the great masters. Many also aspired to work for wealthy clients and patrons themselves. In the field of sculpture, this meant either competing with the superiority of the famous Bernini, or working for him. Forerunners like Camillo Mariani (1556–1611), Francesco Mocchi (1580–1654), or Stefano Maderno (1576–1636) were far surpassed by Bernini's exceptional creative genius, and only very few sculptors managed to achieve works of comparable quality. One of these was Alessandro Algardi (1598–1654), whose clear and sober style made him a popular portraitist. The Flemish François Duquesnoy (1597–1643), more than anyone else, was able to successfully free himself from Bernini's influence and produce work on a par with his.

OPPOSITE: **Francesco Mocchi,** equestrian statue of Alessandro Farnese, 1620–1625, bronze, Piacenza, Piazza del Cavalli

FOLLOWING TWO PAGES: **Stefano Maderno,** *St. Cecilia*, 1600, marble, 102 cm, Rome, S. Cecilia in Trastevere

Antes y después de Bernini

Roma se sigue considerando en el siglo XVII como centro del arte y atrae a numerosos artistas de toda Europa que desean estudiar las famosas obras de la antigüedad y los grandes maestros. Muchos de ellos anhelan incluso trabajar para clientes ricos y mecenas. Para el mundo de la escultura esto significa que hay que imponerse a la superioridad del famoso Bernini o trabajar para él. Si bien precursores como Camillo Mariani (1556–1611), Francesco Mocchi (1580–1654) o Stefano Maderno (1576–1636) destacan ante la predominante capacidad creadora de Bernini, sólo muy pocos escultores logran presentar obras equivalentes. Es el caso, por ejemplo, de Alessandro Algardi (1598–1654), un retratista muy solicitado por su estilo claro y austero. Sobre todo consigue el flamenco François Duquesnoy (1597–1643) liberarse de la influencia de Bernini y crear obras de una categoría semejante.

ENFRENTE: **Francesco Mocchi,** monumento ecuestre de Alessandro Farnese, 1620–25, bronce, Piacenza, Piazza del Cavalli

PÁGINA DOBLE SIGUIENTE: **Stefano Maderno,** *Santa Cecilia*, 1600, mármol, 102 cm, Roma, S. Cecilia en Trastevere

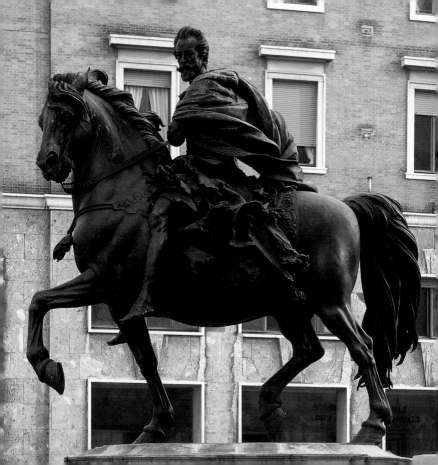

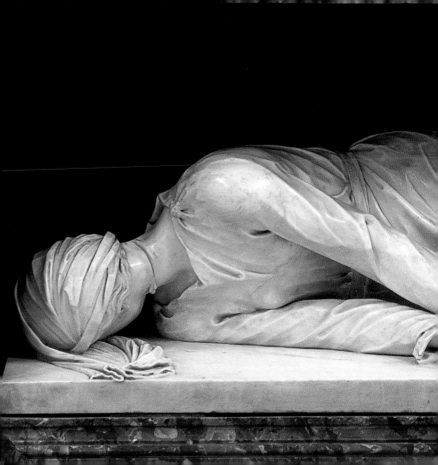

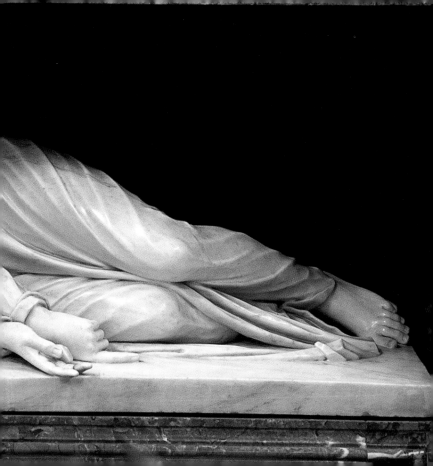

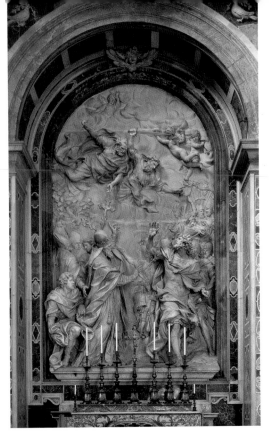

LEFT AND OPPOSITE:
Alessandro Algardi, *The Meeting of Attila and Pope Leo I*, 1646–1653, marble relief, Rome, St. Peter's

A LA IZQUIERDA Y ENFRENTE:
Alessandro Algardi, *Papa León el Grande y Atila*, 1646–53, relieve de mármol, Roma, San Pedro

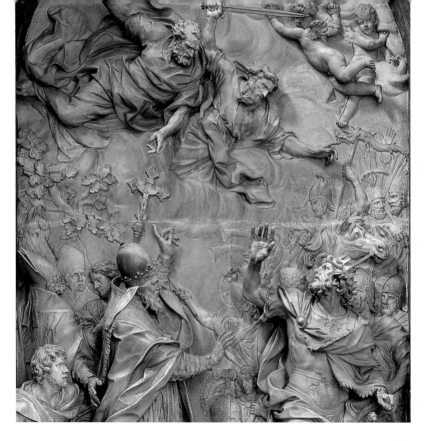

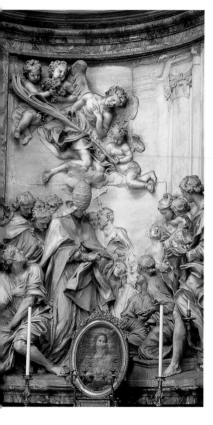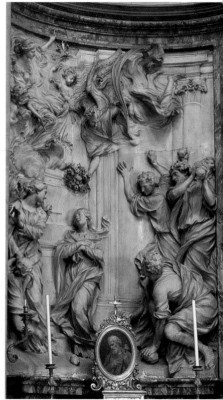

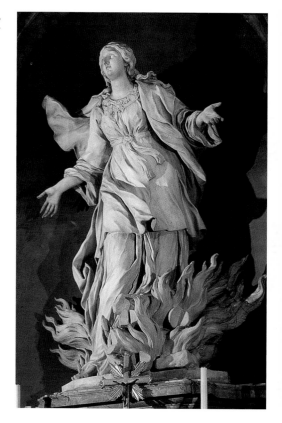

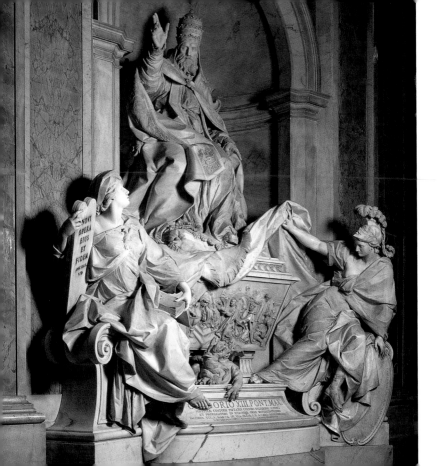

NOVI
OPERA
EIUS
ET
FIDEM
...

...ORIO XIII PONT MAX
...

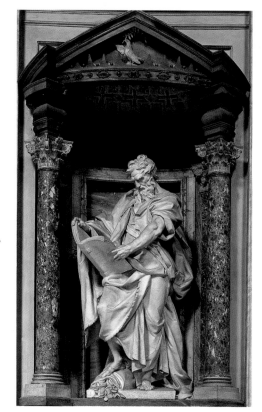

Camillo Rusconi
OPPOSITE: Tomb of Pope
Gregory XIII, 1719–1725, marble,
Rome, St. Peter's

RIGHT: *St. Matthew*, 1708–1718,
marble, over life-size, Rome,
S. Giovanni in Laterano

Camillo Rusconi
ENFRENTE: Tumba del papa
Gregorio XIII, 1719–25, mármol,
Roma, San Pedro

A LA DERECHA: *El apóstol Mateo*,
1708–18, mármol, de tamaño
superior al natural, Roma, San
Giovanni en Laterano

504

OPPOSITE AND LEFT:
Filippo della Valle, *Temperantia,*
1732, marble, overall view, detail,
Rome, S. Giovanni in Laterano

P. 506/507: **Nicola Salvi et al,**
Trevi Fountain, 1732–1751,
marble, Rome, Palazzo Poli

ENFRENTE Y A LA IZQUIERDA:
Filippo della Valle, *Temperantia,*
1732, mármol, vista total, detalle,
Roma, San Giovanni en Laterano

P. 506/07: **Nicola Salvi entre
otros,** Fontana di Trevi, 1732–51,
mármol, Roma, palacio Poli

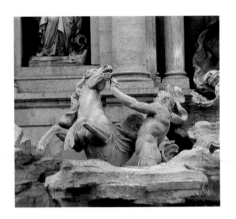

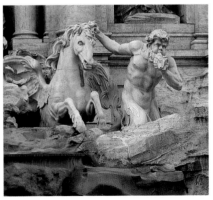

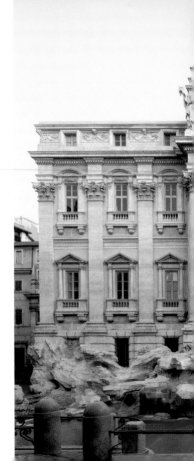

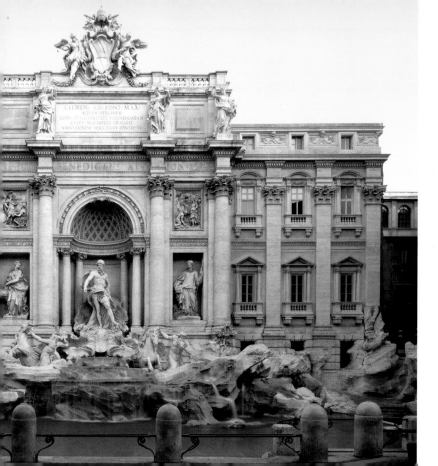

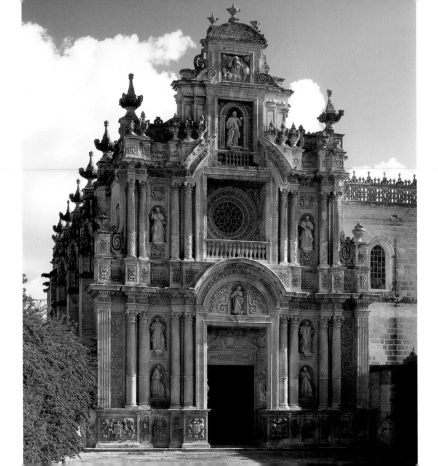

Spain

In seventeenth- and eighteenth-century Spain, Catholicism was the dominant factor in a deeply religious society. As a result, the sacred sculptures made far outnumbered the secular. In addition to the cathedrals, monasteries, and parish churches that required altarpieces with large retables, in particular, the nobility also contributed to the creation of sculpture by having not only their palaces and gardens, but also their tombs, magnificently decorated. With the surge of processions during the Holy Week, city governments also played a role in financing sculpture, because cities were temporarily transformed into monumental sacred spaces in the week preceding Easter. In addition, city councils made substantial sums of money available for the artistic configuration of Stations of the Cross through the installation of entire sculpture groups. In conjunction with the propaganda-like imparting of Church doctrine spurred by the Counter-Reformation, Spanish sculptors often resorted to crude, naturalistic means such as wigs made from genuine hair, tears or eyes of crystal, ivory teeth, and more.

OPPOSITE: **Jerez de la Frontera,** facade of the charterhouse Sta. María de la Defensión, 1667

España

El catolicismo determinaba la sociedad profundamente religiosa de la España de los siglos XVII y XVIII, lo que tuvo como consecuencia que el número de esculturas religiosas superara el de las profanas. A las catedrales, conventos e iglesias conventuales que se construyeron fundamentalmente con altares que disponían de grandes retablos, sumó la nobleza las esculturas con que ornamentó castillos, jardines y también sepulturas, algunas de ellas pomposas. Con el auge de las procesiones durante la Semana Santa, los gobiernos municipales se vieron forzados a cooperar en la financiación de las esculturas porque las ciudades se convertían temporalmente en monumentales espacios sacros. Y la administración municipal dispuso considerables sumas de dinero para la ornamentación artística de las estaciones del calvario mediante la instalación de grupos completos de esculturas. Los escultores españoles, en conexión con la propaganda de Contrarreforma de la doctrina eclesiástica, emplearon gustosos efectos toscos y naturalistas tales como pelucas de cabello natural, lágrimas u ojos de cristal, dientes de marfil y detalles semejantes.

ENFRENTE: **Jerez de la Frontera,** fachada del cartujo Santa María de la Defensión, 1667

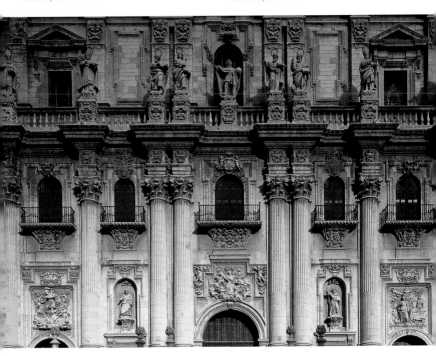

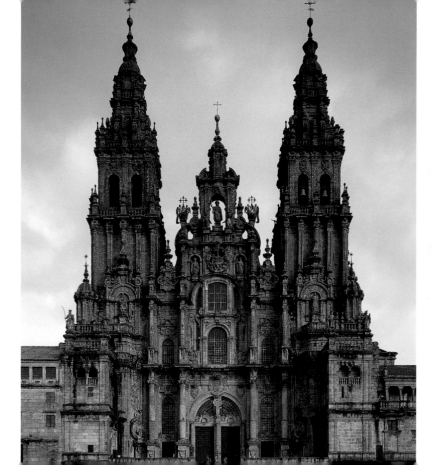

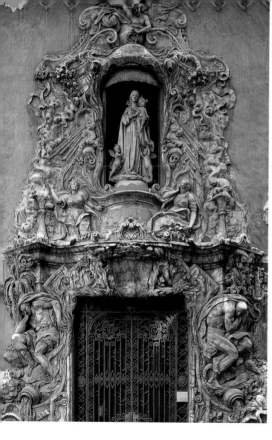

LEFT AND OPPOSITE:
Hipólito Rovira, Casa del Marqués de Dos Aguas, portal, 1740–1744, Valencia

A LA IZQUIERDA Y ENFRENTE:
Hipólito Rovira, casa del marqués de Dos Aguas, portal, 1740–44, Valencia

OPPOSITE, BELOW AND FOLLOWING
TWO PAGES: René Frémin, Jean
Thierry et al, La Granja, fountain,
1721–1728

ENFRENTE, ABAJO Y PÁGINA DOBLE
SIGUIENTE: René Frémin, Jean
Thierry entre otros, La granja,
conjunto de fuentes, 1721–28

BELOW AND OPPOSITE: **Mateus Vincente and Jean Baptiste Robillon**, Queluz, royal palace, completed after 1747, fountain in front of the "Fachada de Ceremónia" (below), gardens in front of the Don Quixote wing (opposite)

ABAJO Y ENFRENTE: **Mateus Vincente y Jean Baptiste Robillon**, Queluz, palacio real, ampliado a partir de 1747, fuente de la fachada de Ceremonia (abajo), jardines ante el ala de Don Quijote (enfrente)

P. 520/521: Lisbon, Palácio
Fronteira, after 1667–1679, gardens
with the "Casa do Tanque"

P. 520/21: Lisboa, Palácio Fronteira,
después de 1667–79, jardines con la
"Casa do Tanque"

523

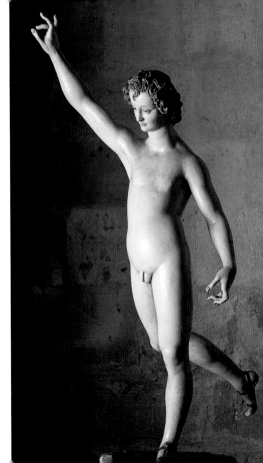

OPPOSITE: **Pedro de Mena,**
Malaga, cathedral, choir stall,
detail, 1658–1662, unpainted
cedar wood

RIGHT: **Gregorio Fernández,**
Archangel Gabriel, begun 1606,
painted wood, 110 cm, Valladolid,
Museo Diocesano

ENFRENTE: **Pedro de Mena,**
Málaga, catedral, sillería de coro,
detalle, 1658–62, madera de
cedro, sin pintar

A LA DERECHA: **Gregorio
Fernández,** *Arcángel Gabriel,*
principios de 1606, madera
pintada, 110 cm, Valladolid,
museo Diocesano

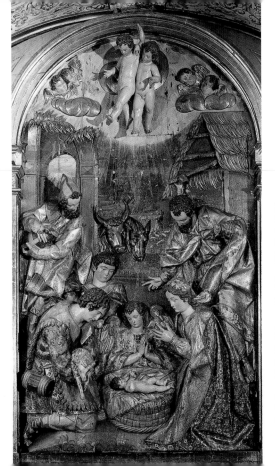

LEFT AND OPPOSITE:
Gregorio Fernández, retable
with the *Adoration of the
Shepherds*, 1614–1616,
painted wood, central panel
187 x 102 cm (left), detail:
the Christ child (opposite),
Valladolid, Monasterio de las
Huelgas

A LA IZQUIERDA Y ENFRENTE:
Gregorio Fernández, retablo
con la *Adoración de los
pastores*, 1614–16, madera
pintada, retablo central
187 x 102 cm (a la izquierda),
detalle: el Niño Jesús
(enfrente), Valladolid,
monasterio de las Huelgas

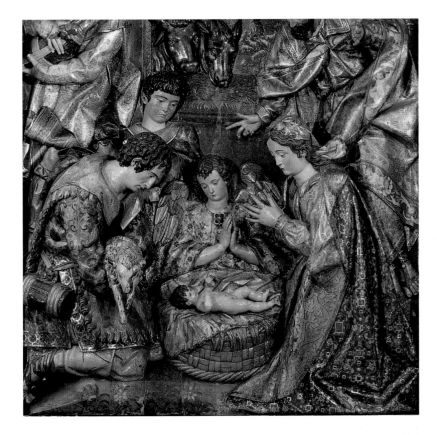

527

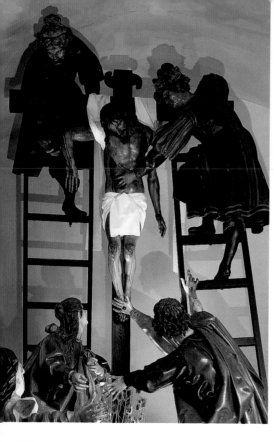

Gregorio Fernández
LEFT: *Paso* (procession group) depicting the Descent from the Cross, 1623–1625, painted wood, over life-size

OPPOSITE: *Christ at the Scourging Post*, ca. 1619, painted wood, 177 cm

Valladolid, Vera Cruz

FOLLOWING TWO PAGES: Plasencia, cathedral, retable and detail, 1632, wood, sculptures painted, width 161 cm

Gregorio Fernández
A LA IZQUIERDA: *Paso* (grupo de procesión) con el *Descendimiento de la cruz*, 1623–25, madera pintada, de tamaño superior al natural

ENFRENTE: *Cristo durante la flagelación*, hacia 1619, madera pintada, 177 cm

Valladolid, Vera Cruz

PÁGINA DOBLE SIGUIENTE: Plasencia, catedral, retablo y detalle, 1632, madera, esculturas pintadas 16,1 m

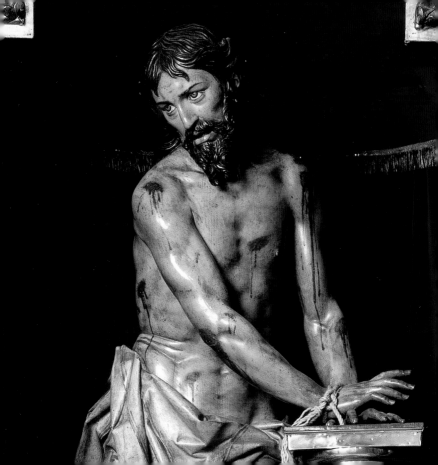

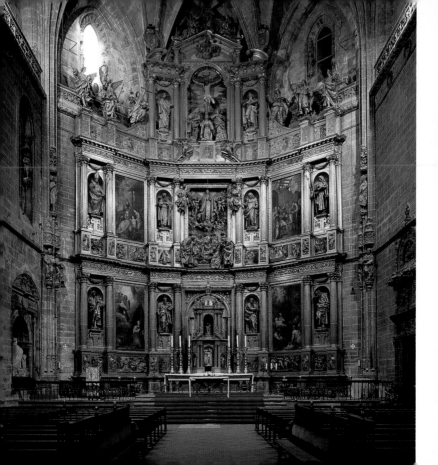

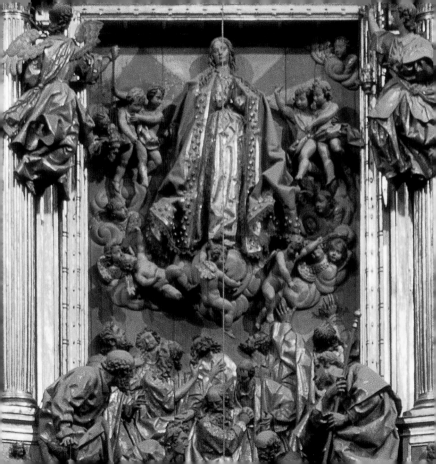

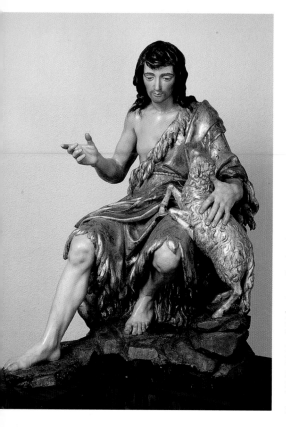

LEFT: **Alonso Cano,** *John the Baptist,* 1634, painted wood, 119 cm, Valladolid, Museo Nacional de Escultura

OPPOSITE: **Sebastián Ducete and Esteban de Rueda,** *St. Anna,* first half of the 17th c., painted wood, 102 cm, Villavelliz (Valladolid), parish church

A LA IZQUIERDA: **Alonso Cano,** *Juan Bautista,* 1634, madera pintada, 119 cm, Valladolid, museo Nacional de Escultura

ENFRENTE: **Sebastián Ducete y Esteban de Rueda,** *Santa Ana,* primera mitad del siglo XVII, madera pintada, 102 cm, Villavelliz (Valladolid), iglesia parroquial

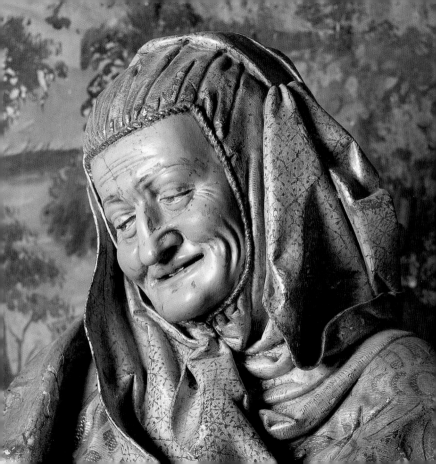

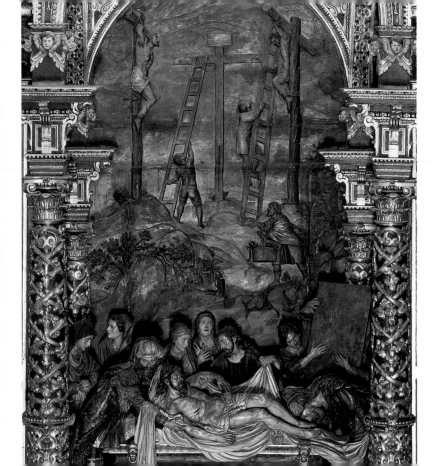

OPPOSITE: **Pedro Roldán**, *Entombment of Christ*, 1670–1672, painted wood, over life-size, Seville, Hospital de la Caridad

RIGHT: **Francisco Ruiz Gijón**, *Dying Christ (El Cachorro)*, 1682, painted wood, 184 cm, Seville, Iglesia del Patrocinio

ENFRENTE: **Pedro Roldán**, *Entierro de Cristo*, 1670–72, madera pintada, de tamaño superior al natural, Sevilla, hospital de la Caridad

A LA DERECHA: **Francisco Ruiz Gijón**, *Cristo agonizante (El cachorro)*, 1682, madera pintada, 184 cm, Sevilla, iglesia del Patrocinio

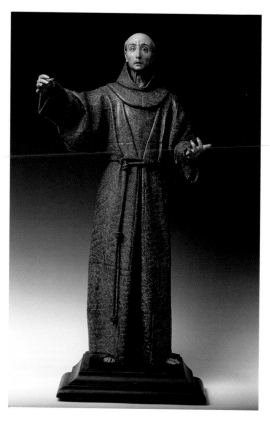

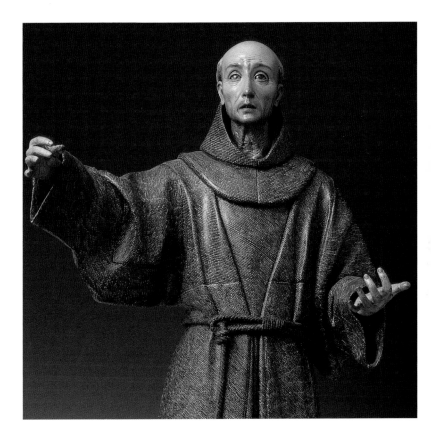

The Churriguera Family of Artists

Among the artists of the Spanish baroque, the members of the extensive Churriguera family achieved particular distinction. The brothers José Benito (1665–1725), Joaquín (1674–1724) and Alberto (1676–1750), who were descended from a family of sculptors in Barcelona, were architects by training, but specialized in the execution of finely carved altar retables with extraordinarily ornate decoration. Especially in the realm of ephemeral decorative art, such as the embellishment of triumphal arches for festivals or catafalques for burials, but also in connection with sovereigns' representations of power, a style emerged that was named after the most significant representative of the family, José Benito. This style entered the annals of art history as Churriguerism or Churriguera style. While the overwrought decoration such as that on the catafalque for Queen Maria Luisa of Bourbon tended toward the grotesque, with the exception of Madrid, altars and tabernacles in the Churriguera style were found in churches throughout Spain.

OPPOSITE: **José Benito de Churriguera**, Salamanca, S. Esteban, altar retable, 1692–1694

La familia de maestros Churriguera

Entre los maestros del barroco español destacan sobre todo los miembros de la familia de maestros ampliamente ramificada Churriguera. Los hermanos José Benito (1665–1725), Joaquín (1674–1724) y Alberto (1676–1750), que procedían de una familia de escultores en Barcelona, eran arquitectos, pero, sin embargo, se habían especializado en la creación de retablos de altar suntuosamente tallados y recargados en la decoración. Especialmente en el ámbito del efímero arte decorativo, evidente en los adornos festivos de arcos de triunfo o catafalcos fúnebres, pero también a propósito de la representación del poder soberano, se había desarrollado un estilo que ha pasado a la historia como churriguerismo o estilo churriguera, llamado así en honor del representante más importante de esta familia, José Benito. Mientras que la decoración sobrecargada desembocó en lo grotesco, como en el catafalco para la reina María Luisa de Borbón, los altares y tabernáculos se difundieron en toda España, con excepción de las iglesias madrileñas.

ENFRENTE: **José Benito de Churriguera**, Salamanca, San Esteban, retablo del altar 1692–94

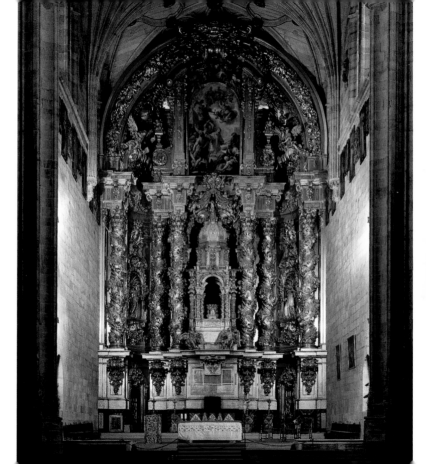

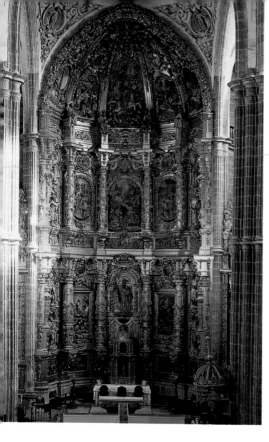

LEFT AND OPPOSITE:
Tomás de Sierra, Medina de Rioseco, Iglesia de Santiago, retable (left), details (opposite), 1704, painted wood, width 12 m

A LA IZQUIERDA Y ENFRENTE:
Tomás de Sierra, Medina de Rioseco, iglesia de Santiago, retablo (a la izquierda), detalles (enfrente), 1704, madera pintada, 12 m de ancho

541

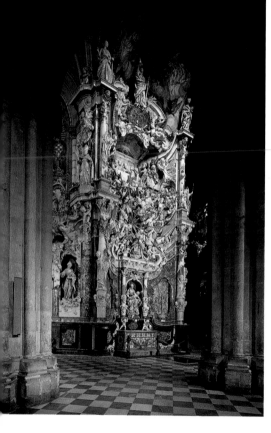

LEFT AND OPPOSITE:
Narciso Tomé, *El Transparente* (left), detail (opposite), 1721–1732, marble and bronze, Toledo, cathedral

A LA IZQUIERDA Y ENFRENTE:
Narciso Tomé, *El transparente* (a la izquierda), detalle (enfrente), 1721-32, mármol y bronce, Toledo, catedral

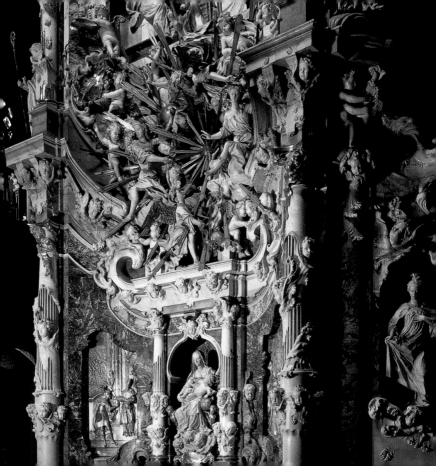

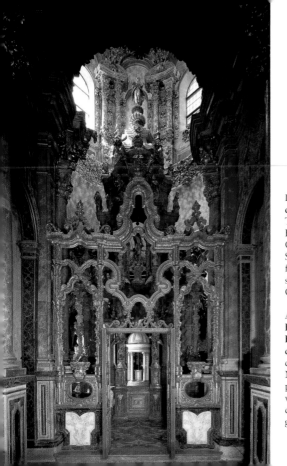

LEFT AND OPPOSITE: **Francisco de Hurtado Izquierdo and Theodosio Sánches de Rueda**, El Paular, Sagrario of the Carthusian monastery Nuestra Señora del Paular, begun 1718, floor plan, interior views, and sculptures by Pedro Duque Cornejo, full view and details

A LA IZQUIERDA Y ENFRENTE: **Francisco de Hurtado Izquierdo y Theodosio Sánches de Rueda**, El Paular, sagrario del convento cartujo de Nuestra Señora del Paular, principios de 1718, planta, vistas del interior y esculturas de Pedro Duque Cornejo, vista general y detalles

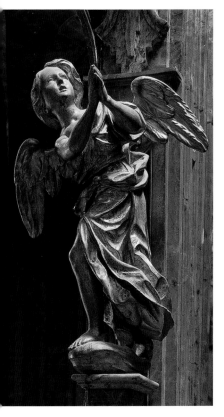
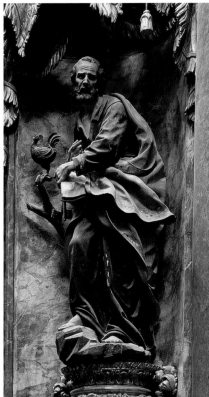

545

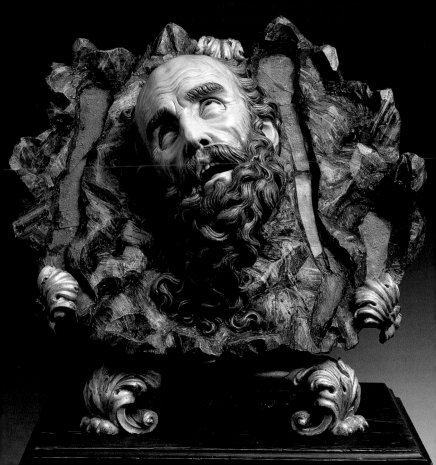

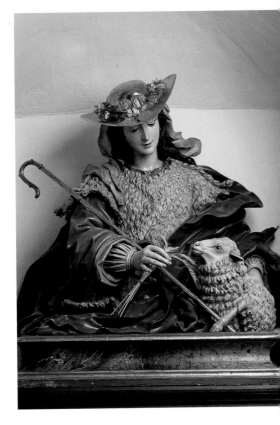

OPPOSITE: **Juan Alonso Villabrille**, *The Head of St. Paul*, 1707, painted wood, 55 x 61.5 cm (height x width), Valladolid, Museo Nacional de Escultura

RIGHT: **Luis Salvador Carmona**, *La Divina Pastora*, mid-18th c., painted wood and silver, 90 cm, Nava del Rey (Valladolid), Convento de Madres Capuchinas

ENFRENTE: **Juan Alonso Villabrille**, *Cabeza de San Pablo*, 1707, madera pintada, 55 x 61,5 cm (alto x ancho), Valladolid, museo Nacional de Escultura

A LA DERECHA: **Luis Salvador Carmona**, *La divina pastora*, mediados del siglo XVIII, madera pintada, 90 cm, Nava del Rey (Valladolid), convento de madres capuchinas

PAVILLON SULLY

548

France

Baroque sculpture in France presents a far less unified picture than in Italy. The influences at work there stemmed from various European sculptors or schools of sculpture, which range from Roman baroque all the way to Flemish/Dutch sculpture. While there were general tendencies in both naturalistic and classicising directions, fundamental monumentalizing themes that had developed during the transition to French early baroque nonetheless remained decisive. Under the influence of Bernini and Duquesnoy, as well as his studies of antiquity, Jacques Sarrazin (1592–1660) developed the French classicizing style and can be seen as its early proponent. In contrast, the work of the sculptor Pierre Puget (1620–1694) tends to be steeped in baroque pathos and dramatic effects. François Girardon (1628–1715), who was devoted to the Parisian Académie's understanding of form, glorified the Sun King with the famous Apollo Fountain.

Francia

La escultura barroca se manifiesta en Francia mucho menos uniformemente que que en Italia. En este país influyen diversos escultores europeos o escuelas de escultura que van desde el barroco romano hasta la escultura flamenco-holandesa. La tendencia general se basa tanto en corrientes naturalistas como clásico-antiguas; sin embargo, los rasgos monumentales, que se habían originado durante la transición al barroco temprano francés, siguen siendo determinantes. Bajo la influencia de Bernini y Duquesnoy y por su estudio de la antigüedad, Jacques Sarrazin (1592–1660) desarrolla el clasicismo francés y se convierte en su primer exponente. Por otra parte, la obra del escultor Pierre Puget (1620–94) se caracteriza más que nada por el patetismo barroco y los efectos dramáticos. François Girardon (1628–1715), influido profundamente por el concepto de formas de la Academia Francesa, enaltece al Rey Sol con el famoso baño de Apolo.

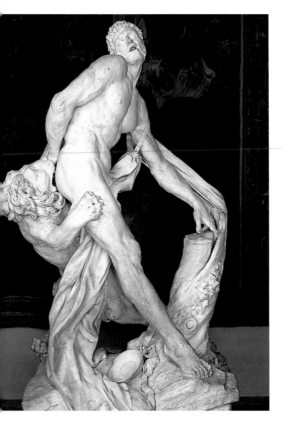

LEFT: **Pierre Puget**, *Milo of Crotona*, 1672–1682, marble, 270 cm, Paris, Musée du Louvre

OPPOSITE: **François Girardon**, tomb of Cardinal Richelieu, 1675–1694, marble, Paris, Chapelle de la Sorbonne

FOLLOWING TWO PAGES: **Louis Le Vau and Jules Hardouin-Mansart**, Versailles, palace, garden facade, 1668–1678

A LA IZQUIERDA: **Pierre Puget**, *Milon de Croton*, 1672–82, mármol, 270 cm, París, Museo del Louvre

ENFRENTE: **François Girardon**, sepultura del cardenal Richelieu, 1675–94, mármol, capilla de la Sorbonne

PÁGINA DOBLE SIGUIENTE: **Louis Le Vau y Jules Hardouin-Mansart**, Versailles, palacio, fachada al jardín, 1668–78

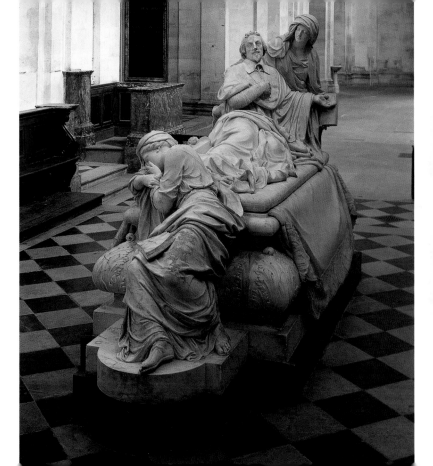

Versailles, park
LEFT: Parterre with vase

P. 556: **Jean-Baptiste Tuby,**
detail of the Apollo Fountain:
Apollo with his team, 1668–
1670, lead, formerly gilt

P. 557: Apollo Fountain with
view of the Grand Canal

The role played by the court of
Versailles between 1600 and 1715
(when Louis XIV died) as spon-
sor of the arts is unparalleled in
France, and indeed, throughout
European societies of the time.

Versalles, parque del palacio
A LA IZQUIERDA: Parterre con
jarrón

P. 556: **Jean-Baptiste Tuby,**
detalle de la fuente de Apolo:
Apolo con su cuadrilla, 1668–
70, plomo, antiguamente dorado

P. 557: Fuente de Apolo con
vista al gran canal

El papel que la corte de Ver-
salles tuvo entre 1660 y 1715
(muerte de Luis XIV) en fun-
ción de patrocinador de los
artistas es incomparable tanto
en Francia como en el resto de
Europa de la época.

555

557

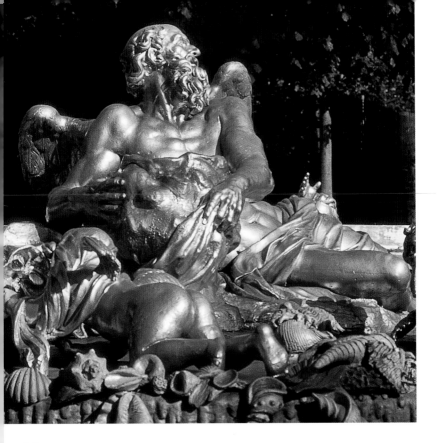

561

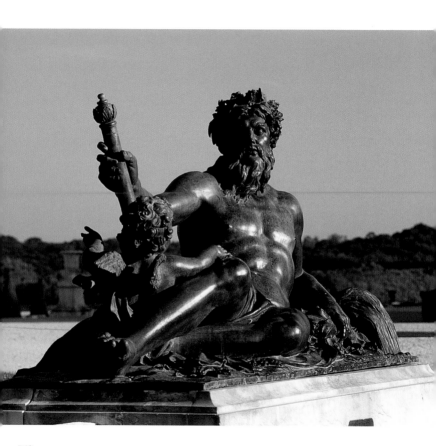

Versailles, park
OPPOSITE: **Jean-Baptiste Tuby**,
The River God Rhône, ca. 1685

RIGHT: **Lerambert(?)**, small
fountain on the *Allée d'Eau*

P. 564/565: **François Girardon**,
Apollo Tended by the Nymphs,
detail: washing of the feet, 1666–
1675, marble and grotto stone,
life-size

Versalles, parque del palacio
ENFRENTE: **Jean-Baptiste Tuby**,
Dios del río Ródano, hacia 1685

A LA DERECHA: **Lerambert(?)**,
pequeña fuente de la *Allée d'eau*

P. 564/65: **François Girardon**,
Apolo y las ninfas (baño de
Apolo), detalle: lavado de pies,
1666–75, mármol y roca de gruta,
de tamaño natural

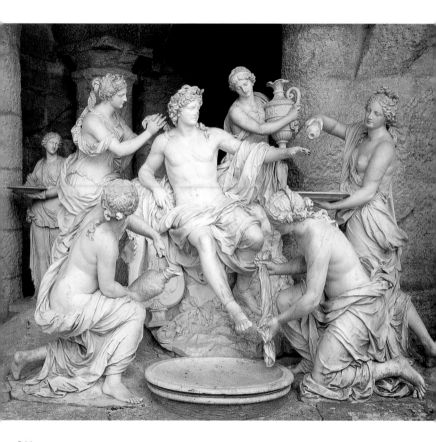

564

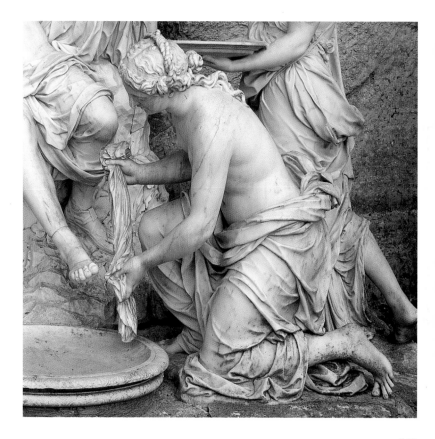

565

Versailles, park
LEFT: **Laviron**, *Ganymede*, 1682, marble

OPPOSITE: **Balthazar and Gaspard Marsy**, *Sun Horses*, 1668–1675, marble

P. 568: Path with vases and figures

P. 569: **Étienne Le Hongre**, *Air*, 1685 (left), **La Perdrix**, *Melancholy*, 1680 (center), marble

Versalles, parque del palacio
A LA IZQUIERDA: **Laviron**, *Ganímedes*, 1682, mármol

ENFRENTE: **Balthazar y Gaspard Marsy**, *Corceles de sol*, 1668–75, mármol

P. 568: Camino con jarrones y figuras

P. 569: **Étienne Le Hongre**, *El aire*, 1685 (a la izquierda), **La Perdrix**, *El melancólico*, 1680 (centro), mármol

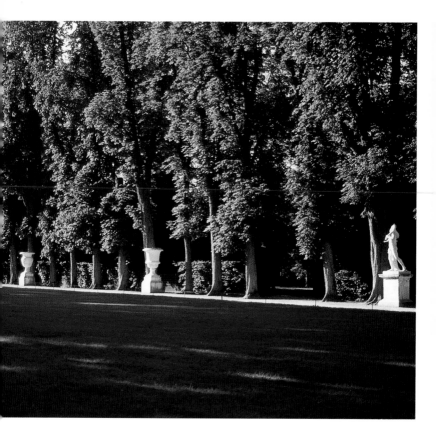

OPPOSITE: **Antoine Coysevox**, tomb of
Cardinal Mazarin, 1689–1693, marble and
bronze, 160 cm (cardinal), Paris, Institut de
France

BELOW: **Jean-Baptiste Tuby**, allegory of
Prudentia from the tomb of Cardinal
Mazarin, 1693, bronze, 140 cm

ENFRENTE: **Antoine Coysevox**, sepultura para
el cardenal Mazarino, 1689–93, mármol y
bronce, 160 cm (cardenal), París, Instituto de
Francia

ABAJO: **Jean-Baptiste Tuby**, alegoría de la
prudencia de la sepultura del cardenal
Mazarino, 1693, bronce, 140 cm

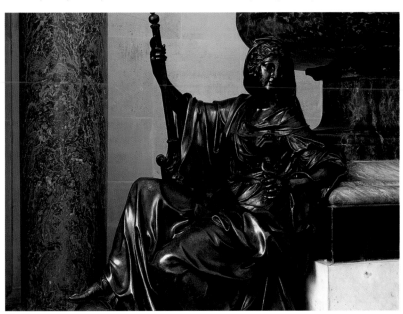

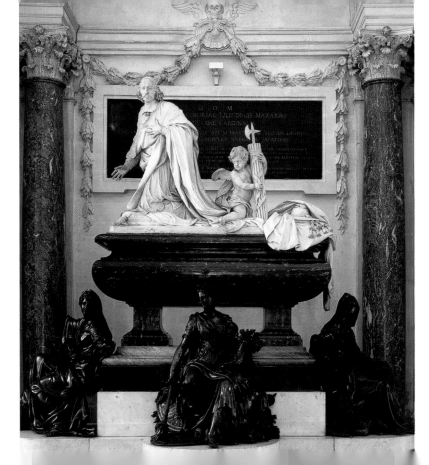

France in the Eighteenth Century

In French sculpture of the eighteenth century, a more austere early classicizing style emerged from the previously rather playful approach of rococo. The pair of *Horse Tamer* statues by Guillaume Coustou the Elder (1677–1746), for example, display the apparently effortless way that rococo handled the forces of nature, which have already been subdued. The mane and tail of the horses, which rear up as if in a riding school pose, remain purely ornamental. His student, Edmé Bouchardon (1698–1762), combined a classical columned facade with elements of the late French rococo in his major work, the Grenelle Fountain. The work of the Parisian sculptor Jean Baptiste Pigalle (1714–1785) moved between the contrasting poles of a radical naturalism of anatomic details and polished, classically-oriented forms, thus marking the transition from rococo to classicism.

Francia en el siglo XVIII

En la escultura francesa del siglo XVIII se desarrolla estilo clasicista temprano austero a partir del enfoque más bien desenvuelto del rococó anterior. Guillaume Coustou el Viejo (1677–1746), por ejemplo, muestra con su *Domador de caballos* la relación aparentemente carente de esfuerzo del rococó con las fuerzas domadas de la naturaleza. De ahí que las crines y la cola del caballo encabritado en postura de escuela de equitación sean solamente un adorno. Su alumno Edmé Bouchardon (1698–1762) combina en su obra principal, la Fontaine de Grenelle, una fachada de columnas clasicista con elementos del rococó francés tardío. La obra del escultor parisino, Jean Baptiste Pigalle (1714–85), se mueve en oposición a un naturalismo radical de detalles anatómicos y formas alisadas con orientación clasicista, marcando así al mismo tiempo la transición del rococó al clasicismo.

OPPOSITE: **Emmanuel Héré de Corny**, Nancy, Place Royal (today Place Stanislas), fountain and wrought iron fence by Jean Lamour

ENFRENTE: **Emmanuel Héré de Corny**, Nancy, Place Royal (hoy Place Stanislas), fuente y reja de hierro forjado de Jean Lamour

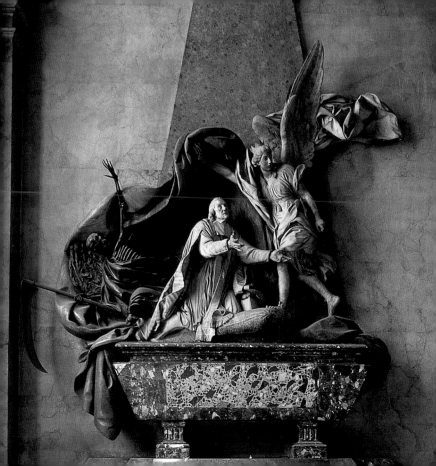

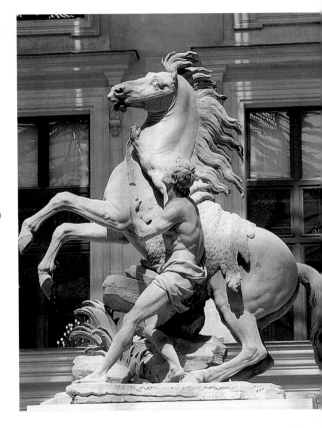

OPPOSITE: **René Michel (Michel-Ange) Slodtz**, tomb of Languet de Gergy, 1753, marble, Paris, St Sulpice, Chapelle St-Jean Baptiste

RIGHT: **Guillaume Coustou**, *Horse Tamers* (also called *Horses of Marly*), 1745, marble, ca. 350 cm, Paris, Champs Élysées

ENFRENTE: **René Michel (Michel-Ange) Slodtz**, sepultura de Languet de Gergy, 1753, mármol, París, Église St-Sulpice, Chapelle St-Jean Baptiste

A LA DERECHA: **Guillaume Coustou**, *Domador de caballos*, 1745, mármol, aprox. 350 cm, París, campos Elíseos

575

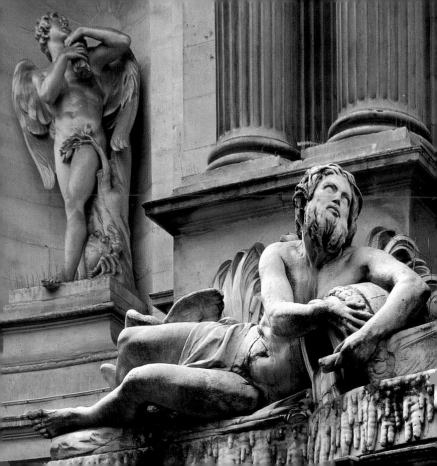

OPPOSITE AND BELOW: **Edmé Bouchardon,**
Fountain of the Four Seasons, also called the
Grenelle Fountain, 1739–1745; the city of
Paris between personifications of the Seine
and Marne Rivers, marble, ca. 210 cm
(statue), Paris, Rue de Grenelle

ENFRENTE Y ABAJO: **Edmé Bouchardon,**
fuente de las cuatro estaciones, 1739–
45; la ciudad de París entre las
personificaciones del Sena y del Marne,
mármol, aprox. 210 cm (estatua),
París, Rue de Grenelle

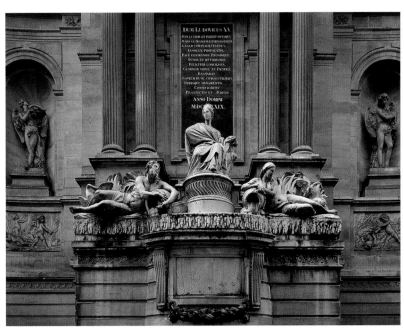

Jean Baptiste II Lemoyne,
Comte de la Tour d'Auvergne,
1765, marble bust, 71 cm,
Frankfurt a. M., Liebieghaus

Jean Baptiste II Lemoyne,
Comte de la Tour d'Auvergne,
1765, busto de mármol, 71
cm, Francfort del Main, casa
Liebieghaus

Jean Antoine Houdon,
Mademoiselle Servat, 1777,
marble bust, 76.5 cm,
Frankfurt a. M., Liebieghaus

Jean Antoine Houdon,
Mademoiselle Servat, 1777,
busto de mármol, 76,5 cm,
Francfort del Main, casa
Liebieghaus

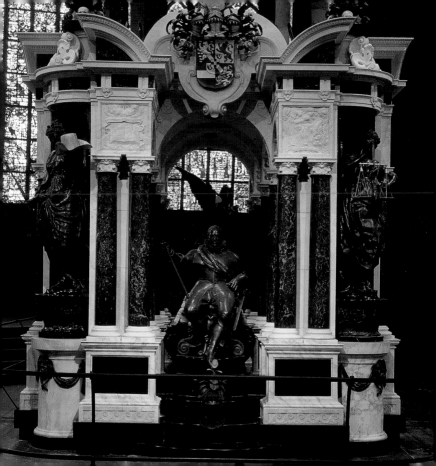

The Netherlands and Belgium

The only sculptor from the Protestant northern part of the Netherlands to achieve international recognition is Hendrik de Keyser (1565–1621). Primarily responsible for his status is his masterpiece, the tomb of William I of Orange-Nassau. On the other hand, the workshop in Antwerp headed by Artus Quellinus the Elder (1609–1668), one of the masters of seventeenth-century Dutch sculpture, was an exceptional sculpting school. In his work, Quellinus translated the artistic approach of the painter Peter Paul Rubens into sculpture. The work of Lucas Fayd'herbe (1617–1697) from Mecheln also shows the influence of Rubens, with whom he worked for three years. The sensitive and naturalistic approach of Rombout Verhulst (1624–1698), also from Mechelen, earned him ranking among the best sculptors of the Netherlands. Hendrik Frans Verbruggen (1654–1724) created one of the most unusual works of sculpture in the south of the Netherlands, the chancel in St-Michel-et-Gudule in Brussels.

OPPOSITE: **Hendrik de Keyser,** tomb of William I, 1614–1622, marble and bronze, 7.65 m, Delft, Nieuwe Kerk

Países Bajos y Bélgica

El único escultor del norte protestante de los Países Bajos que destaca en el ámbito internacional es Hendrik de Keyser (1565–1621); ante todo es digna de mención su obra principal, la sepultura de Guillermo I de Orange. Por el contrario, el taller Quellinus en Amberes era una escuela extraordinaria de escultores, con Artus Quellinus el Viejo (1609–68) como maestro principal de la escultura de los Países Bajos del siglo XVII. En su obra se transmite la interpretación artística del pintor P. P. Rubens en la escultura. Lucas Fayd'herbe (1617–97) de Mecheln muestra asimismo la influencia de Rubens, con quien trabajó tres años. Debido a su concepción sensible y naturalista, Rombout Verhulst (1624–98) de Mecheln es considerado uno de los escultores de mayor calidad de los Países Bajos. Hendrik Frans Verbruggen (1654–1724) creó una de las obras más extraordinarias de la escultura del sur de los Países Bajos, el púlpito en St-Michel-et-Gudule en Bruselas.

ENFRENTE: **Hendrik de Keyser,** sepultura para Guillermo I, 1614–22, mármol y bronce, 7,65 m, Delft, Nieuwe Kerk

LEFT AND OPPOSITE:
Lucas Fayd'herbe, tomb of
Archbishop André Cruesen,
before 1666, marble, Mecheln,
cathedral

A LA IZQUIERDA Y ENFRENTE:
Lucas Fayd'herbe, sepultura
para el arzobispo André
Cruesen, antes de 1666,
mármol, Mecheln, catedral

583

RIGHT: **Rombout Verhulst**, tomb of Johan Polyander van Kerchoven, 1663, marble, Leiden, Pieterskerk

FOLLOWING TWO PAGES: **Hendrik Frans Verbrugghen**, chancel and detail (Death and the Expulsion from Paradise), 1695–1699, oak and gold leaf, 7 x 3.5 x 2 m (height x width x depth), Brussels, St-Michel-et-Gudule

A LA DERECHA: **Rombout Verhulst**, sepultura para Johan Polyander van Kerchoven, 1663, mármol, Leiden, Pieterskerk

PÁGINA DOBLE SIGUIENTE: **Hendrik Frans Verbrugghen**, púlpito y detalle del púlpito (Eva y la muerte antes de la expulsión del paraíso), 1695–99, madera de roble y dorado, 7 x 3,5 x 2 m (alto x ancho x profundidad), Bruselas, St-Michel-et-Gudule

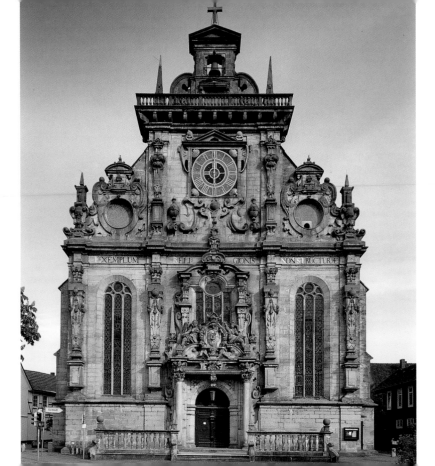

Germany

Among the major works of German Baroque art is the magnificent Zwinger in Dresden, with its rich sculptural decoration. While the architect Matthäus Daniel Pöppelmann (1662–1736) erected the various building structures, the sculptor Balthasar Permoser (1651–1732), director of the sculpture workshops at the Zwinger, was responsible for the figural ornamentation. In addition to the figures on the Crown Gate—Ceres and Vulcan—as well as the Venus of Wiederau, the central supporting pillars on the Wall Pavilion are among Permoser's most famous sculptures. One of the most important tasks of secular baroque art was the resplendent decoration of palaces and noble residences. Decorative elements for the stately stairways, in particular, required numerous plasterers, most of whom came from Italy, who worked alongside the sculptors. The stucco artists G. D. Castelli and C. P. Morsegni are known to have been active in Brühl, while D. Schenk worked in Pommersfelden. The stucco work in the Würzburg Residenz was executed by Antonio Bossi in 1744 and 1745.

OPPOSITE: **Bückeburg**, Evangelische Stadtkirche (Protestant city church), 1611–1615

Alemania

Entre las obras principales del arte barroco alemán figura el Zwinger de Dresde con su ornamento de esculturas. Fue un trabajo conjunto del arquitecto Matthäus Daniel Pöppelmann (1662–1736) y el escultor Balthasar Permoser (1651–1732); mientras el primero levantaba las varias edificaciones, el segundo era responsable, en calidad de director de los talleres de escultura del Zwinger de Dresde, del adorno escultural. Junto a las figuras de Ceres y Vulcano y de Venus de Wiederau en la Kronentor o puerta de la Corona destacan, entre las figuras más famosas de Permoser, las pilastras centrales con busto en el Wallpavillon o pabellón del Recinto. Una de las tareas más importantes del arte profano barroco es la decoración pomposa de los castillos y residencias. Ante todo, la ornamentación de las escaleras representativas exigió la presencia de numerosos estucadores, la mayoría procedentes de Italia, que trabajaron junto con los escultores. Así, son conocidos en Brühl los estucadores G. D. Castelli y C. P. Morsegni, mientras que D. Schenk trabajó en Pommersfelden. De los trabajos de estucado en la residencia de Würzburg se encargó Antonio Bossi en los años 1744–45.

ENFRENTE: **Bückeburg**, iglesia municipal evangélica, 1611–15

Matthäus Daniel Pöppelmann,
Dresden, Zwinger, 1697–1716

LEFT AND OPPOSITE:
Crown Gate (details)

P. 592: Supporting pillars of the
Wall Pavilion

P. 593: Wall Pavilion

Matthäus Daniel Pöppelmann,
Dresde, Zwinger, 1697–1716

A LA IZQUIERDA Y ENFRENTE:
Puerta de la Corona (detalles)

P. 592: Pilastras con busto del
Wallpavillon o pabellón del
Recinto

P. 593: Wallpavillon o Pabellón
del Recinto

591

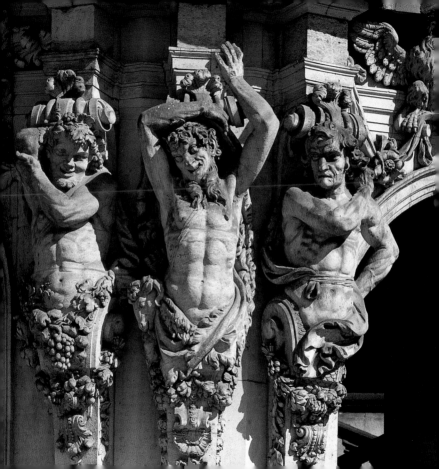

Balthasar Neumann, Brühl,
Schloss Augustusburg, staircase,
1741–1744

Balthasar Neumann, Brühl,
palacio Augustusburg, escalera,
1741–44

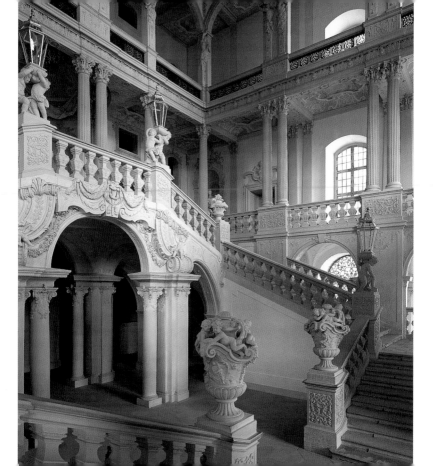

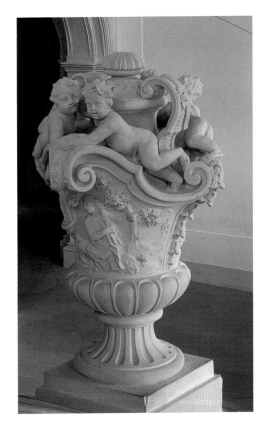

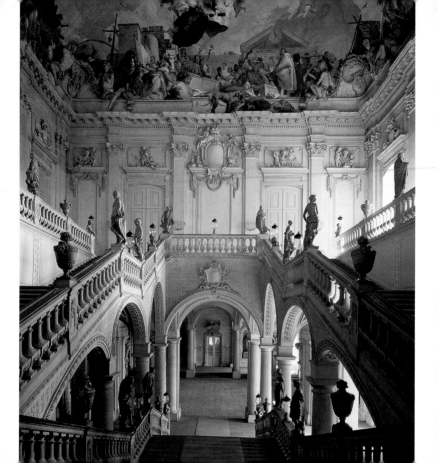

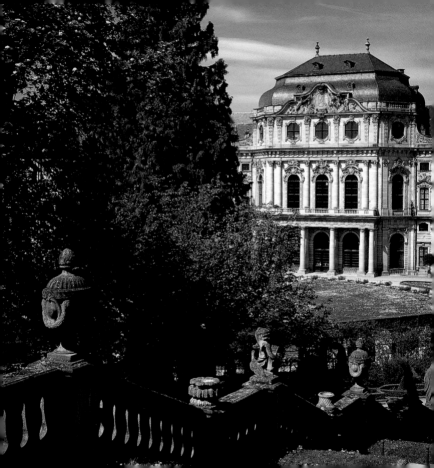

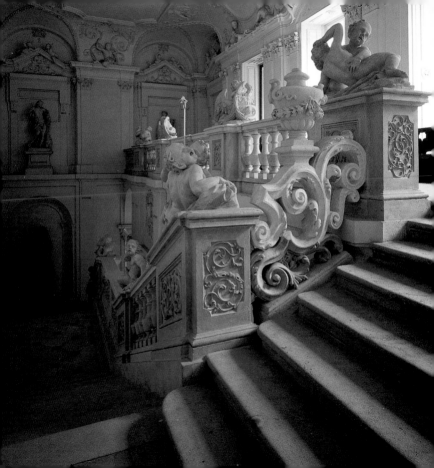

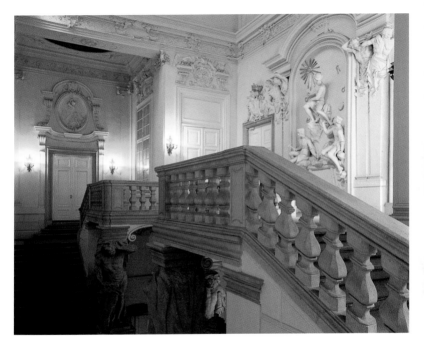

ABOVE: **Johann Bernhard Fischer von Erlach**, Vienna, City Palace of Prince Eugene, 1695, staircase

OPPOSITE: **Gabriel de Gabrieli**, Vienna, Liechtenstein Palace, 1691–1705, staircase

ARRIBA: **Johann Bernhard Fischer von Erlach**, Viena, palacio municipal del príncipe Eugenio, 1695, escalera

ENFRENTE: **Gabriel de Gabrieli**, Viena, palacio Liechtenstein 1691–1705, escalera

601

Augsburg, Munich

The demand for art that arose from the Counter-Reformation led to the development of artistic centers in southern Germany at the end of the sixteenth century and during the seventeenth century; they, in turn, had a strong impact on large-scale sculpture. A new relationship between architecture and sculpture developed—often with the participation of Dutch artists, who had previously trained in Italy. Hubert Gerhard (ca. 1550–1622/23), for example, a native of Amsterdam, had worked with Giambologna before Hans Fugger commissioned him for the creation of the Augustus Fountain in Augsburg. Gerhard influenced Hans Krumper (1570–1634) of Weilheim, who as an architect and a sculptor was responsible for the renovation of the Munich Residenz including allegories of the cardinal virtues and the famous *Patrona Bavariae*. Another excellent Dutch artist was Adriaen de Vries (ca. 1545–1626), who transformed the formal language of Mannerism into the Hercules and Mercury fountains in Augsburg.

Hans Krumper, *Patrona Bavariae*, 1615, bronze, ca. 3 m, Munich, Residenz facade

OPPOSITE: Duke Albert V of Bavaria, tomb of Emperor Ludwig of Bavaria, 1619–1622, bronze, over life-size, Munich, Frauenkirche

Augsburgo, Múnich

Con el anhelo de anhelos de nuevas imágenes que trajo consigo Contrarreforma a finales de los siglos XVI y XVII se crearon en el sur de Alemania centros artísticos de los que surgieron fuertes impulsos para la creación de grandes obras plásticas, complementándose la arquitectura y la escultura de una forma nueva — a menudo con la participación de maestros holandeses que se habían formado con anterioridad en Italia. Así, por ejemplo, Hubert Gerhard de Ámsterdam (hacia 1550–1622/23) había trabajado con Giambologna antes de que fuera encargado por Hans Fugger de la construcción de la fuente de Augusto en Augsburgo. Hans Krumper (1570–1634), de Weilheim, bajo la influencia de Gerhard, trabajó como arquitecto y escultor en la reconstrucción de la residencia de Múnich con las alegorías de las virtudes cardinales y la famosa *Patrona Bavariae*. Digno de mención es asimismo el holandés Adriaen de Vries (hacia 1545–1626), quien hizo realidad el mundo del manierismo en las fuentes de Hércules y Mercurio en Augsburgo.

ENFRENTE: **Hans Krumper**, *Patrona Bavariae*, 1615, bronce, aprox. 3 m, Múnich, fachada de la residencia

Duque Alberto V de Baviera, tumba de Luis de Baviera, 1619–22, bronce, de tamaño superior al natural, Múnich, Frauenkirche

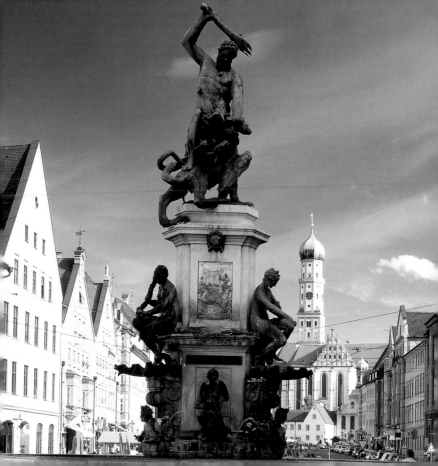

ABOVE: **Hubert Gerhard,**
Augustus Fountain, 1589–1594,
detail, figures in bronze, Augsburg

OPPOSITE: **Adriaen de Vries,**
Hercules Fountain, 1596–1602,
figures in bronze, Augsburg

ARRIBA: **Hubert Gerhard,** fuente
de Augusto, 1589–94, detalle,
figuras de bronce, Augsburgo

ENFRENTE: **Adriaen de Vries,**
fuente de Hércules, 1596–1602,
figuras de bronce, Augsburgo

LEFT: **Hubert Gerhard**, *Archangel Michael*, 1588, bronze, over life-size, Munich, facade of the Michaelskirche

OPPOSITE: **Hans Reichle**, *Archangel Michael*, 1603–1606, bronze, over life-size, Augsburg, facade of the Zeughaus

A LA IZQUIERDA: **Hubert Gerhard**, *Arcángel Miguel*, 1588, bronce, de tamaño superior al natural, Múnich, fachada de la iglesia Michaelskirche

ENFRENTE: **Hans Reichle**, *Arcángel Miguel*, 1603–06, bronce, de tamaño superior al natural, Augsburgo, fachada de la casa Zeughaus

607

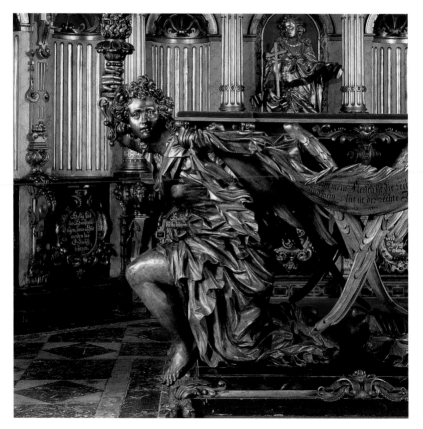

608

Altars and Crucifixion Groups

At the beginning of the seventeenth century, in the northern German town of Bückeburg the Wolff family of sculptors developed a German Mannerism, which stemmed from the Weser Renaissance, into an indigenous Protestant early baroque. Almost simultaneously, the sculptor Hans Degler (1564–1634) from Weilheim unveiled his monumental altarpieces in the light-flooded church spaces of the collegiate church of SS. Ulrich and Afra in Augsburg. Their superstructures were later expanded upon in the form of the Lady Altar by Jörg Zürn (around 1583–1635) in St. Nikolaus in Überlingen. With expansive gestures, the bronze figures in the crucifixion group by Hans Reichle (ca. 1570–1624) dominate the open crossing of SS. Ulrich and Afra. This group, the most important predating the Thirty Years' War, contrasts markedly with that of Justus Glesker (between 1610 and 1623–1678), who created the first noteworthy large-scale sculptural work after the war in 1648, for Bamberg Cathedral. In Mary's grieving posture, especially, there are strong classical qualities of stance and motion.

Altares y crucifixiones

A principios del siglo XVII, la familia de escultores Wolff en Bückeburg en el norte de Alemania convierte el manierismo alemán procedente del estilo renacentista del Weser en un barroco temprano protestante. Casi al mismo tiempo, el escultor de Weilheim, Hans Degler (1564–1634), desarrolla sus altares monumentales en el recinto colmado de luz de la colegiata de San Ulrich y Afra en Augsburgo, cuyas estructuras se pueden encontrar aún más elaboradas en el diseño del altar de María de Jörg Zürn (hacia 1583–1635) en San Nicolás en Überlingen. Con dramáticas posturas dominan las figuras de bronce de la crucifixión de Hans Reichle (hacia 1570–1624) la intersección abierta de la nave en la colegiata de San Ulrich y Afra. Este conjunto, el más importante antes de la guerra de los 30 años, es comparable al de Justus Glesker (entre 1610 y 1623–78), quien realiza en 1648 el primer trabajo digno de mención en escultura monumental después de la guerra para la catedral de Bamberg. Sobre todo en la postura de María afligida se pueden encontrar profundas reminiscencias de antiguos motivos de ponderación y compensación.

OPPOSITE AND FOLLOWING TWO PAGES:
Eckbert Wolff the Younger, altar table; detail: angel holding a torch, 1601–1604, gilt wood, Bückeburg, palace chapel

ENFRENTE Y EN LA PÁGINA DOBLE SIGUIENTE:
Eckbert Wolff el Joven, mesa de altar; detalle: ángel sujetando una antorcha, 1601–04 madera, dorada, Bückeburg, capilla del palacio

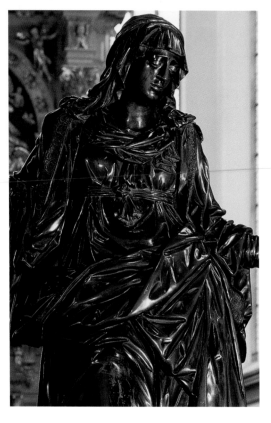

Hans Reichle, crucifixion group, 1605

LEFT: Mary Full of Sorrow (detail), bronze, 190 cm

OPPOSITE: Choir with crucifixion group and altars by Hans Degler, 1604–1607

Augsburg, collegiate church of SS. Ulrich and Afra

Hans Reichle, crucifixión, 1605

A LA IZQUIERDA: María afligida (detalle), bronce, 190 cm

ENFRENTE: Coro con crucifixión y los altares de Hans Degler, 1604–07

Augsburgo, colegiata de San Ulrich y Afra

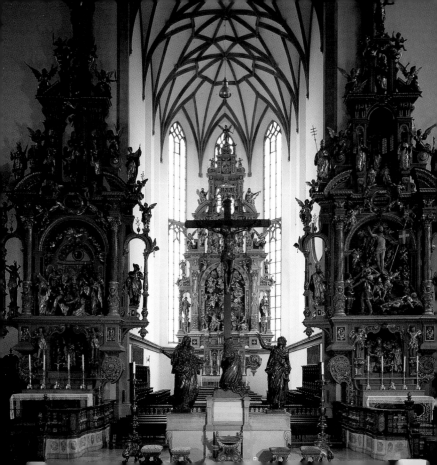

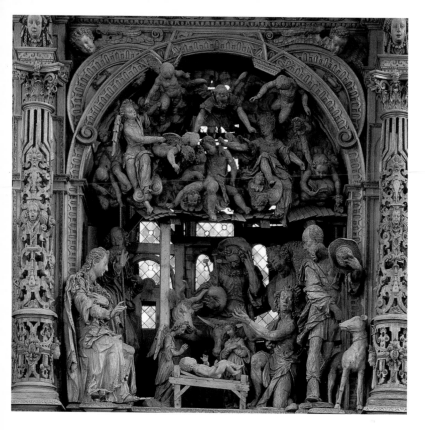

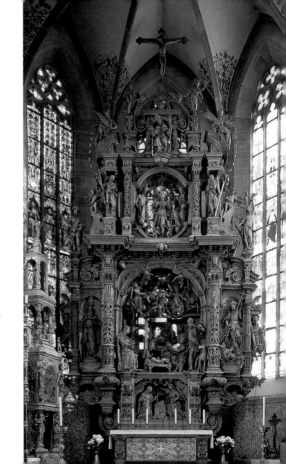

OPPOSITE AND RIGHT:
Jörg Zürn, Lady Altar, detail, 1613–1616, limewood, not painted, Überlingen, parish church

ENFRENTE Y A LA DERECHA:
Jörg Zürn, altar de María, detalle, 1613–16, madera de tilo, sin pintar, Überlingen, iglesia parroquial municipal

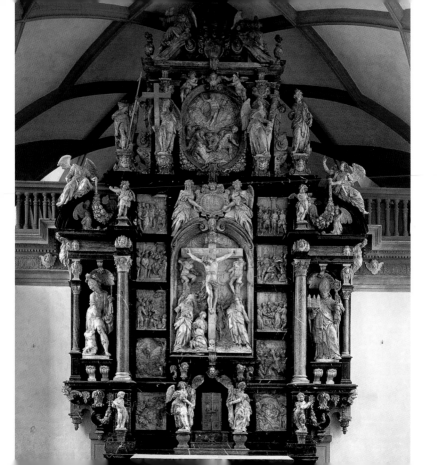

OPPOSITE: **Johannes Juncker**,
Passion Altar, 1609–1613, black
and red marble, alabaster,
Aschaffenburg, palace chapel

RIGHT: **Georg Petel**, *Ecce Homo*,
ca. 1630/31, painted limewood,
175 cm, Augsburg, cathedral choir

ENFRENTE: **Johannes Juncker**,
altar de la pasión, 1609–13,
mármol rojo y negro, alabastro,
Aschaffenburg, capilla del palacio

A LA DERECHA: **Georg Petel**,
Eccehomo, hacia 1630/31,
madera de tilo, pintado, 175 cm,
Augsburg, coro de la catedral

LEFT AND OPPOSITE:
Justus Glesker, crucifixion group,
1648–1649, detail: Mary Full of
Sorrow, wood, newly gilt, 220 cm
(Christ), Bamberg, cathedral

A LA IZQUIERDA Y ENFRENTE:
Justus Glesker, grupo de
crucifixión, 1648–49, detalle:
María afligida, madera, dorado
recientemente, 220 cm
(Jesucristo), Bamberg, catedral

Thomas Schwanthaler
Left: *Christ on the Scourging Post*, wood, painted and gilt

Opposite: Double altar, 1675–1676, wood, painted and gilt

St. Wolfgang am Abersee

Thomas Schwanthaler
A la izquierda: *Cristo en la columna de flagelación*, madera, pintado y dorado

Enfrente: Altar doble, 1675–76, madera, pintado y dorado

San Wolfgang junto al lago Abersee

Meinrad Guggenbichler

BOTTOM LEFT: *St. Sebastian*

BOTTOM RIGHT: *St. Rochus*

ca. 1682, painted wood, slightly
less than life-size, Mondsee
Museum

OPPOSITE: *Christ Crowned with
Thorns*, ca. 1682, painted wood,
slightly less than life-size,
Mondsee, former abbey church

Meinrad Guggenbichler

ABAJO A LA IZQUIERDA: *San Sebastián*

ABAJO A LA DERECHA: *San Roque*

hacia 1682, madera pintada, ligeramente
menor que el tamaño natural, museo del
Mondsee

ENFRENTE: *Cristo con la corona de
espinas*, hacia 1682, madera, pintado,
ligeramente menor que el tamaño natural,
lago Mondsee, antigua iglesia conventual

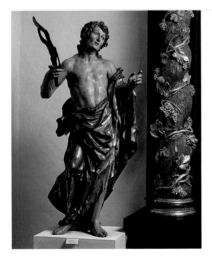
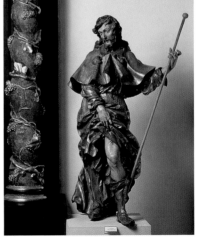

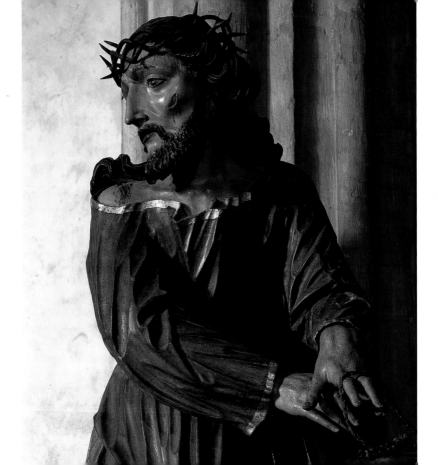

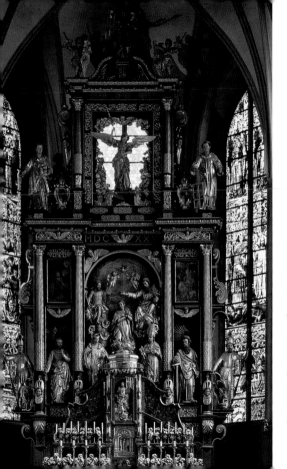

LEFT AND OPPOSITE:
Salzburg Master (Waldburg?),
Coronation of Mary altar,
1626, detail: Coronation of
Mary, wood, painted and gilt,
Mondsee, former monastic
church

A LA IZQUIERDA Y ENFRENTE:
**Maestro de Salzburg
(Waldburg?)**, altar de la
coronación de María, 1626,
detalle: coronación de María,
madera, pintada y dorada,
Mondsee, antigua iglesia
conventual

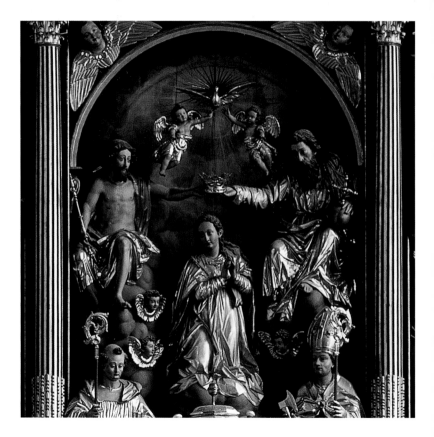

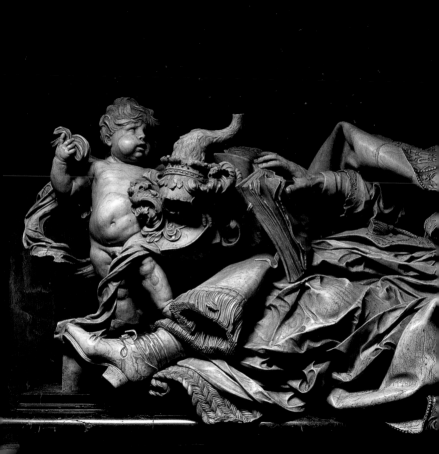

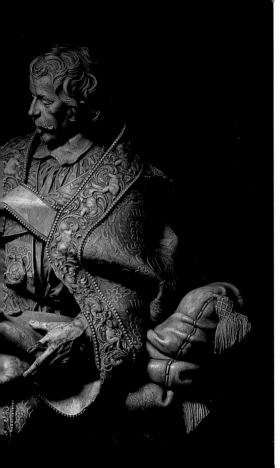

Matthias Rauchmiller, tomb of Karl von Metternich, ca. 1675, marble, slightly over life-size, Trier, Liebfrauenkirche

Matthias Rauchmiller, tumba de Karl von Metternich, hacia 1675, mármol, ligeramente mayor que el tamaño natural, Tréveris, Liebfrauenkirche

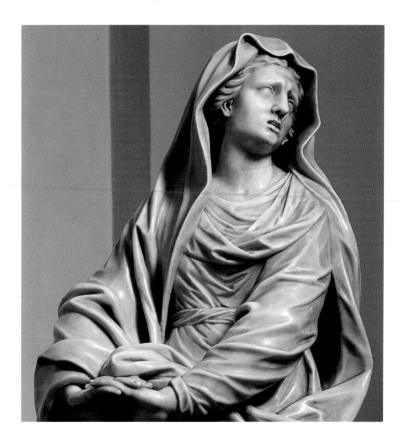

628

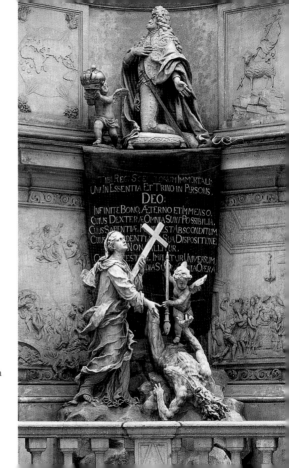

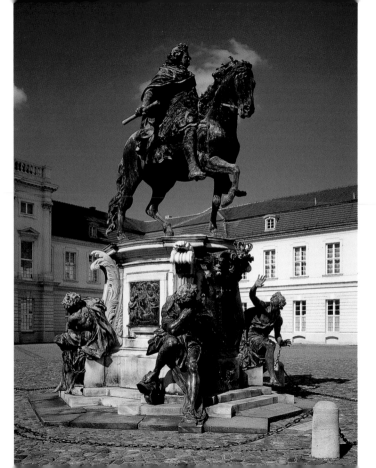

OPPOSITE AND BELOW: **Andreas Schlüter**, equestrian statue of the Great Elector Friedrich Wilhelm I of Brandenburg, 1689–1703, bronze, 290 cm, stone pedestal 270 cm, Berlin, Schloss Charlottenburg, Ehrenhof (main courtyard)

ENFRENTE Y ABAJO: **Andreas Schlüter**, estatua ecuestre del Gran Elector de Brandenburgo Friedrich Wilhelm I, 1689–1703, bronce, 290 cm, base de piedra 270 cm, Berlín, castillo Charlottenburg, patio de honor

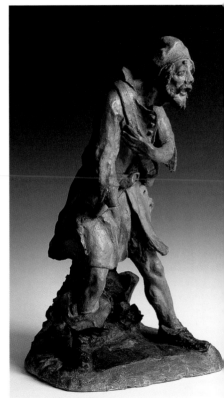

OPPOSITE: **Johann Christian Wenzinger**, figures from the Ölberg in Staufen, 1745, Ministering angel, 82 cm (left), Pilgrim with flask, 54.5 cm (right), painted terracotta

RIGHT: **Andrea Brustolon**, *Jacob's Struggle with the Angel*, 1700–1710, beechwood, 46.5 cm

P. 634/635: **Matthias Steinl**, *Maria Immaculata*, 1688, wood, formerly gilt, 93 cm

Frankfurt a. M., Liebieghaus

ENFRENTE: **Johann Christian Wenzinger**, figuras del Ölberg de Staufen, 1745, genio afligido, 82 cm (a la izquierda), peregrino con cantimplora, 54,5 cm (a la derecha), terracota, pintado

A LA DERECHA: **Andrea Brustolon**, *Lucha de Iago con el ángel*, 1700–10, madera de boj, 46,5 cm

P. 634/35: **Matthias Steinl**, *María Inmaculada*, 1688, madera, antiguamente dorada, 93 cm

Francfort del Main, casa Liebieghaus

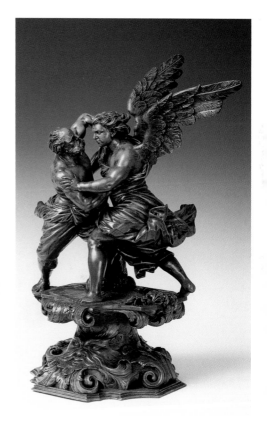

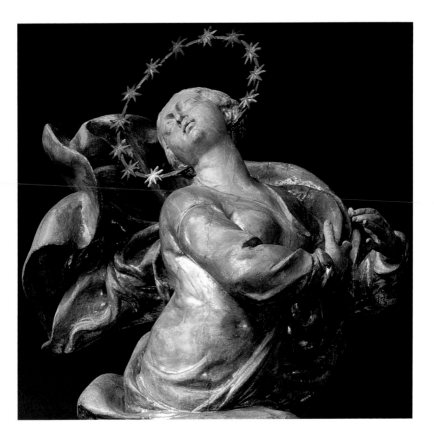

634

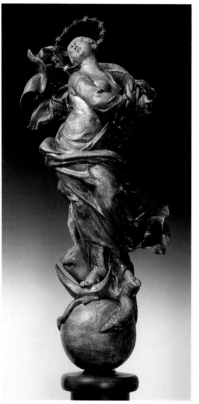

635

Late Baroque and Rococo

Without doubt, the *Apotheosis of Prince Eugene* is Permoser's masterpiece, a work that portrays the conquerer of the Turks in full armor, but also with a sensitively composed, individual physiognomy. The brothers Cosmas Damian Asam (1686–1739) and Egid Quirin Asam (1692–1750) are among the founders of southern German rococo. Typical late-baroque total works of art are the Benedictine church of Weltenburg and St. Johann Nepomuk in Munich (also known as the Asam church), whose architecture as well as sculpture, stucco decoration, and painting were created by the two brothers working together. Other significant southern German rococo sculptors such as Joseph Anton Feuchtmayr (1696–1770) or Johann Josef Christian (1706–1777) also made life-size figures of plaster. Johann Franz Schwanthaler (1683–1762) proved to be the founder of a widespread and—in southern Germany and the Austrian region—important sculptor family. His works are rather lyrical and introspective, in accordance with the style of the times.

Balthasar Permoser, *Apotheosis of Prince Eugene,* 1718–1721, marble, 230 cm, Vienna, Österreichische Galerie

Barroco tardío y rococó

Sin duda es la *Apoteosis del príncipe Eugenio* la obra principal de Permoser, que lo muestra triunfador sobre los turcos con armadura completa, pero con una fisonomía creada también con sensibilidad e individualidad. Los hermanos Cosmas Damian (1686–1739) y Egid Quirin Asam (1692–1750) se cuentan entre los fundadores del rococó en el sur de Alemania. Entre las obras de arte típicas del barroco tardío se encuentran la iglesia benedictina de Weltenburg y la iglesia de Juan de Nepomuco (denominada Asamkirche) en Múnich, cuya arquitectura, así como escultura y decoración de estucado y pintura crean los hermanos en conjunto. Asimismo, otros escultores significativos del rococó en el sur de Alemania, como Joseph Anton Feuchtmayer (1696–1770) o Johann Josef Christian (1706–77), crean figuras de tamaño natural en estucado. En las obras de Johann Franz Schwanthaler (1683–1762), vástago de una familia de escultores ampliamente extendida e importante en el sur de Alemania y en Austria, se hallan esculturas que, acorde al estilo de la época, tienen un efecto más bien lírico y ensimismado.

Balthasar Permoser, *Apoteosis del príncipe Eugenio,* 1718–21, mármol, 230 cm, Viena, galería Austríaca

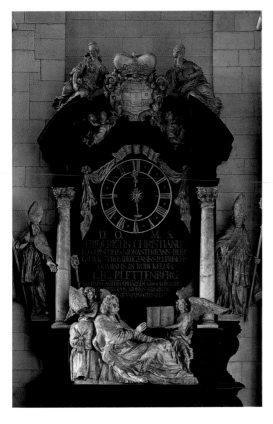

LEFT AND OPPOSITE: **Johann Mauritz, Johann W. Gröninger, Gottfried L. Pictorius,** tomb of Prince-Bishop Friedrich Christian von Plettenberg, begun 1707, marble and alabaster, Münster, cathedral

P. 640: **Egid Quirin Asam and Cosmas Damian Asam,** Munich, Asam church, 1733–1734, interior

P. 641: **Egid Quirin Asam,** *St. George and the Dragon,* 1721, stucco, gilt and silver-plated, Weltenburg, abbey church

A LA IZQUIERDA Y ENFRENTE: **Johann Mauritz, Johann W. Gröninger, Gottfried L. Pictorius,** sepultura del príncipe obispo Friedrich Christian von Plettenberg, comienzos de 1707, mármol y alabastro, Münster, catedral

P. 640: **Egid Quirin y Cosmas Damian Asam,** Múnich, iglesia de Juan Nepomuco "Asam-kirche", 1733–34, interior

P. 641: **Egid Asam,** *San Jorge luchando contra el dragón,* 1721, estucado, dorado y plateado, Weltenburg, iglesia conventual

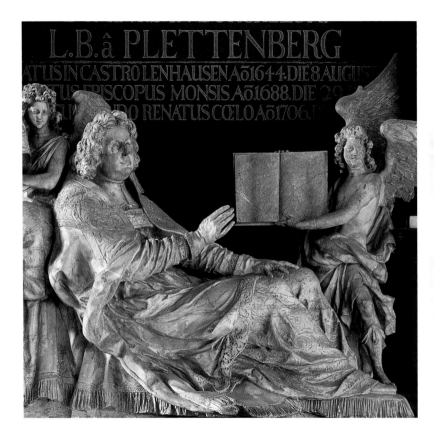

L.B. â PLETTENBERG

...ATUS IN CASTRO LENHAUSEN Aō 1644. DIE 8 AUGUS...
...TUS EPISCOPUS MONSIS Aō 1688. DIE 29...
...RENATUS CŒLO Aō 1706....

639

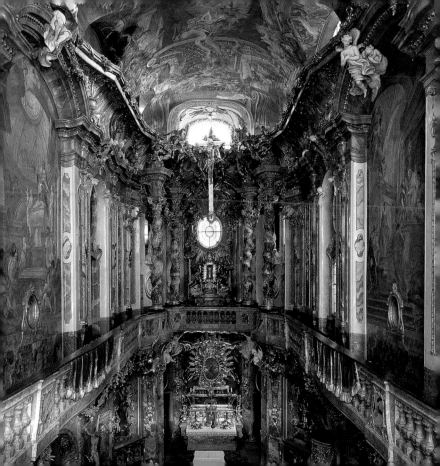

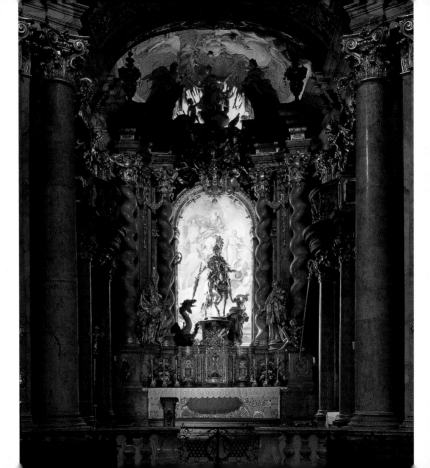

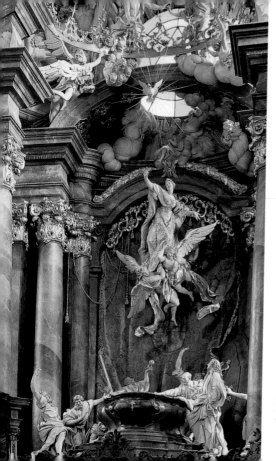

LEFT AND OPPOSITE:
Egid Quirin Asam,
Assumption of the Virgin,
1723, stucco decorated with
gold, Rohr, Augustian abbey
and collegiate church

A LA IZQUIERDA Y ENFRENTE:
Egid Quirin Asam, *Asunción
de Nuestra Señora*, 1723,
estucado adornado con oro,
Rohr, iglesia conventual de los
coristas augustinos

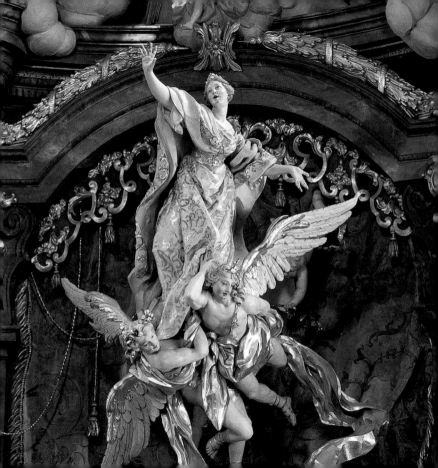

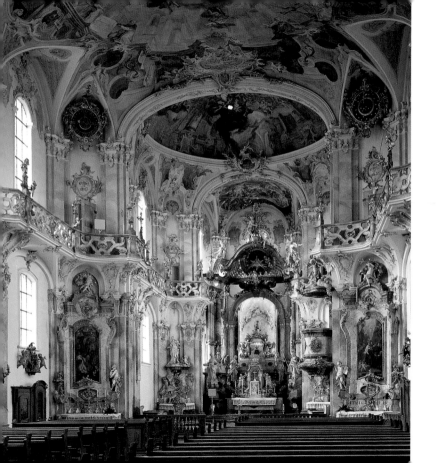

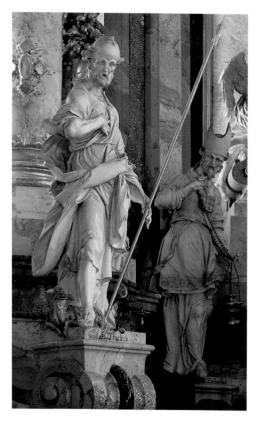

Joseph Anton Feuchtmayr

OPPOSITE: Birnau, pilgrimage
church of Our Lady, 1748–1750,
interior view

LEFT: St. Joachim, 1749, stucco,
life-size, Birnau, pilgrimage church
of Our Lady

Joseph Anton Feuchtmayr

ENFRENTE: Birnau, iglesia de
Peregrinación de Nuestra Señora,
1748–50, vista del interior

A LA IZQUIERDA: San Joaquín,
1749, estucado, de tamaño
natural, Birnau, iglesia de
Peregrinación de Nuestra Señora

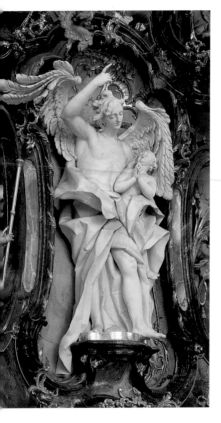
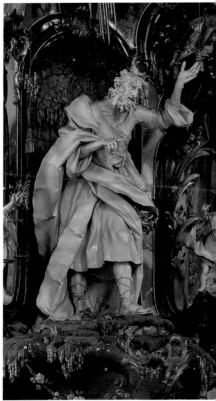

Johann Joseph Christian

OPPOSITE LEFT: Benedictine abbey church, angel on altar in the southern crossing, ca. 1760

OPPOSITE RIGHT: the prophet Ezekiel, 1752–1756, stucco, life-size, Zwiefalten, Benedictine abbey church

RIGHT: **Johann Franz Schwanthaler**, St. Margaret, ca. 1750, painted and gilt wood, Wippenham bei Ried, parish church

Johann Joseph Christian

ENFRENTE A LA IZQUIERDA: Ottobeuren, iglesia de la abadía benedictina, ángel del altar en la intersección sur de la nave, hacia 1760

ENFRENTE A LA DERECHA: El profeta Ezequiel, 1752–56, estucado, de tamaño natural, Zwiefalten, iglesia conventual benedictina

A LA DERECHA: **Johann Franz Schwanthaler**, Santa Margarita, hacia 1750, madera, pintada y dorada, Wippenham bei Ried, iglesia parroquial

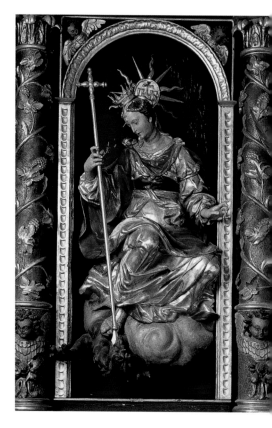

647

LEFT: **Johann Lukas von Hildebrand**, Vienna, Lower Belvedere, 1713–1716, with figures by Messerschmidt and others

P. 650/651: **Georg Raphael Donner**, Mehlmarkt or Providentia Fountain, 1737–1739, lead-tin alloy, 337 cm, Vienna, Österreichische Galerie, Lower Belvedere

A LA IZQUIERDA: **Johann Lukas von Hildebrand**, Viena, Belvedere inferior, 1713–16, con figuras de Messerschmidt entre otros

P. 650/51: **Georg Raphael Donner**, fuente Mehlmarkt, 1737–39, aleación plomo-cinc, 337 cm, Viena, galería Austriaca, Belvedere inferior

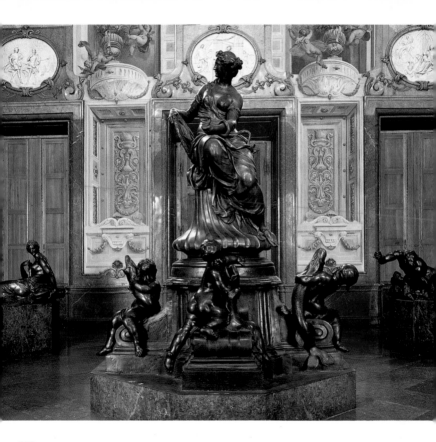

650

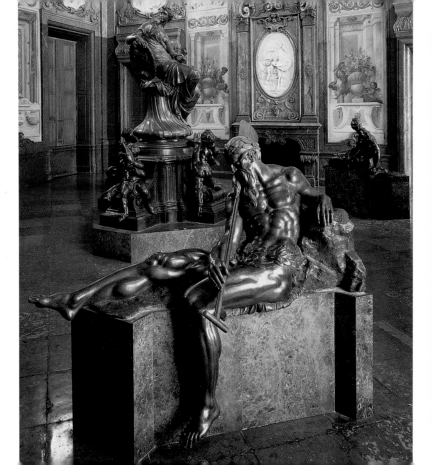

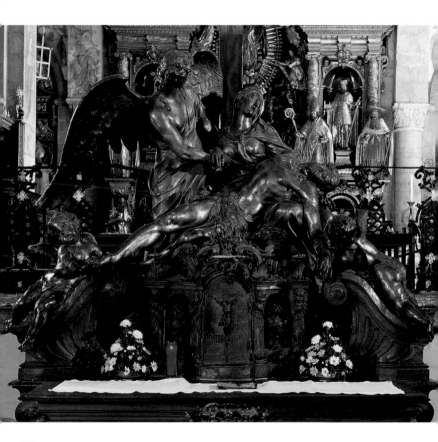

Late Baroque in Austria

One of the most important sculptors of the Austrian late baroque period is Georg Raphael Donner (1639–1741). The Viennese Mehlmarkt Fountain, one of his internationally outstanding works, like his later masterpiece the *Pietà* in Gurk, is difficult to categorize stylistically. His sculpture turns away from the heavy pathos of the baroque in favor of a rococo style that already displays classicist elements. The sculptor Josef Thaddäus Stammel (1695–1765) from Graz completed the decoration of the magnificent abbey library in the Austrian town of Admont. In his expressive figures he combined local stylistic traditions with the Italian baroque understanding of form. More spectacular and mysterious is the impression made by the character heads of German sculptor Franz Xaver Messerschmidt (1736–1783), whose work reflects the transition between Austrian rococo and classicism.

OPPOSITE: **Georg Raphael Donner**, *Pietá*, 1740–1741, lead, 220 x 280 cm (height x width), Gurk, cathedral

P. 654/655: **Joseph Thaddäus Stammel**, *Hell* (p. 655 left, detail p. 654) and *Death* (p. 655 right) from the *Four Last Things* group, 1760, bronzed wood, ca. 250 cm, Admont, abbey library

Barroco tardío en Austria

Uno de los escultores más importantes del barroco tardío en Austria es Georg Raphael Donner (1639–1741). La fuente vienesa Mehlmarkt, una de sus obras más destacadas en el ámbito internacional, presenta igual que su obra tardía, la *Pietá* de Gurk, un estilo difícil de categorizar. En sus obras el artista abandona el patetismo recargado del barroco a favor de un estilo rococó con muestras ya de elementos clasicistas. El escultor de Graz, Josef Tahaddäus Stammel (1695–1765), se encarga en Admont en Austria de la decoración externa escultórica de la pomposa biblioteca canóniga. En sus expresivas figuras se aglomeran las tradiciones estilísticas de la región con la filosofía de formas del barroco italiano. Las cabezas con expresiones de carácter del escultor alemán Franz Xaver Messerschmidt (1736–83) impresionan por su efecto espectacular y enigmático, y dan muestras de la transición del rococó austriaco al clasicismo.

ENFRENTE: **Georg Raphael Donner**, *Pietá*, 1740–41, plomo, 220 x 280 cm (alto x ancho), Gurk, catedral

P. 654/55: **Joseph Thaddäus Stammel**, *El infierno* (p. 655 a la izquierda; detalle p. 654) y *La muerte* (p. 655 a la derecha) del grupo *Las cuatro últimas cosas*, 1760, madera, bronceada, aprox. 250 cm, Admont, biblioteca canóniga

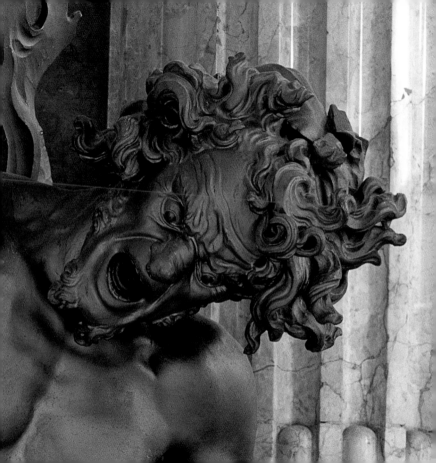

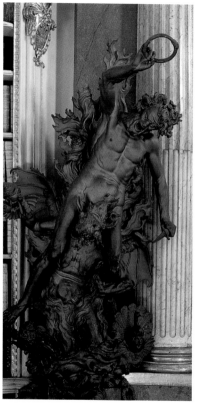
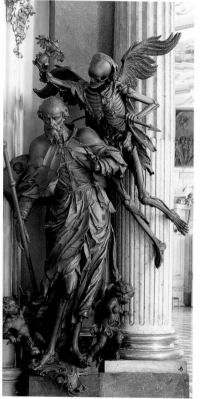

BELOW AND OPPOSITE: **Johann Bernhard Fischer von Erlach, Daniel Gran, Michael Rottmayr** (design), **Johann Georg Pichler** and **Johann Nikolaus Moll** (execution), **Balthasar Moll** (additions), tomb of Charles VI, ca. 1750, cast tin, Vienna, Imperial Vault in the Capuchin Church

ABAJO Y ENFRENTE: **Johann Bernhard Fischer von Erlach, Daniel Gran, Michael Rottmayr** (bocetos), **Johann Georg Pichler** y **Johann Nikolaus Moll** (realización), **Balthasar Moll** (añadiduras), féretro de Carlos VI, hacia 1750, fundición de cinc, Viena, sepultura imperial en la iglesia de los capuchinos

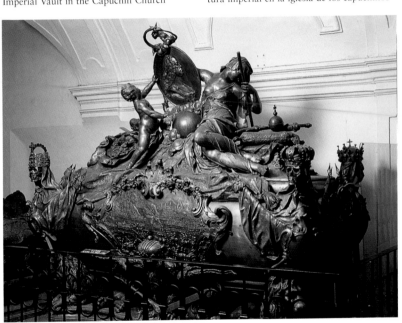

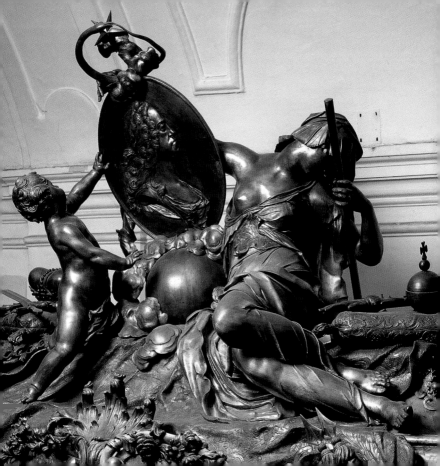

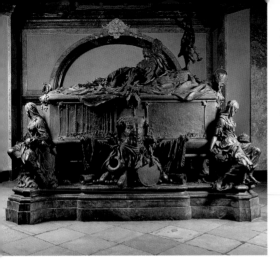

Balthasar Moll
LEFT: Double tomb of Maria Theresa and Francis I, 1754, cast tin, Vienna, Imperial Vault in the Capuchin Church

OPPOSITE ABOVE: Two crowned skulls from the tomb of Charles VI

OPPOSITE BOTTOM LEFT: Mourners from the double tomb of Maria Theresa and Francis I

OPPOSITE BOTTOM RIGHT: Mourners from the casket of Empress Elizabeth Christina

Balthasar Moll
A LA IZQUIERDA: Féretro doble de María Teresa y Francisco I, 1754, fundición de cinc, Viena, sepultura imperial en la iglesia de los capuchinos

ENFRENTE ARRIBA: Dos calaveras con coronas de la sepultura de Carlos VI

ENFRENTE ABAJO A LA IZQUIERDA: Afligidos junto al féretro doble de María Teresa y Francisco I

ENFRENTE ABAJO A LA DERECHA: Afligidos junto al féretro de la emperatriz Isabel Cristina

In order to be present to the living in several places at the same time even after their death, the Habsburgs had their bodies, hearts, and inner organs buried in different tombs, which resulted in a spate of baroque tomb sculpture.

A fin de estar presentes entre los vivientes en varios lugares al mismo tiempo, incluso después de la muerte, los Habsburgo sepultaron en tumbas diferentes cuerpo, corazón y entrañas, lo cual tuvo como consecuencia un florecimiento de la escultura fúnebre barroca.

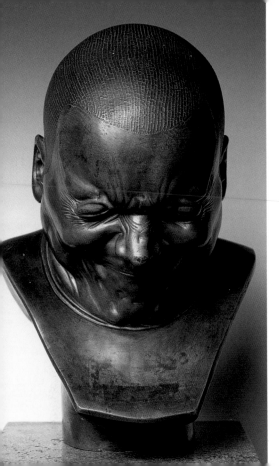

LEFT, OPPOSITE, P. 662/663:
Franz Xaver Messerschmidt,
four character heads, 1770–
1783, Vienna, Österreichische
Galerie, Lower Belvedere

The Arch-Evil, tin-lead alloy,
38.5 cm (left),
The Hanged, alabaster, 38 cm
(opposite),
The Lecher, marble, 45 cm
(p. 662),
The Beaked (frontal and side
views), alabaster, 43 cm (p.
663)

A LA IZQUIERDA, ENFRENTE,
P. 662/63: **Franz Xaver
Messerschmidt,** *cuatro cabezas
con expresiones de carácter,
1770-83, Viena, galería
Austriaca, Belvedere inferior*

Un malvado, aleación cinc-
plomo, 38,5 cm (a la
izquierda),
Un colgado, alabastro, 38 cm
(enfrente),
Fatuo lascivo, mármol, 45 cm
(p. 662),
Segunda cabeza de pico (fron-
tal, vista lateral), alabastro,
43 cm (p. 663)

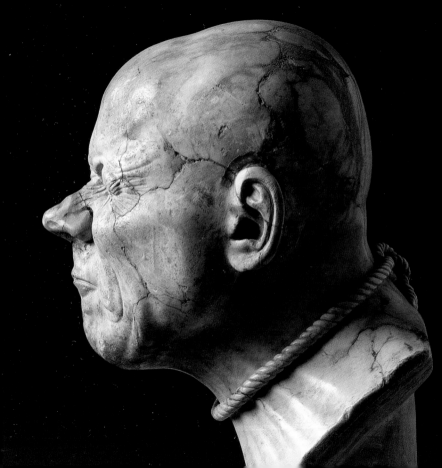

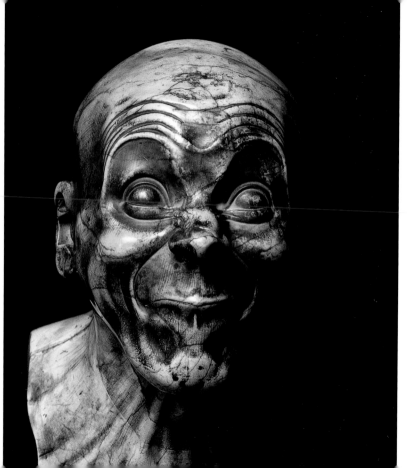

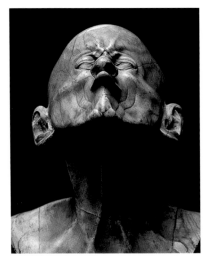

Plagued by base sensuality, the artist tries to ward off evil by embodying doom in the grimaces of his character heads. The portrait-like quality of the heads may explain why they are stylistically so elusive. Messerschmidt clearly distances himself from the absolutist past and draws on the most intimate motives.

Atormentado por una sensualidad animal, el artista intenta defenderse contra el mal personificando artísticamente la fatalidad en las muecas. La calidad de retrato hace posible argumentar que las cabezas no son estilísticamente comprensibles. Así, el artista se distancia claramente del pasado absolutista y reivindica motivos personales.

Adam Ferdinand Tietz
OPPOSITE: *Parnassus*, 1766,
sandstone, formerly gilt,
Veitshöchheim bei Würzburg,
palace park

RIGHT: One of the numerous
sculptures by Ferdinand Tietz in
the gardens at Veitshöchheim

Adam Ferdinand Tietz
ENFRENTE: *El Parnaso*, 1766,
piedra arenisca, antiguamente
dorada, Veitshöchheim cerca de
Würzburg, parque del palacio

A LA DERECHA: Una de las
numerosas esculturas de
Ferdinand Tietz en el jardín de
Veitshöchheim

Three representations of the *Pietà* from the hand of one sculptor mark the transition from late baroque to classicism. The deep intimacy between mother and dying son conveyed in the first example (below and p. 668) gradually recedes in the second work (right), finally becoming only a generalization of sacrificial death and mourning (opposite right and p. 669).

Franz Ignaz Günther
BOTTOM AND P. 668: *Pietà*, 1758, painted wood, Kircheiselfing bei Wasserburg, parish church of St. Rupertus

RIGHT: *Pietà*, 1764, painted wood, 113 cm, Weyarn, former Augustian monastery and collegiate church

P. 667 RIGHT AND P. 669: *Pietà*, 1774, painted wood, 163 cm, Nenningen, cemetery chapel

Franz Ignaz Günther
ABAJO Y P. 668: *Pietá*, 1758, madera, pintada, Kircheiselfing junto a Wasserburg, iglesia parroquial San Ruperto

A LA DERECHA: *Pietá*, 1764, madera, pintada, 113 cm, Weyarn, antigua iglesia conventual de coristas augustinos

P. 667 A LA DERECHA P. 669: *Pietá*, 1774, madera, pintada, 163 cm, Nenningen, capilla del cementerio

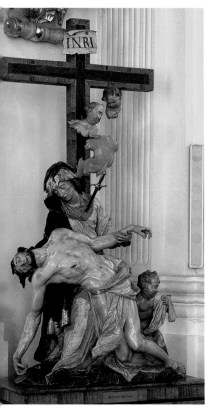

Tres representaciones de la *Piedad* de la mano de un escultor marcan la transición del barroco tardío al clasicismo. Así, se va deshaciendo en la segunda escultura (a la izquierda) la intimidad profunda que aparece en primer lugar, de madre e hijo agonizante (enfrente a la izquierda y p. 668), para enseñar únicamente una generalización del sacrificio y la aflicción (abajo y p. 669).

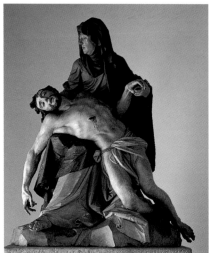

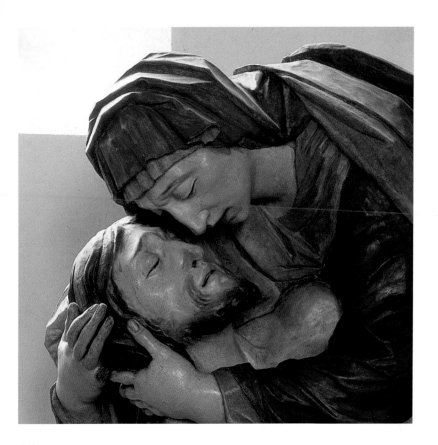

668

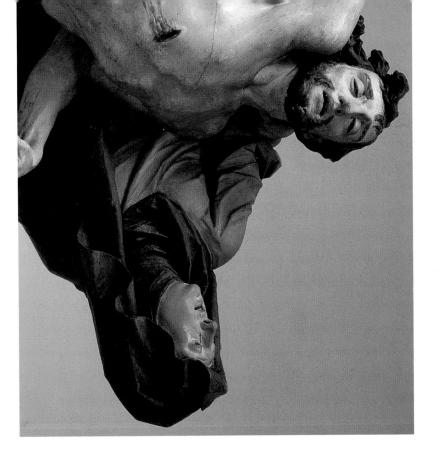

Picture Credits

Bencini, Raffaello: 263, 370, 371, 372, 375, 376, 377, 381, 382, 386, 387, 388, 389 l., 415, 417, 419, 420, 421, 424, 425

Böhm, Osvaldo: 426

Fantoni: 404, 405

McLean, Alick: 410 l., r.

Marton, Paolo: 389 r., 408, 428, 432, 434, 435

Orsi Batttaglini, Nicoló: 414

Rabatti, Marco, and Domingie, Serge: 378 l., r., 379, 392, 393, 394, 396, 397, 411, 418 l., r., 433 l., r.

Scala: 395, 409, 422, 429

All remaining illustrations – with the exception of pieces belonging to museums in London, Paris, Vienna, Berlin and Braunschweig – are from the archive of the photographer Achim Bednorz in Cologne.

Créditos fotográficos

Bencini, Raffaello: 263, 370, 371, 372, 375, 376, 377, 381, 382, 386, 387, 388, 389 i., 415, 417, 419, 420, 421, 424, 425

Böhm, Osvaldo: 426

Fantoni: 404, 405

McLean, Alick: 410 i., d.

Marton, Paolo: 389 d., 408, 428, 432, 434, 435

Orsi Batttaglini, Nicoló: 414

Rabatti, Marco, y Domingie, Serge: 378 i., d., 379, 392, 393, 394, 396, 397, 411, 418 i., d., 433 i., d.

Scala: 395, 409, 422, 429

Todas las ilustraciones restantes —a excepción de los que pertenecen a los museos de Londres, París, Viena, Berlín y Brunswick— son del archivo del fotógrafo Achim Bednorz en Colonia.